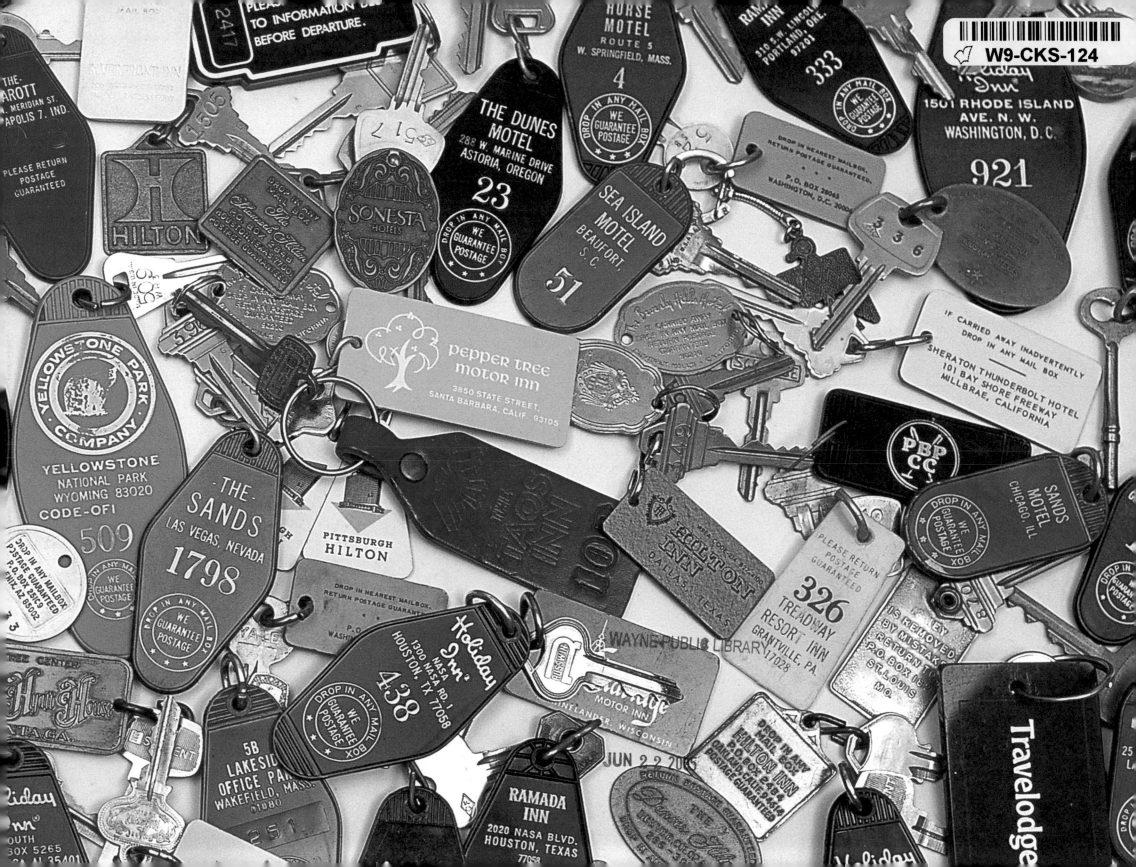

HARRY BENSON'S AMERICA

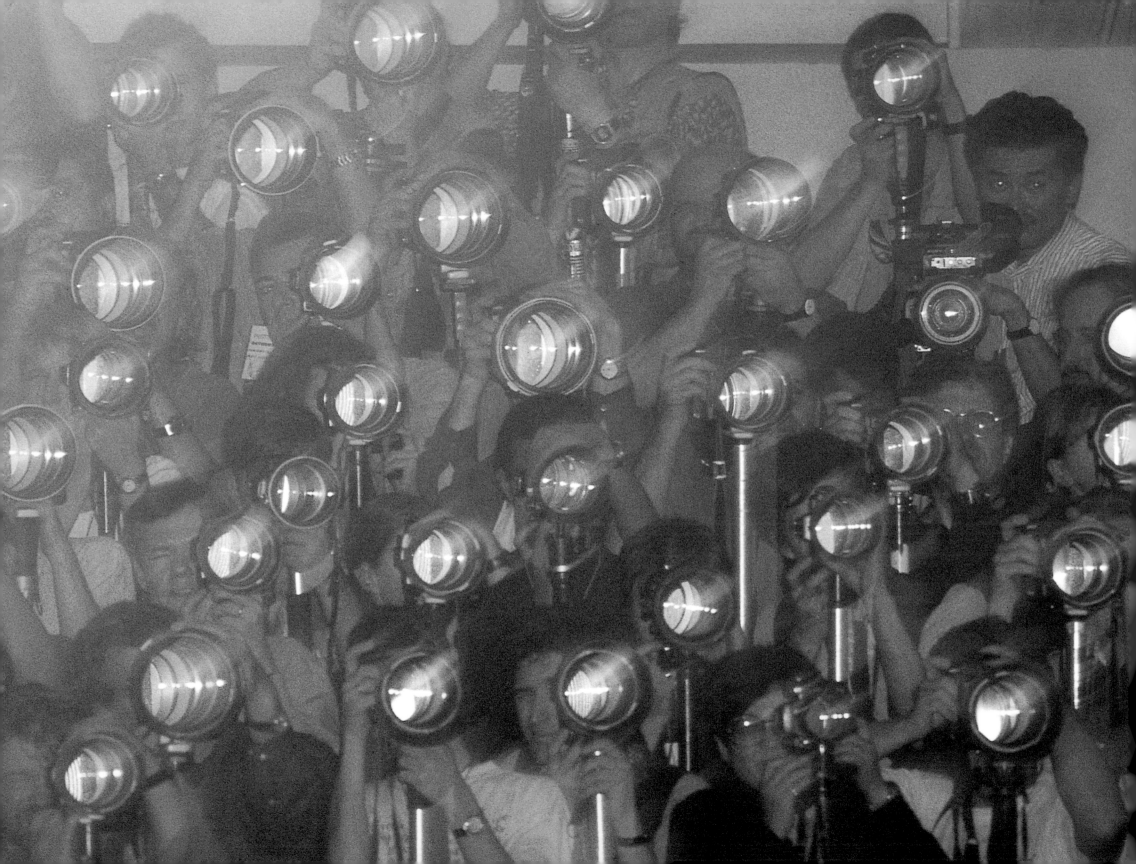

HARRY BENSON'S AMERICA

HARRY N. ABRAMS, INC., PUBLISHERS

PROJECT MANAGER: Eric Himmel
EDITORS: Deborah Aaronson and Gigi Benson
ART DIRECTOR / DESIGNER: Michael J. Walsh, Jr
PRODUCTION MANAGER: Maria Pia Gramaglia

Library of Congress Cataloging-in-Publication Data

Benson, Harry.
 Harry Benson's America / by Harry Benson.
 p. cm.
 ISBN 0-8109-5896-1
 1. Photojournalism–United States. 2. United States–Social life and
customs–Pictorial works. 3. Celebrities–United States–Portraits. I. Title.

TR820.B426 2005
779'.9973—dc22
 2004023440

Text by Gigi Benson
Copyright © 2005 Harry Benson

Printed and bound in China

10 9 8 7 6 5 4 3 2 1

Harry N. Abrams, Inc.
100 Fifth Avenue
New York, N.Y. 10011
www.abramsbooks.com

Abrams is a subsidiary of LA MARTINIÈRE

Page 2: Photojounalists. NEW YORK, NEW YORK, 1994.

To Wendy, Tessa, and Mimi

ACKNOWLEDGMENTS

I would like to thank my wife, Gigi, and Deborah Aaronson, editor, Michael Walsh, creative director, and Eric Himmel, editor-in-chief, of Harry N. Abrams for making this book a reality. My thanks to editors and colleagues whom I have worked with over the years: John Loengard, Dick Stolley, Jim Gaines, David Friend, Sean Callahan, Bobbi Baker Burrows, M.C. Marden, Mary Dunn, Graydon Carter, Lanny Jones, Dan Okrent, Robert Sullivan, David Remnick, David Schonauer, Jean-Jacques Naudet, Ian Spanier, Jay Lovinger, Simon Barnett, Margot Dougherty, Tom Reynolds, Eleanore and Ralph Graves, Ed Kosner, Susan White, Lisa Berman, David Harris, Karen Frank, Judy Fayard, Susan Vermazen, Tina Brown, James Danziger, Robin Bierstedt, Robert Friedman, MaryAnne Golon, Etheleen Staley, Take Wise, Jodi and Holden Luntz, David Barenholtz, Carlo Pediani, Stuart Woods, Francine Crescent, Roberta Doyle, Val Atkinson, Andy Fyall, Victor Davis, Ivor Davis, Jimmy Walsh, Sam Kusumoto, Michael Coady, Clay Felker, Stef Heckscher, Mel Scott, Tala Skari, Dave Metz, Chris Whipple, Ron Bailey, David Sherman, Steve Robinson, Edward Barnes, Marie Schumann, Phil Seltzer, David Breul, Lord Beaverbrook, Sir Max Aitken, Frank Spooner, Peter Baker, Harold Keeble, Derek Marks, Derek Lambert, Freddy Wackett, Bob Edwards, Tom Murray, Sir David English, Andrew Robb, Len Franklin, Sir Ted Pickering, Jeremy Banks, Ronnie Burns, Alex Thomson, Sarah McDonald, Matthew Butson, Alex Timms, Amy Hidalgo, Lou Desiderio, Zee Morin, Kenneth and Richard Troiano, and Igor Bakht; photographers Jonathan Delano, Charlie McBain, David Cairns, Alfred Eisenstadt, Tommy Fitzpatrick, and Ralph Morse, who gave me my first assignment at LIFE. And my parents for giving me my first camera.

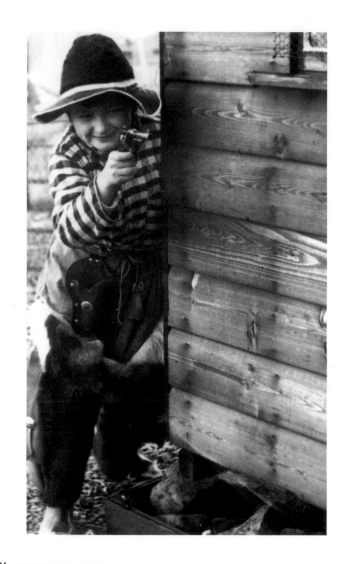

Me. CHRISTMAS DAY, GLASGOW, SCOTLAND, 1936.

AMERICAN JOURNEY

I WAS CONCEIVED IN AN APARTMENT ON FLATBUSH AVENUE in Brooklyn in 1929. My father thought 1929 was the time to come to America, which, in retrospect, it wasn't. In three months' time the family was back in Glasgow.

When I was growing up, my father spoke about his time in New York as if he'd been there for years when actually it was only a matter of months. He would mention different parts of the city that I have come to know so well. He spoke about the church on Wall Street. While working in a bank nearby, he would take his sandwich and coffee and eat lunch on a bench there each day. My mother told me she had always wanted to stay, but my father missed his friends and his football (soccer) games.

When I was young my major ambition was to play football for Scotland, and actually it still is. I also loved looking at paintings and photographs and listening to the news, especially of America. I had thought about America for a very long time before I accompanied the Beatles here in 1964. My favorite song has always been the Rodgers and Hart classic, "Manhattan." The lyrics described a distant place full of excitement and possibilities for me.

As a child in Glasgow, I became fascinated with America when my mother started taking me to see American movies after school when I was about six years old. I loved Myrna Loy, Fred Astaire, the Ziegfeld Follies, and especially Roy Rogers and Hopalong Cassidy. As we were leaving the theater she always said, "Now don't tell your father." It was a little secret my mother and I shared. I thought of America as exciting, far-off, and exactly as it was in the movies, and that's how I have found it. Well, almost. But America has not disappointed me.

I had never seen a person of another race until the United States armed forces came over to prepare for World War II when I was twelve. To my knowledge we didn't know what segregation was, it was new to us, and yet I remember the black soldiers would march together, not with the other soldiers. This was in 1942 and Glasgow was a big dancing city in those days. In the dance halls, which could be quite rough, there were some nasty fights between the white and the black American soldiers, although I remember all of them as being kind. A few times my parents invited a soldier over for dinner and we shared our rations with him. Our guest would always bring a carton of cigarettes or some candies, and I would ask questions about Edward G. Robinson or James Cagney. These experiences helped shape my idea of America.

When I went to work in London for Lord Beaverbrook's *Daily Express*, considered the best newspaper in Britain at the time, I always kept in mind that I wanted to live and work in the United States. LIFE magazine was the ultimate picture magazine and I wanted to work for LIFE. The vision from the films I had seen as a youth of glamorous America was still in the back of my mind as well.

THE BEATLES CAME ALONG and I was lucky enough to come to New York with them, and I made the most of it. It was February 7, 1964. The Beatles were very excited and concerned because they didn't quite know what to expect, but I think I was even more excited and more thrilled about coming to a city that had been in my imagination forever. It was my first trip to America. "Manhattan" kept coming into my head. Some British photographers and I took a taxi on a very cold night to the boardwalk at Coney Island to eat hot dogs; I strolled

through Central Park. The song was coming alive. I couldn't get enough of it. It sounds a little bit corny, but it's true.

After New York, we went to Washington, D.C., and Miami. I couldn't believe the Miami beaches. The water was brilliant. It was February and it was warm enough to swim. I was overwhelmed by everything I saw and everywhere I went.

Back in London I told Frank Spooner, my picture editor, that if he didn't send me to cover America for the *Express*, I was going anyway. In 1965 I replaced Bill Lovelace, who had been posted in the United States for two years. I traveled to every state, covered every major news story, sporting event, movie star, civil rights march, everything I could possibly photograph. I loved going to the famous landmarks in New York like P.J. Clarke's where I knew part of the Ray Milland drama *The Lost Weekend* had been filmed. New York has a certain mystique that just doesn't fade.

My first real apartment was in New York. I had lived in a virtual hovel in London just to be near the office; it was hot in the summer and freezing in the winter. The doorman of my New York apartment building told me it had previously been Rock Hudson's apartment. (I don't know if that was true, but it was furnished quite nicely.) I could call and get a pizza delivered. I could walk to the movies. I could have friends over for a drink. I wasn't about to give this up without a fight.

The 1960s were turbulent times in the United States: the race riots, the Vietnam protests, the 1968 assassinations of Martin Luther King, Jr., and then Bobby Kennedy, both of whom I had gotten to know. I've always thought that 1968 was the year America had a nervous breakdown. But I still didn't want to leave. I wasn't going back.

One thing I particularly liked was that across this vast country, the people all spoke English, not a different language every few hundred miles. They had a harder time understanding me than I had understanding them. It was my Scottish accent, which I believe has softened over the years. Mind you, I've never lost my love for Scotland, the place where I was born. That would be hard. I love to see old pals, visit old haunts, see a football match, and play a round of golf, but after three or four days I'm ready to get back to my family and my dogs in New York.

Texas was a state that fascinated me: Gene Autry, Roy Rogers, John Wayne, and the Alamo. People always told me Texans were different from other Americans and I believe this is true. Texans have a pride in their state, and they love to tell you where they're from. I met my wife, Gigi, and her parents in Houston at the Rice Hotel, which has long since been demolished. I was covering HRH Prince Philip's visit to the NASA/Lyndon B. Johnson Space Center, and they were at a reception in his honor.

California is another place that has always fascinated me: San Francisco, Beverly Hills, and Larry Parks singing Al Jolson's "California, Here I Come." People say it's plastic, but what's so bad about driving along in a convertible in beautiful weather? Needless to say the city can be tough on those whose dreams don't come true, but that can be said of any place and any career choice. America and Americans are tough.

America has always remained what I had imagined. Even places that were economically depressed I found interesting. There was always that glimmer of hope in the people I would

Sheila, Tillie, Gio, and Susie. NEW YORK, NEW YORK, 1998.

The great LIFE magazine photographer Alfred Eisenstadt, Tessa, and me at the opening of my exhibition at Christie's. The evening was a benefit for The American Cancer Society. NEW YORK, NEW YORK, 1991.

encounter. I have never taken the United States for granted. It's always been new to me.

People often ask me what my favorite place is. It's every place I've taken good photos. If the pictures are good, I like the place where they were taken; it's as simple as that. Every assignment is different. There's always a picture to be had, you just have to find it. Nothing is worse than flying home into JFK airport and having inspiration on the plane about what picture should have been taken. No one ever leaves for an assignment with the idea of bringing in a bad picture, but sometimes it happens. Just move on as quickly as you can. Drop it. Do not try to consolidate mediocrity.

By 1968 I was working for LIFE magazine. In 1971, its last year as a weekly, I was told I was its most published photographer. I would do anything and everything offered to me. I know it sounds naive, but I've always had that attitude toward my photography. To this day, photography doesn't bore me. I could never do anything that bored me. I just want to put my camera in places a camera hasn't been before or take a new look at somewhere cameras have already been. That to me is photojournalism.

Have other photographers influenced me? Perhaps, but I've never found that looking at another photographer's work has consciously helped me the next day on an assignment.

Sundays growing up in Scotland were always rainy, blustery, and cold. There was nothing to do. We didn't have a television until the early 50s, only newspapers and the radio. Then back to school on Monday morning. I loved photography because it could take me places I hadn't been and would have loved to be. Photography wasn't boring; it was an escape, especially news photography. It was the most exciting and it made sense.

Time has gone so quickly. It's hard for me to believe I have photographed ten American presidents from Dwight D. Eisenhower to George W. Bush. I've worked quite closely with some of them. I've always felt the opportunity may be historic; to be there with the president alone photographing what was going on at the time. I've watched them when they were happy and when they were under extreme pressure.

What is it about America that interests me? The diversity of the people is amazing. Yet, in one way I find people more alike than unalike. They're all after a happy life.

Have I met some bad people? Indeed. Some uninformed? Yes. Some of the most forward-thinking? Yes, again. Do I like them all? Of course I do. I even like the excesses and the kooks. It takes all types and America has them all.

America has not been the same since the incredible blow it suffered on September 11, 2001, but Americans are survivors. That horrific day shocked the country back to its roots.

A few years ago I became an American citizen. It was an emotional time for me. Gigi is an American. Our daughters, Wendy and Tessa, and granddaughter, Mimi, are Americans. I live and work here; the United States is my home now.

I came to America and stayed. I knew I would stay. I had to stay. It's where I wanted to be. The photographs in this book are a journal of what I have seen and where I have been. In life you are lucky if you get more ups than downs. For me it is a continuing journey through a country that has fascinated me all my life.

HARRY BENSON

Tessa, me, and Gigi at Wendy's wedding to Michael Landes. NEW YORK, NEW YORK, 2000.

Mimi Cunningham Landes. LONDON, ENGLAND, 2004.

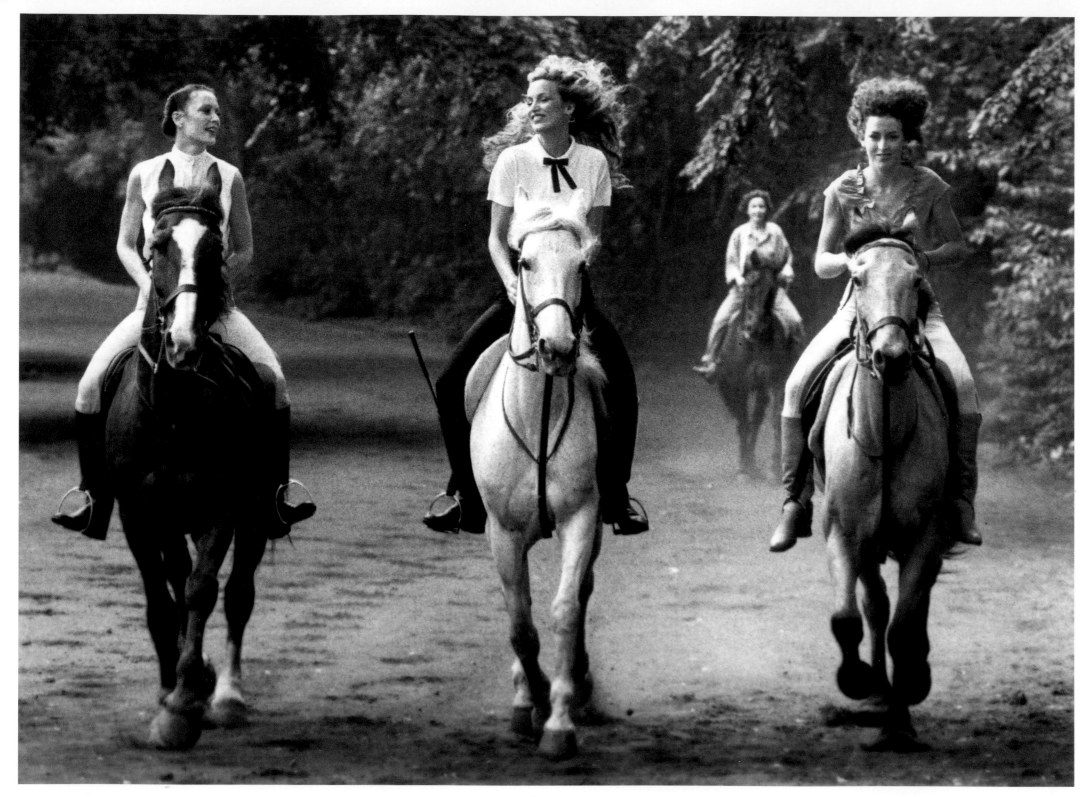

Cyndy, Jerry, Rosie, and Terry Hall (left to right). CENTRAL PARK, NEW YORK, NEW YORK, 1978.

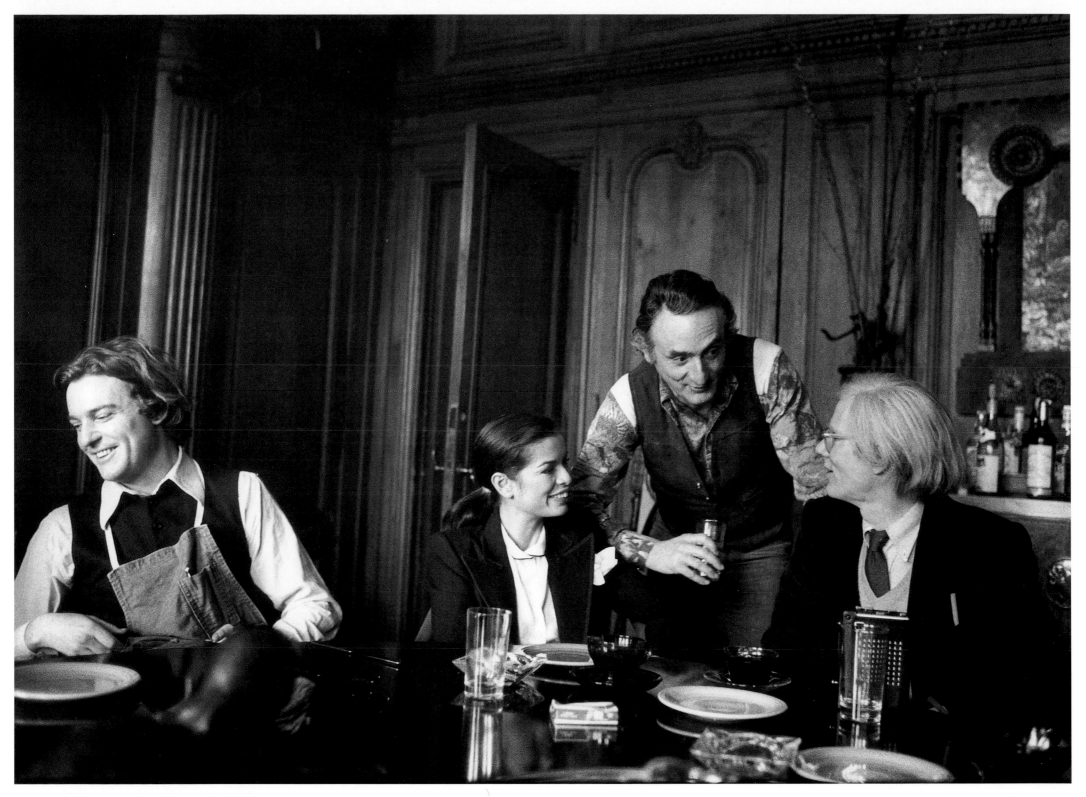

Jamie Wyeth, Bianca Jagger, Larry Rivers, and Andy Warhol. NEW YORK, NEW YORK, 1977

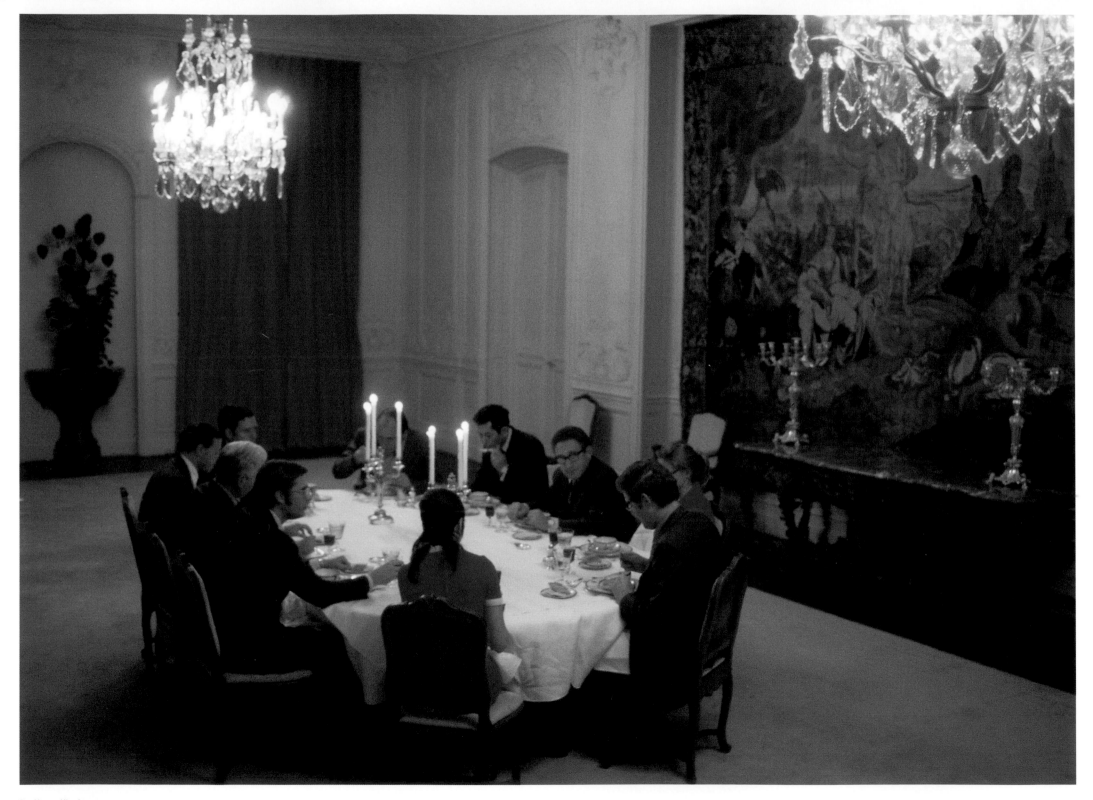

Dr. Henry Kissinger. PARIS, FRANCE, 1971.

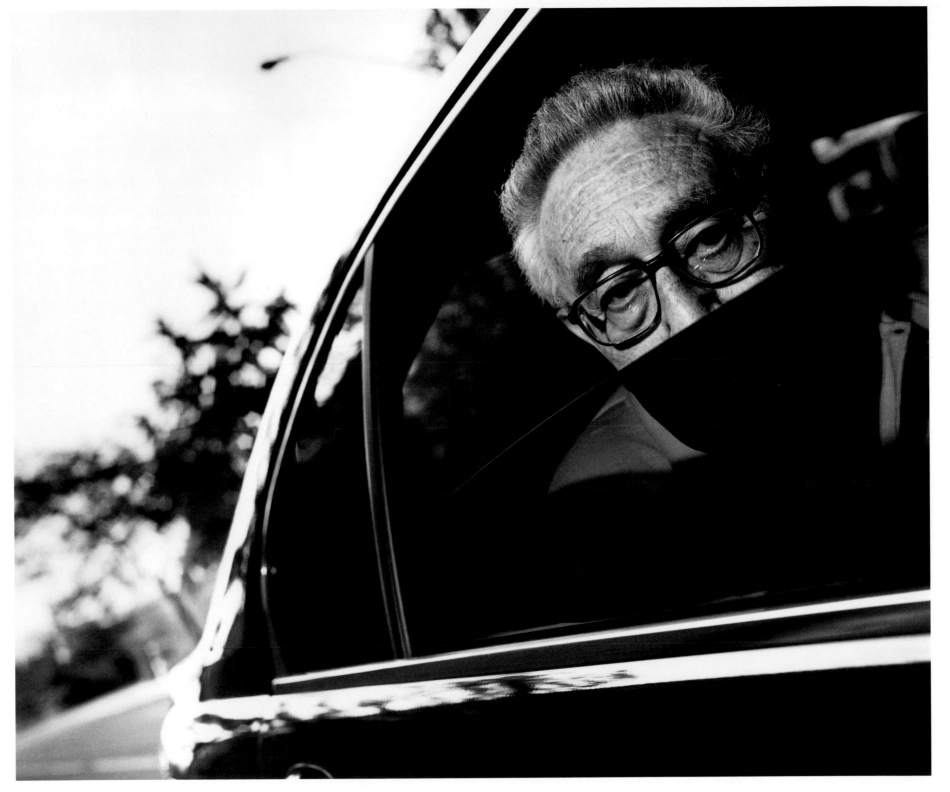

Dr. Henry Kissinger. NEW YORK, NEW YORK, 2003.

Jack Nicholson. ASPEN, COLORADO, 1990.

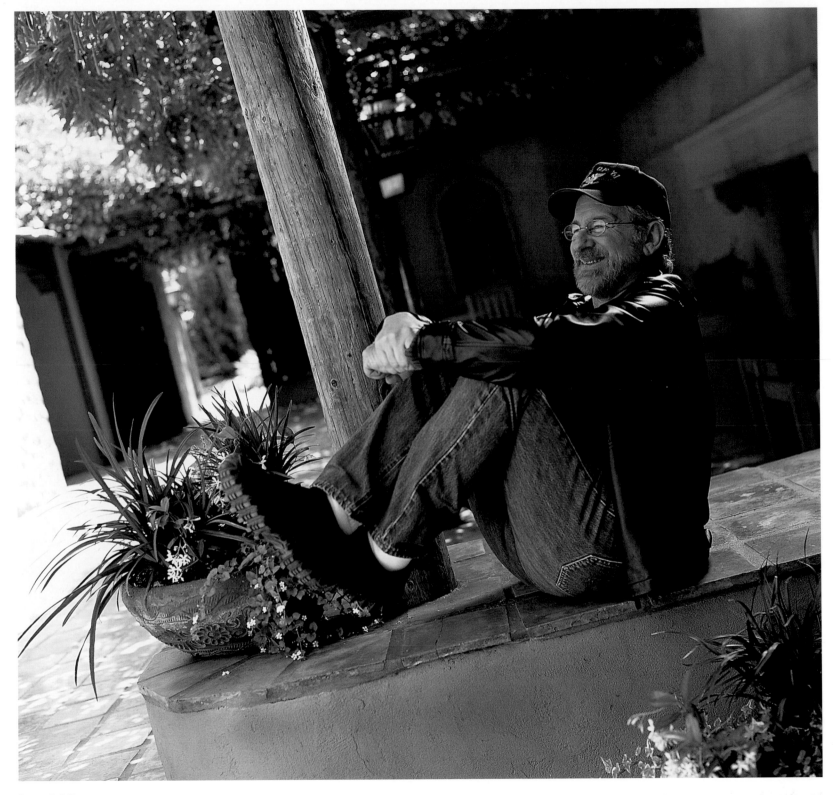

Steven Spielberg. LOS ANGELES, CALIFORNIA, 2002.

Carrie Fisher. NEW YORK, NEW YORK, 1978.

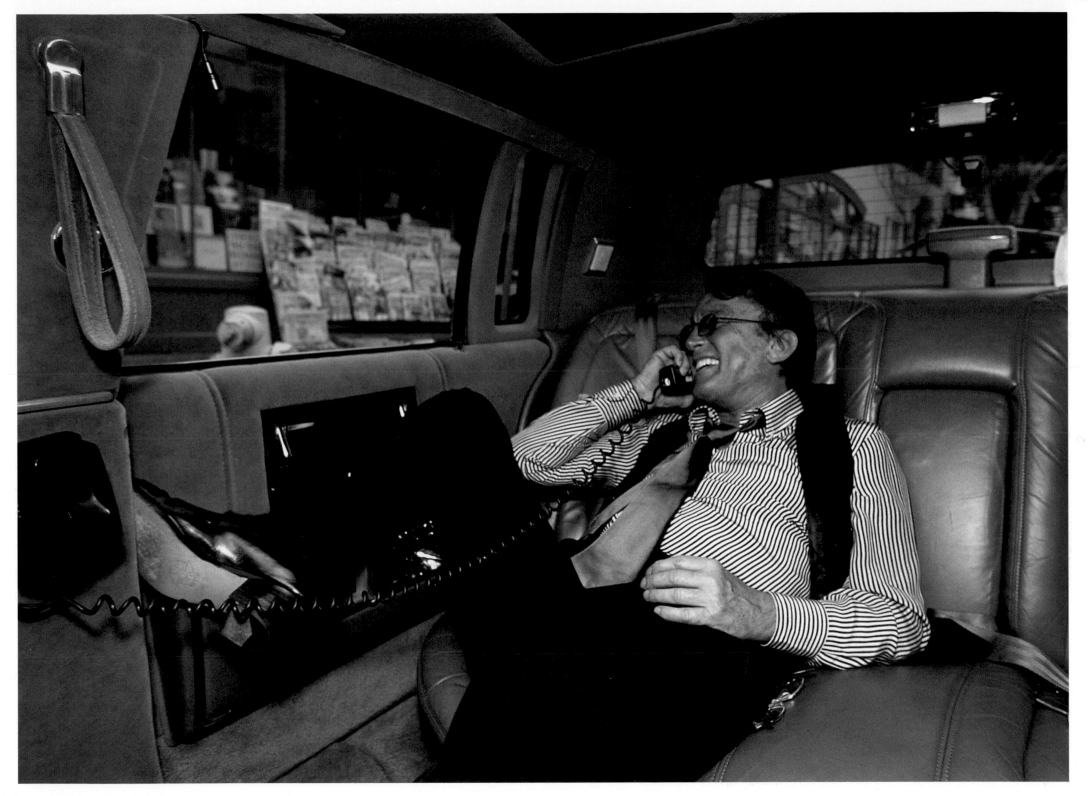

Robert Evans. LOS ANGELES, CALIFORNIA, 1994.

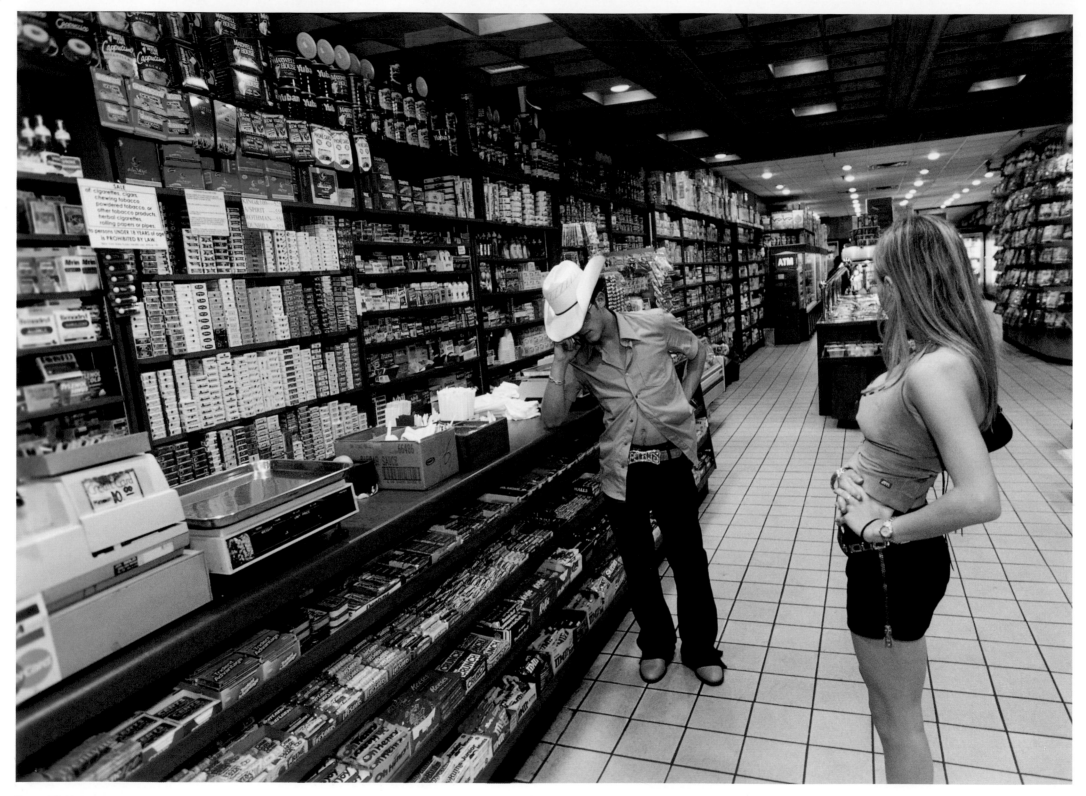

Ben and Dara. NEW YORK, NEW YORK, 2001.

Midtown disco. NEW YORK, NEW YORK, 2001.

Nightclub. SOUTH BEACH, FLORIDA, 2002. (TWO PHOTOS)

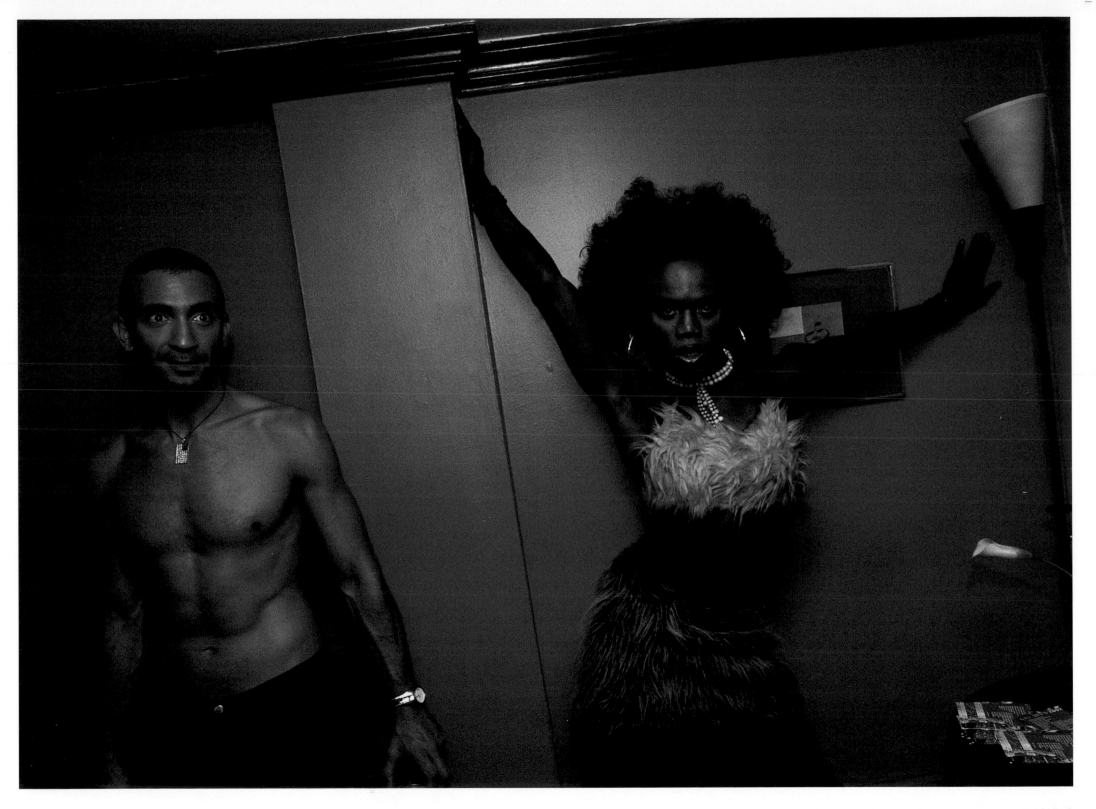

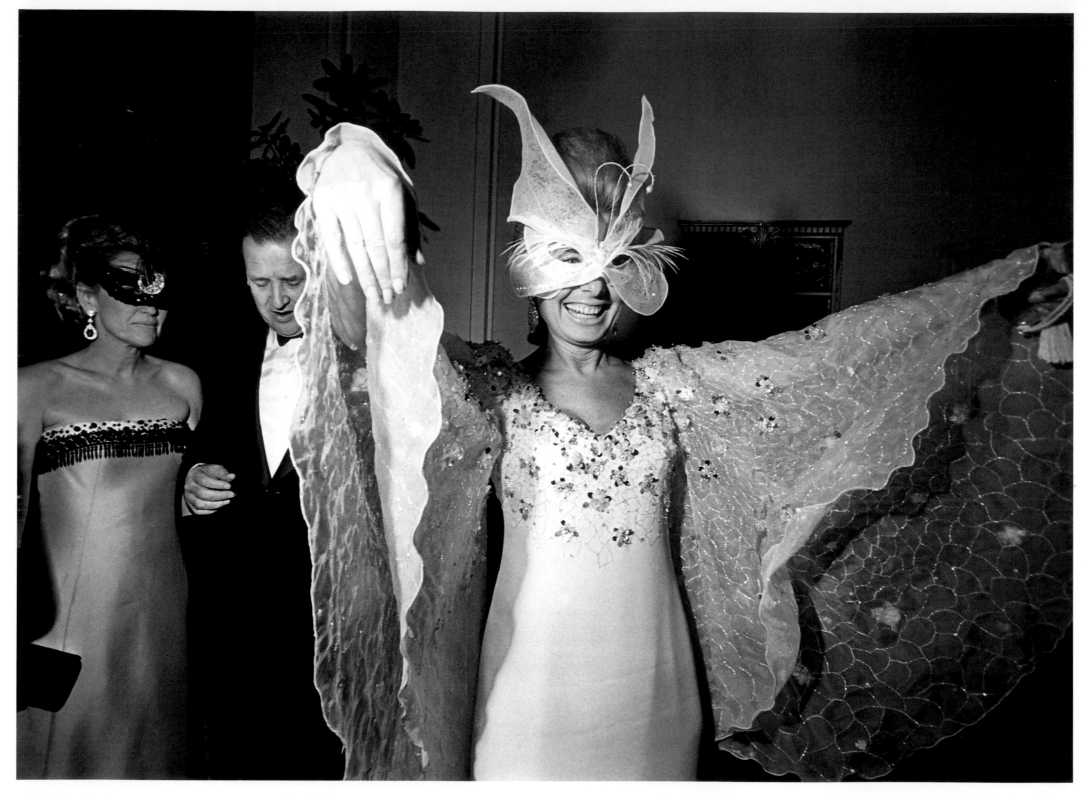

Christina Ford. PLAZA HOTEL, NEW YORK, NEW YORK, 1966.

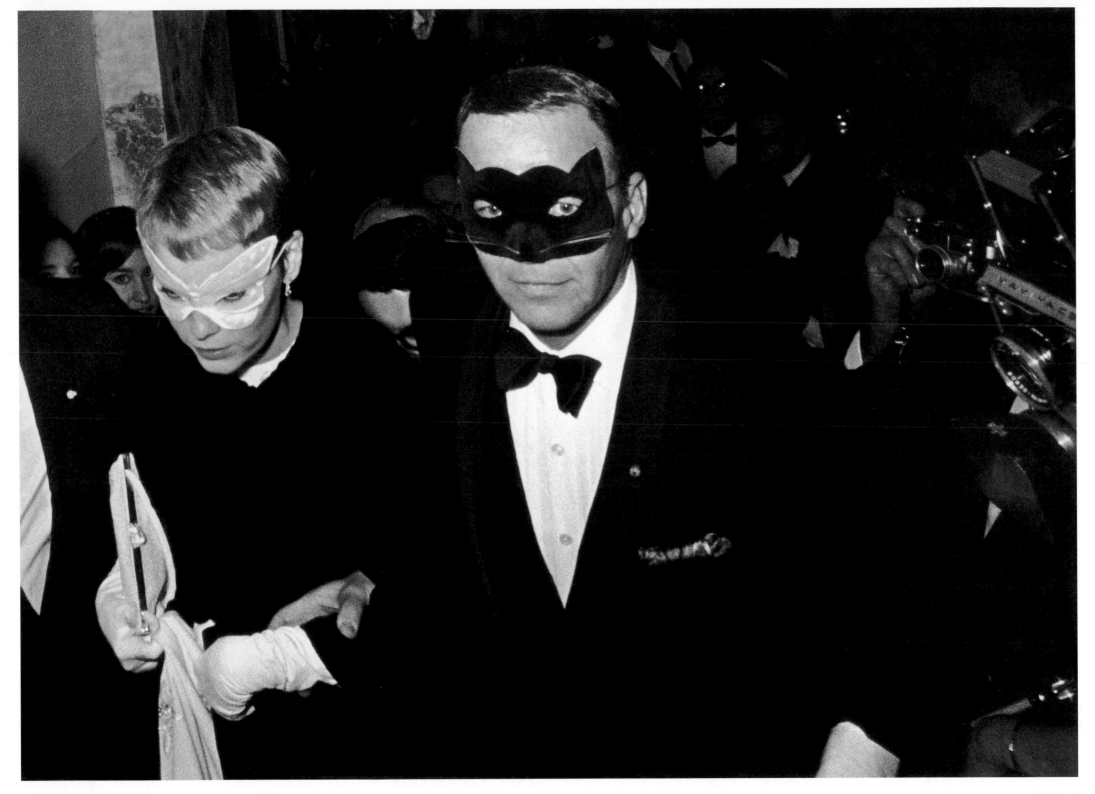

Mia Farrow and Frank Sinatra. PLAZA HOTEL, NEW YORK, NEW YORK, 1966.

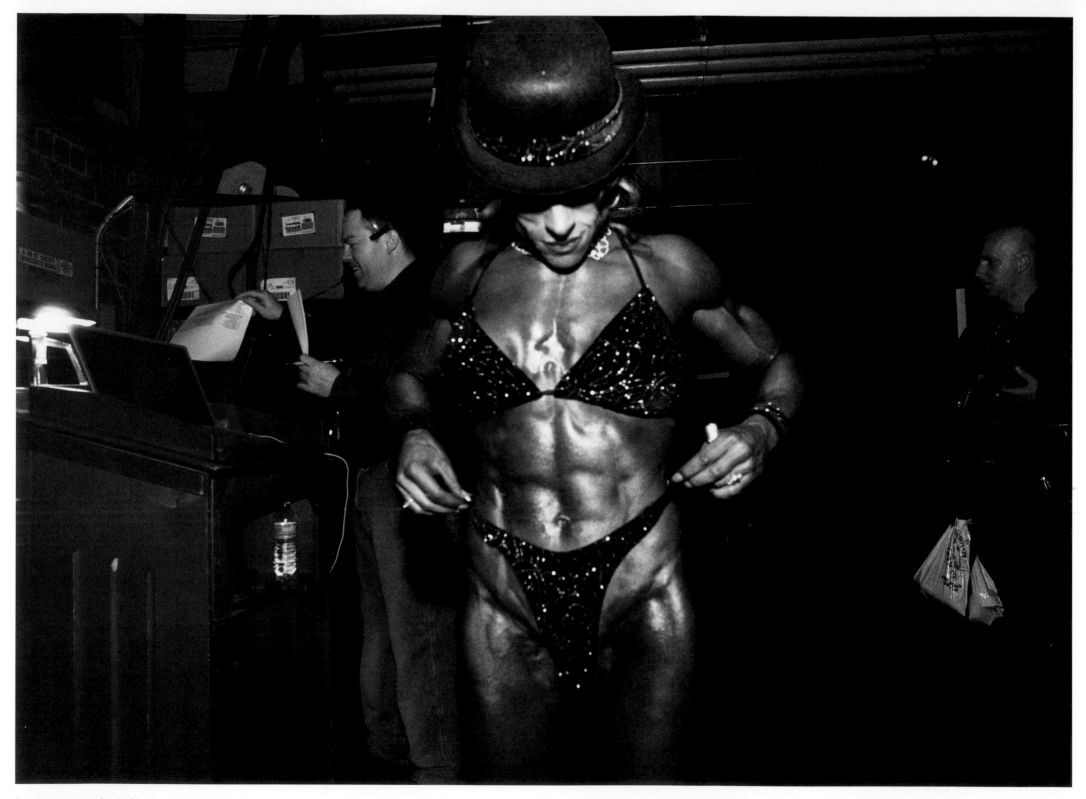

Female contestant, Arnold Classic. COLUMBUS, OHIO, 2004.

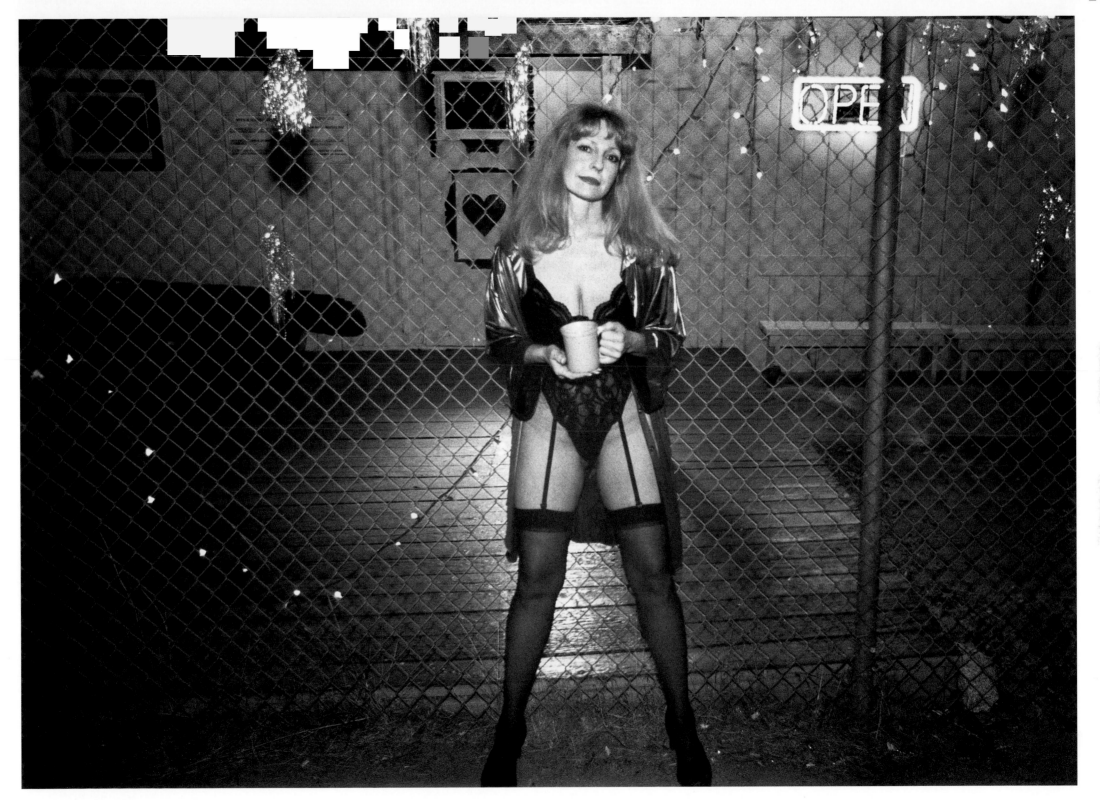

Candy. FALLON, NEVADA, 1999.

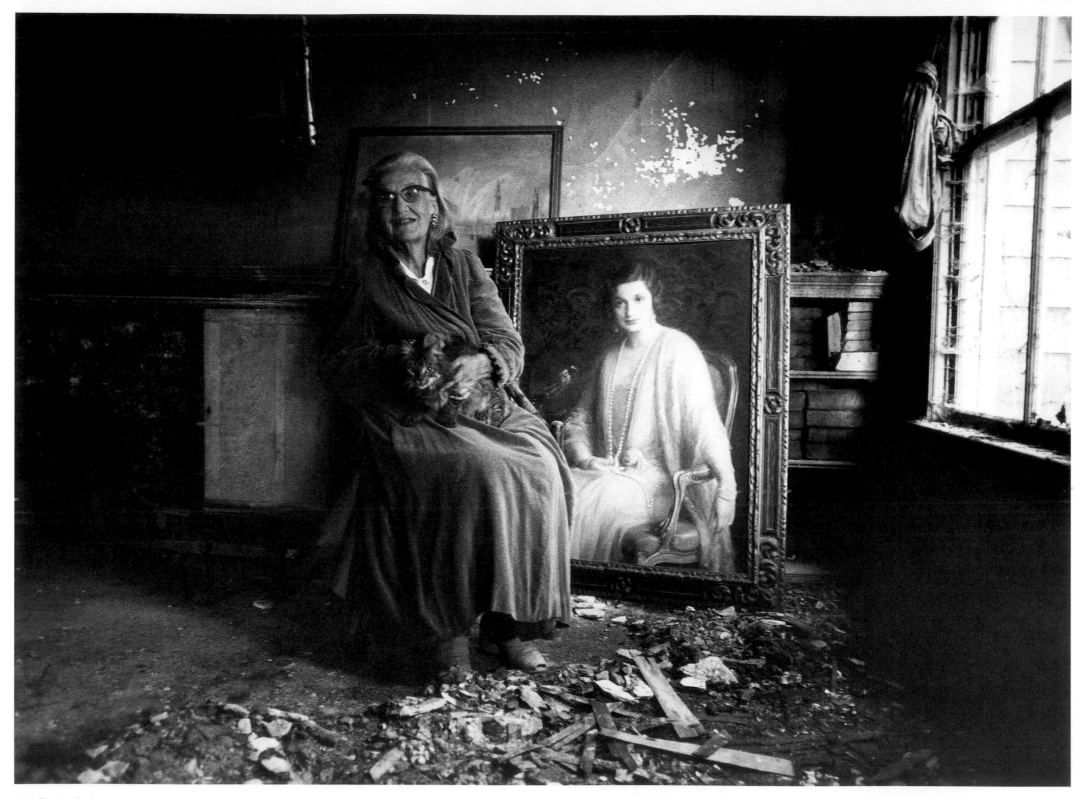

Edith Bouvier Beale. LONG ISLAND, NEW YORK, 1972.

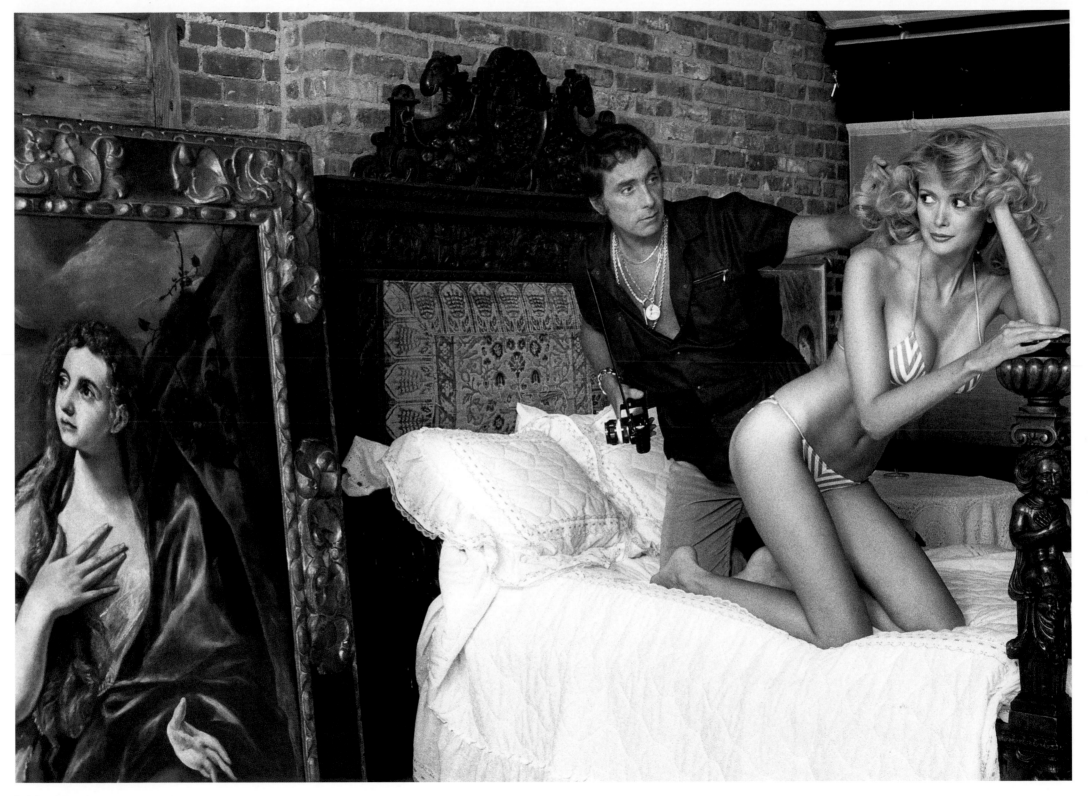

Bob Guccione. NEW YORK, NEW YORK, 1984.

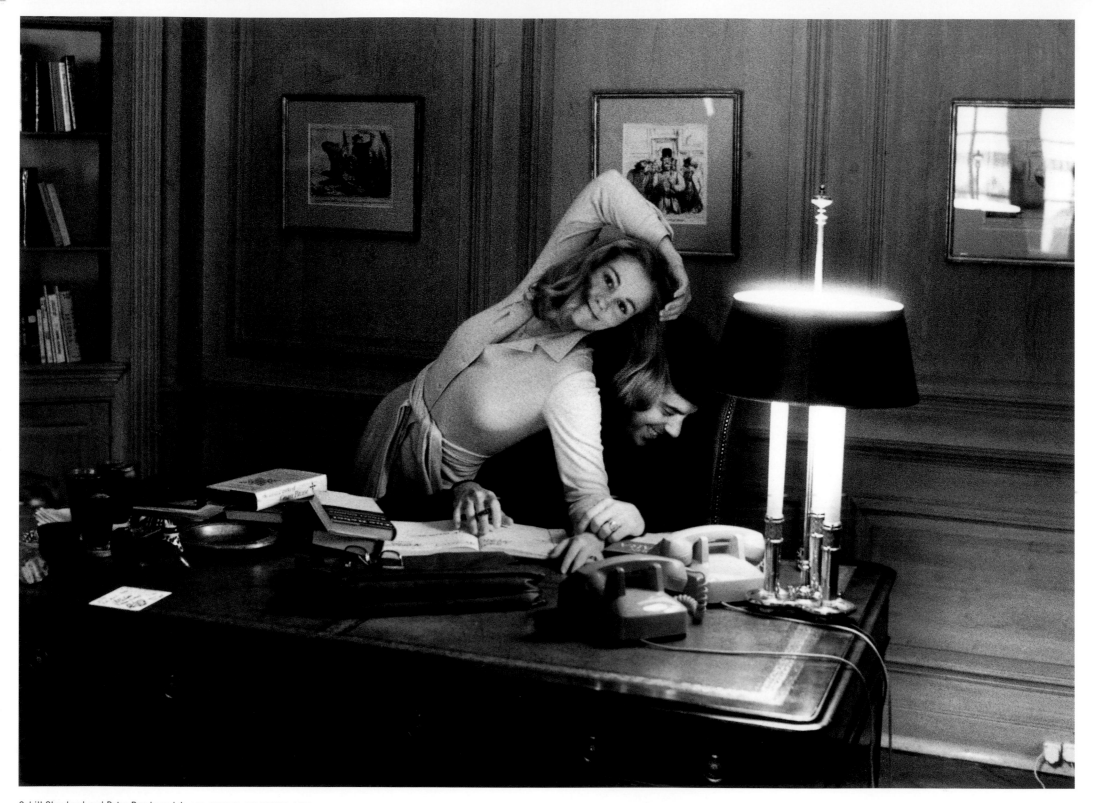

Cybill Shepherd and Peter Bogdanovich. LOS ANGELES, CALIFORNIA, 1974.

Jay and Sharon Rockefeller. CHARLESTON, WEST VIRGINIA, 1967.

Rosalynn Carter, and daughter, Amy. WASHINGTON, D.C., 1979.

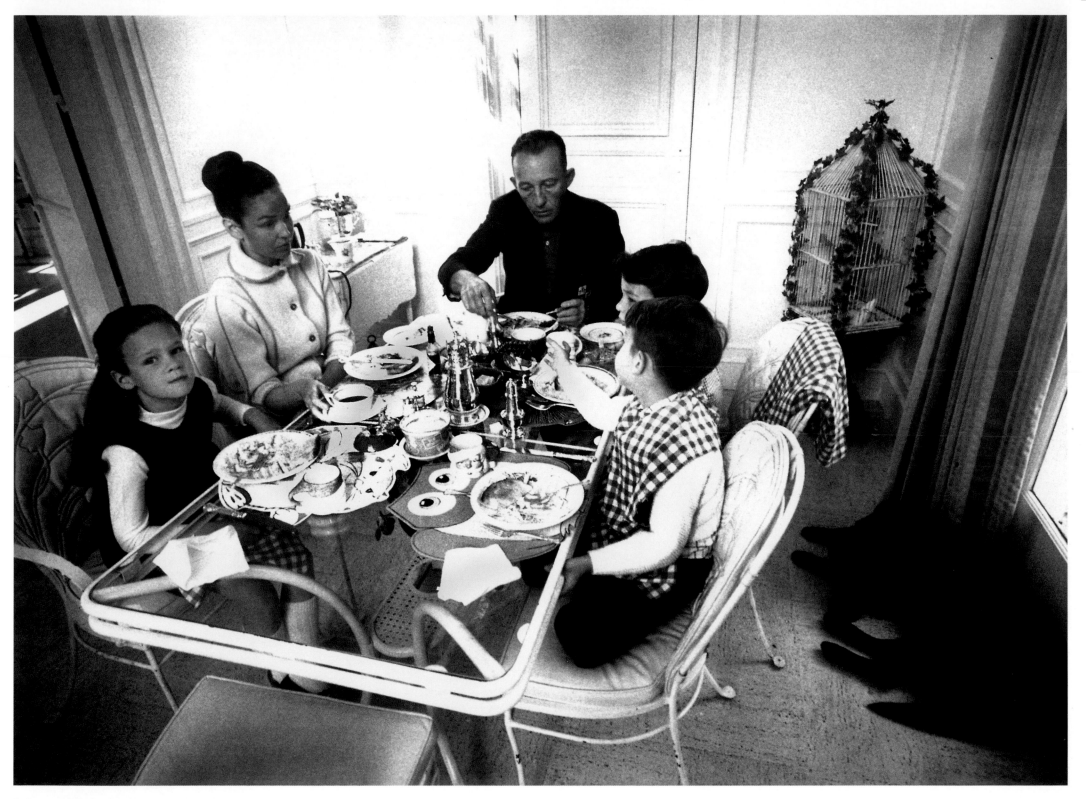

Kathryn and Bing Crosby. SAN FRANCISCO, CALIFORNIA, 1965.

Jacqueline Susann. NEW YORK, NEW YORK, 1973.

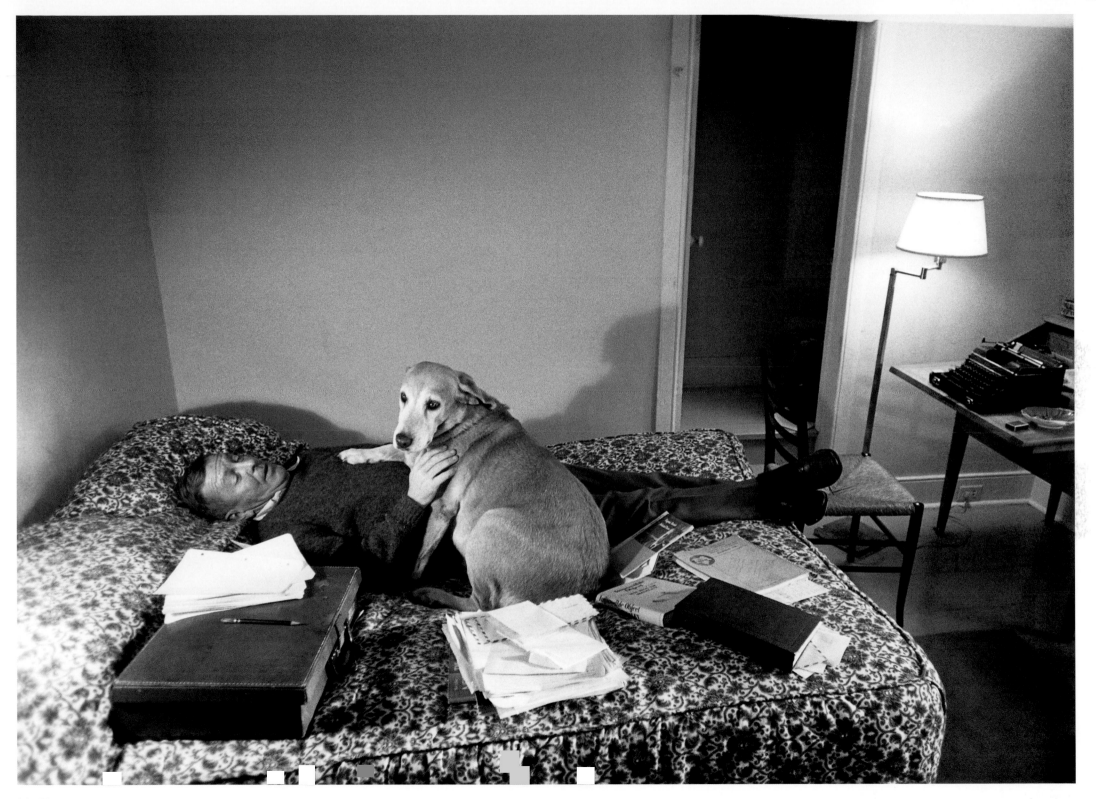

John Cheever. OSSINING, NEW YORK, 1969.

Bobby Fischer. REYKJAVIK, ICELAND, 1972.

Lyle Stuart and Liz Renay. NEW YORK, NEW YORK, 1971.

Frank Sinatra. SANTA CLARA, CALIFORNIA, 1974.

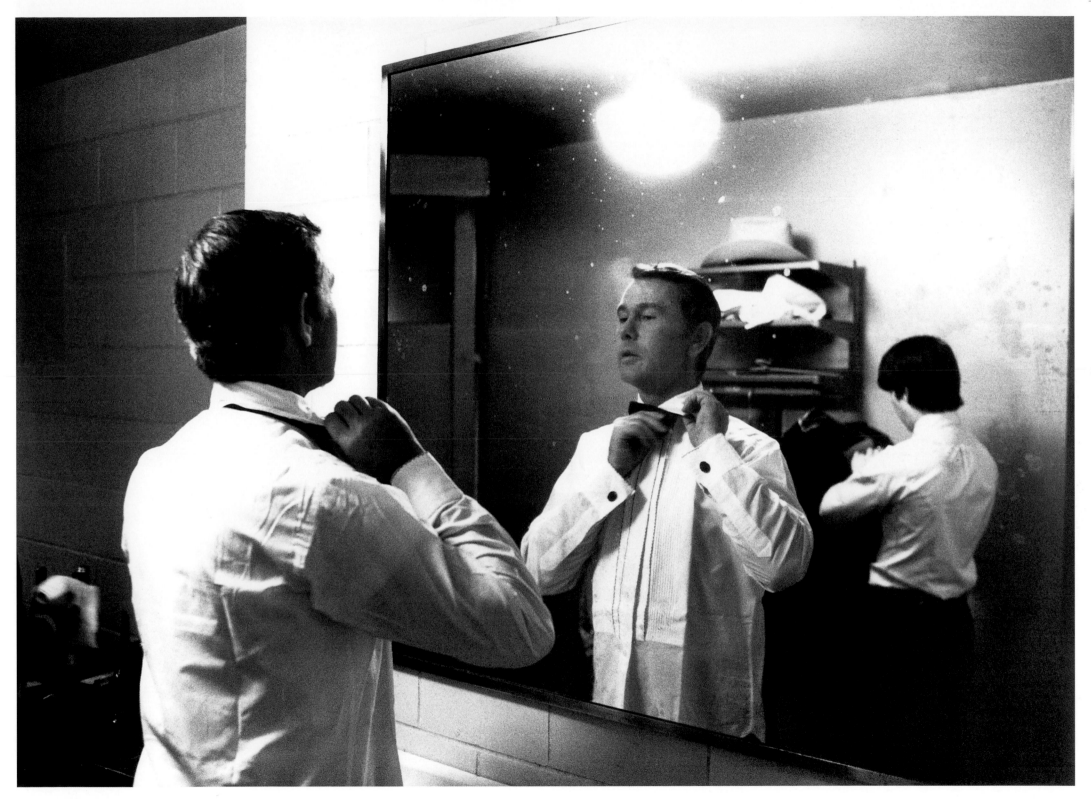

Johnny and Ricky Carson. LUBBOCK, TEXAS, 1970.

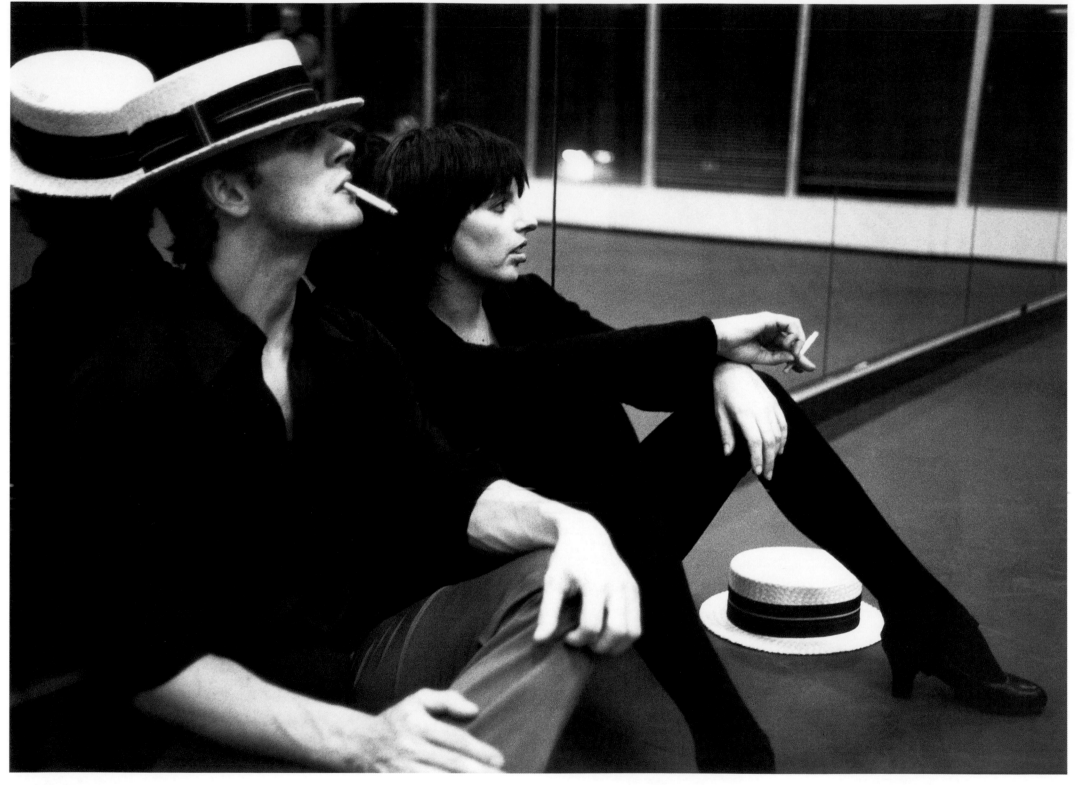

Mikhail Baryshnikov and Liza Minnelli. NEW YORK, NEW YORK, 1980.

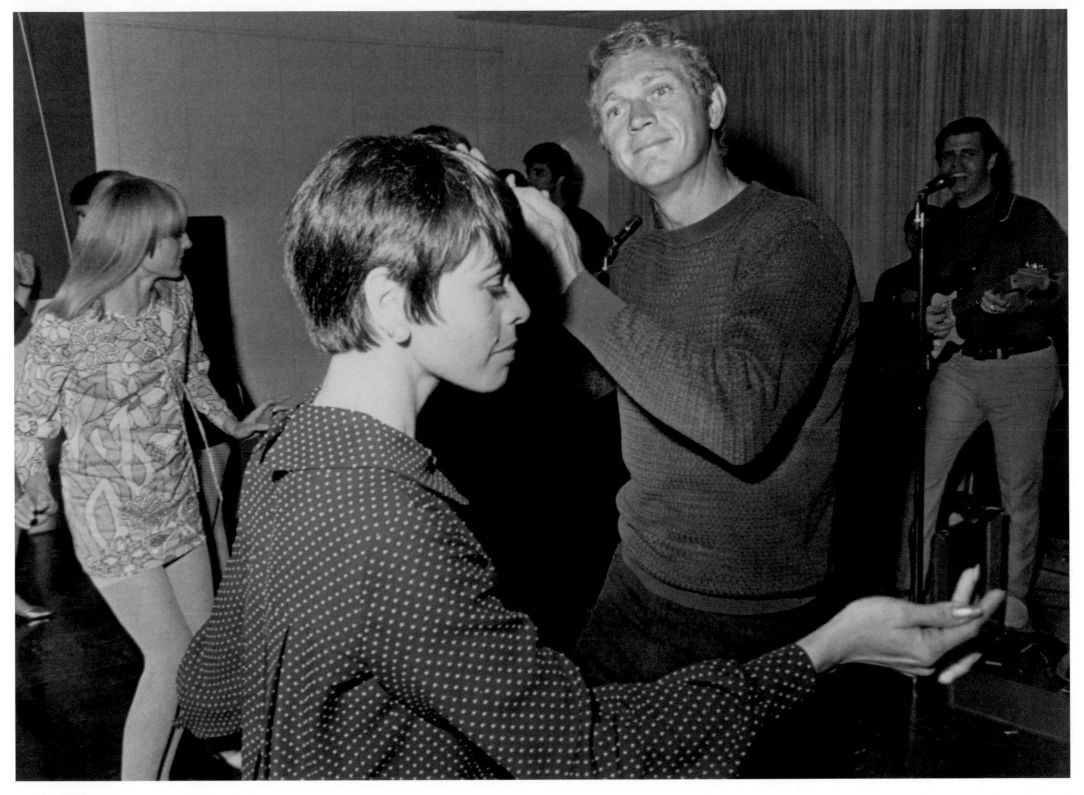

Steve and Neile McQueen. LOS ANGELES, CALIFORNIA, 1966.

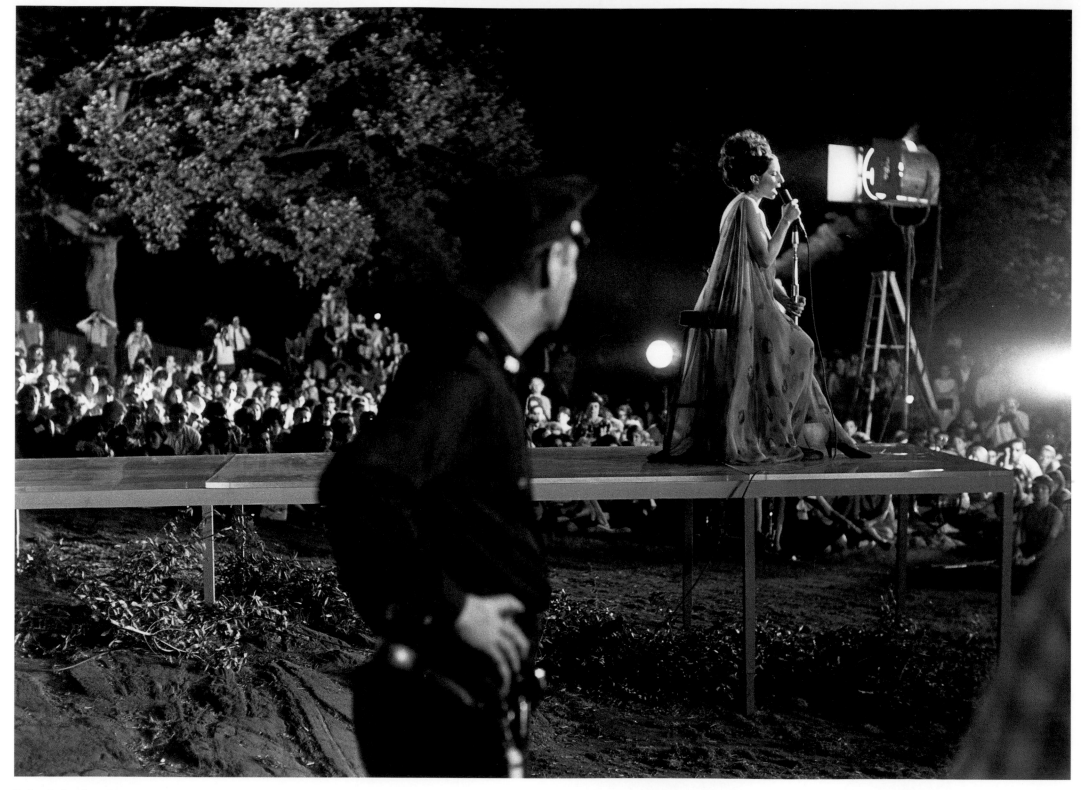

Barbra Streisand. CENTRAL PARK, NEW YORK, NEW YORK, 1967.

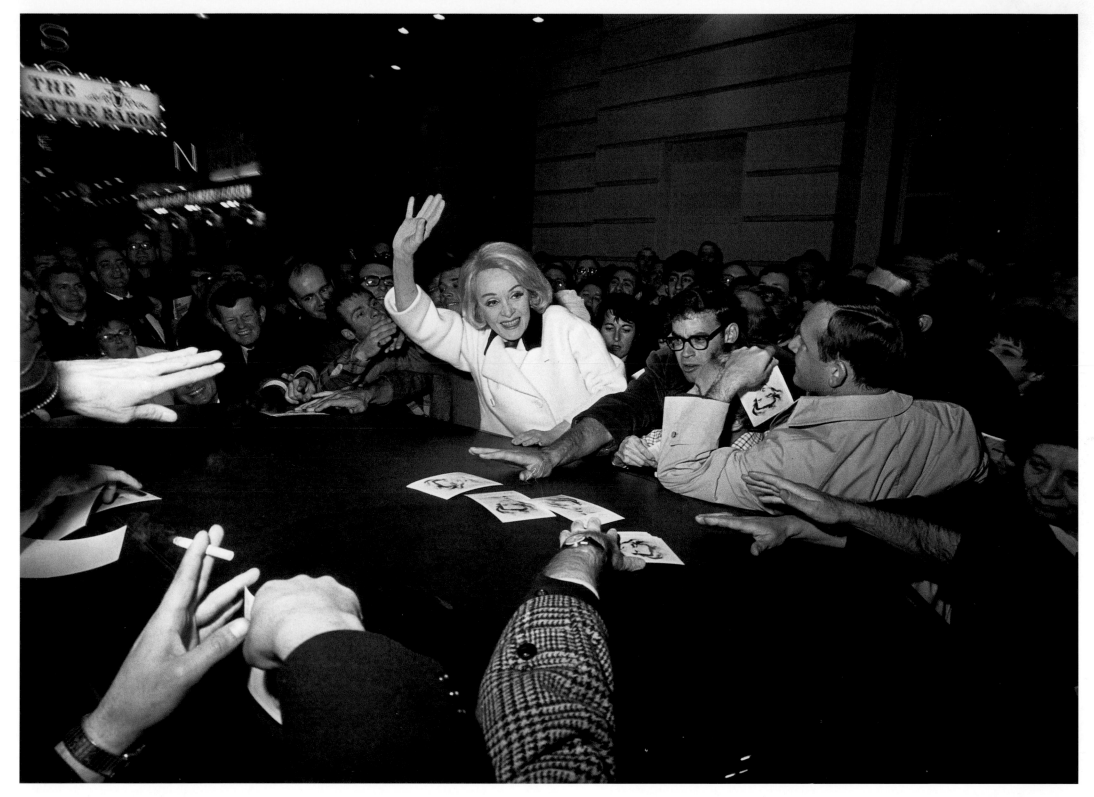

Marlene Dietrich. NEW YORK, NEW YORK, 1967.

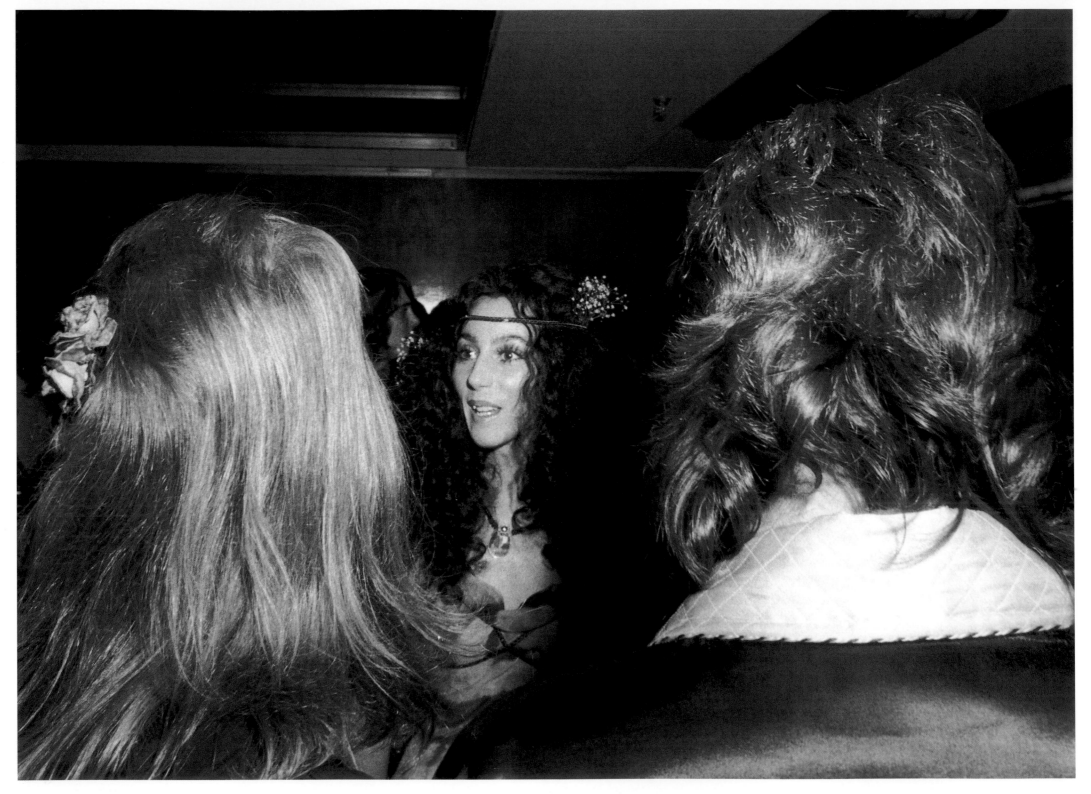

Cher. LONG BEACH, CALIFORNIA, 1975.

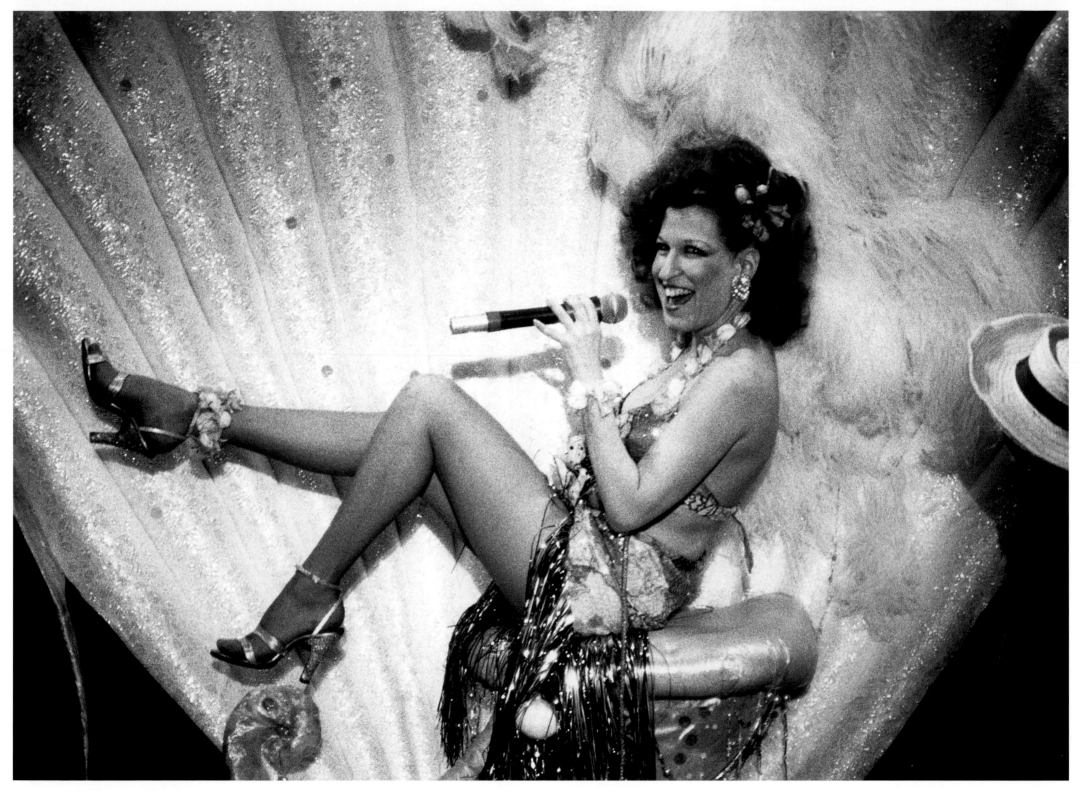

Bette Midler. NEW YORK, NEW YORK, 1975.

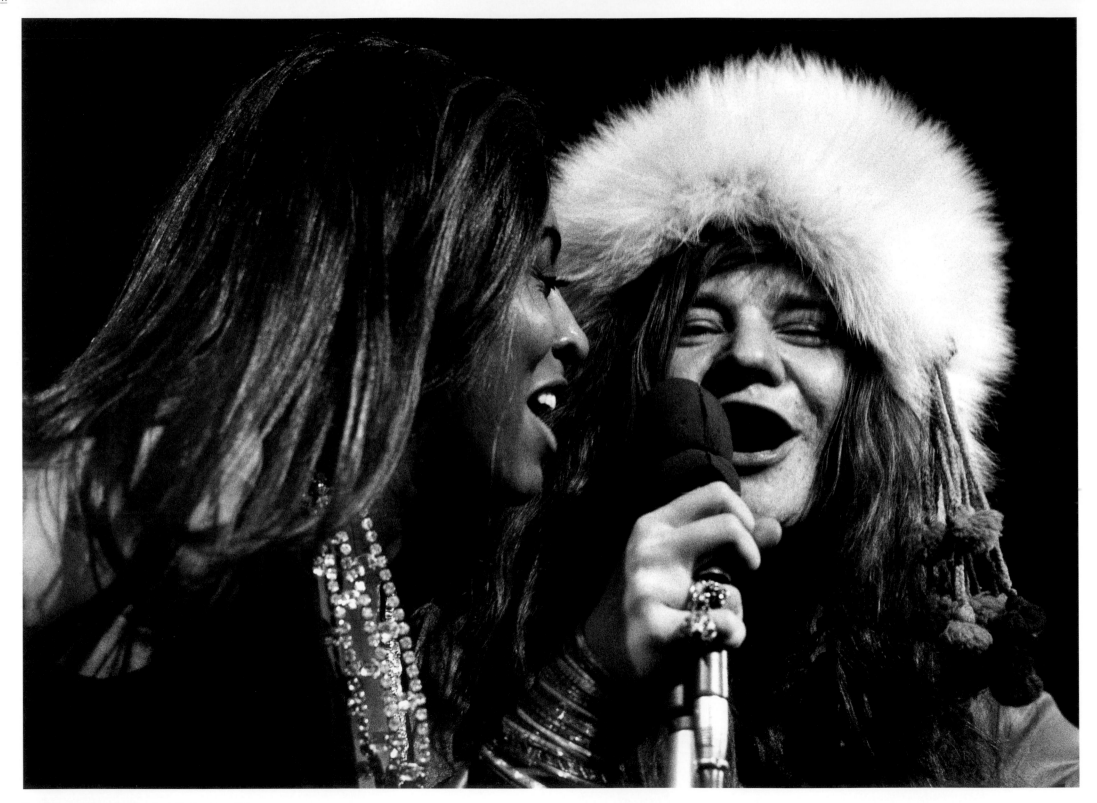

Tina Turner and Janis Joplin. NEW YORK, NEW YORK, 1968.

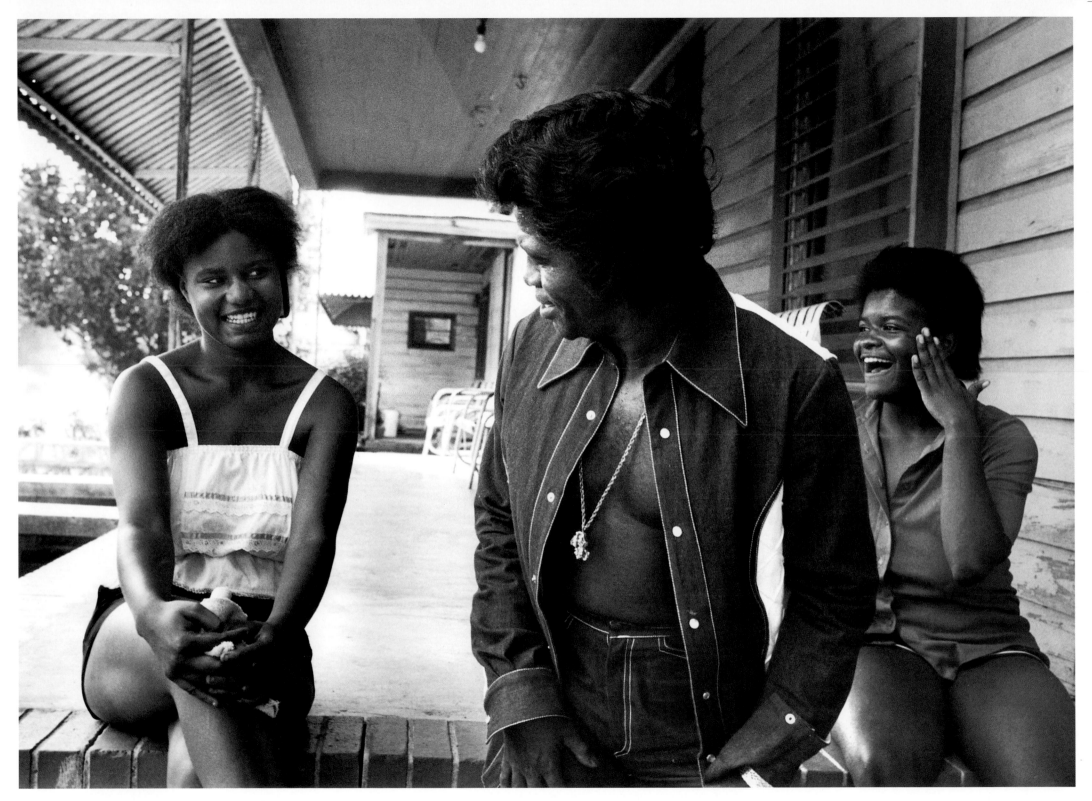

James Brown. AUGUSTA, GEORGIA, 1979.

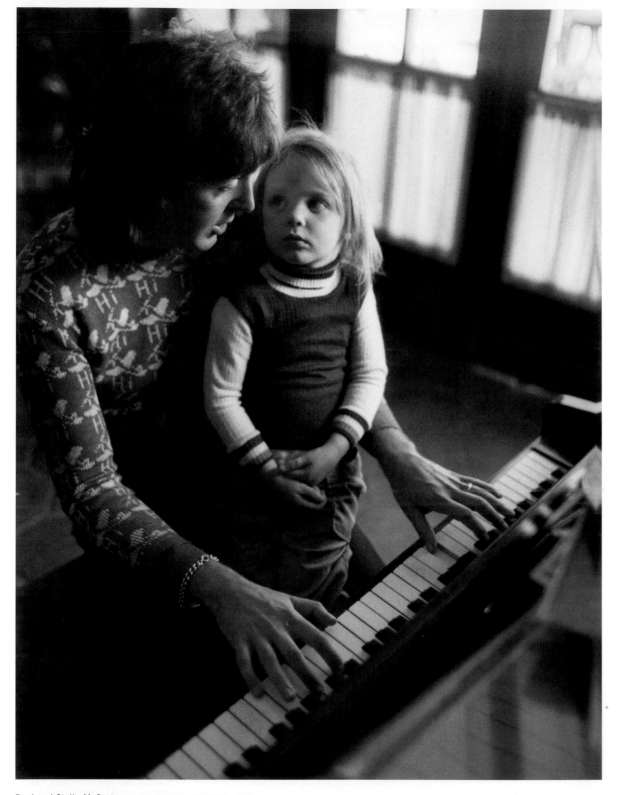

Paul and Stella McCartney. LOS ANGELES, CALIFORNIA, 1975.

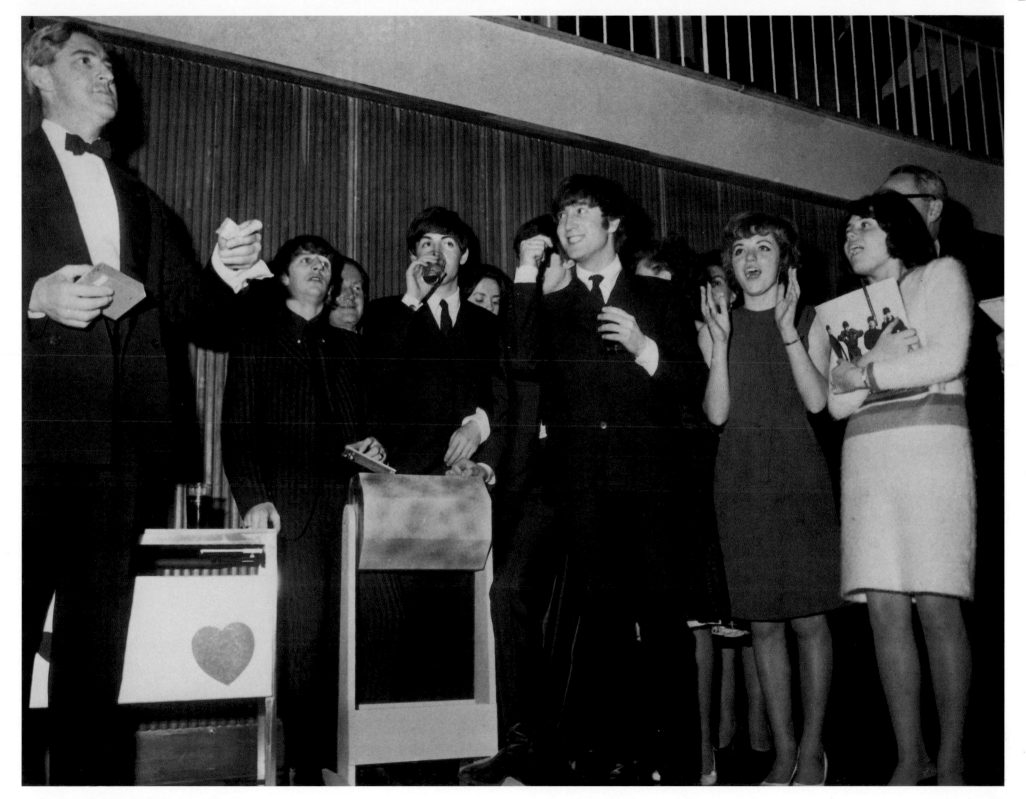

The Beatles at the British Embassy. WASHINGTON, D.C., 1964.

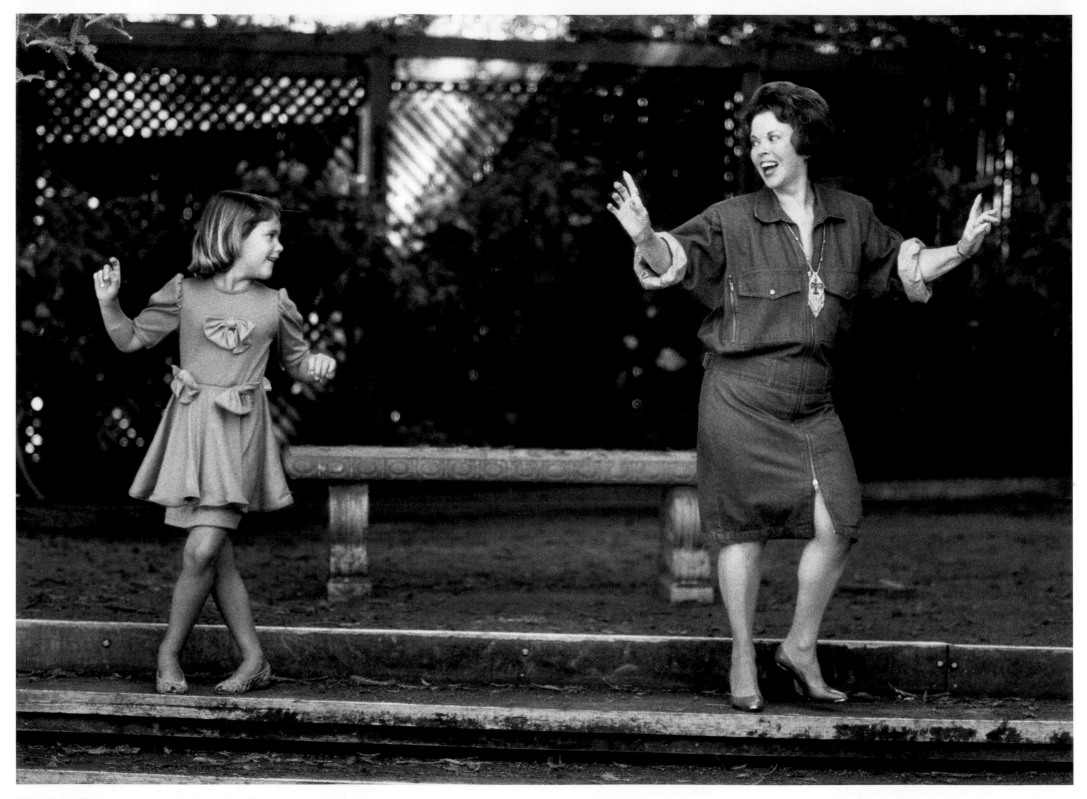

Shirley Temple Black and granddaughter Teresa Falaschi. WOODSIDE, CALIFORNIA, 1988.

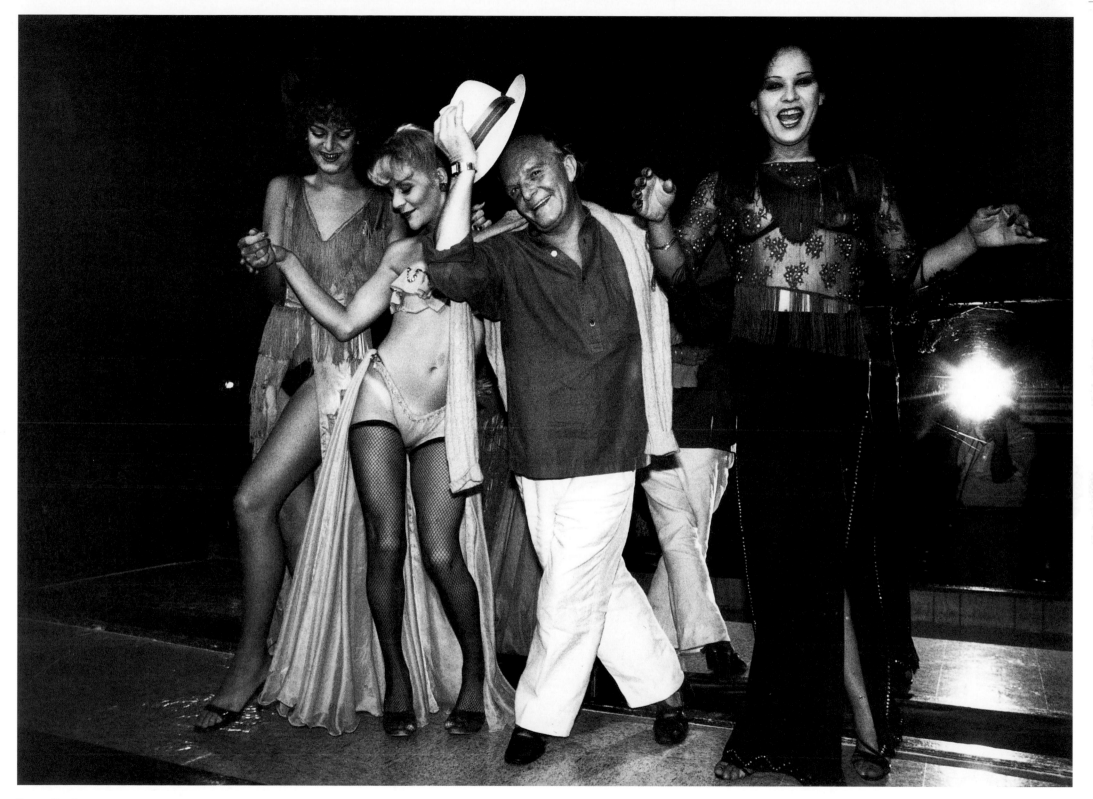

Truman Capote. NEW ORLEANS, LOUISIANA, 1980.

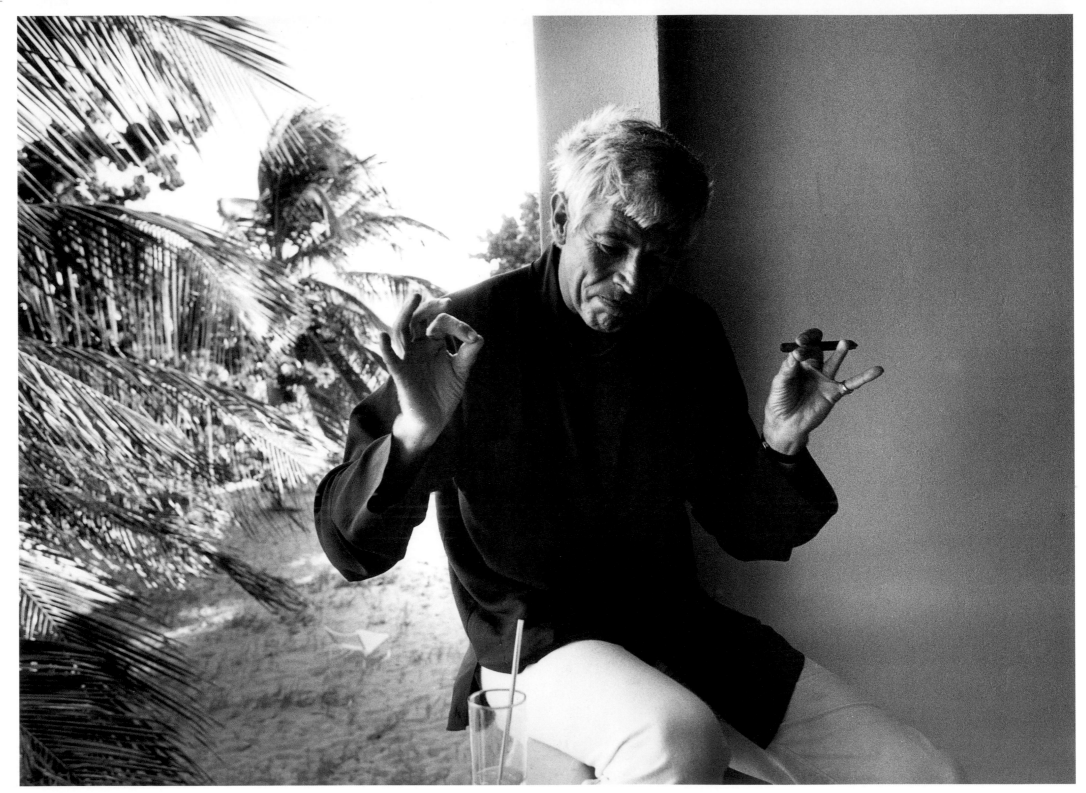

James Coburn. ANTIGUA, WEST INDIES, 1978.

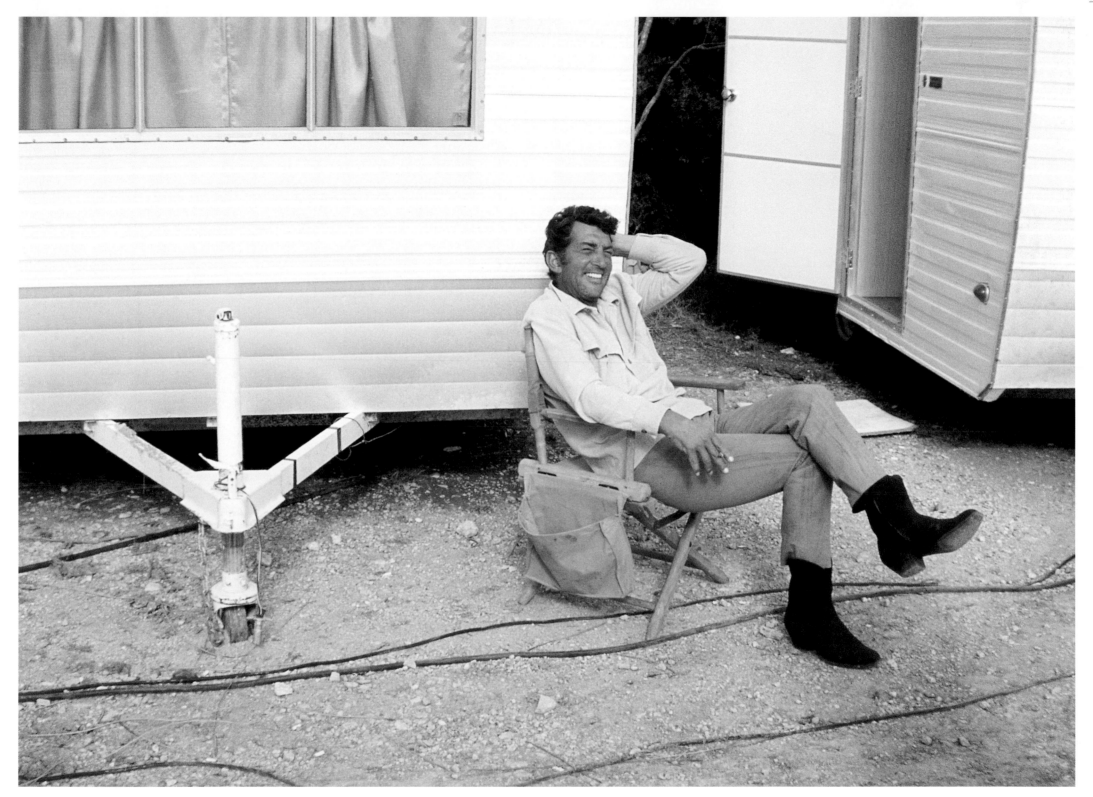

Dean Martin. HAPPY SHAHAN RANCH, BRACKETTVILLE, TEXAS, 1967.

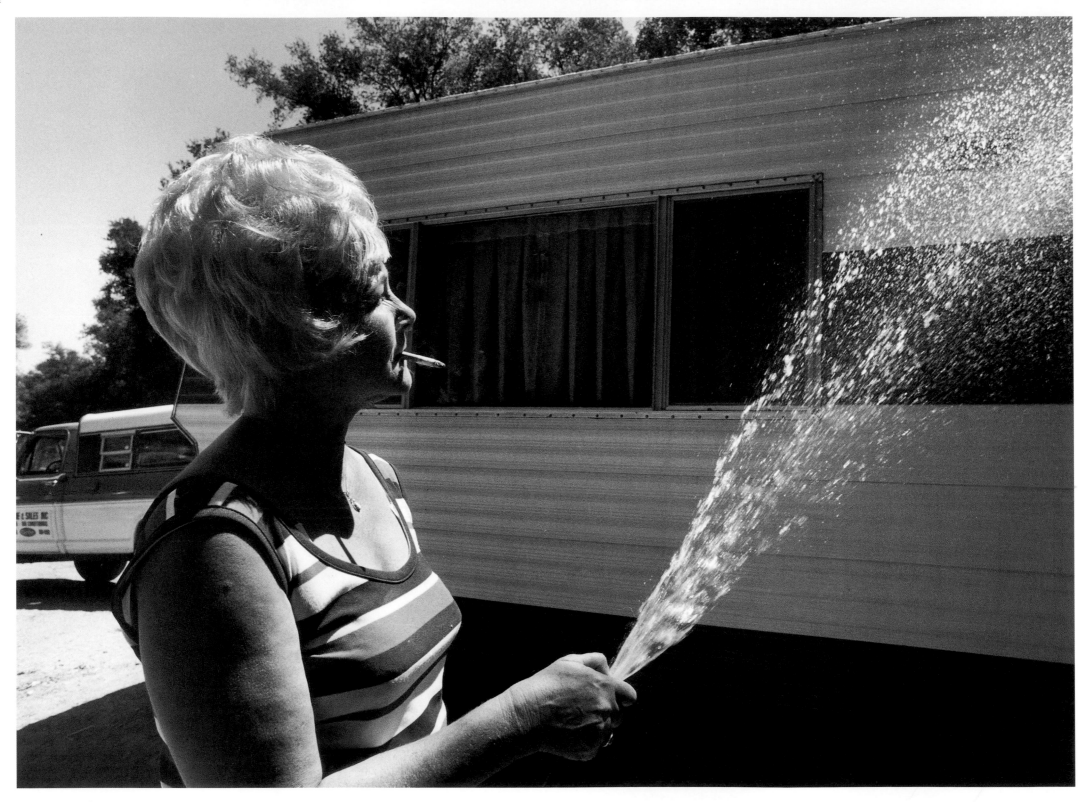

Mobile-home park. SOUTHERN CALIFORNIA, 1970.

Billy Carter. PLAINS, GEORGIA, 1976.

Farrah Fawcett. BEVERLY HILLS, CALIFORNIA, 1970.

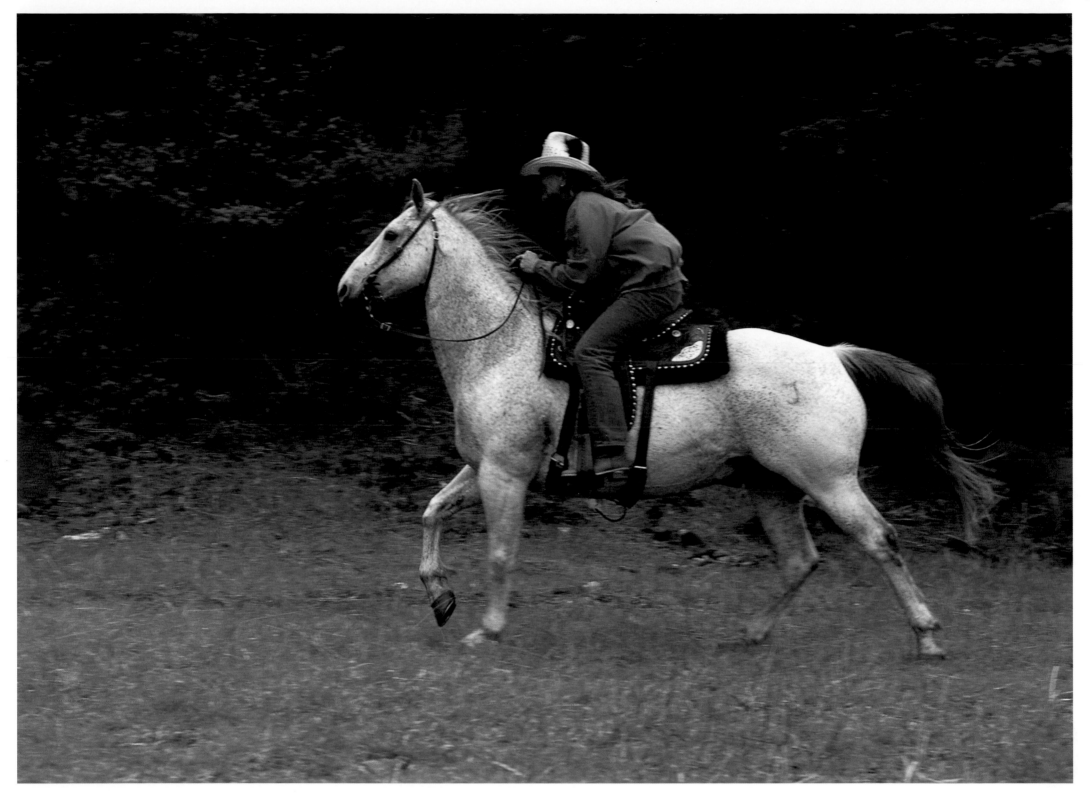

Willie Nelson. EVERGREEN, COLORADO, 1983.

Joe Namath. TUSCALOOSA, ALABAMA, 1976.

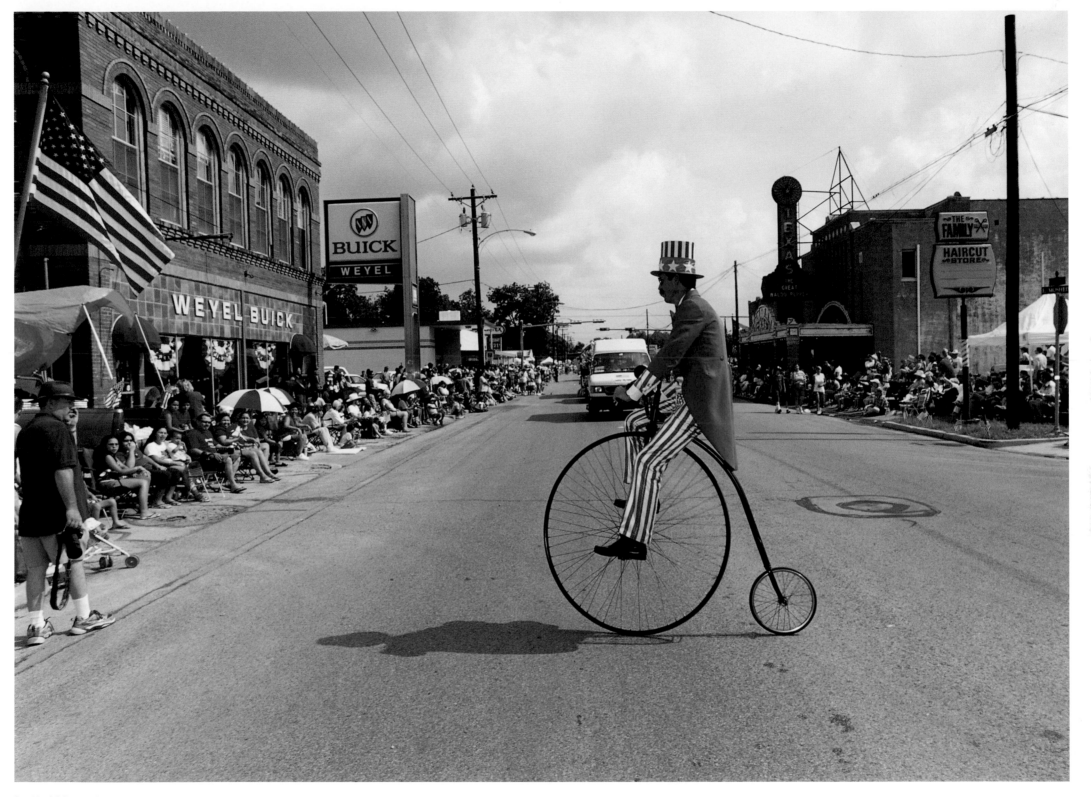

Fourth of July parade. SEGUIN, TEXAS, 2002.

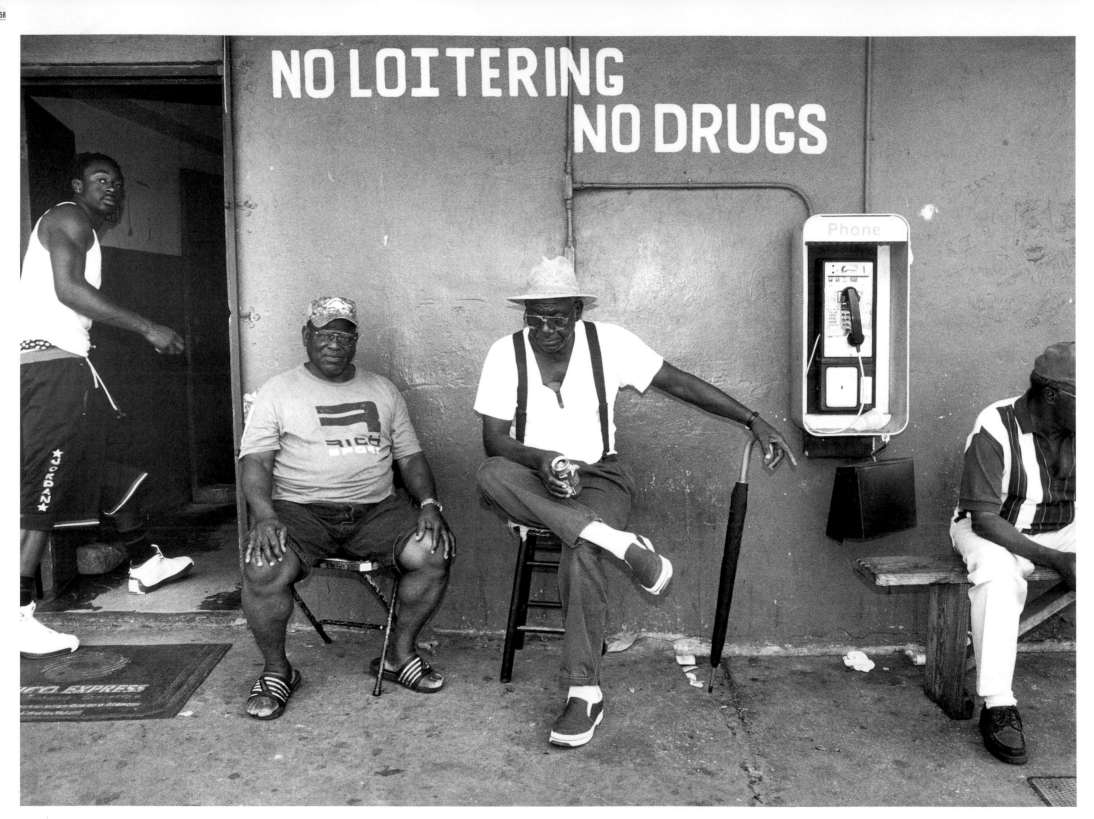

No Loitering, No Drugs. BELLE GLADE, FLORIDA, 2003.

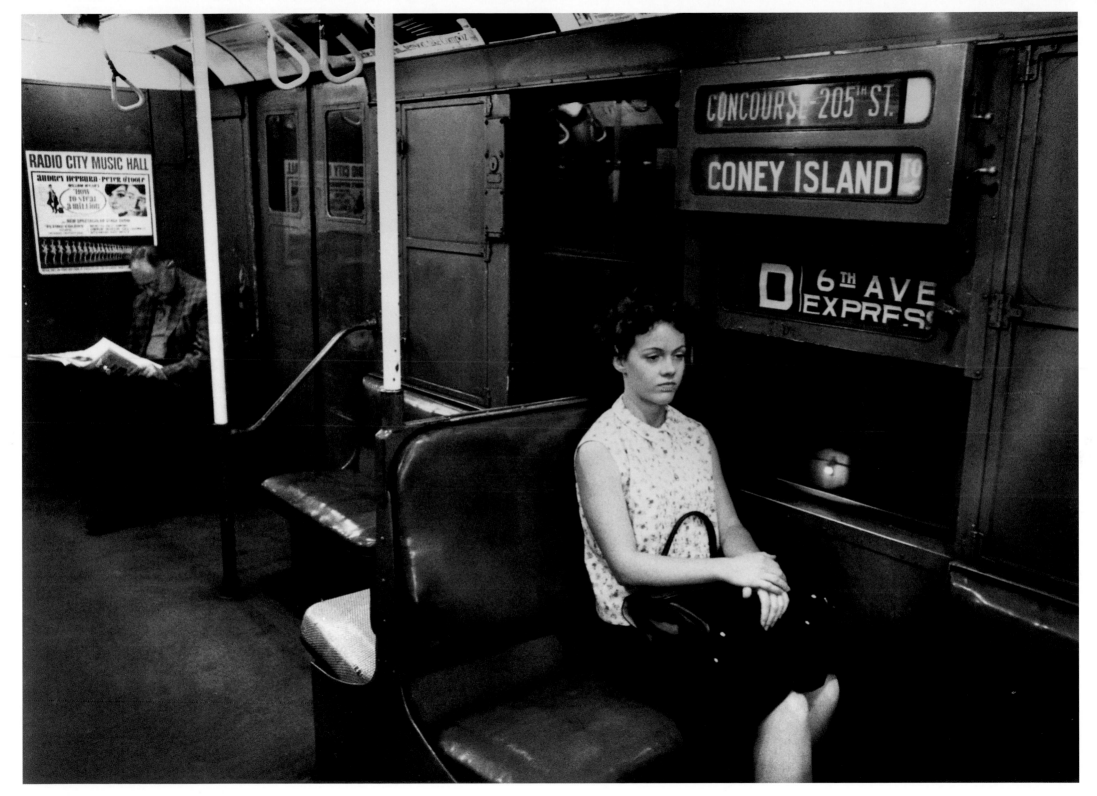

Noreen Quinlan. NEW YORK, NEW YORK, 1966.

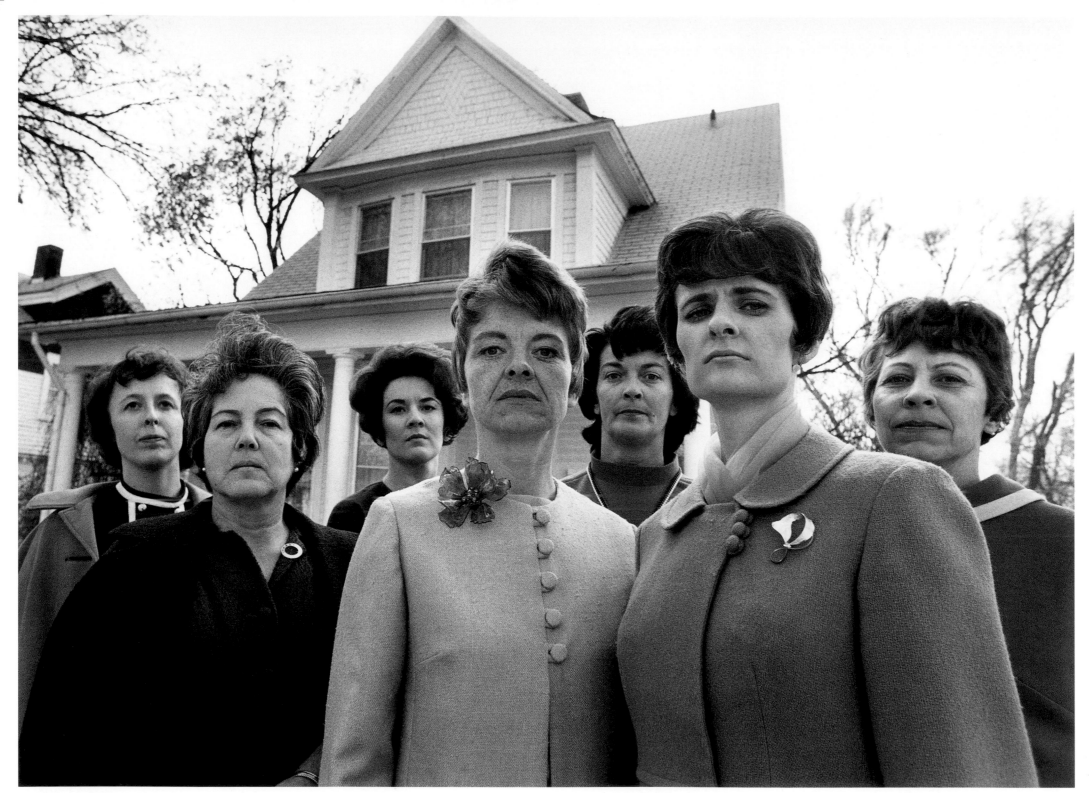

Housewives. CHADRON, NEBRASKA, 1969. (TWO PHOTOS)

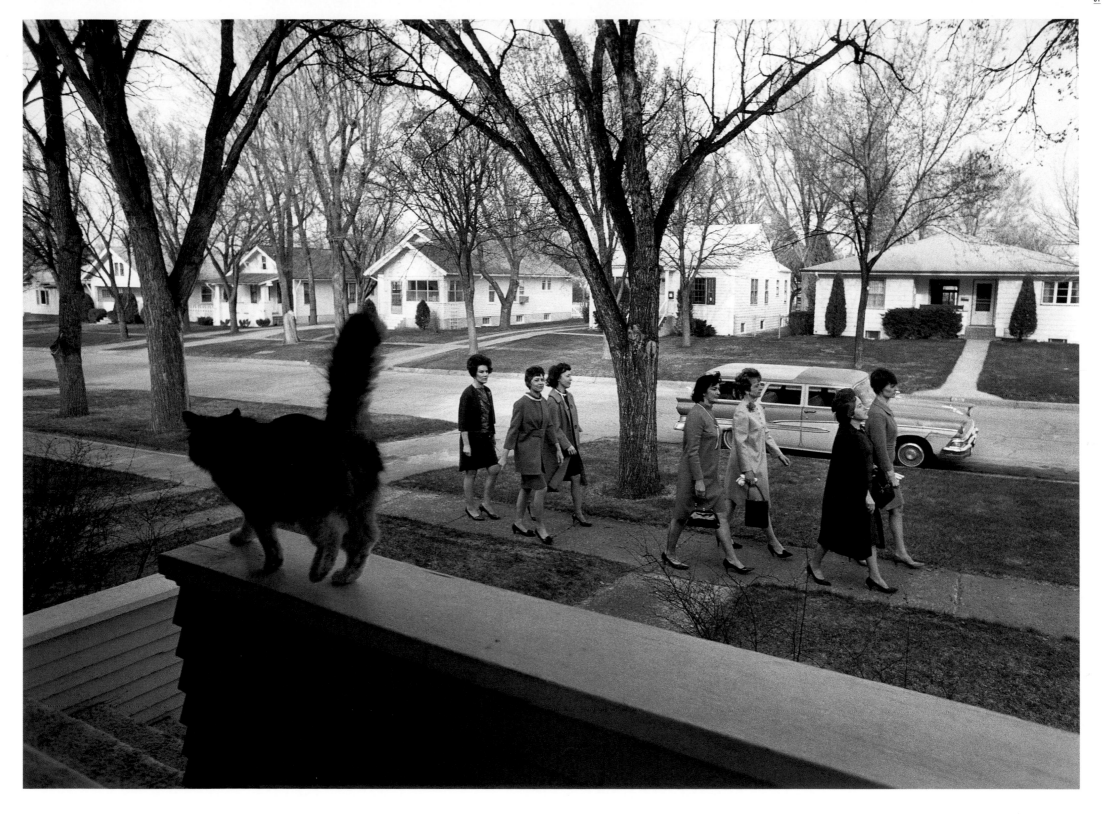

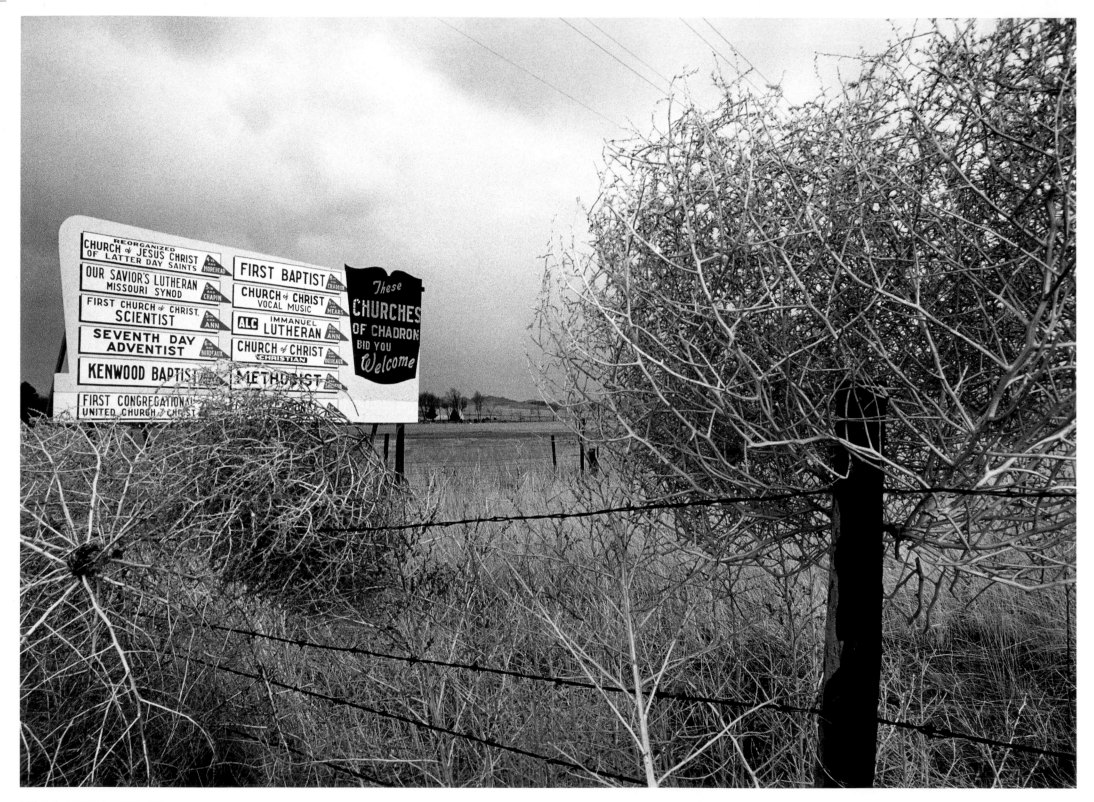

Billboard. CHADRON, NEBRASKA, 1969.

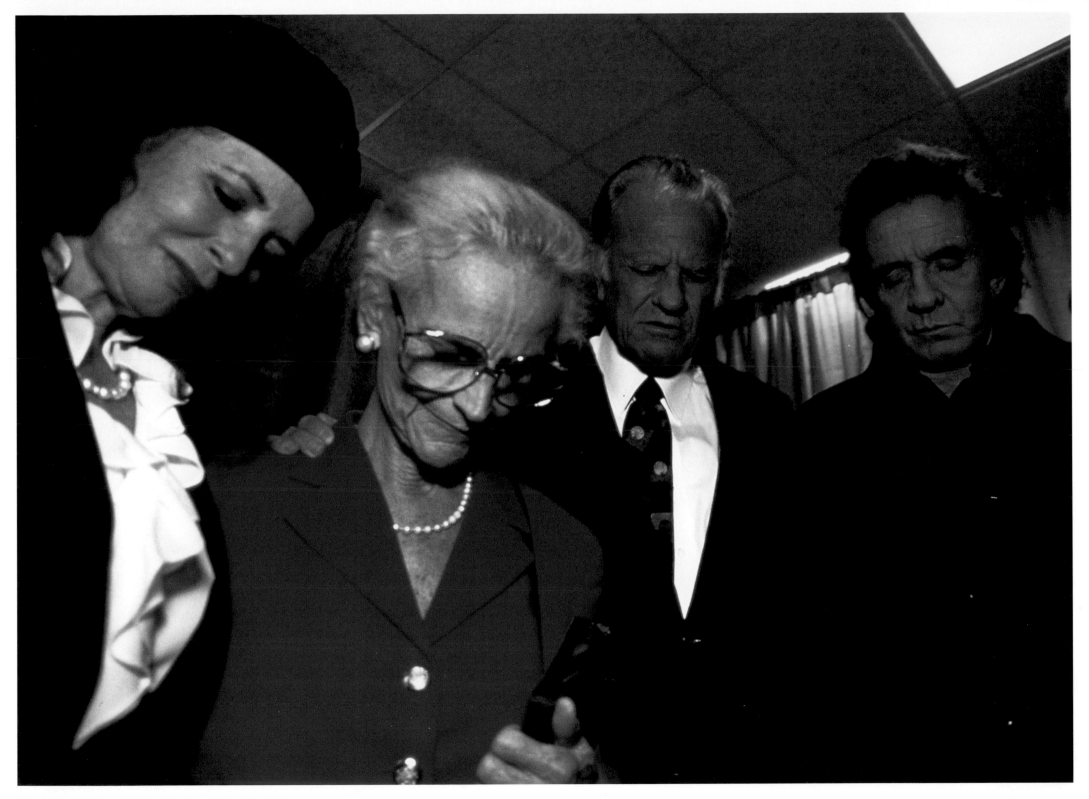

Billy and Ruth Graham with Johnny Cash and June Carter Cash. CHARLOTTE, NORTH CAROLINA, 1993.

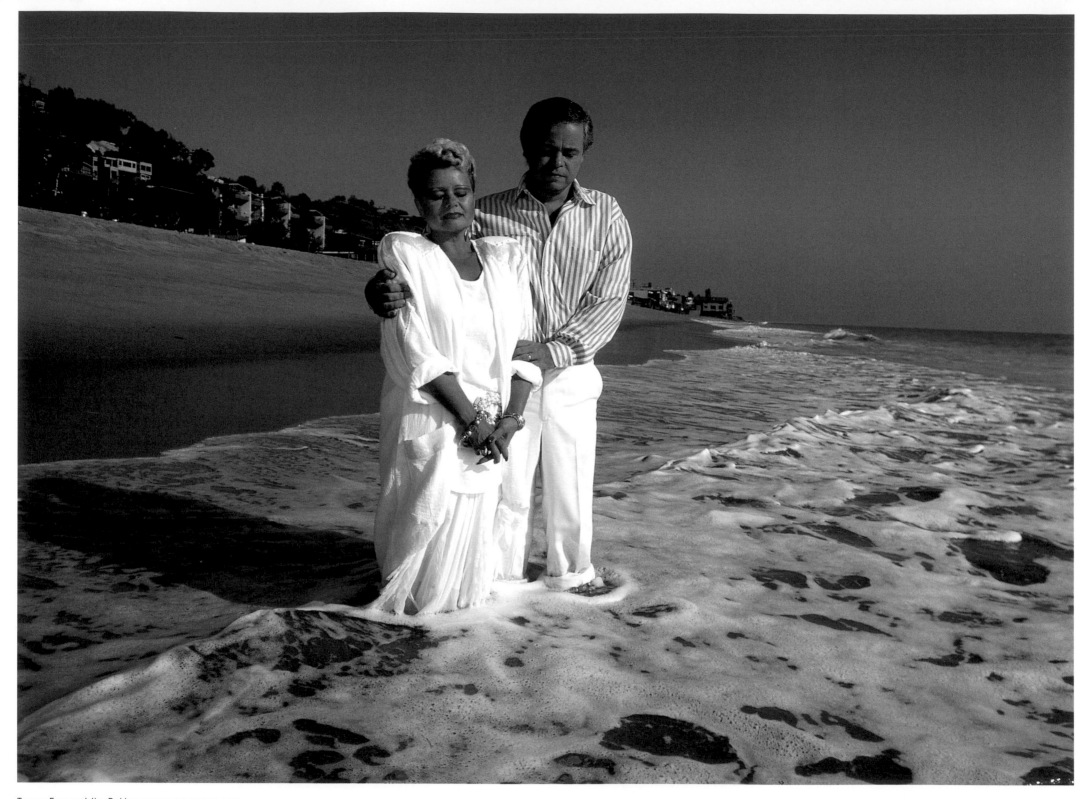

Tammy Faye and Jim Bakker. MALIBU, CALIFORNIA, 1987.

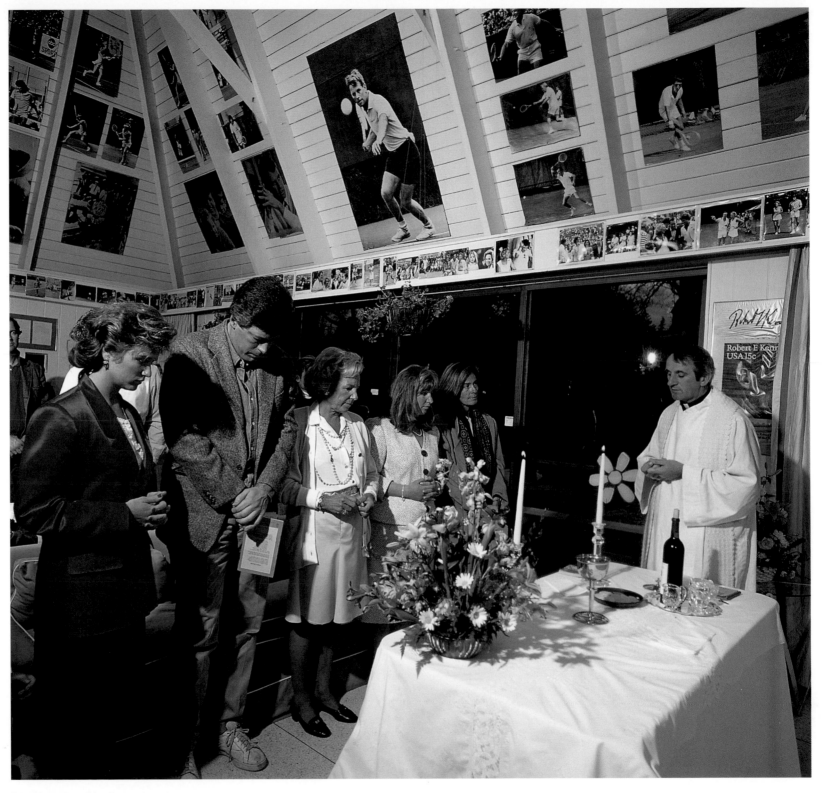

Ethel Kennedy and family. McLEAN, VIRGINIA, 1988.

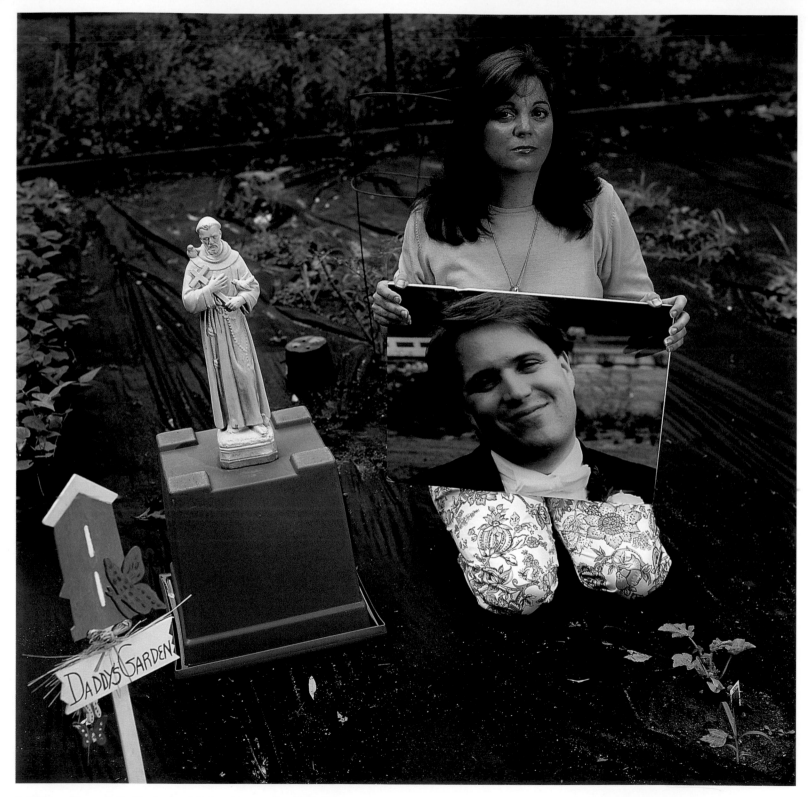

Pat Wotton with a portrait of her husband, Rod. MIDDLETOWN, NEW JERSEY, 2002.

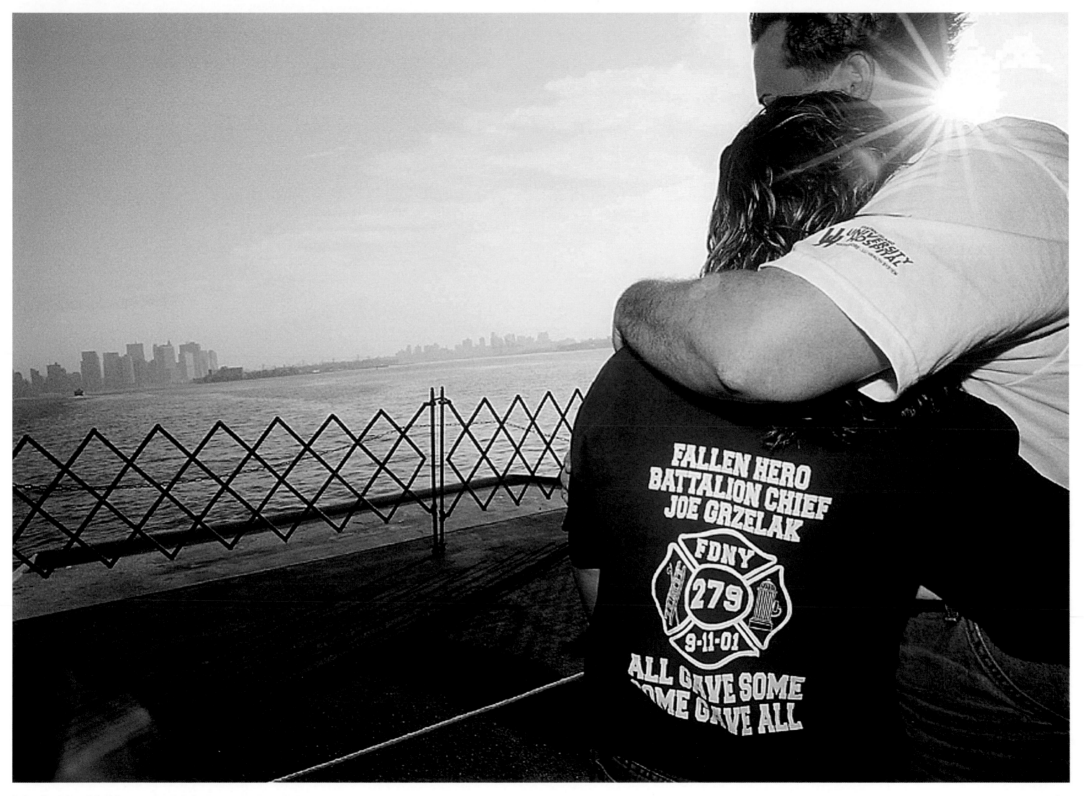

FALLEN HERO
BATTALION CHIEF
JOE GRZELAK

FDNY
279
9-11-01

ALL GAVE SOME
SOME GAVE ALL

Debra Grzelak and Neal Lavro. STATEN ISLAND FERRY, NEW YORK, NEW YORK, 2002.

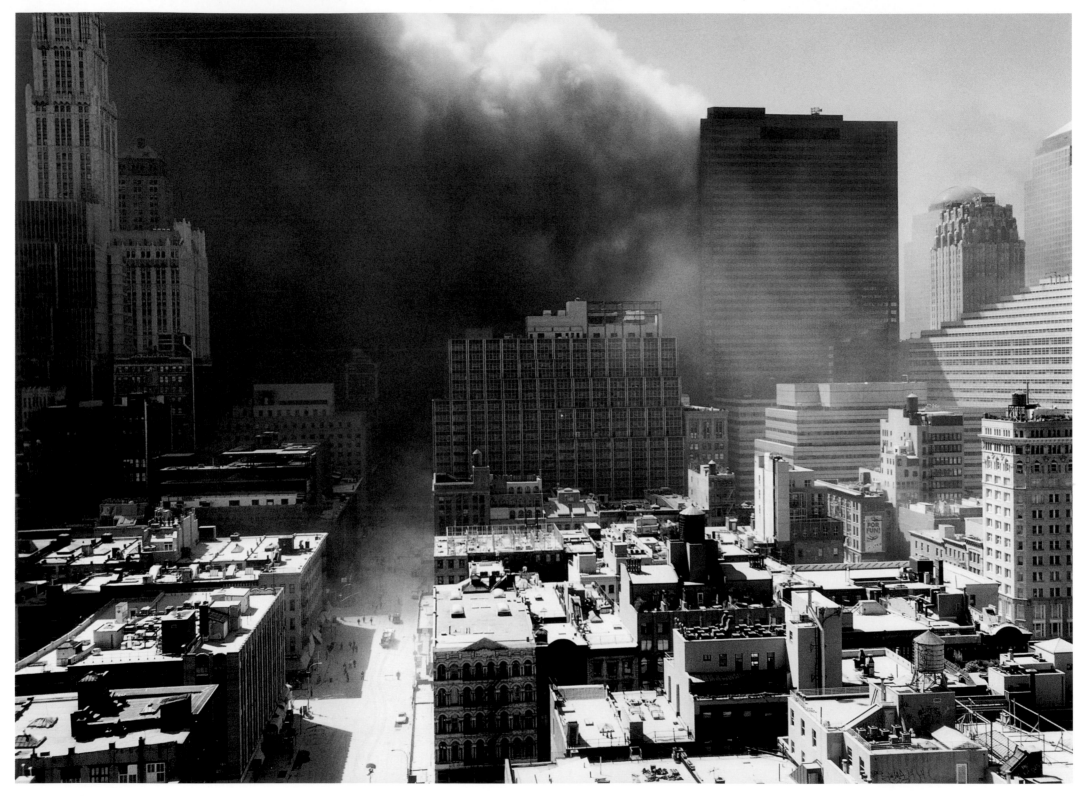

Lower Manhattan. NEW YORK, NEW YORK, SEPTEMBER 11, 2001.

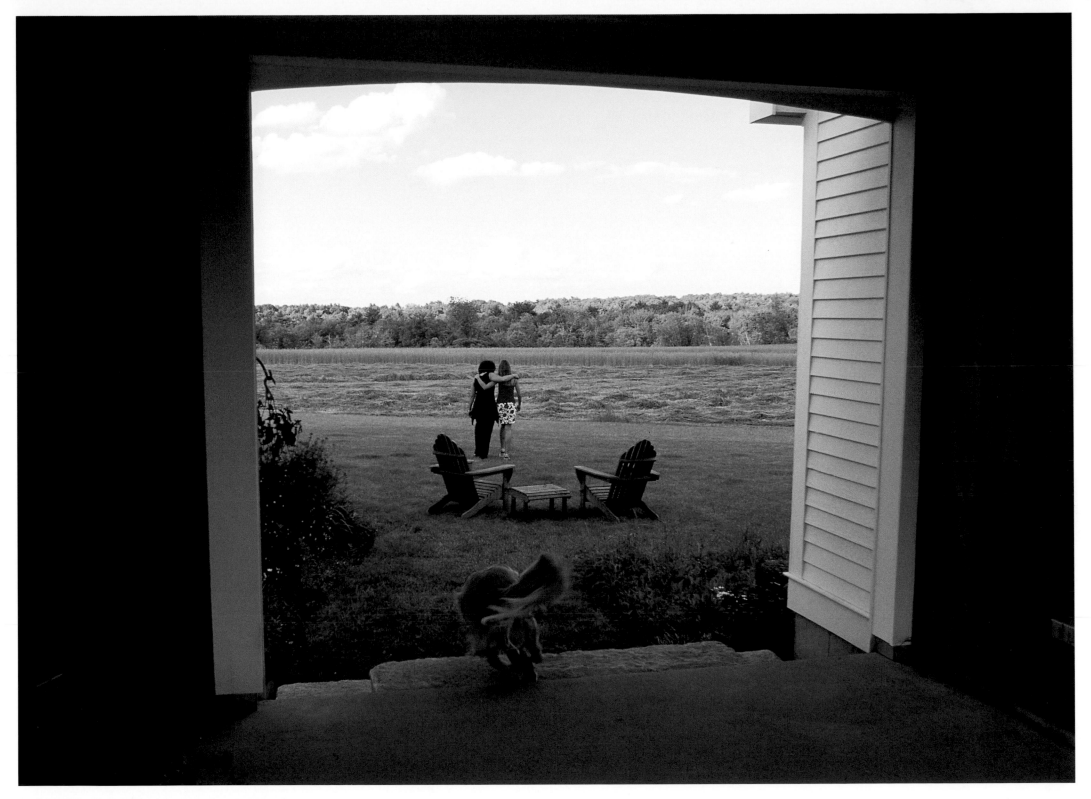

Peg Ogonowski and daughter, Laura. DRACUT, MASSACHUSETTS, 2002.

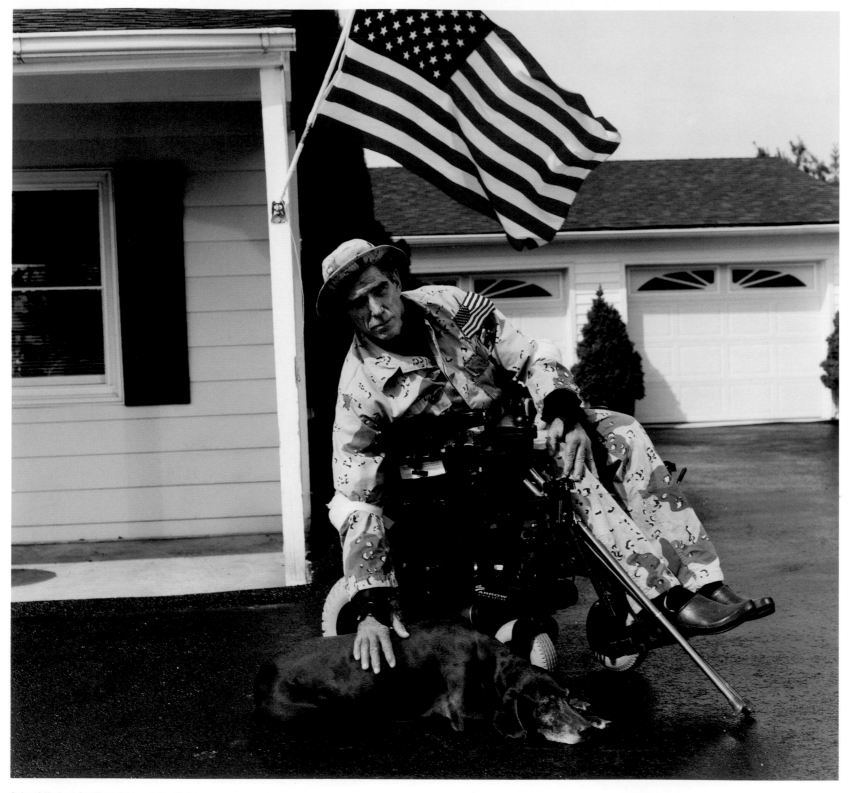

Colonel Herbert Smith and his pointer, Raisin. IJAMSVILLE, MARYLAND, 1999.

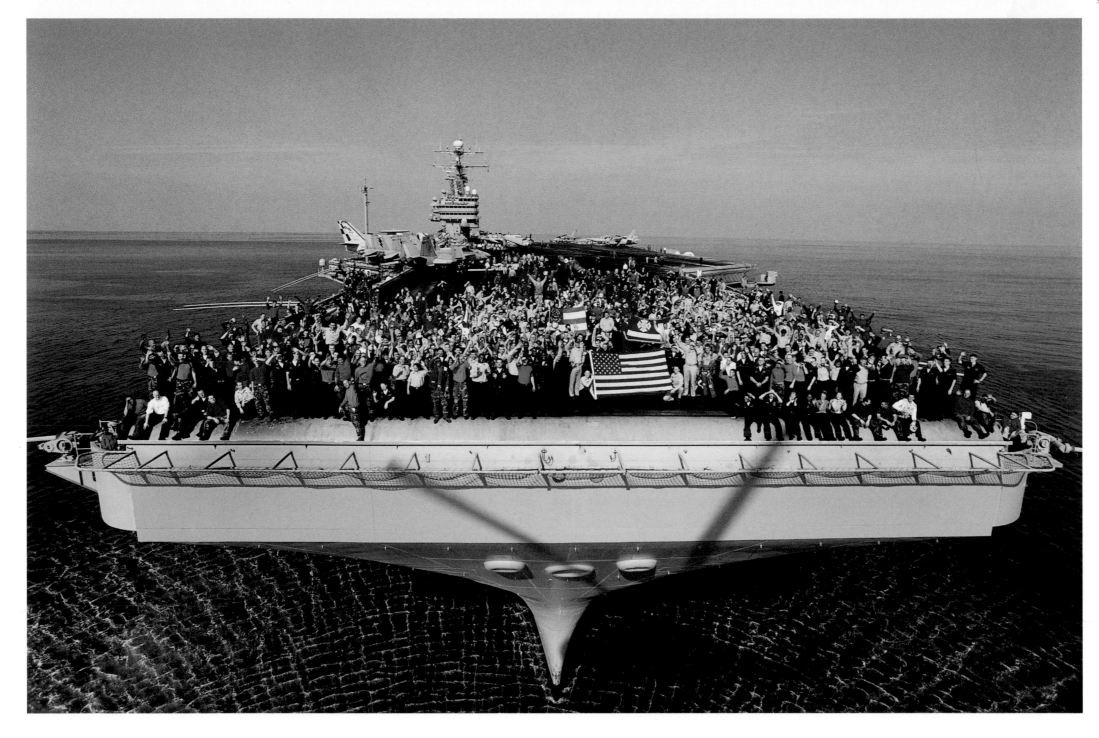

USS *Theodore Roosevelt.* ARABIAN SEA, 2001.

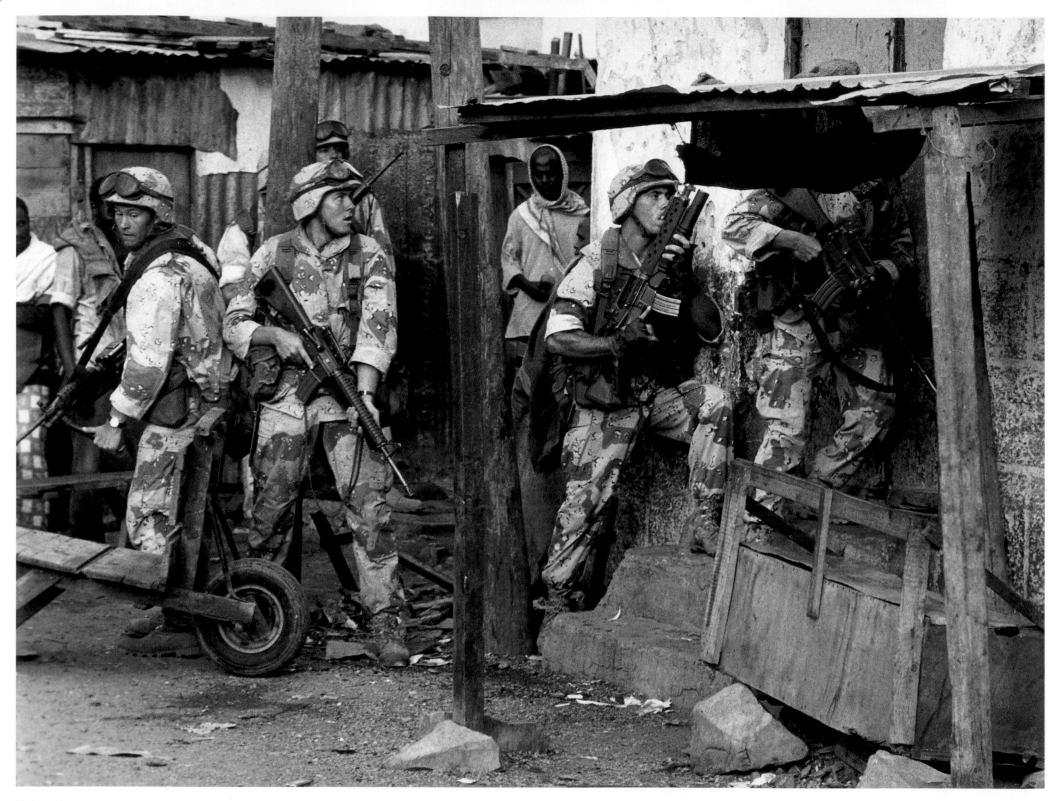

Marine raid. BAIDOA, SOMALIA, 1993.

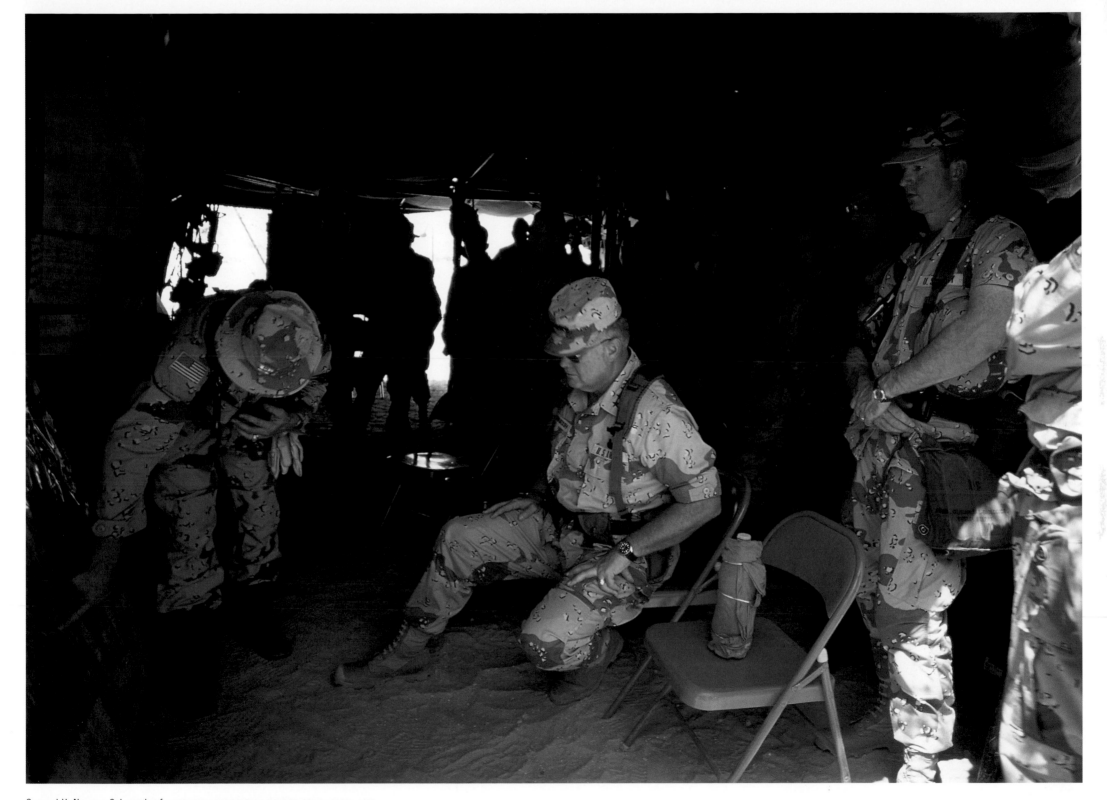

General H. Norman Schwarzkopf. DESERT NEAR THE KUWAIT BORDER, SAUDI ARABIA, 1991.

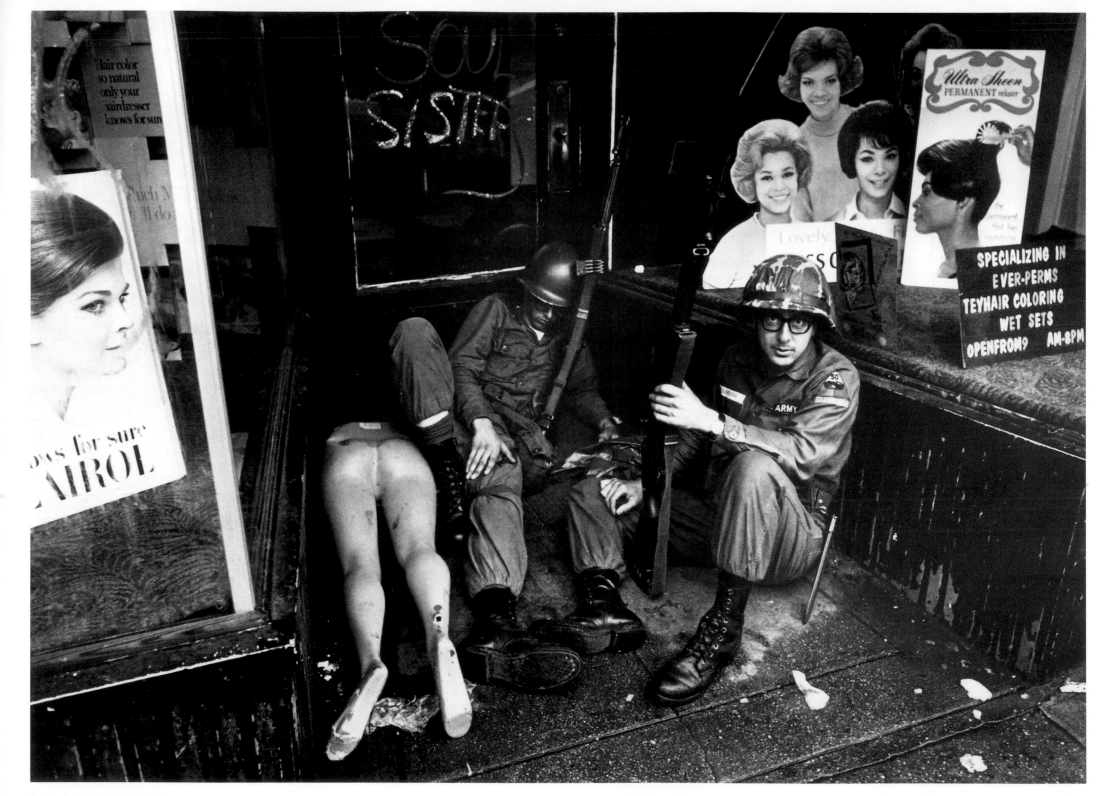

National guardsmen. NEWARK, NEW JERSEY, 1967.

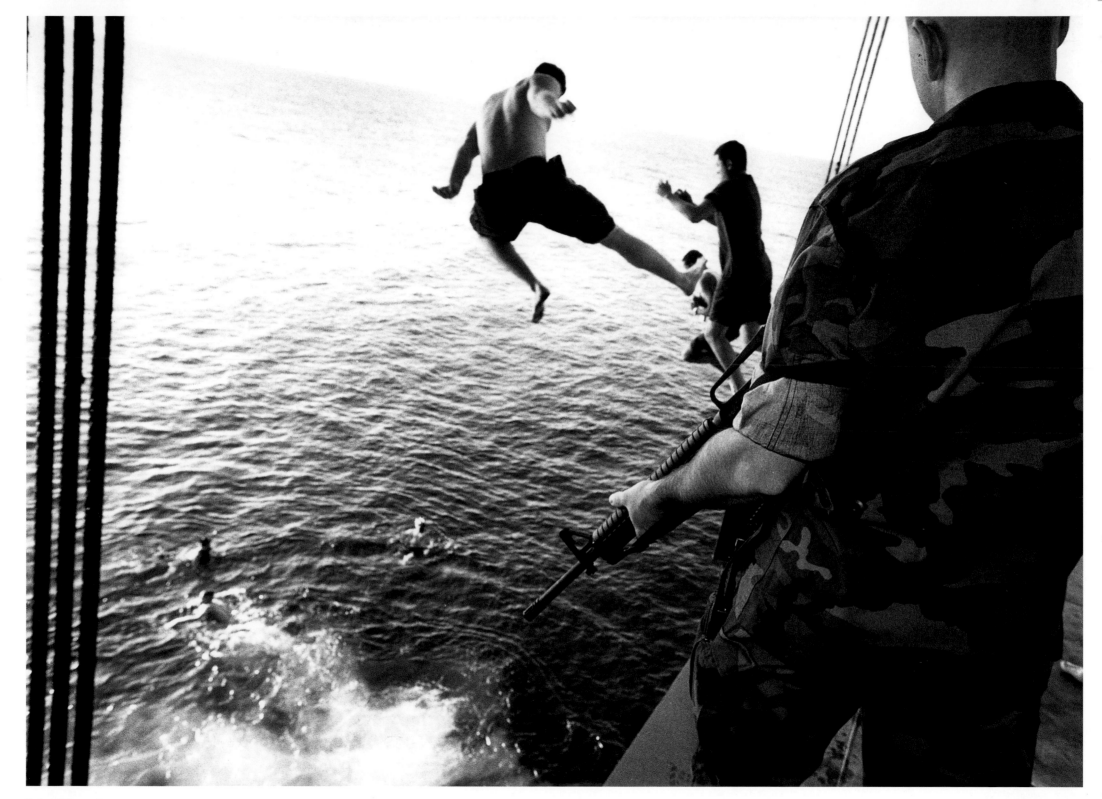

United States sailors. USS *THEODORE ROOSEVELT*, ARABIAN SEA, 2001.

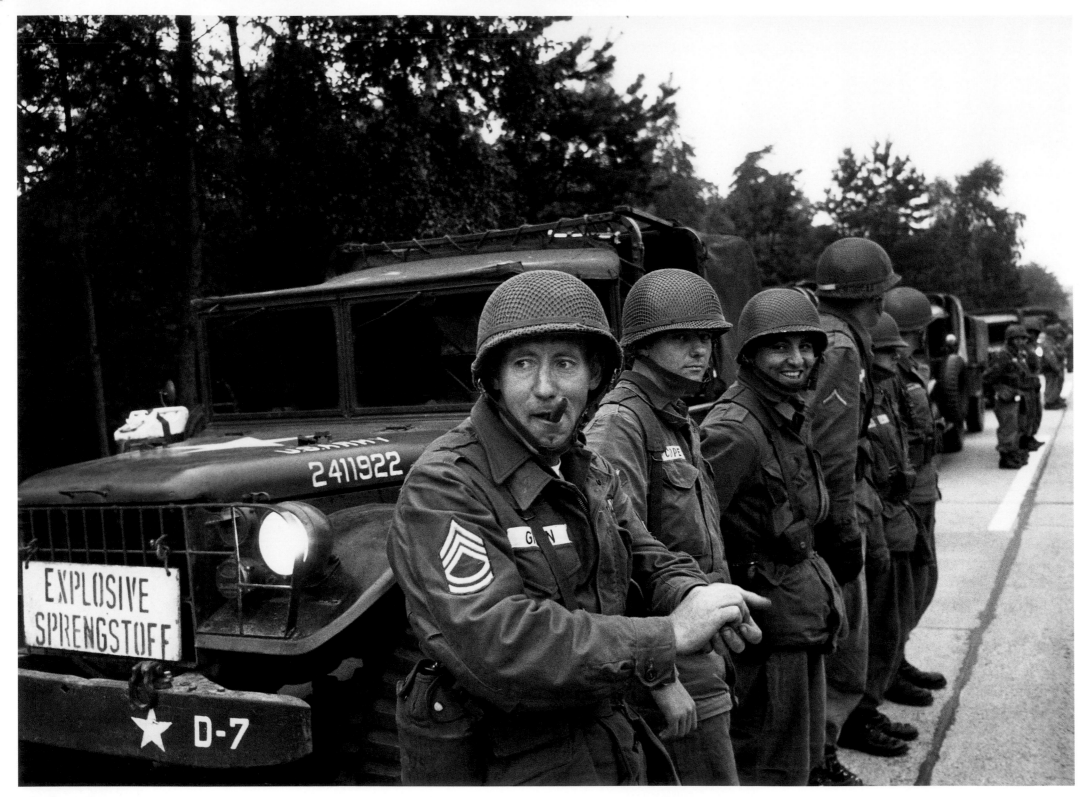

United States soldiers. OUTSIDE BERLIN, GERMANY, 1961.

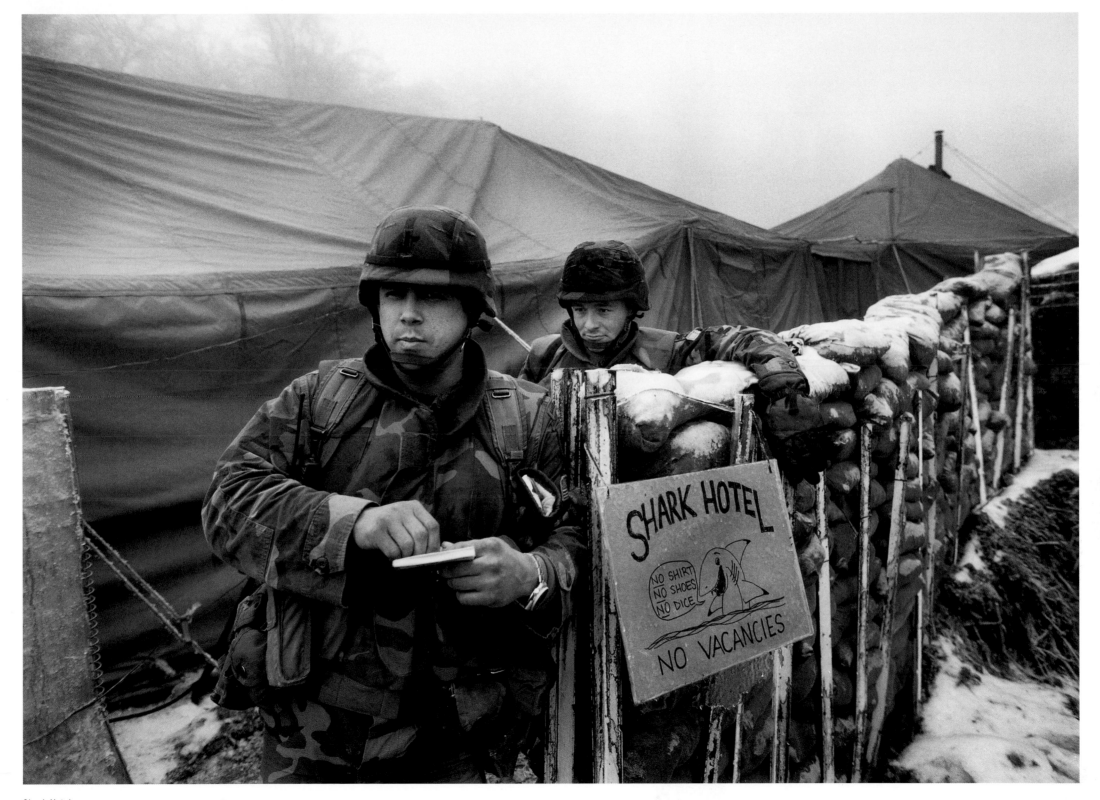

Shark Hotel. NEAR TUZLA, BOSNIA-HERZEGOVINA, 1996.

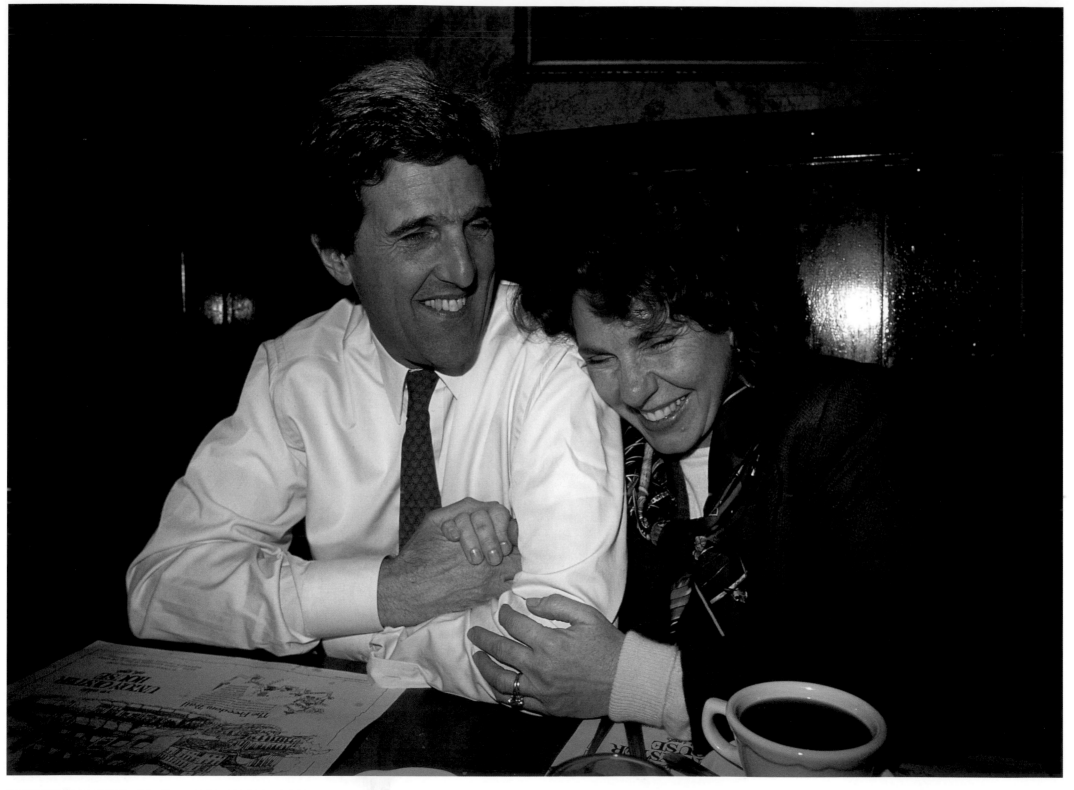

Senator John Kerry and Teresa Heinz Kerry. BOSTON, MASSACHUSETTS, 1996.

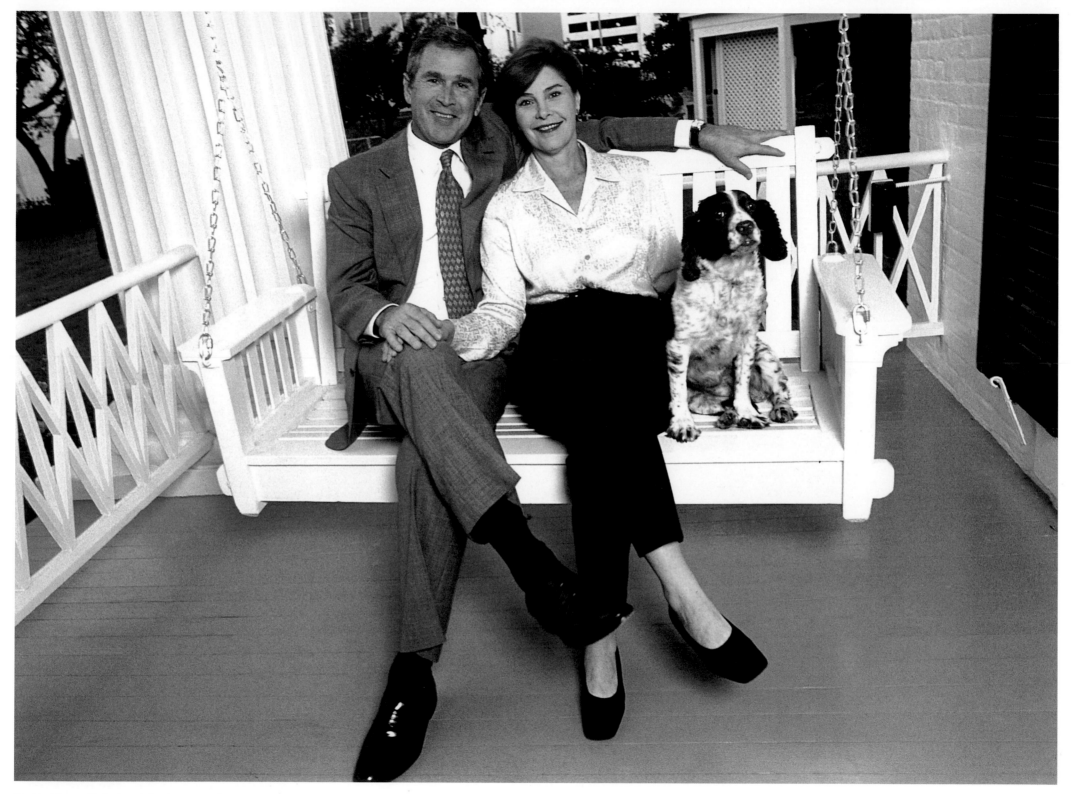

President George W. Bush and First Lady Laura Bush. AUSTIN, TEXAS, 2000.

Jacqueline Bouvier Kennedy. LAURENTIAN MOUNTAINS, CANADA, 1968.

Hillary Rodham Clinton. LITTLE ROCK, ARKANSAS, 1992.

Geraldine Ferraro. SAINT CROIX, U.S. VIRGIN ISLANDS, 1984.

Kathryn Sullivan. LYNDON B. JOHNSON SPACE CENTER, HOUSTON, TEXAS, 1982.

Martha Stewart. WESTPORT, CONNECTICUT, 1990.

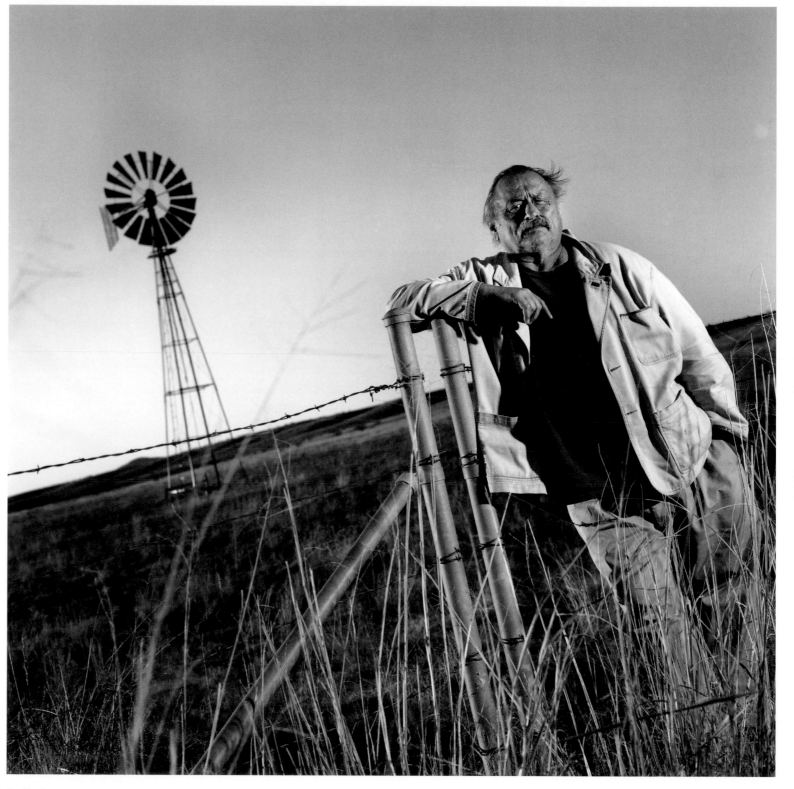

Jim Harrison. PATAGONIA, ARIZONA, 2001.

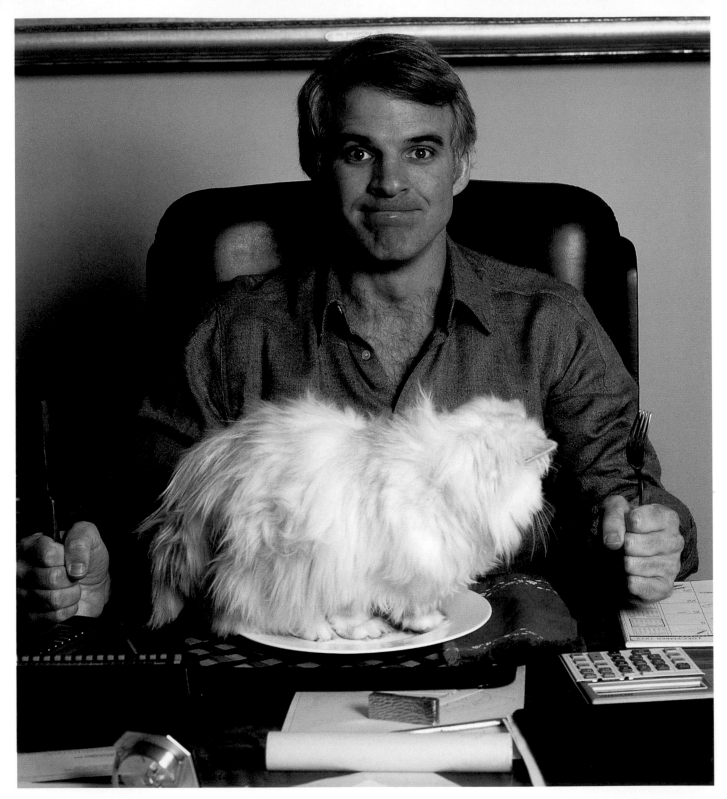

Steve Martin. VAIL, COLORADO, 1978.

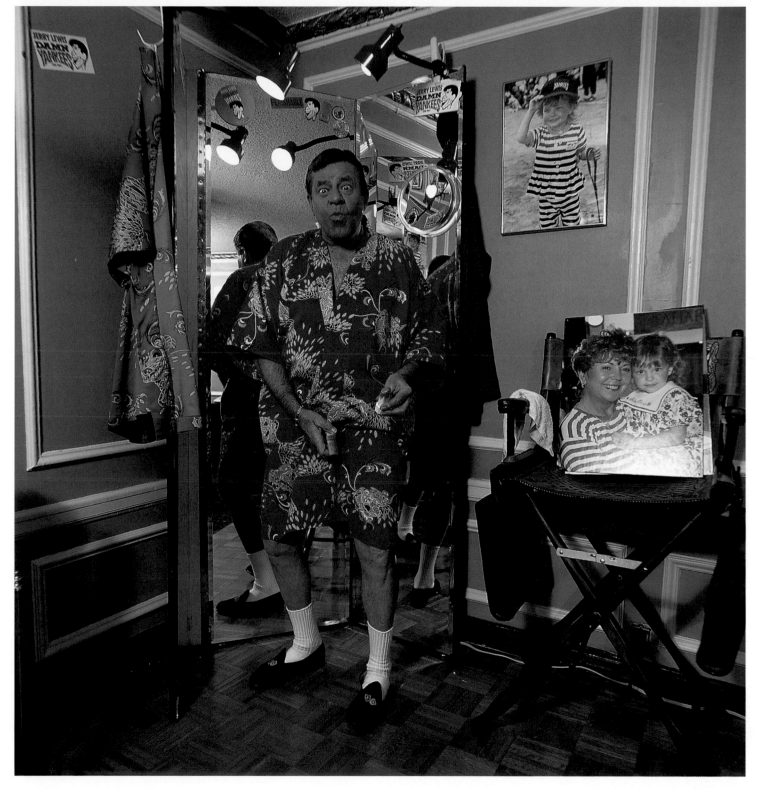

Jerry Lewis. ST. LOUIS, MISSOURI, 1997.

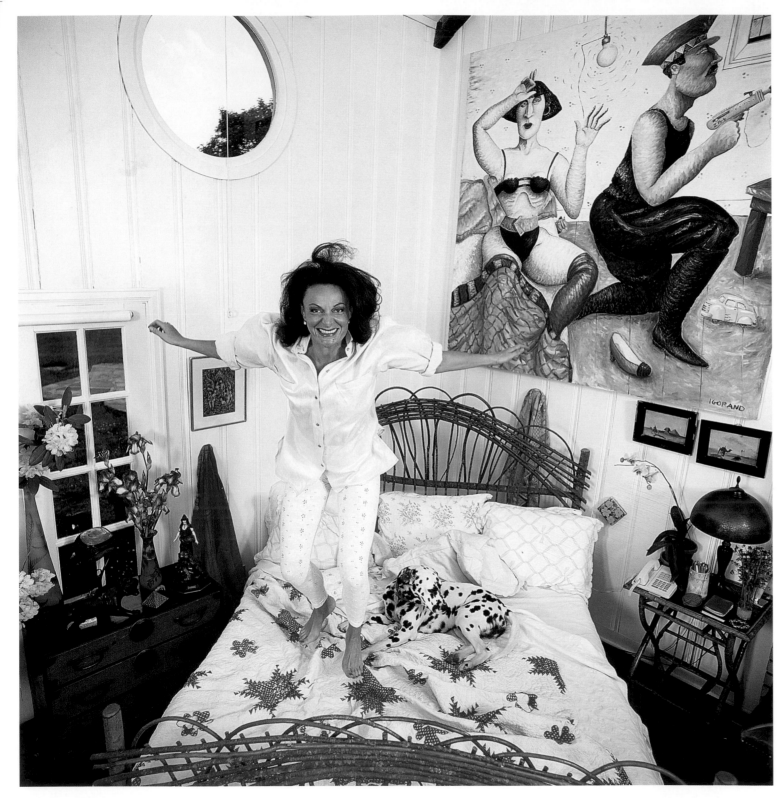

Diane von Furstenberg. NEW MILFORD, CONNECTICUT, 1991.

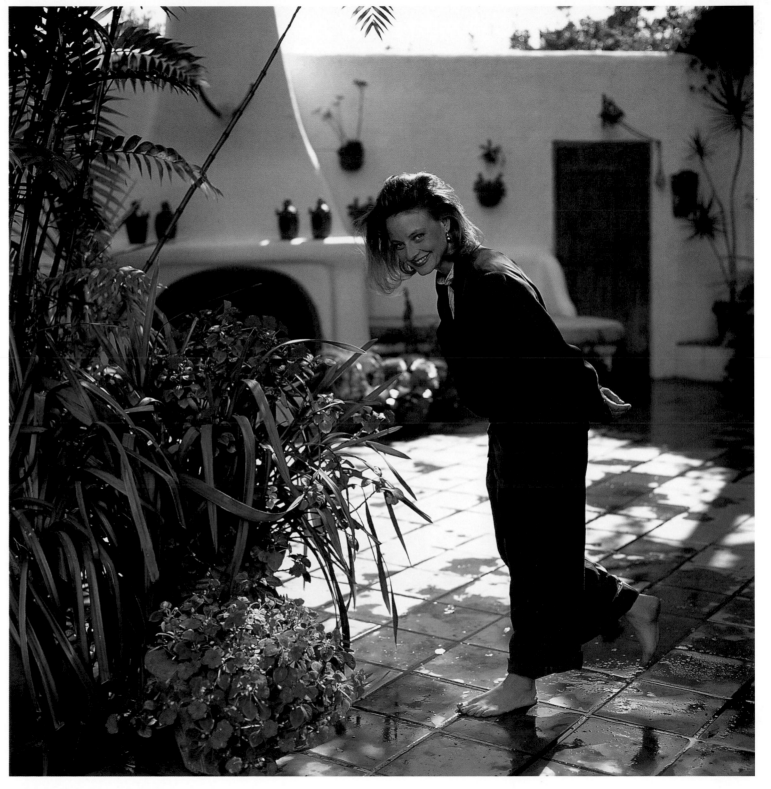

Jodie Foster. BEVERLY HILLS, CALIFORNIA, 1991.

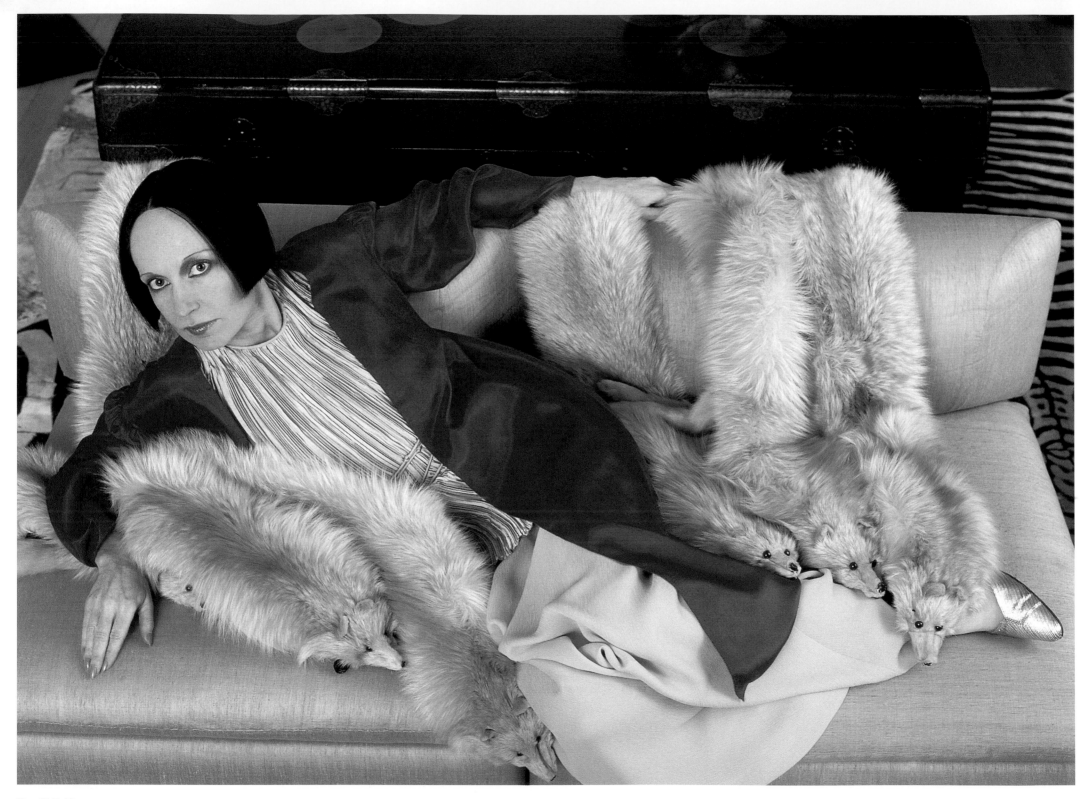

Mary McFadden. NEW YORK, NEW YORK, 1978.

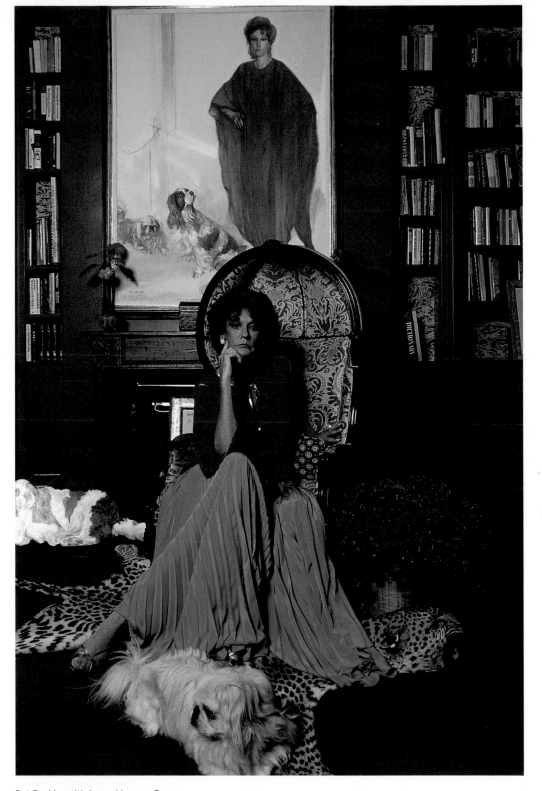

Pat Buckley with her pekingese, Foo. NEW YORK, NEW YORK, 1977.

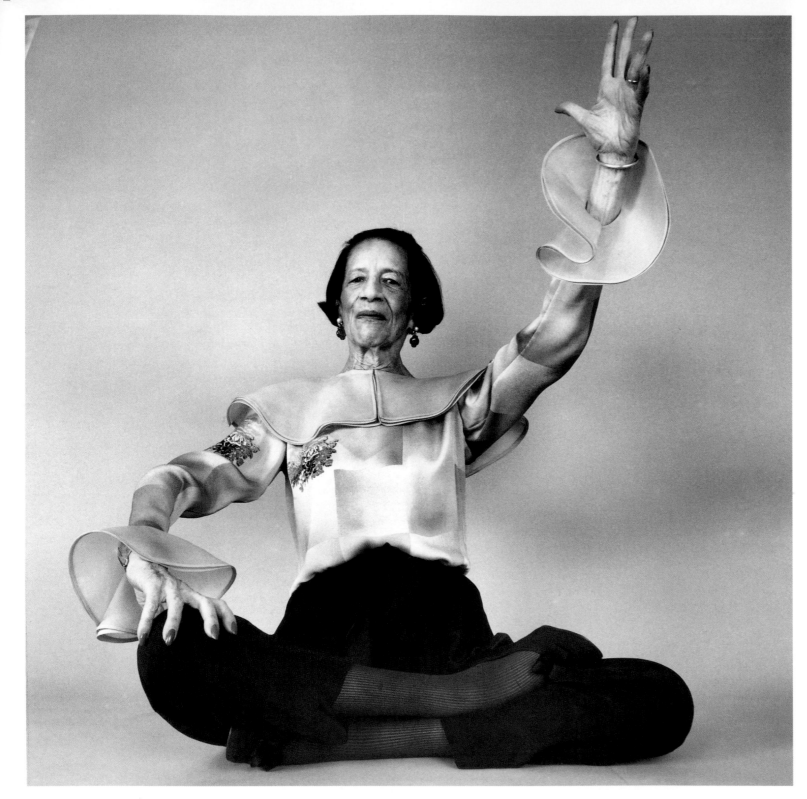

Diana Vreeland. NEW YORK, NEW YORK, 1980.

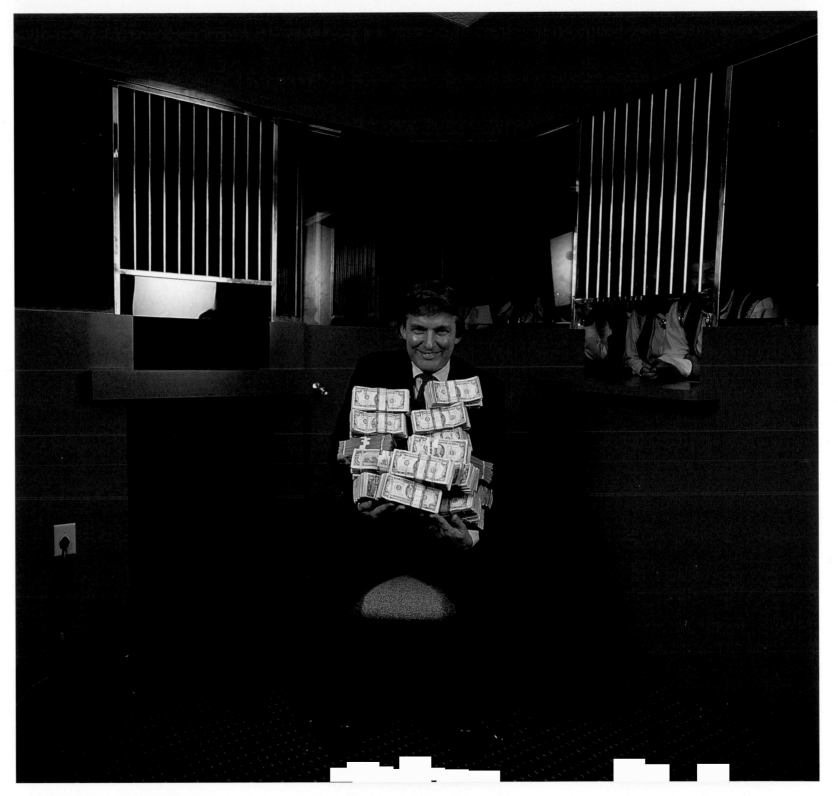

Donald Trump. ATLANTIC CITY, NEW JERSEY, 1990.

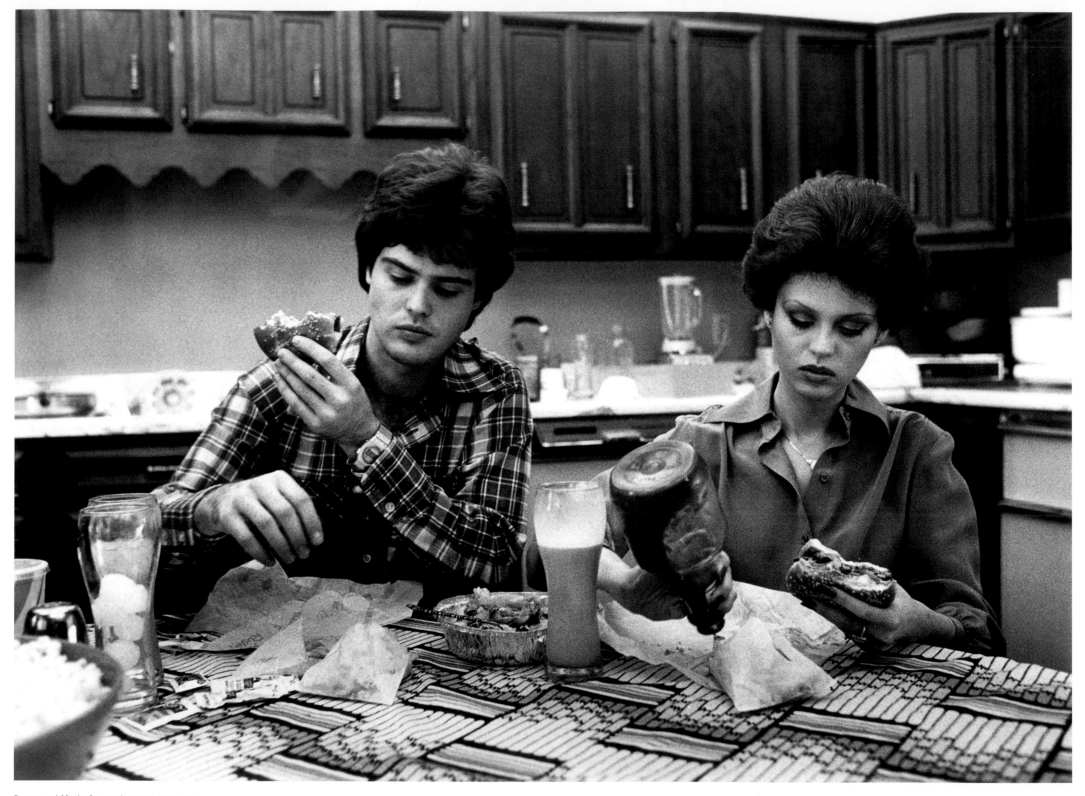

Donny and Marie Osmond. OGDEN, UTAH, 1977.

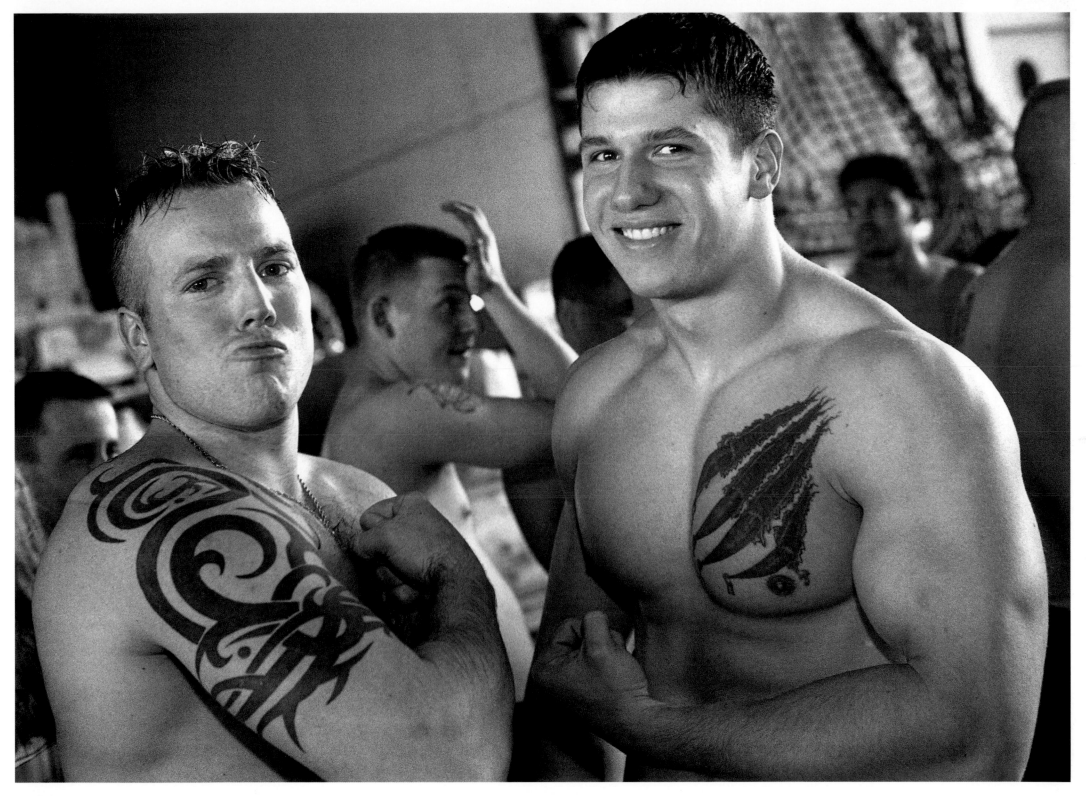

Two Marines. USS *THEODORE ROOSEVELT*, ARABIAN SEA, 2001.

David Merrick. NEW YORK, NEW YORK, 1994.

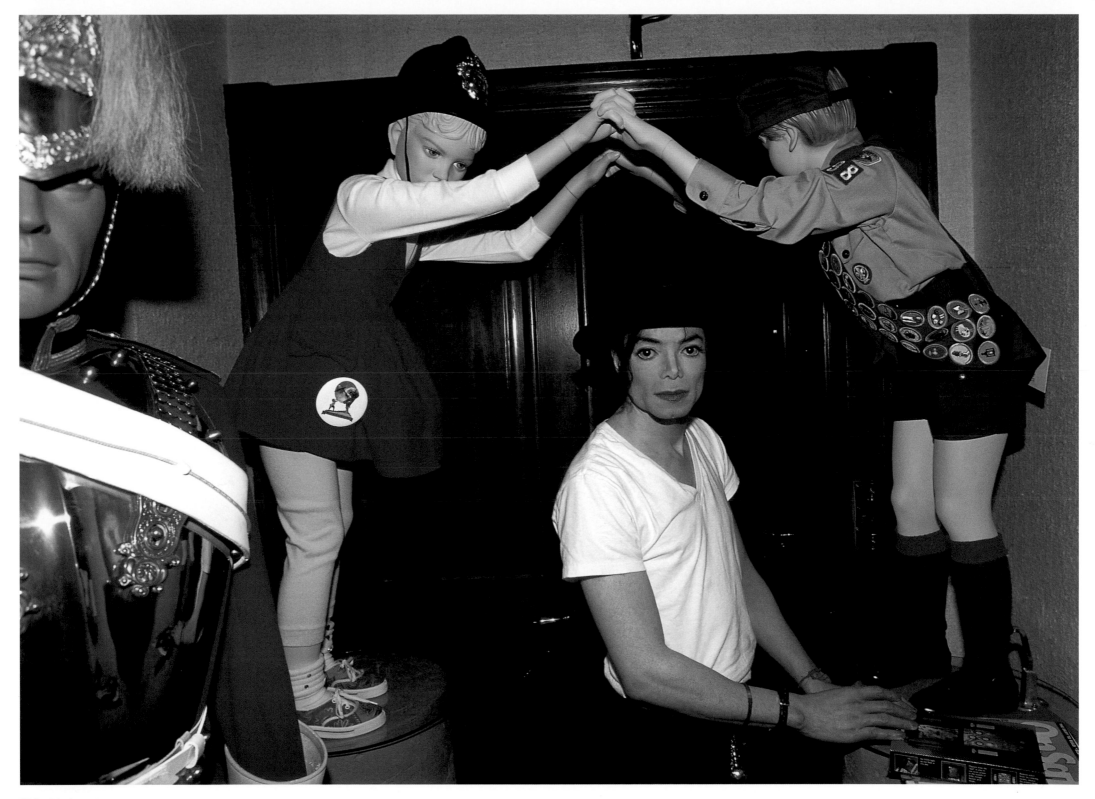

Michael Jackson. SANTA YNEZ, CALIFORNIA, 1993.

Oprah Winfrey. CHICAGO, ILLINOIS, 1996.

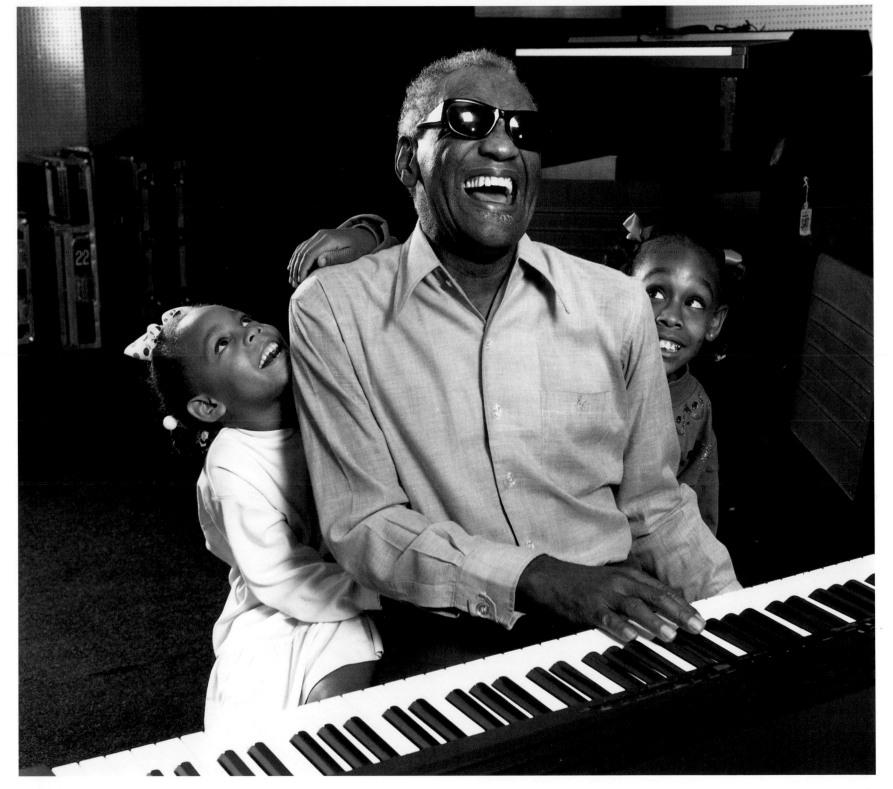

Ray Charles and grandchildren. LOS ANGELES, CALIFORNIA, 1991.

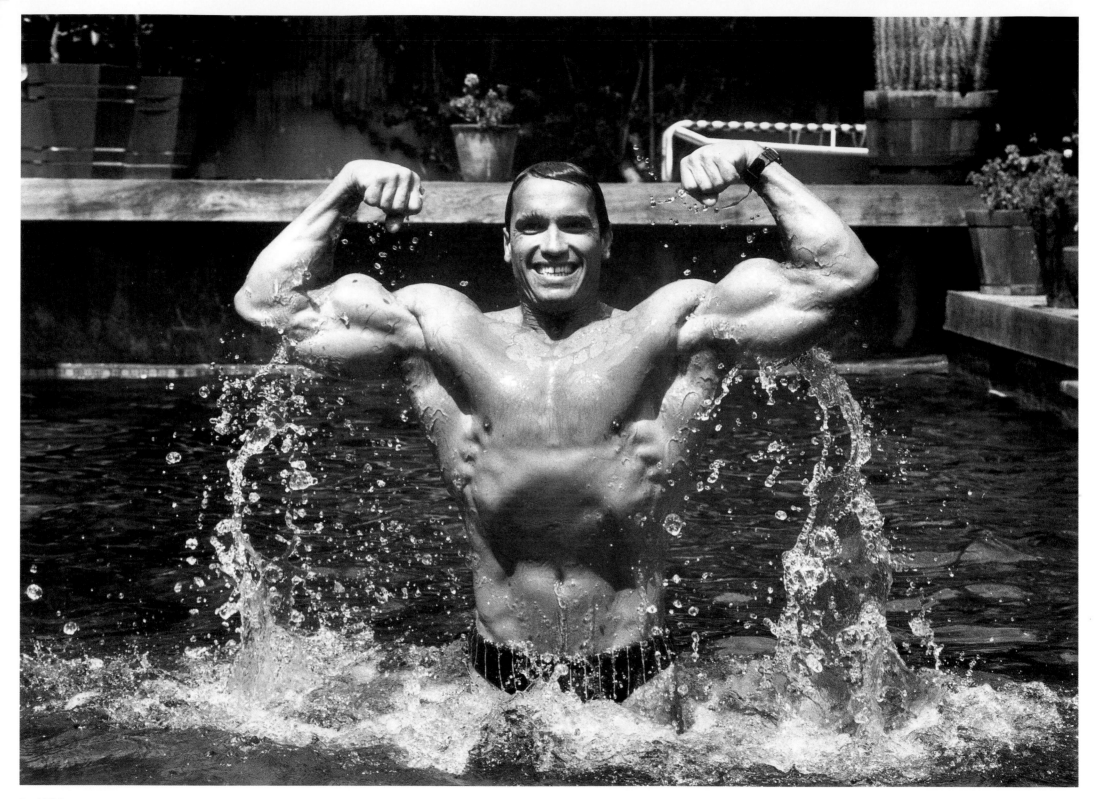

Arnold Schwarzenegger. LOS ANGELES, CALIFORNIA, 1985.

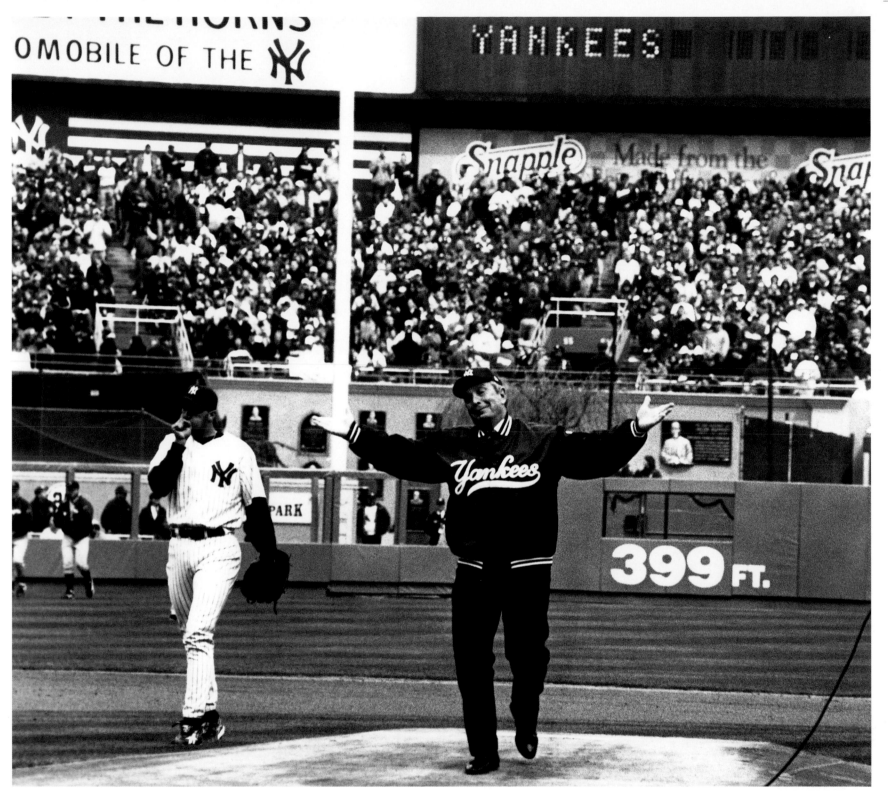

Mayor Michael Bloomberg. YANKEE STADIUM, BRONX, NEW YORK, 2002.

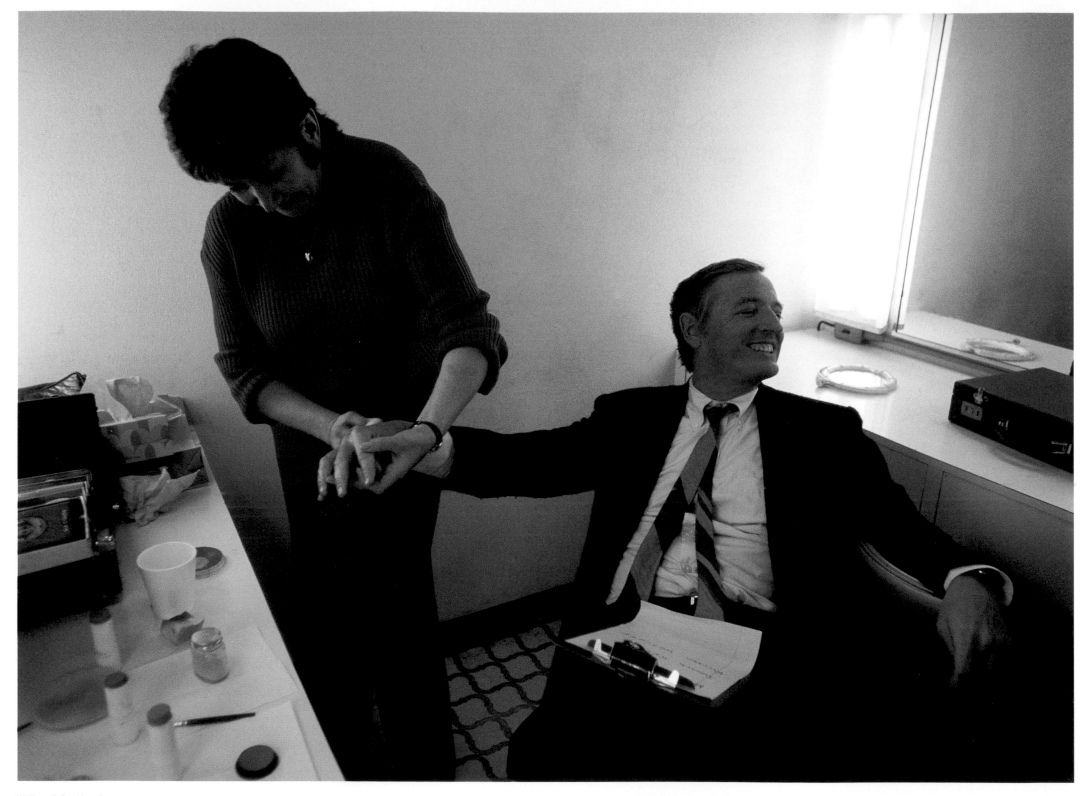

William F. Buckley, Jr. NEW YORK, NEW YORK, 1988.

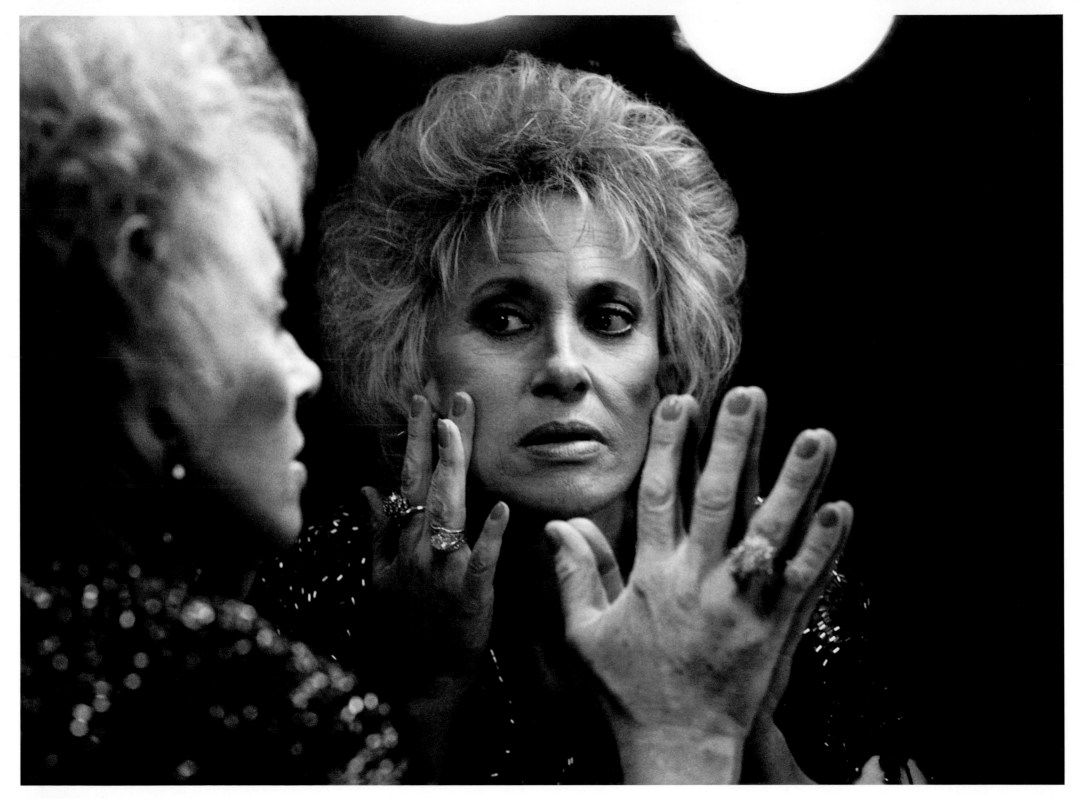

Tammy Wynette. NASHVILLE, TENNESSEE, 1990.

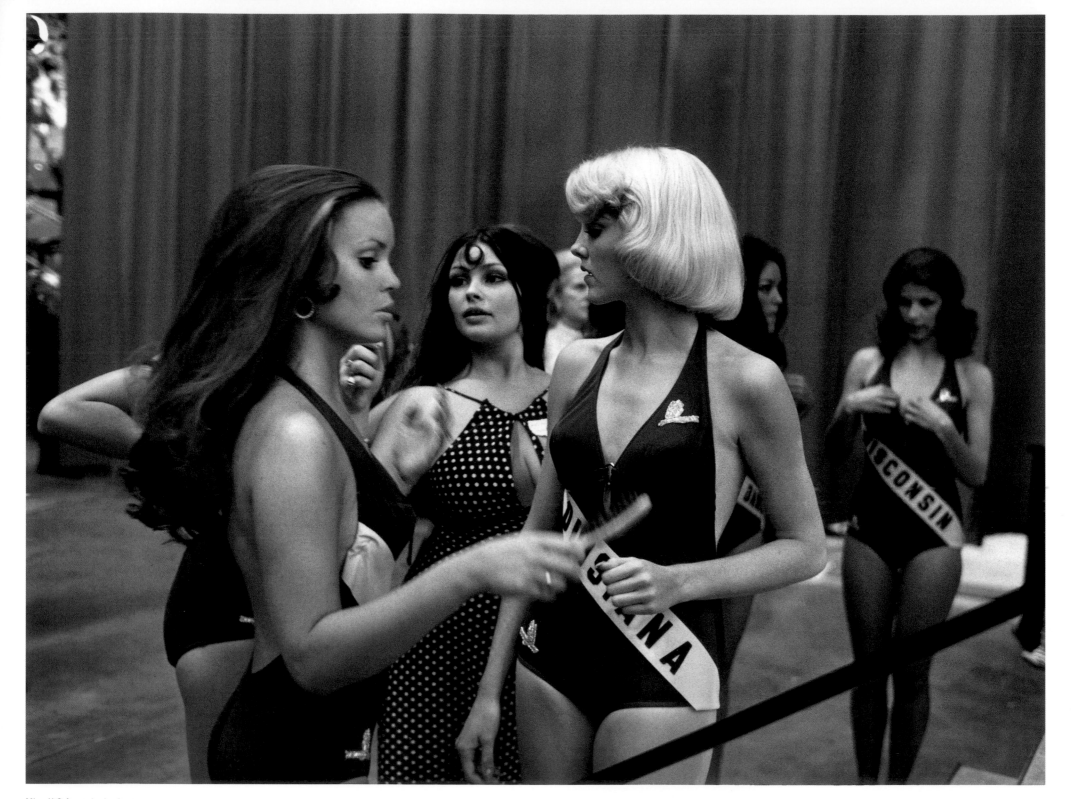

Miss U.S.A. contestants. NIAGARA FALLS, NEW YORK, 1974.

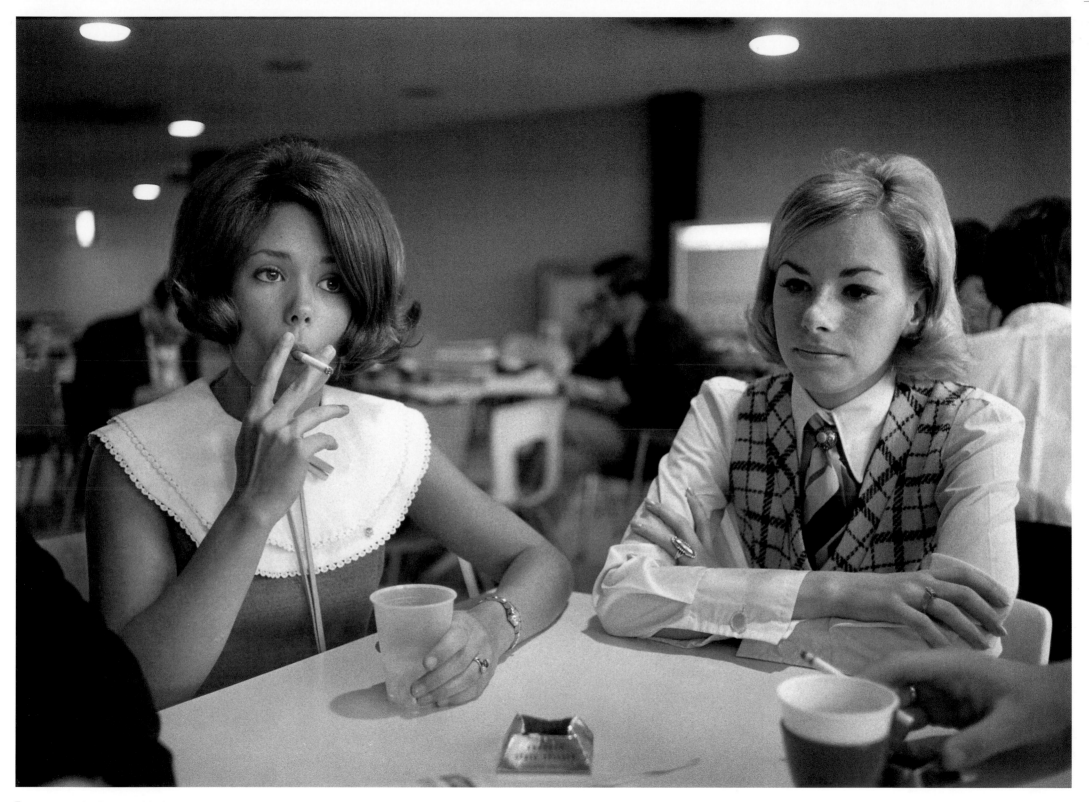

Two young women. CHADRON, NEBRASKA, 1969.

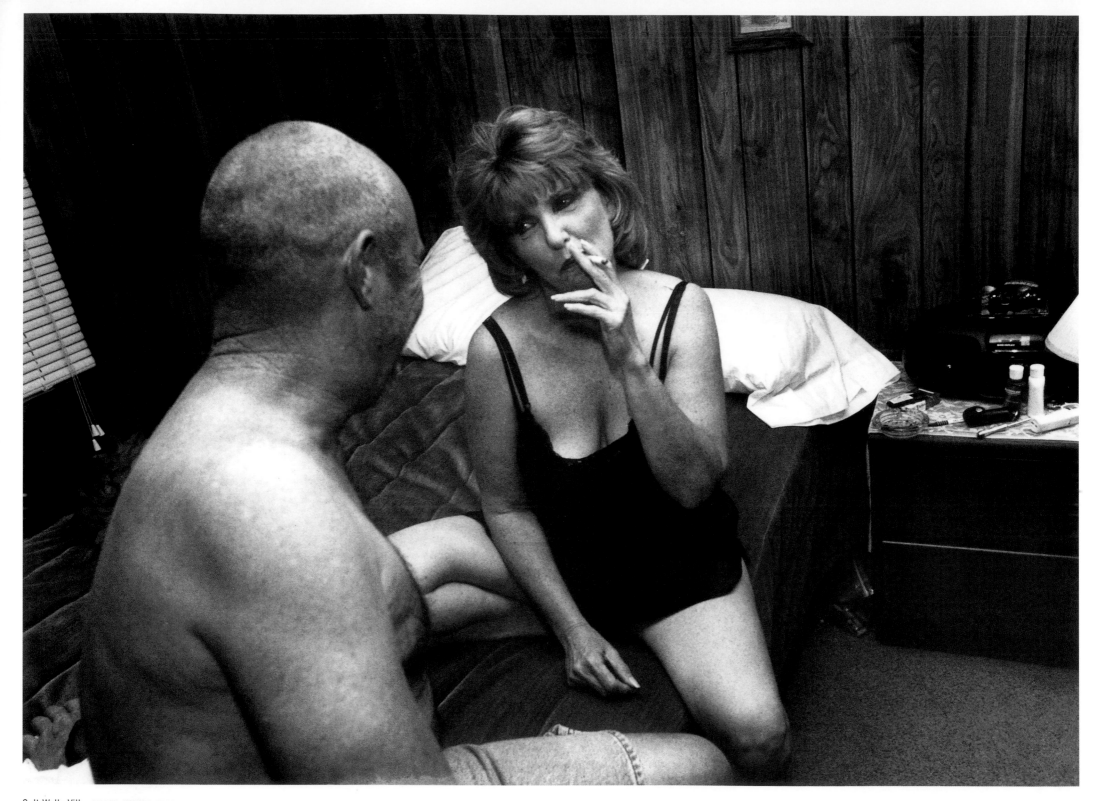

Salt Wells Villa. FALLON, NEVADA, 1999.

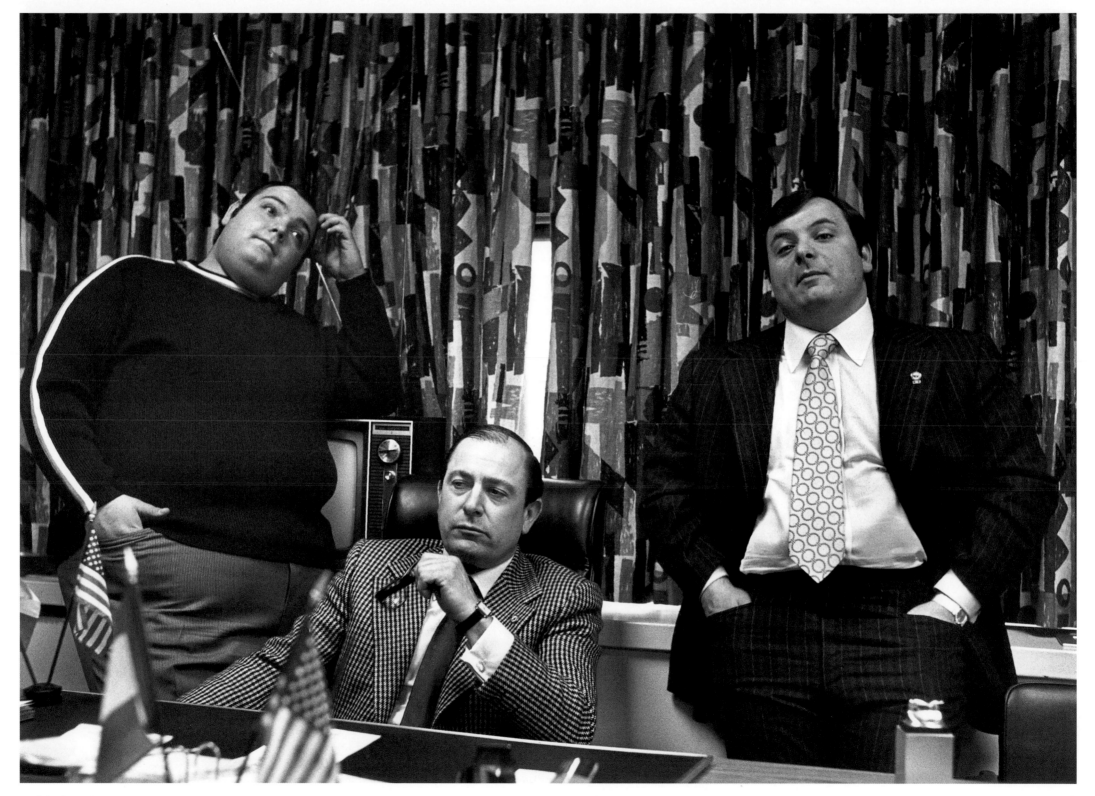

Joe Columbo and sons. NEW YORK, NEW YORK, 1971.

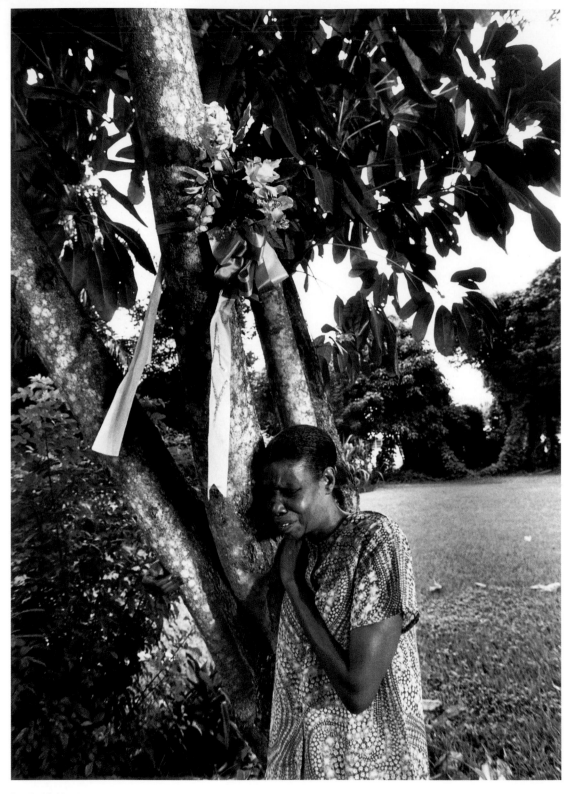

Bernice Golden. BELLE GLADE, FLORIDA, 2003.

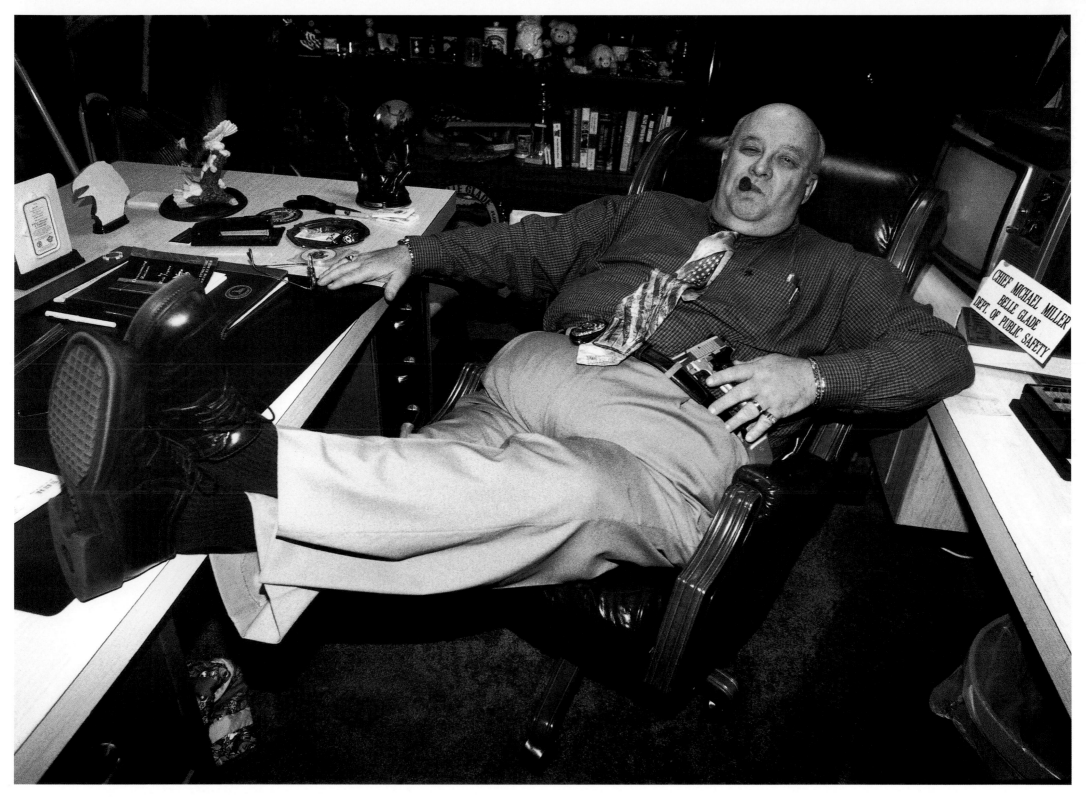

Police Chief Michael Miller. BELLE GLADE, FLORIDA, 2003.

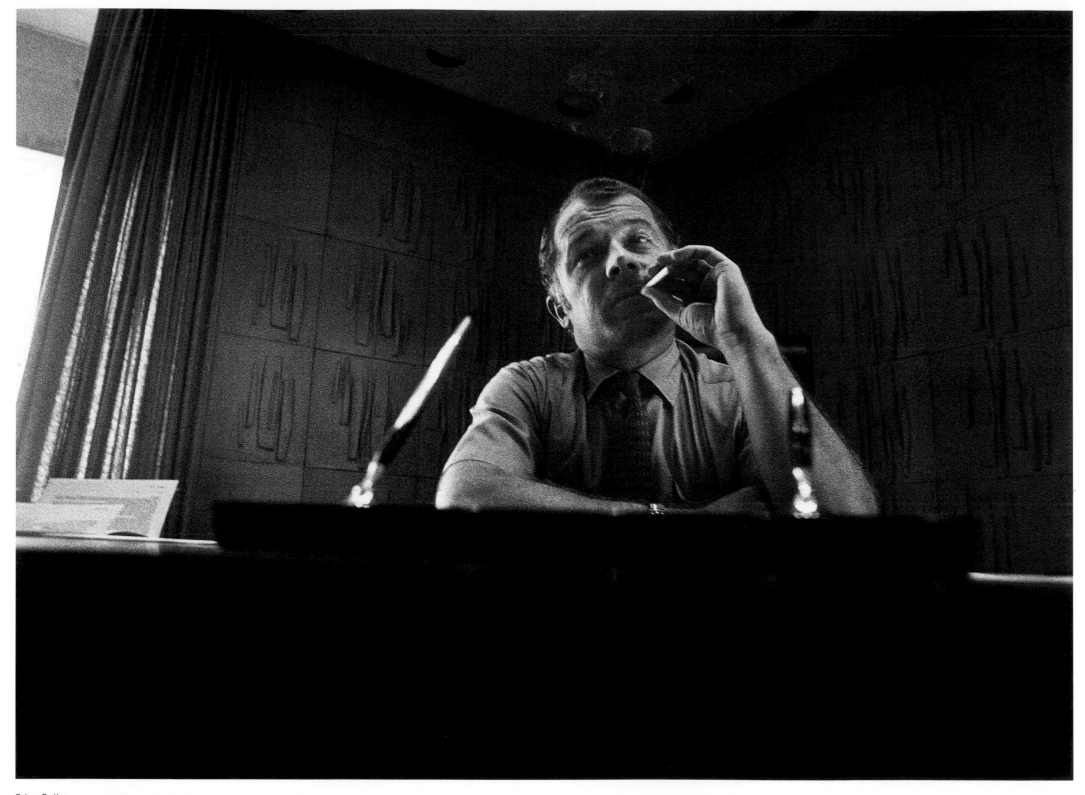

F. Lee Bailey. BOSTON, MASSACHUSETTS, 1972.

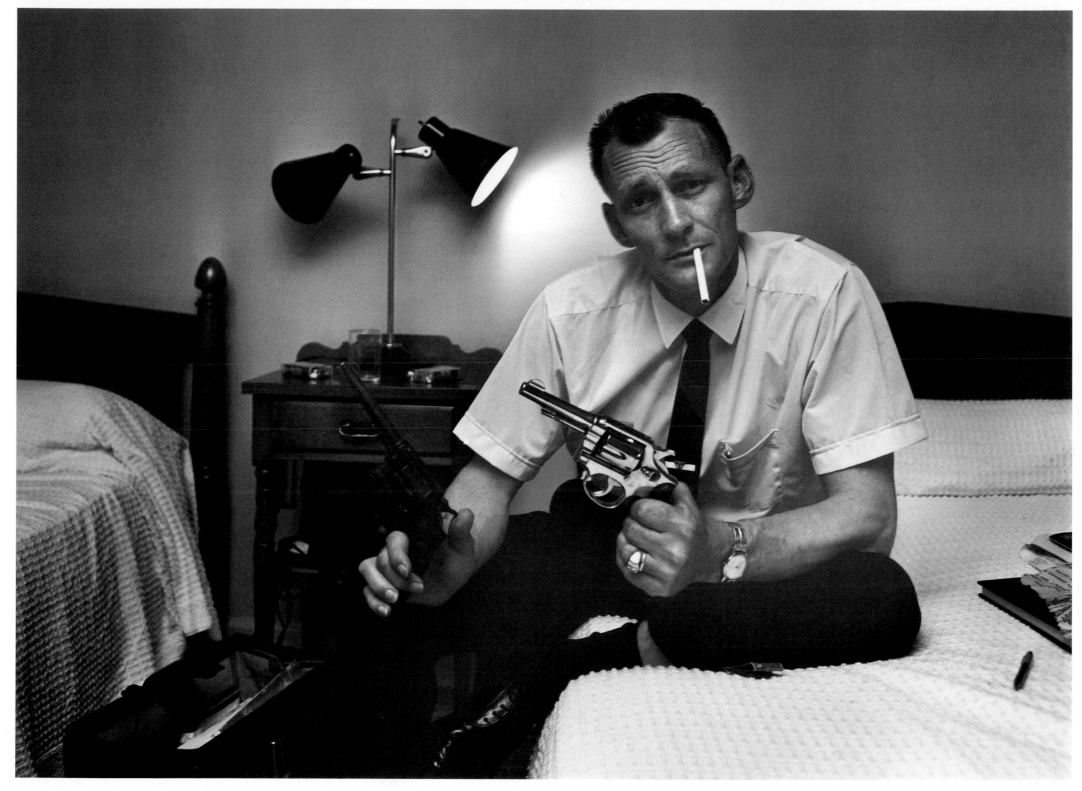

Robert Shelton. BEAUFORT, SOUTH CAROLINA, 1965.

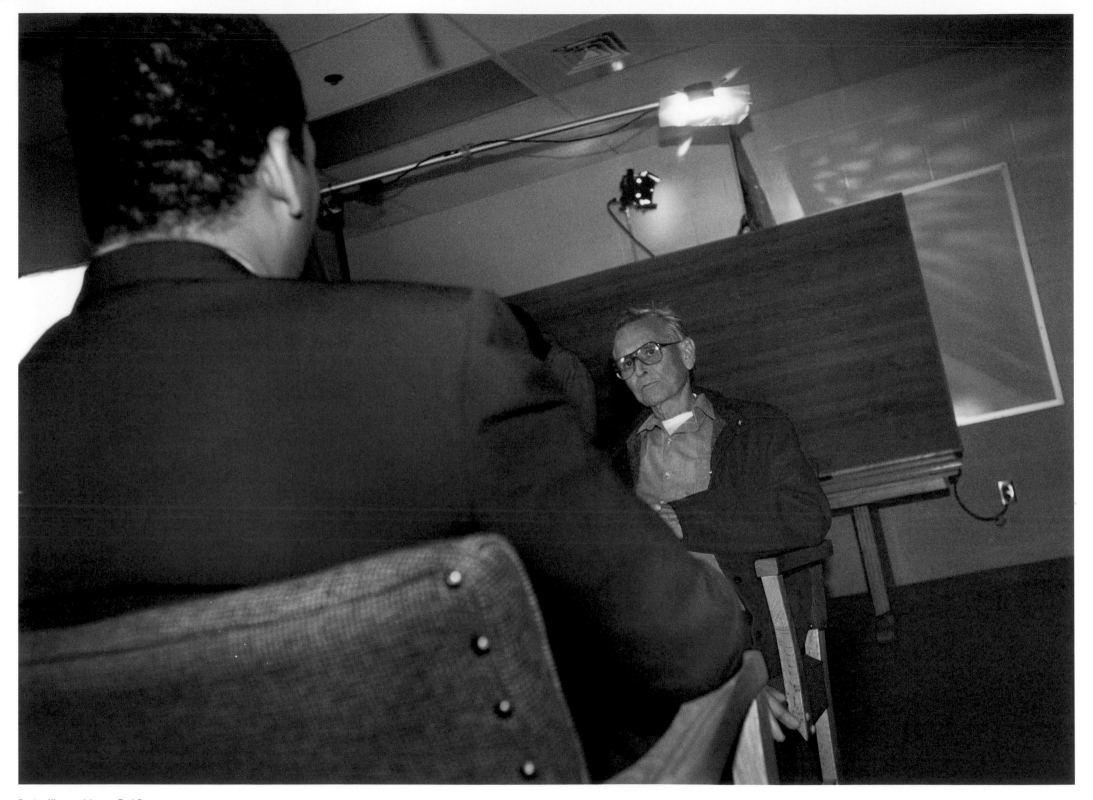

Dexter King and James Earl Ray. TENNESSEE STATE PENITENTIARY, NASHVILLE, TENNESSEE, 1997.

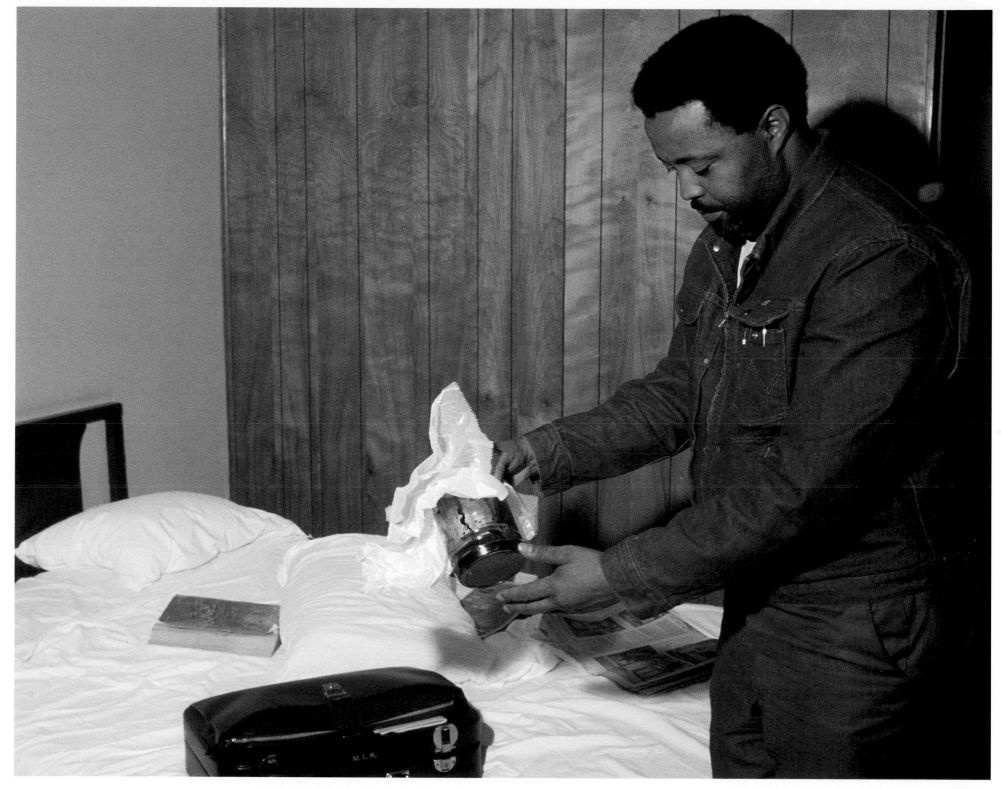

José Williams. MEMPHIS, TENNESSEE, 1968.

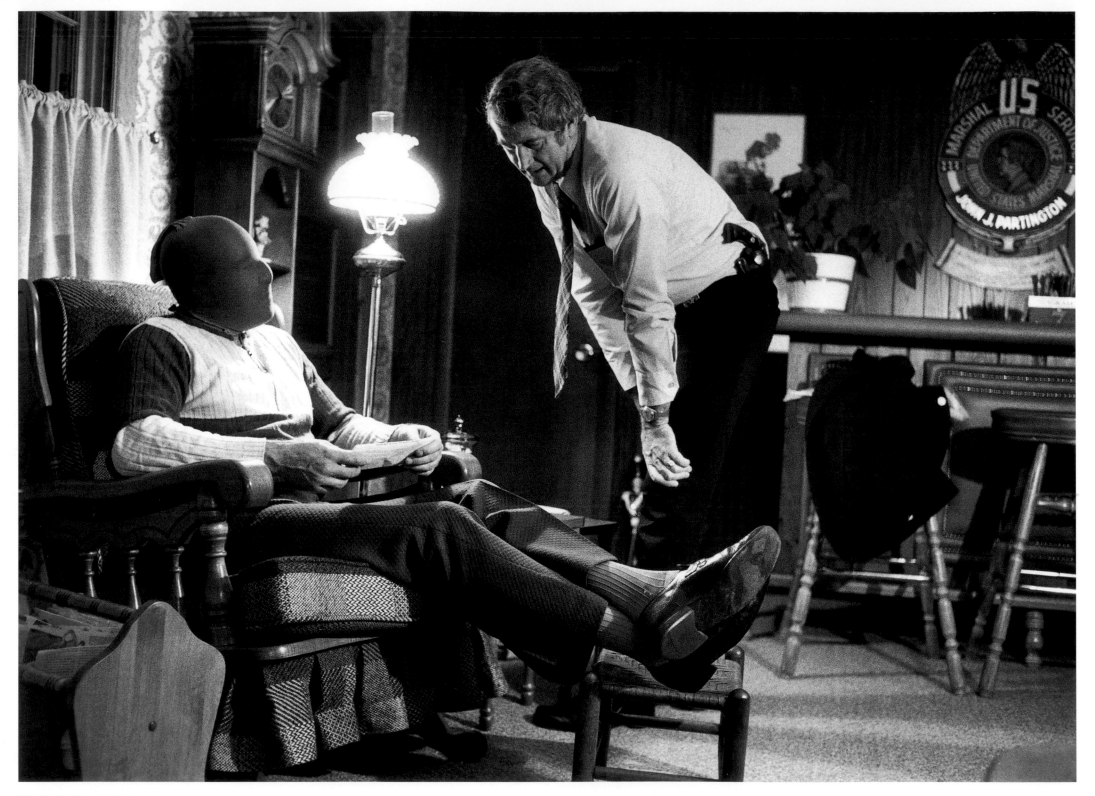

U.S. Marshall John Partington. PROVIDENCE, RHODE ISLAND, 1975.

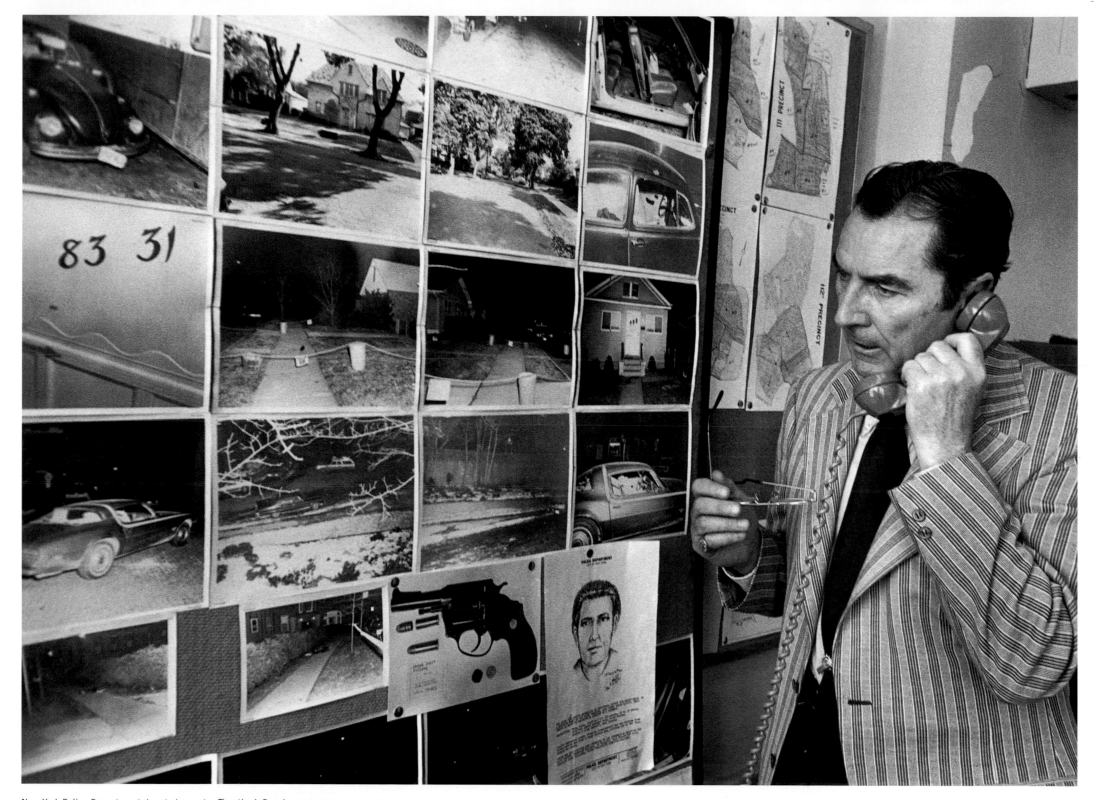

83 31

New York Police Department deputy inspector Timothy J. Dowd. NEW YORK, NEW YORK, 1977.

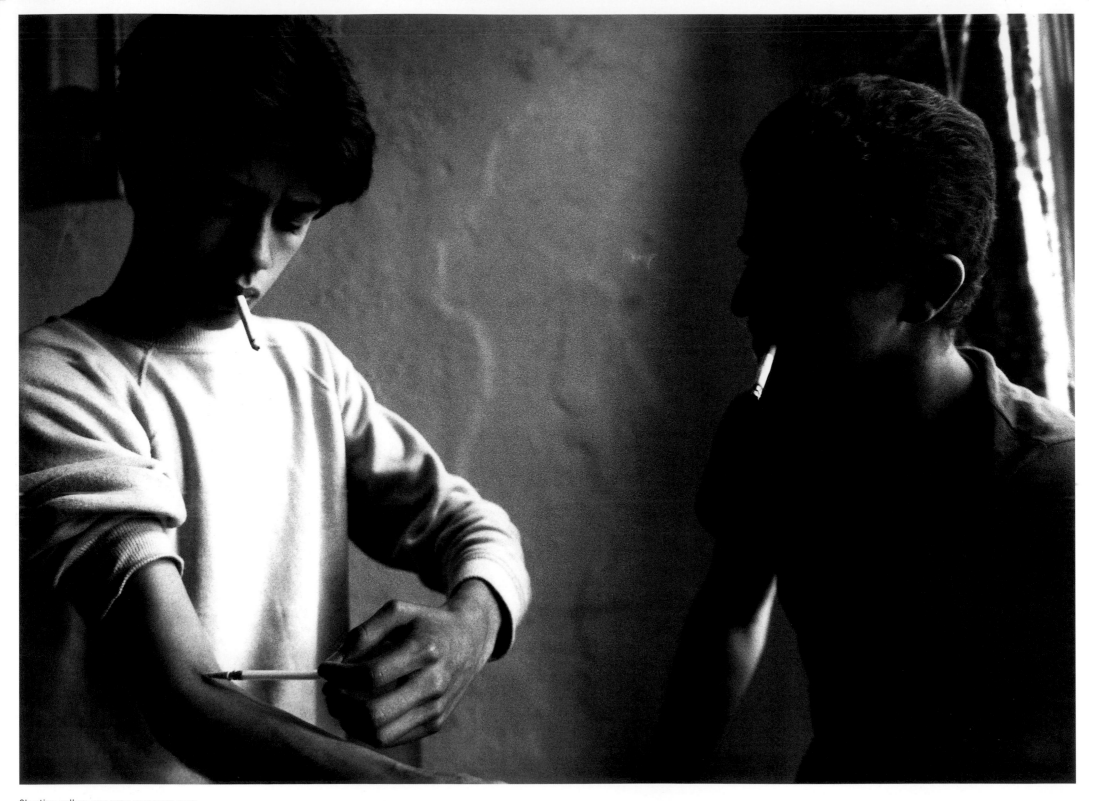

Shooting gallery. NEW YORK, NEW YORK, 1980.

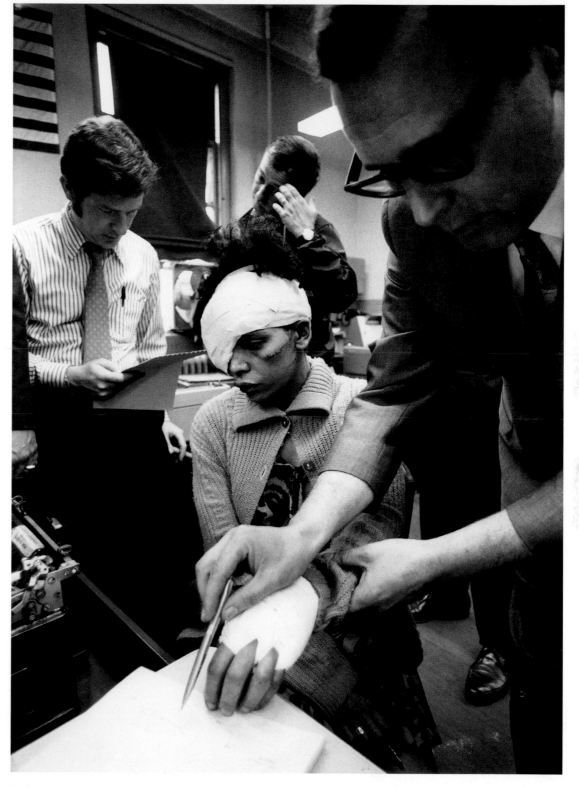

Battered woman. POLICE STATION, SOUTH BRONX, NEW YORK, 1970.

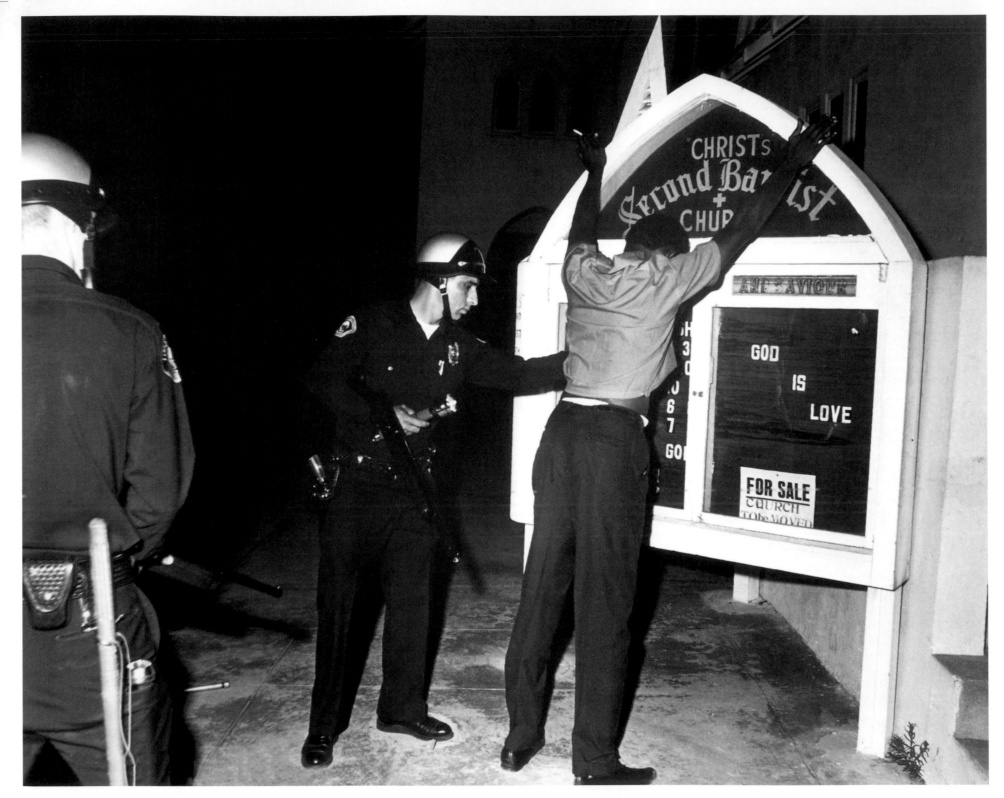

Watts Riots. LOS ANGELES, CALIFORNIA, 1965.

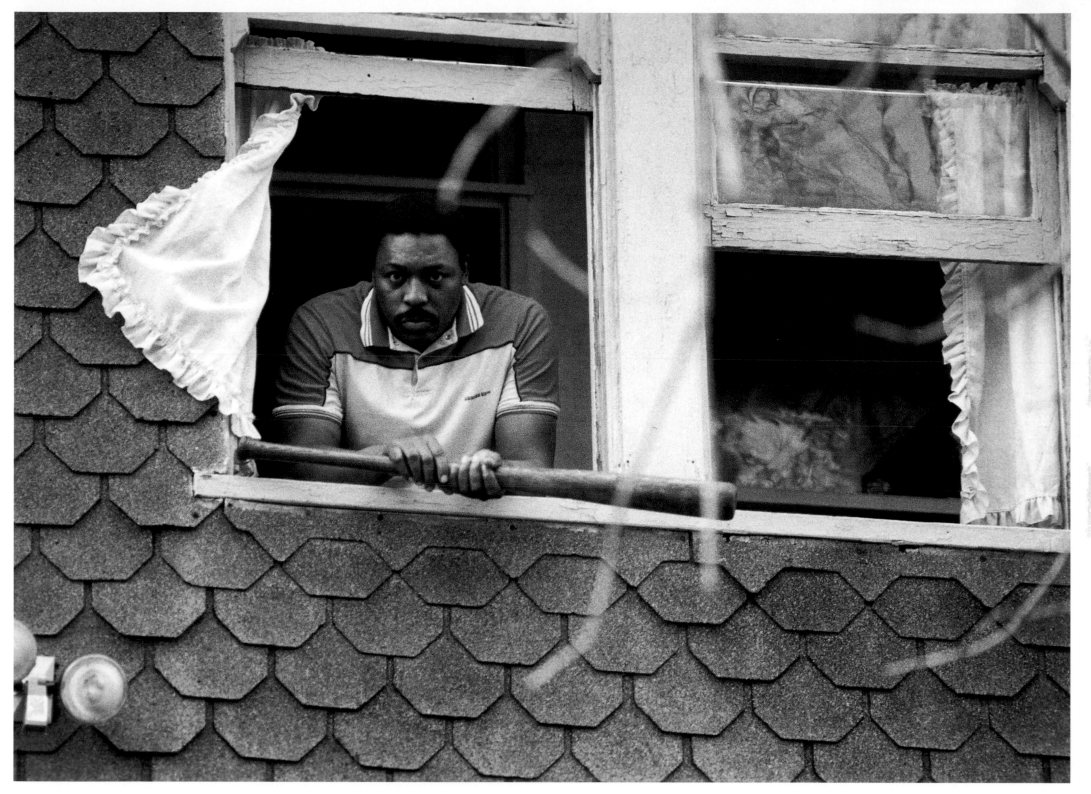

Erwin Keith. CICERO, ILLINOIS, 1983.

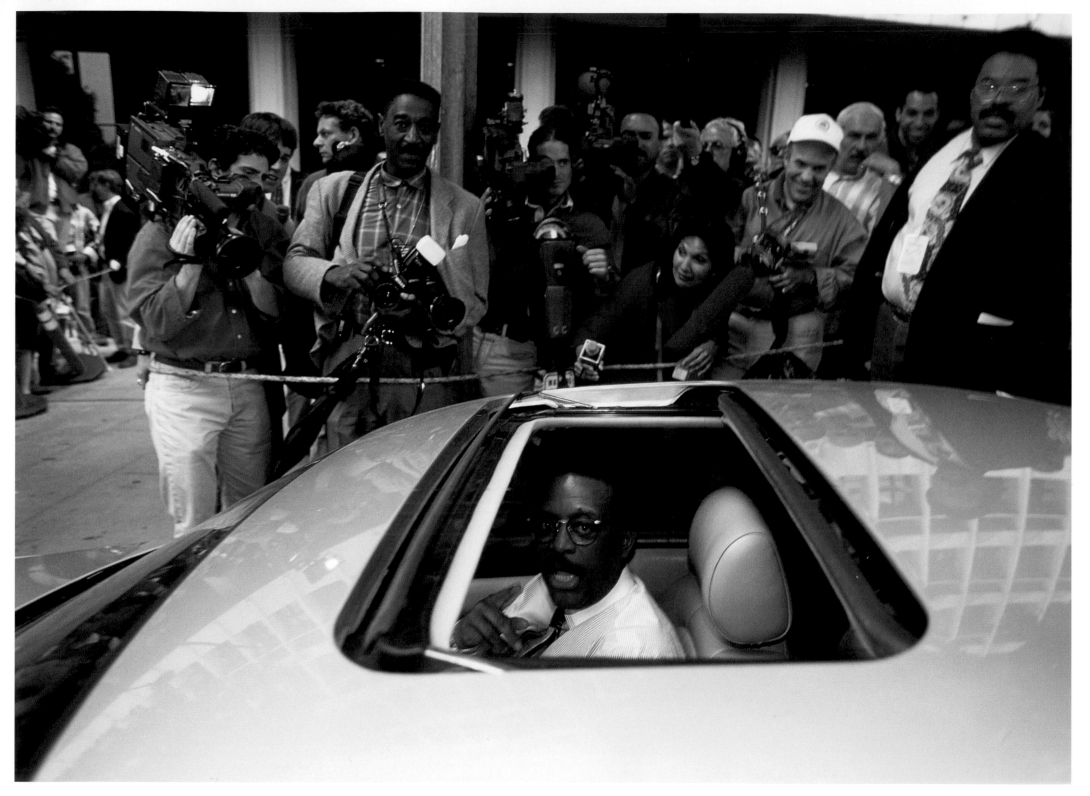

Johnny Cochran. LOS ANGELES, CALIFORNIA, 1995.

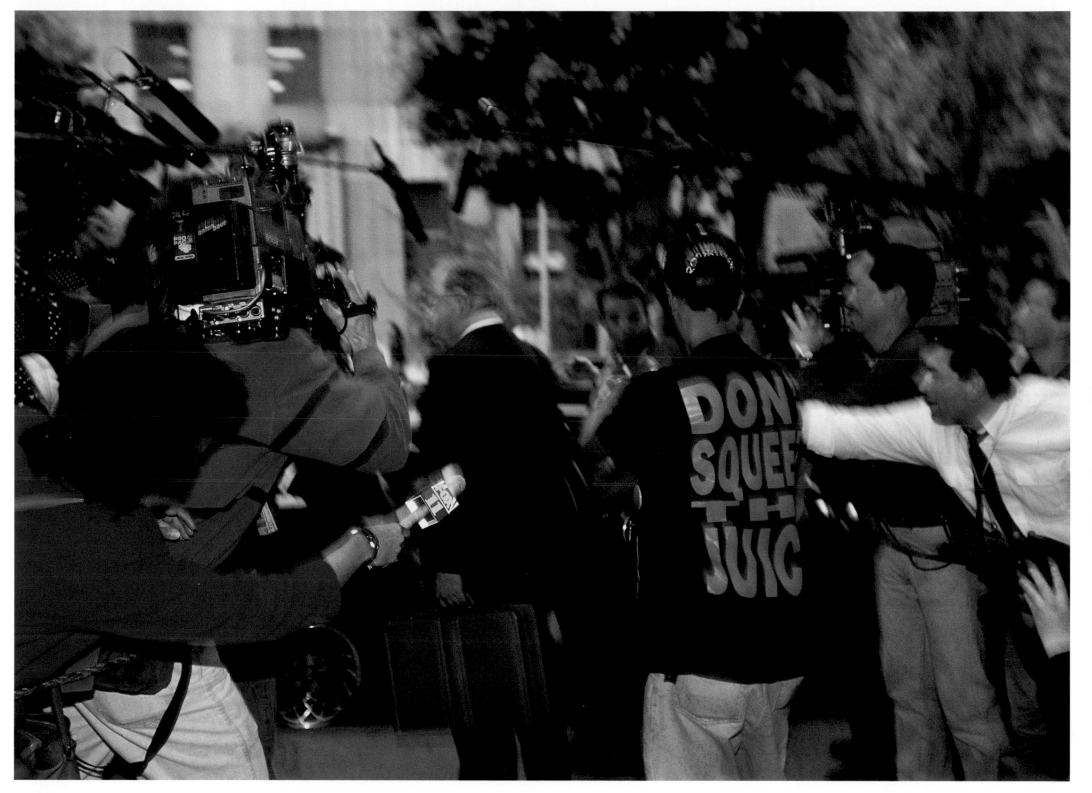

F. Lee Bailey. LOS ANGELES, CALIFORNIA, 1995.

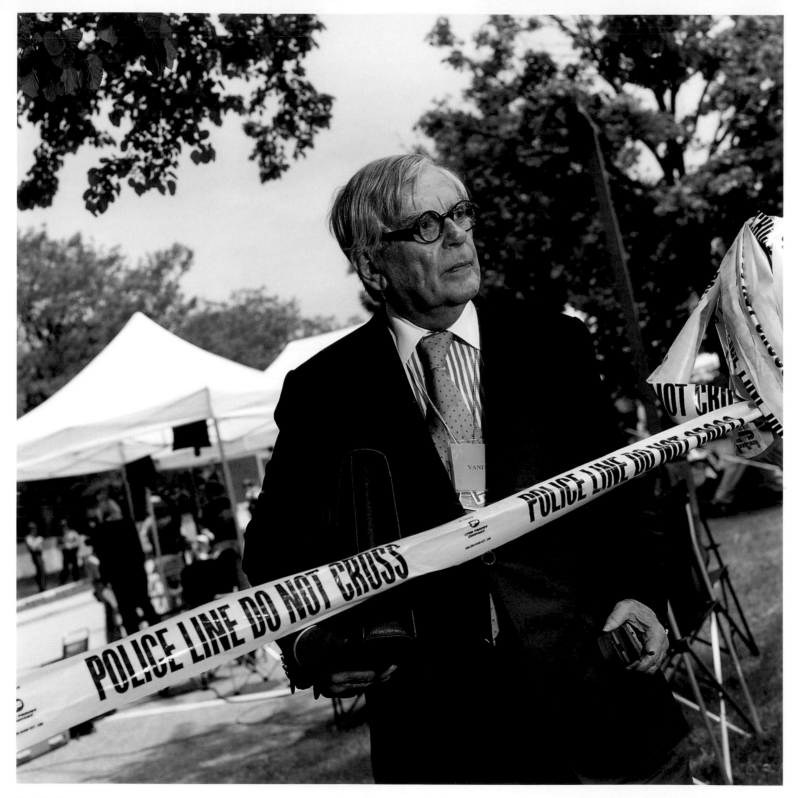

Dominick Dunne. STAMFORD, CONNECTICUT, 2002.

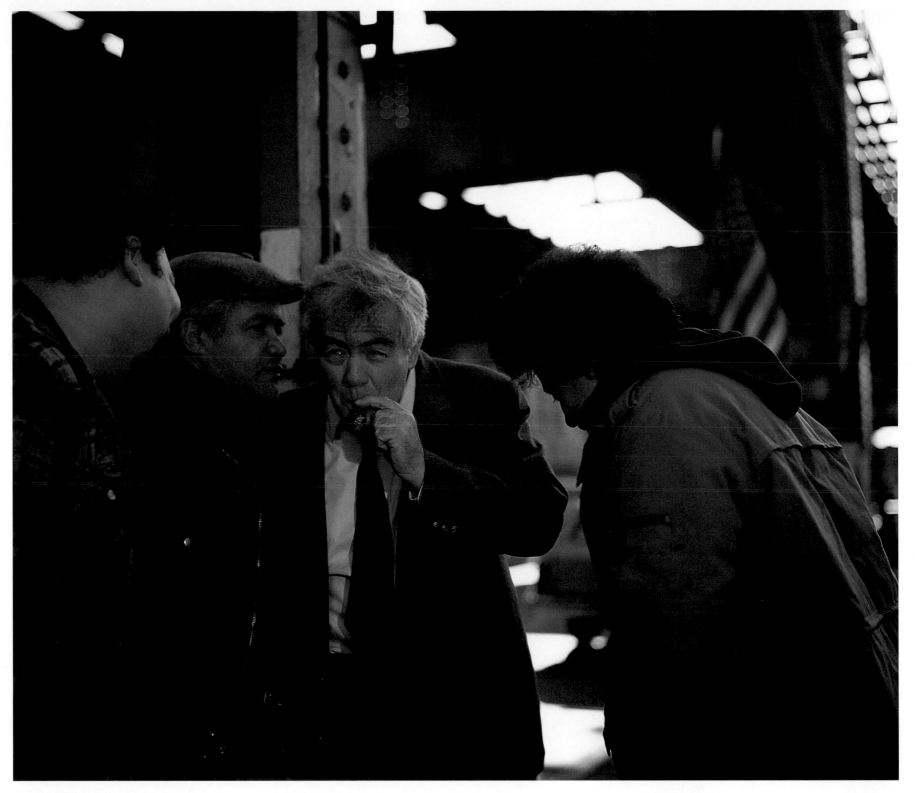

Jimmy Breslin. QUEENS, NEW YORK, 1988.

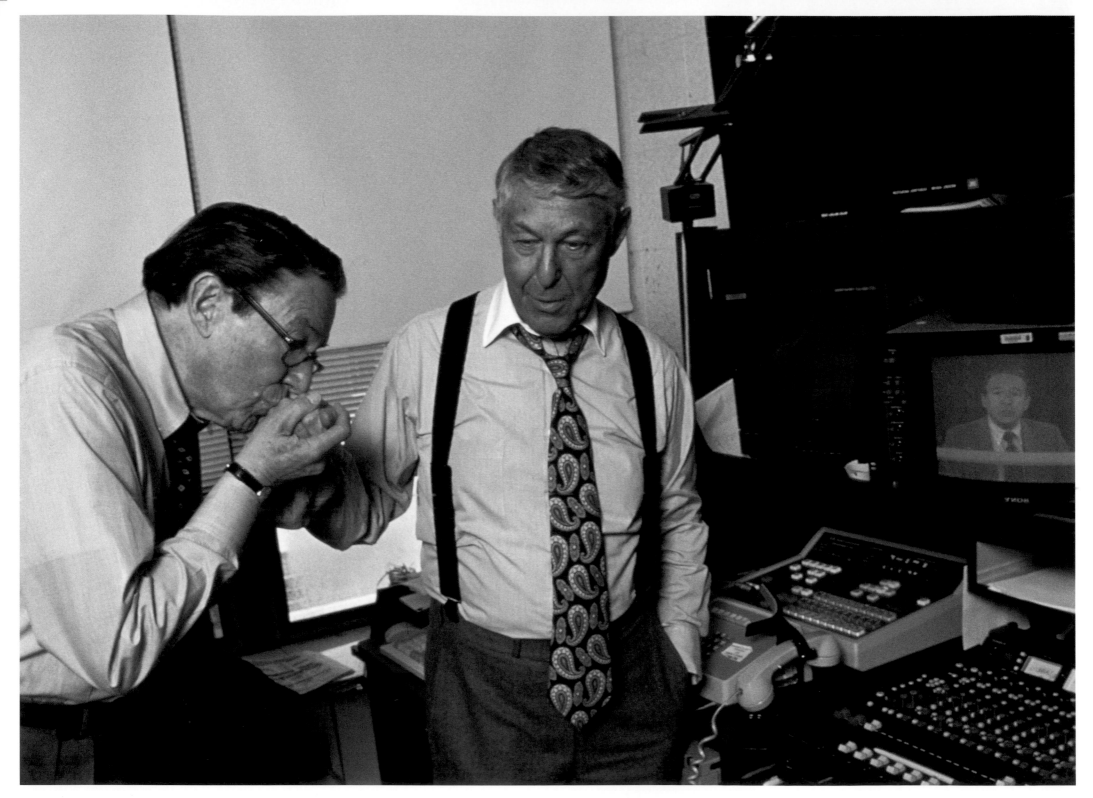

Mike Wallace and Don Hewitt. NEW YORK, NEW YORK, 1993.

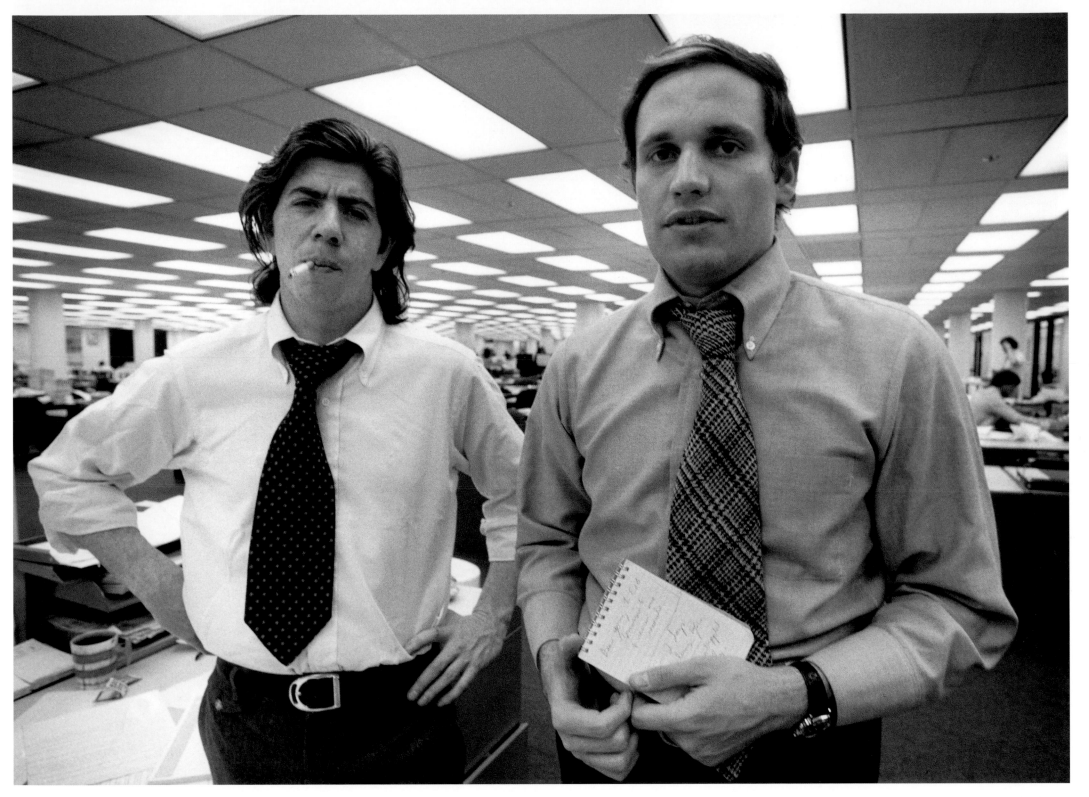

Carl Bernstein and Bob Woodward. WASHINGTON, D.C., 1973.

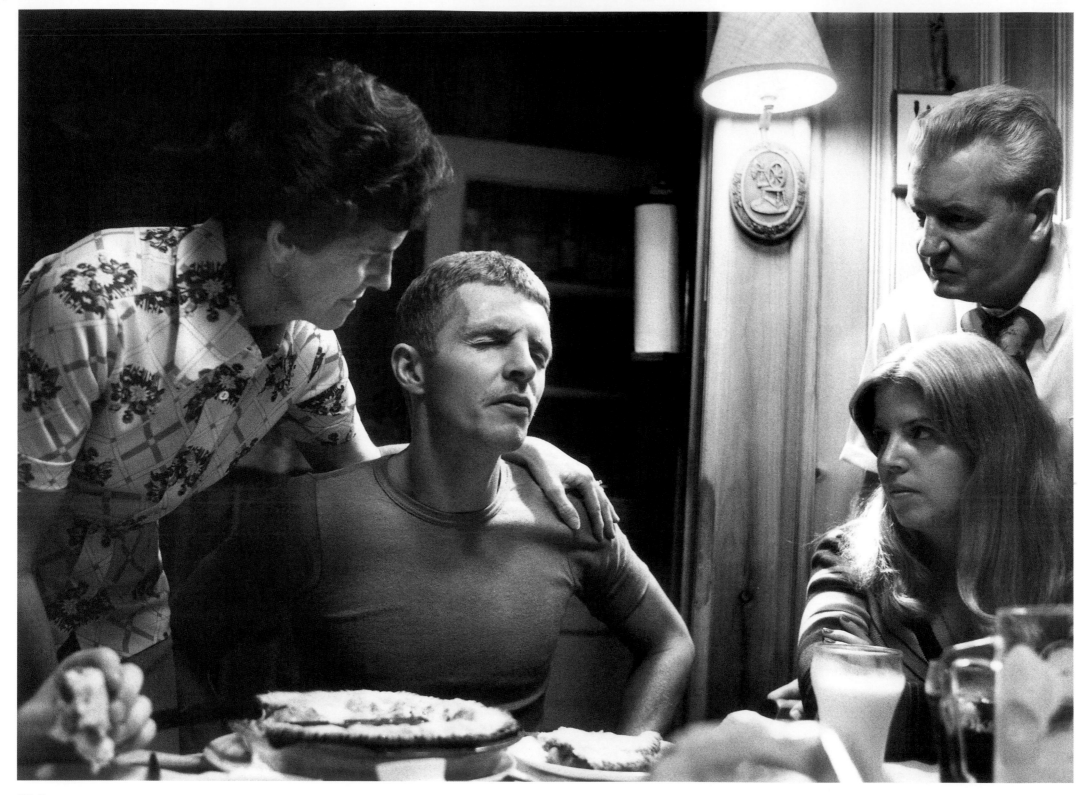

Billy Hayes. LONG ISLAND, NEW YORK, 1975.

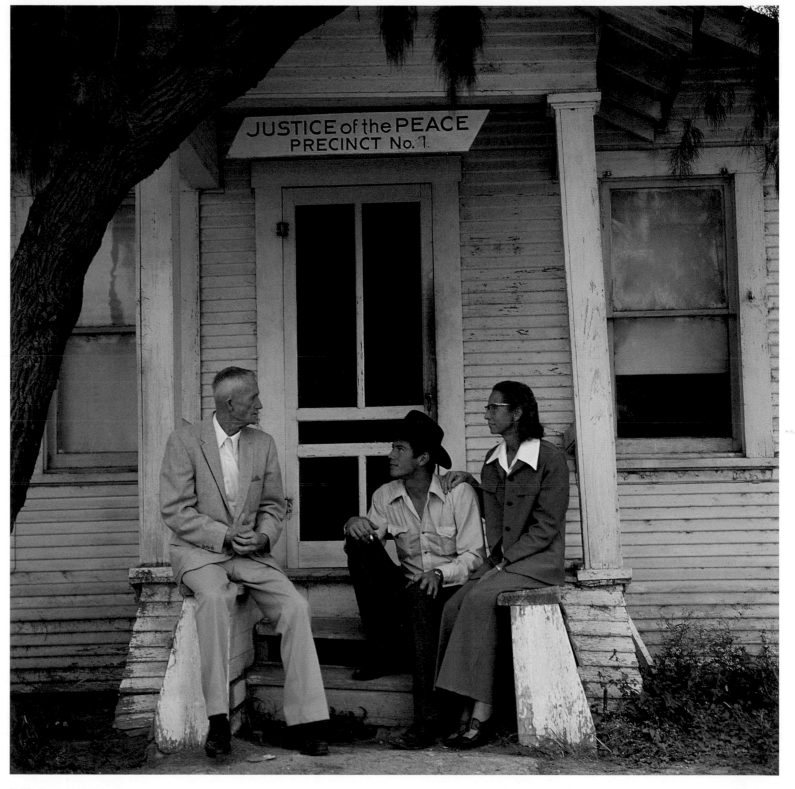

Phillip Rogers. FREER, TEXAS, 1974.

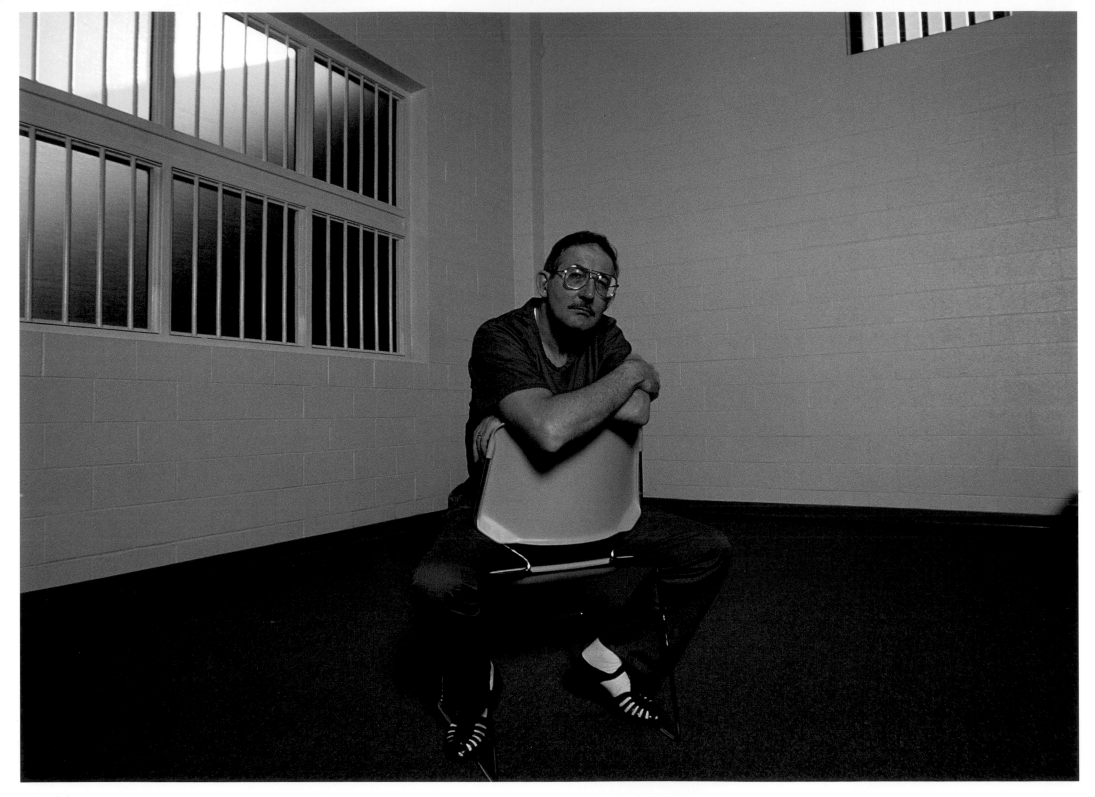

Aldrich H. Ames. ALLENWOOD FEDERAL PENITENTIARY, WHITE DEER, PENNSYLVANIA, 1994.

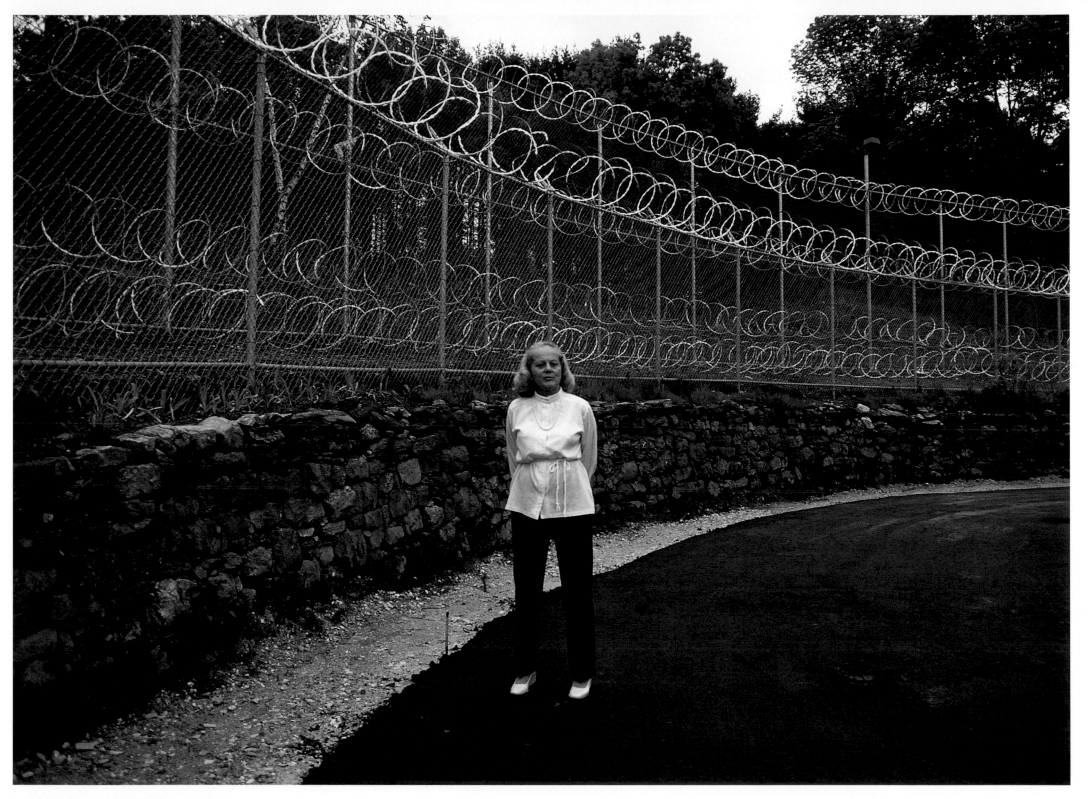

Jean Harris. BEDFORD HILLS CORRECTIONAL FACILITY, BEDFORD HILLS, NEW YORK, 1983.

Mark David Chapman. ATTICA STATE PENITENTIARY, NEW YORK, 1987.

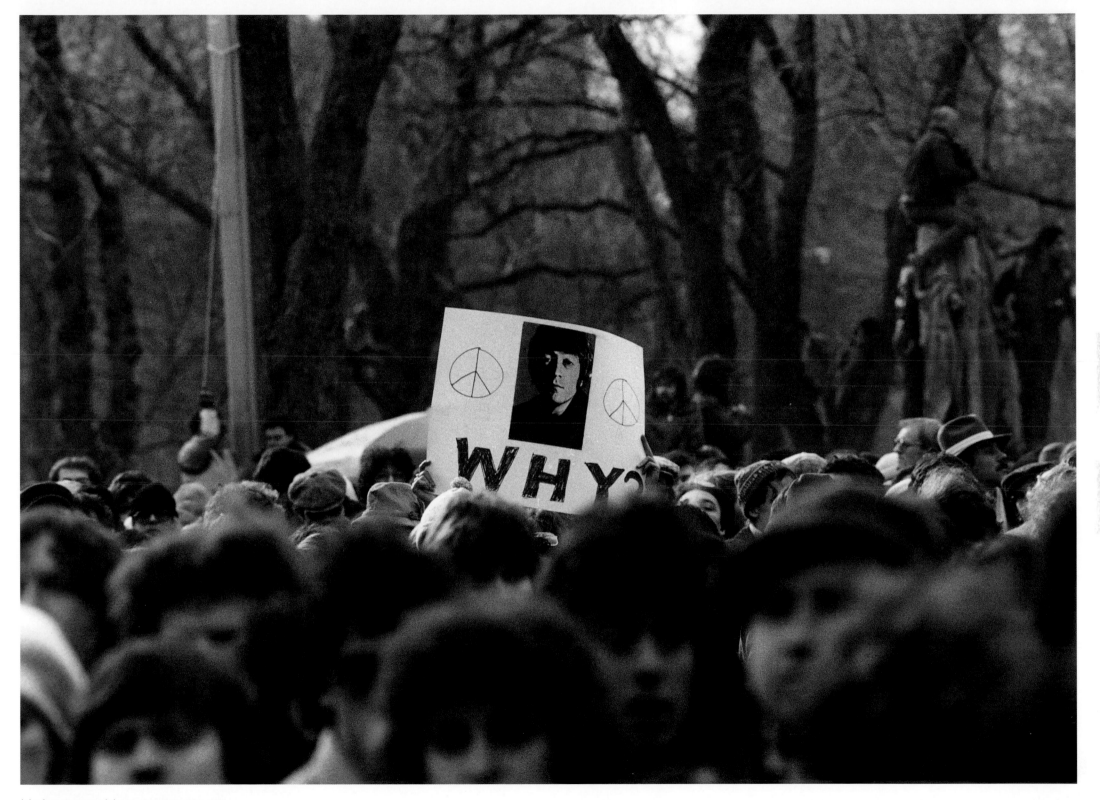

John Lennon memorial. NEW YORK, NEW YORK, 1980.

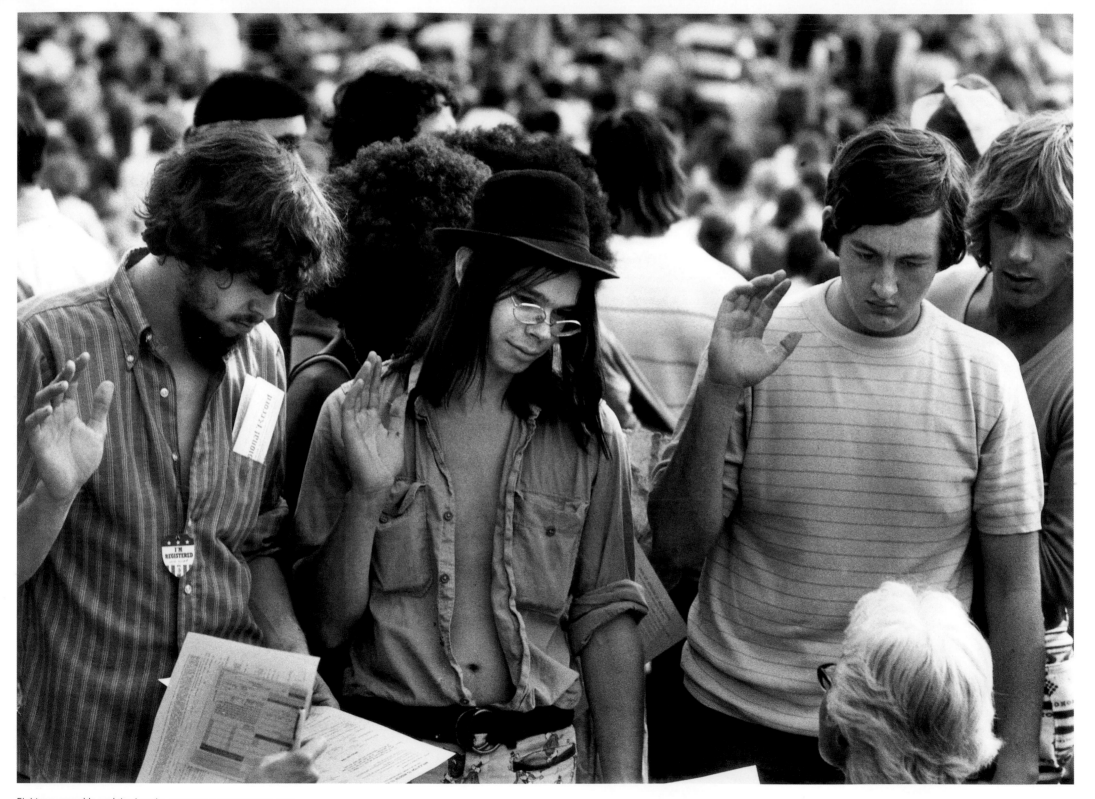

Eighteen-year-olds register to vote. PITTSBURGH, PENNSYLVANIA, 1971.

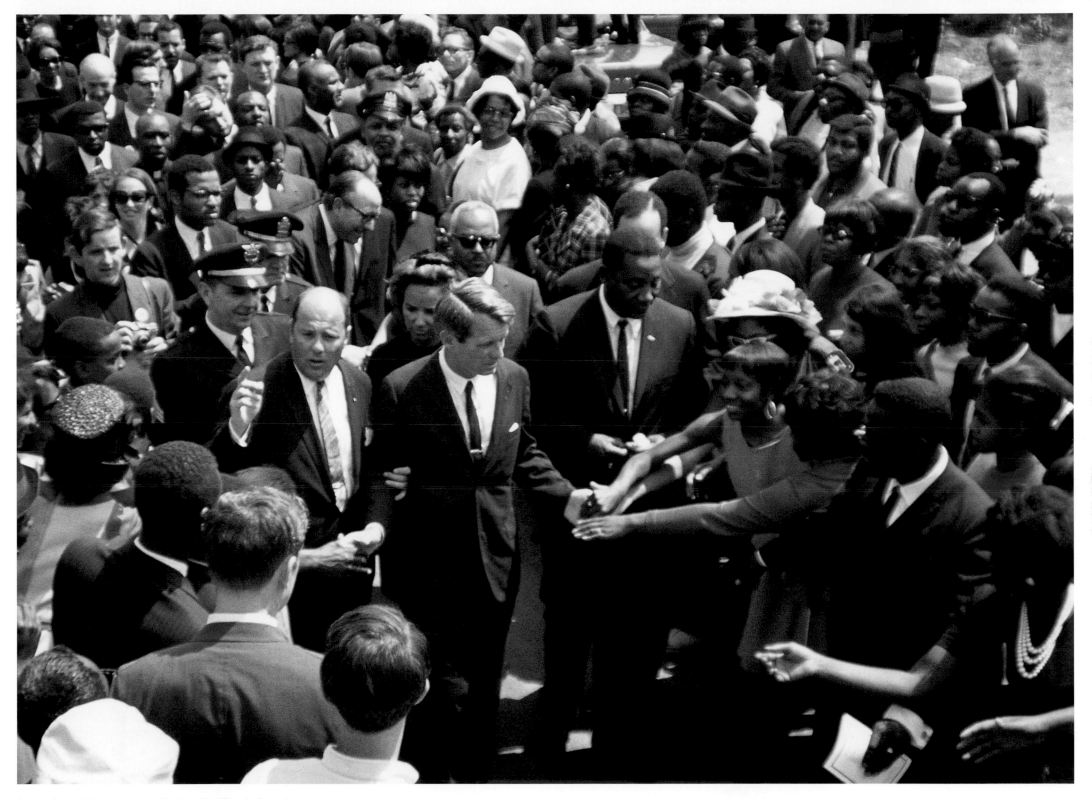

Senator Robert F. Kennedy at the Martin Luther King, Jr. funeral. ATLANTA, GEORIGIA, 1968.

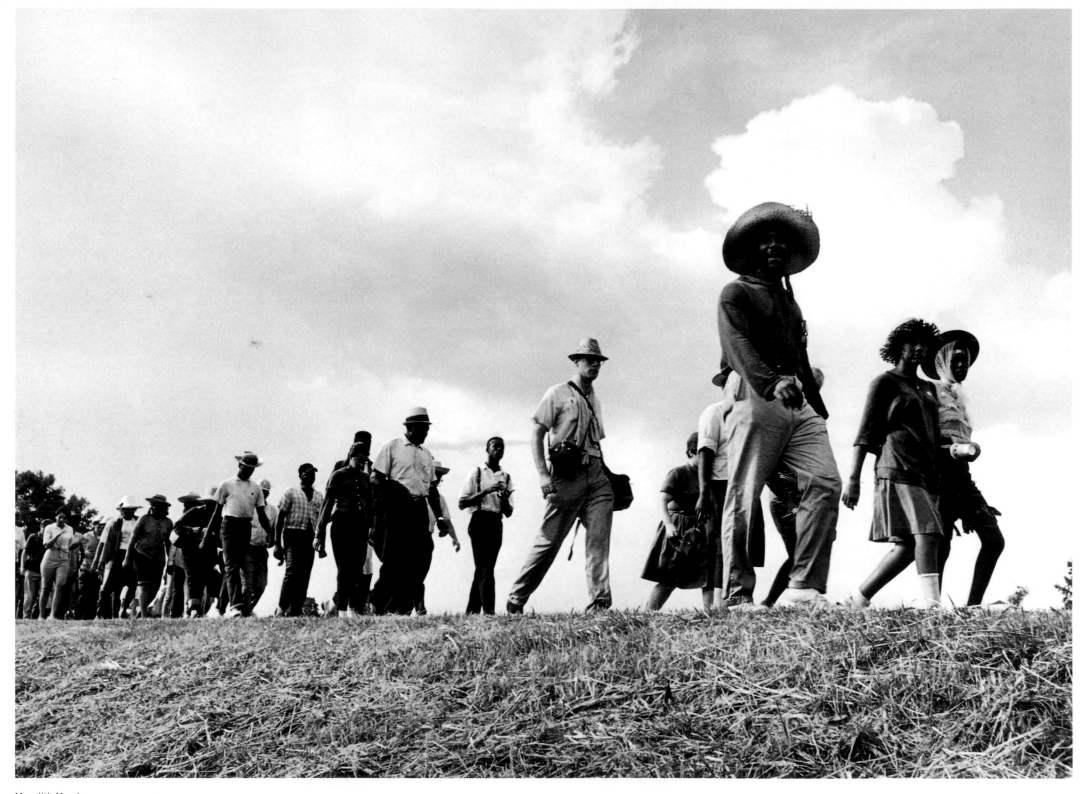

Meredith March. NEARING CANTON, MISSISSIPPI, 1966.

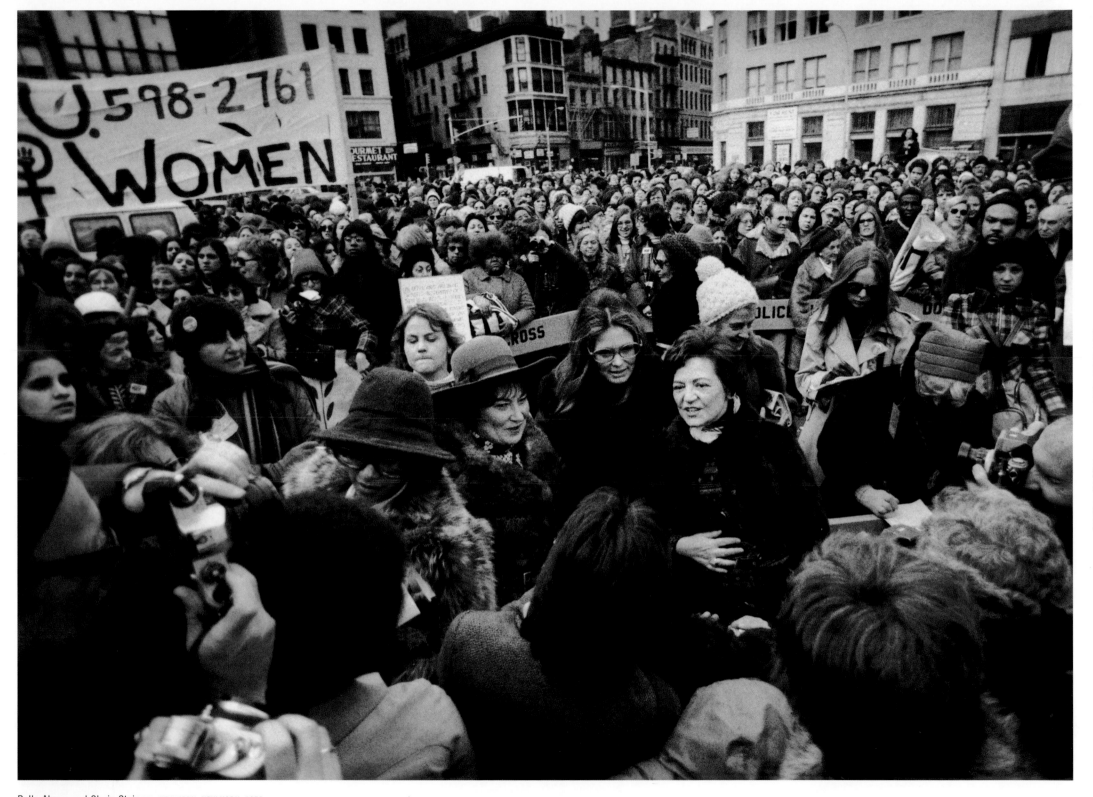

Bella Abzug and Gloria Steinem. NEW YORK, NEW YORK, 1975.

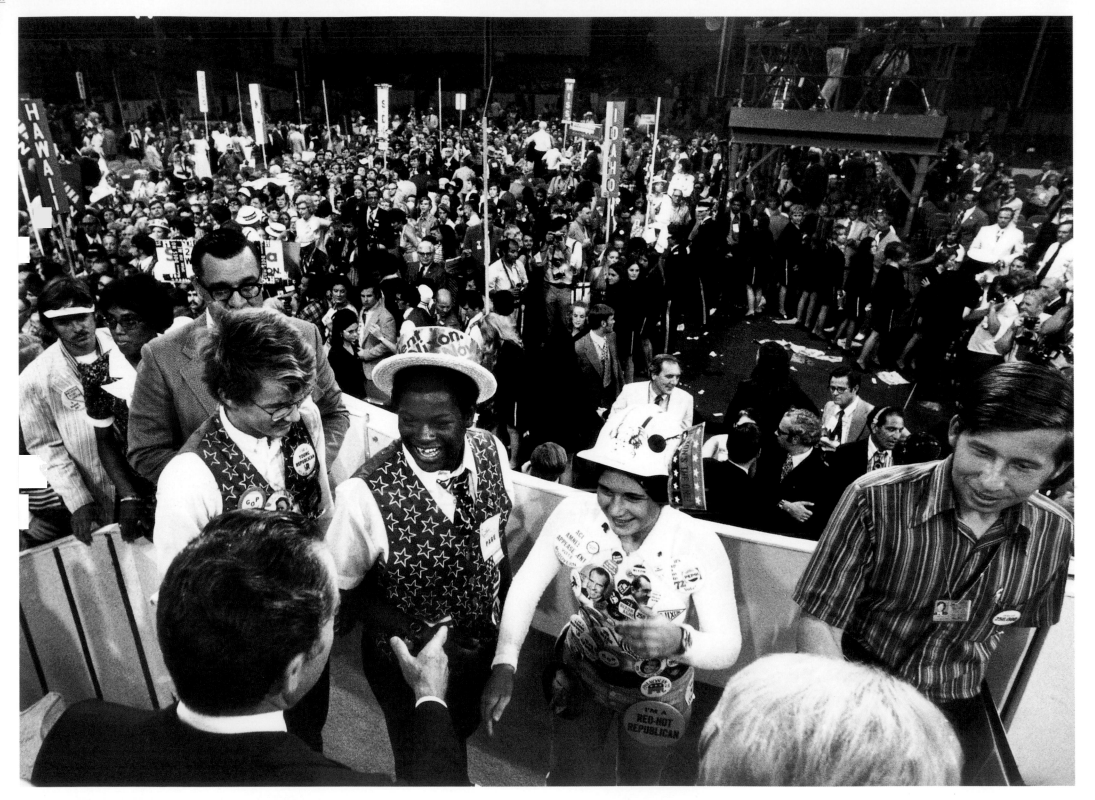

President and Mrs. Richard M. Nixon. GOP CONVENTION, MIAMI, FLORIDA, 1972.

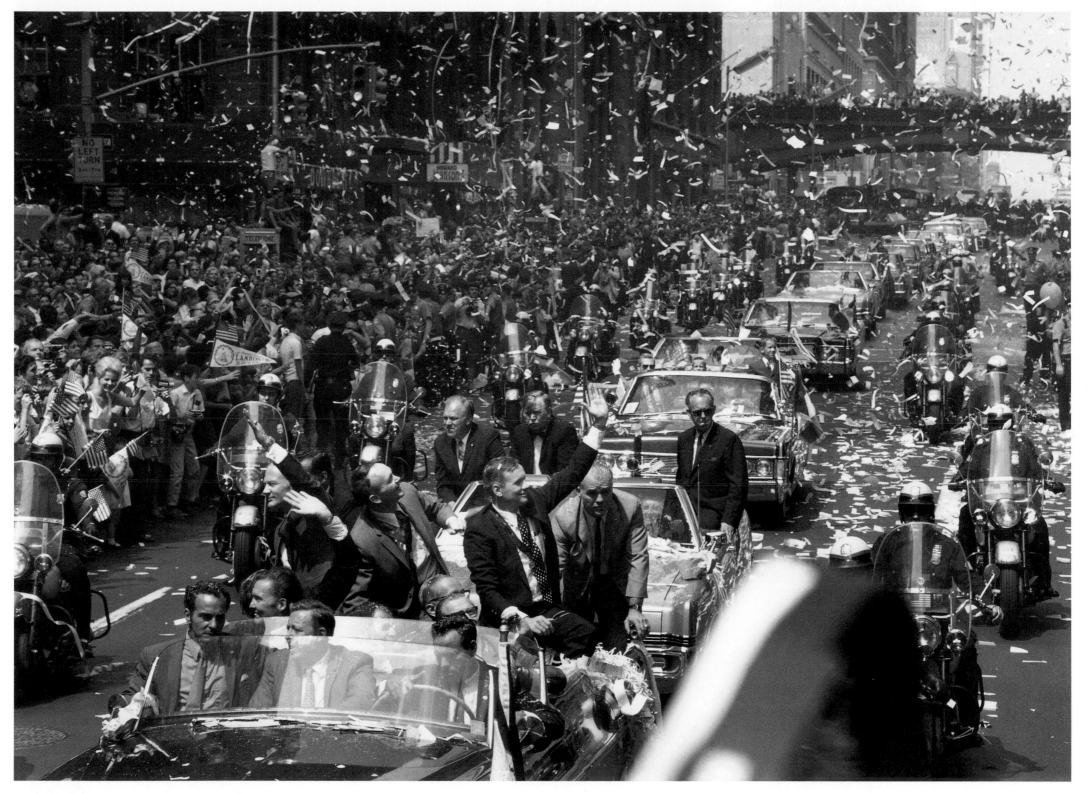

Apollo 11 astronaut parade. NEW YORK, NEW YORK, 1969.

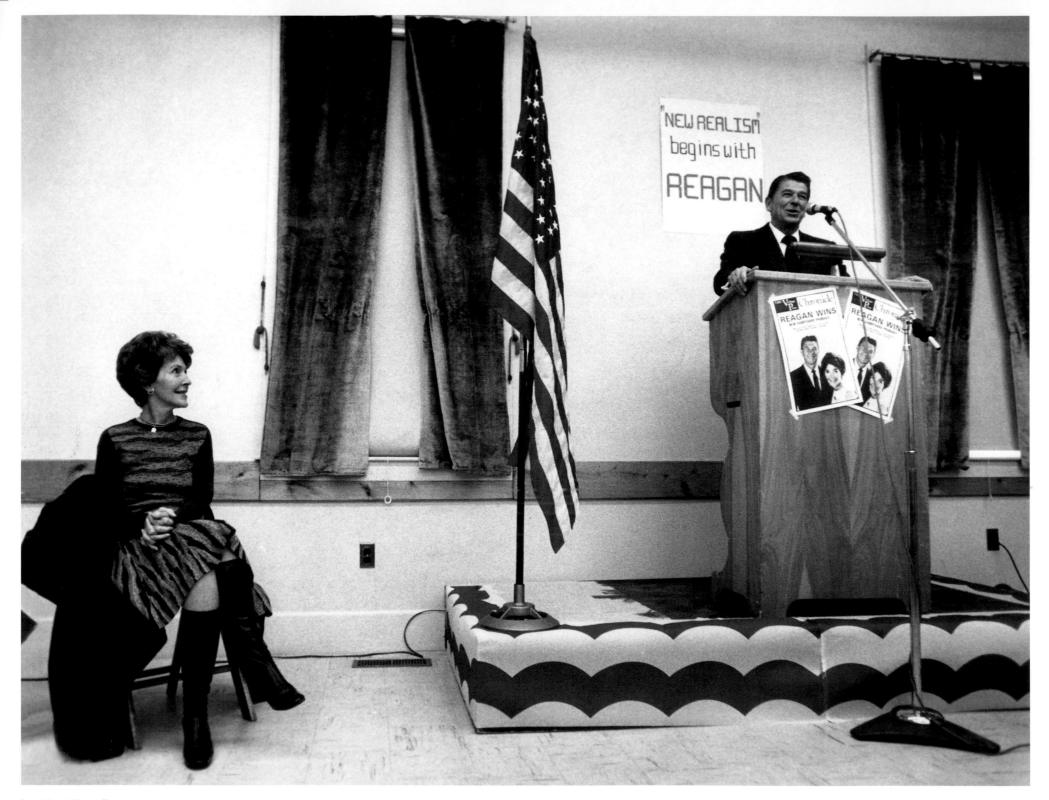

Ronald and Nancy Reagan. NEW HAMPSHIRE, 1976.

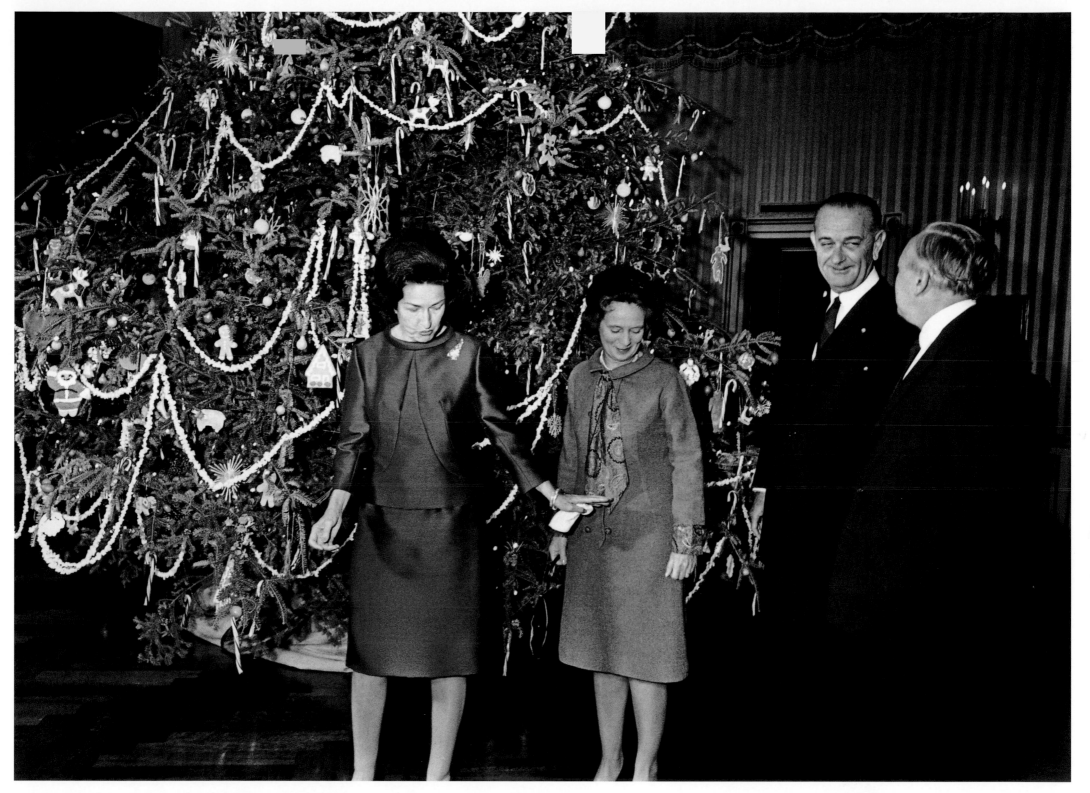

President and Mrs. Lyndon B. Johnson and Prime Minister and Mrs. Harold Wilson. THE WHITE HOUSE, WASHINGTON, D.C., 1966.

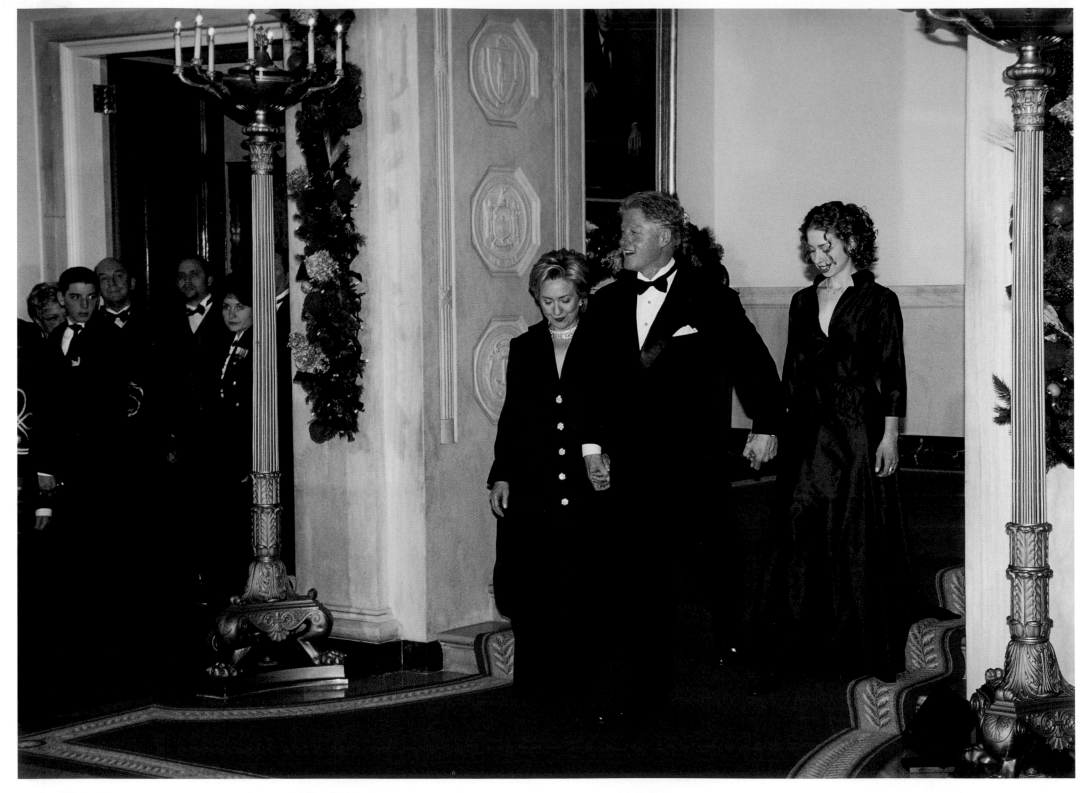

President William J. Clinton and First Lady Hillary Clinton with daughter, Chelsea. THE WHITE HOUSE, WASHINGTON, D.C., 2000.

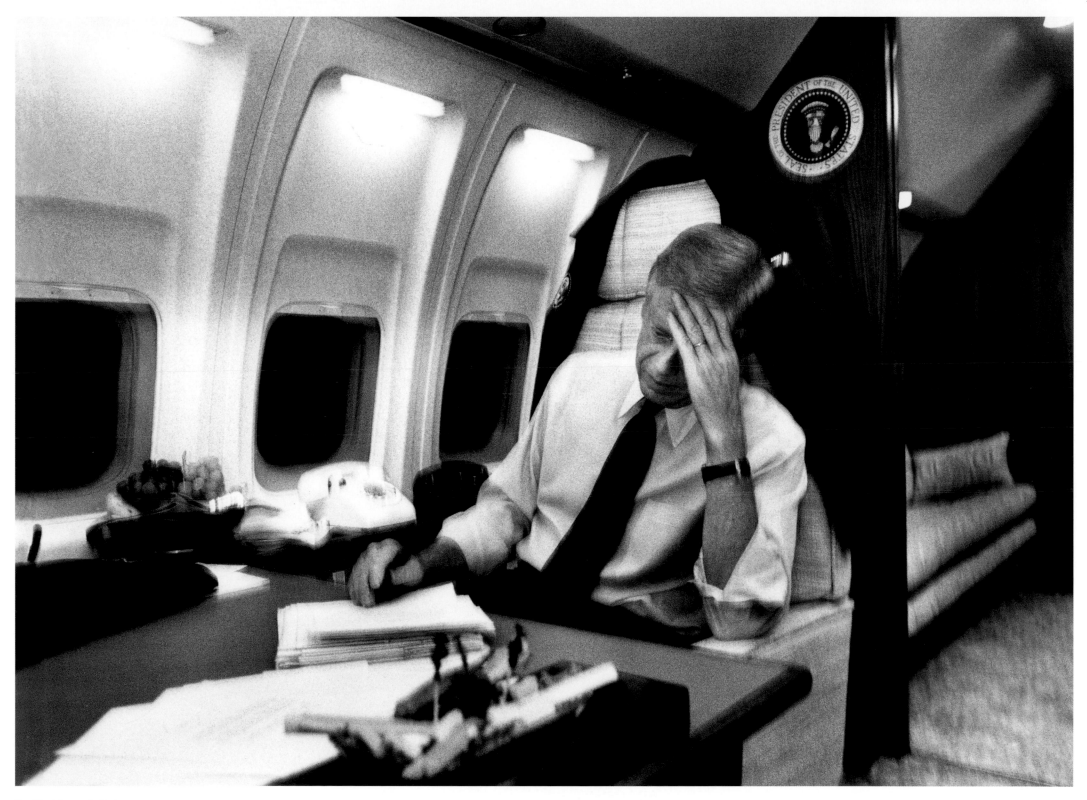

President James E. Carter. *AIR FORCE ONE*, 1979.

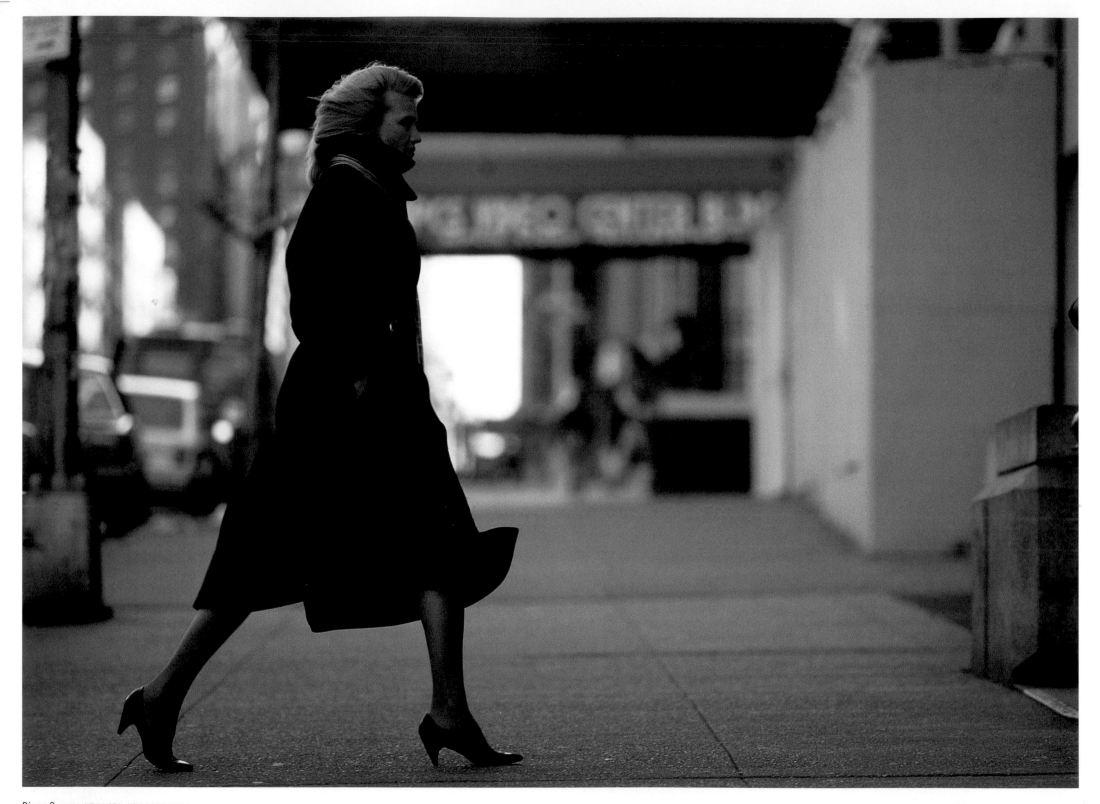

Diane Sawyer. NEW YORK, NEW YORK, 1983.

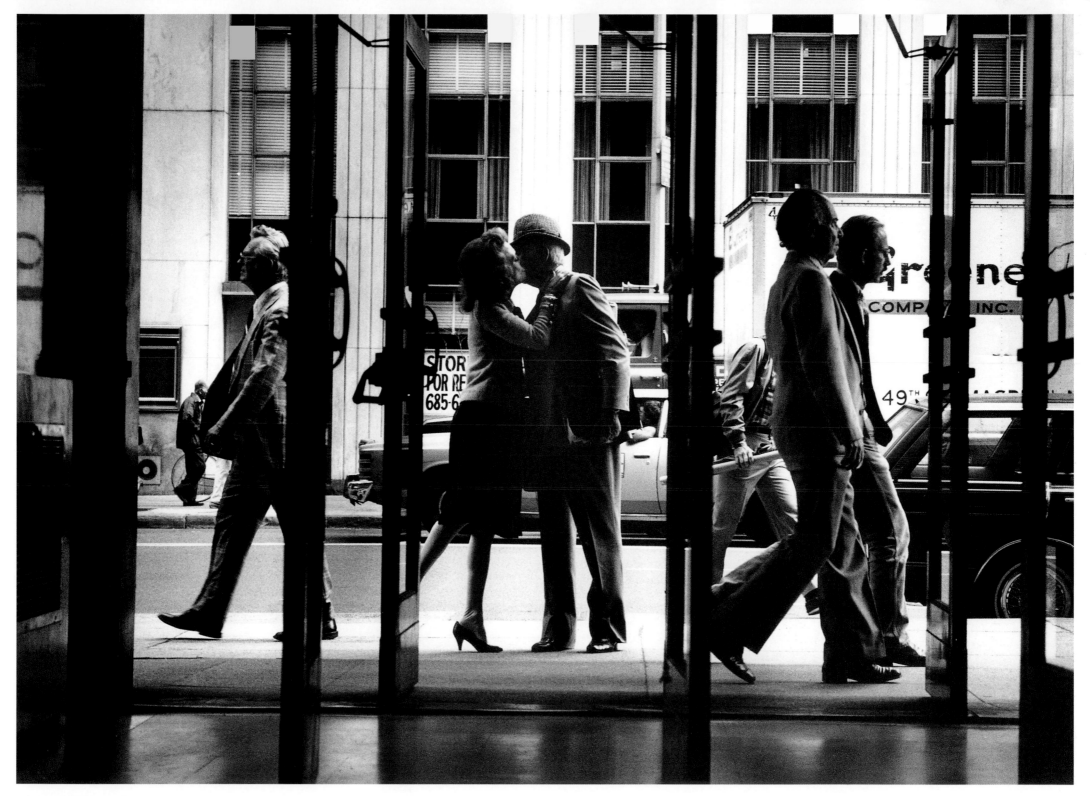

Helen Gurley Brown and David Brown. NEW YORK, NEW YORK, 1982.

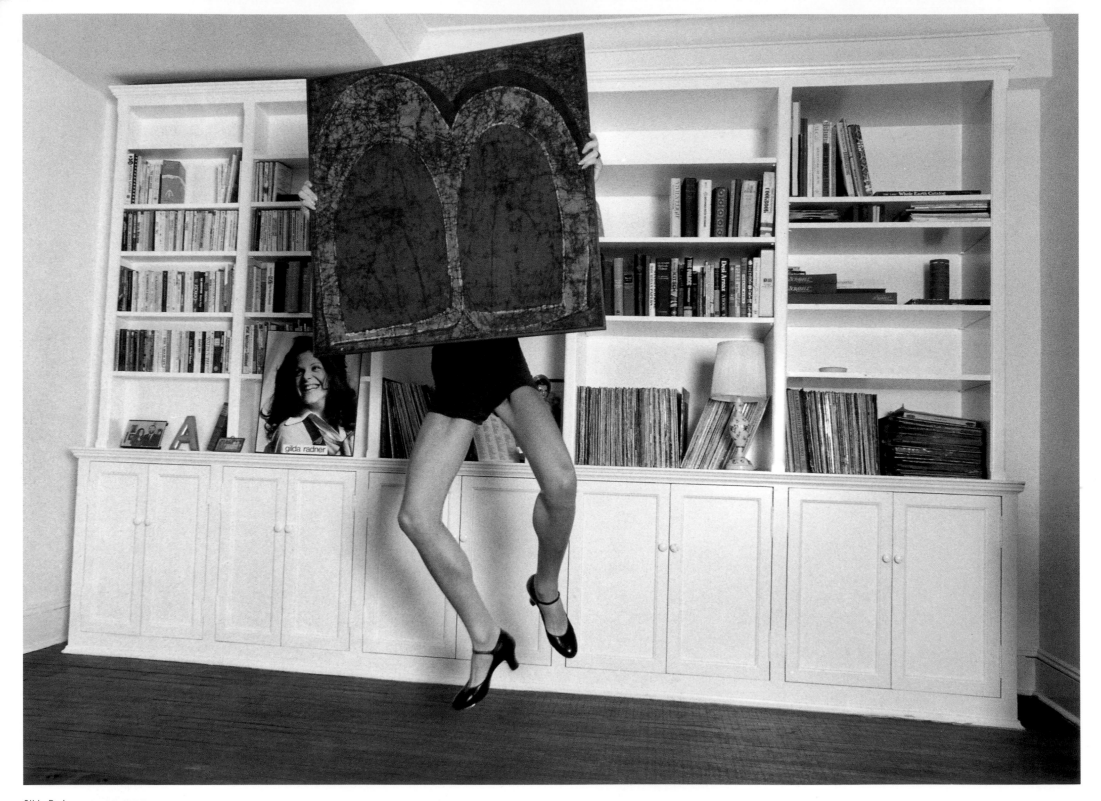

Gilda Radner. NEW YORK, NEW YORK, 1977.

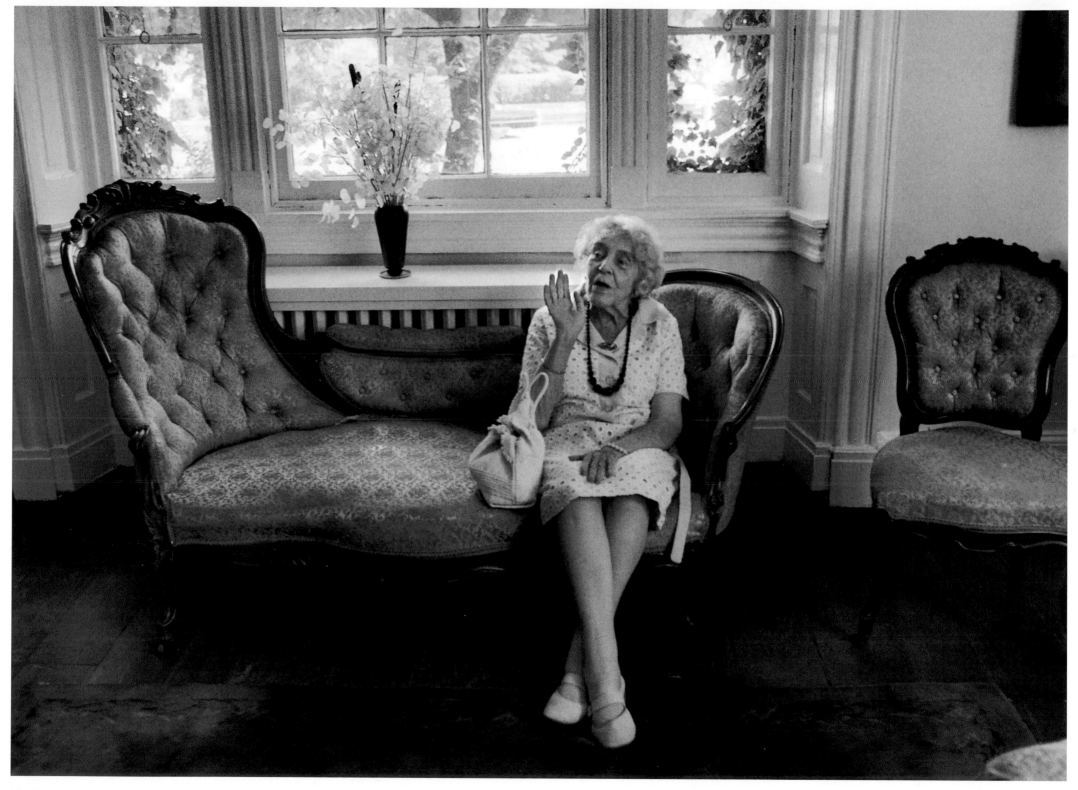

Alice Paul. WASHINGTON, D.C., 1970.

Celia Goldie. CHICAGO, ILLINOIS, 1998. (2 PHOTOS)

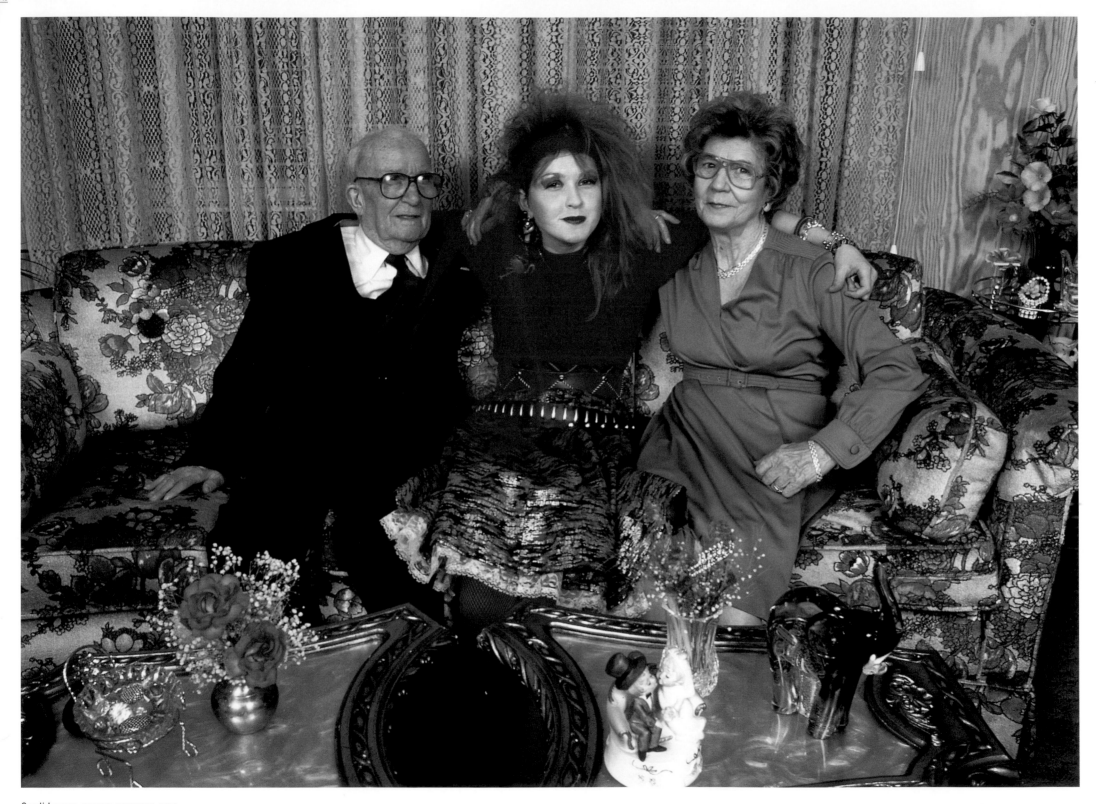

Cyndi Lauper. QUEENS, NEW YORK, 1984.

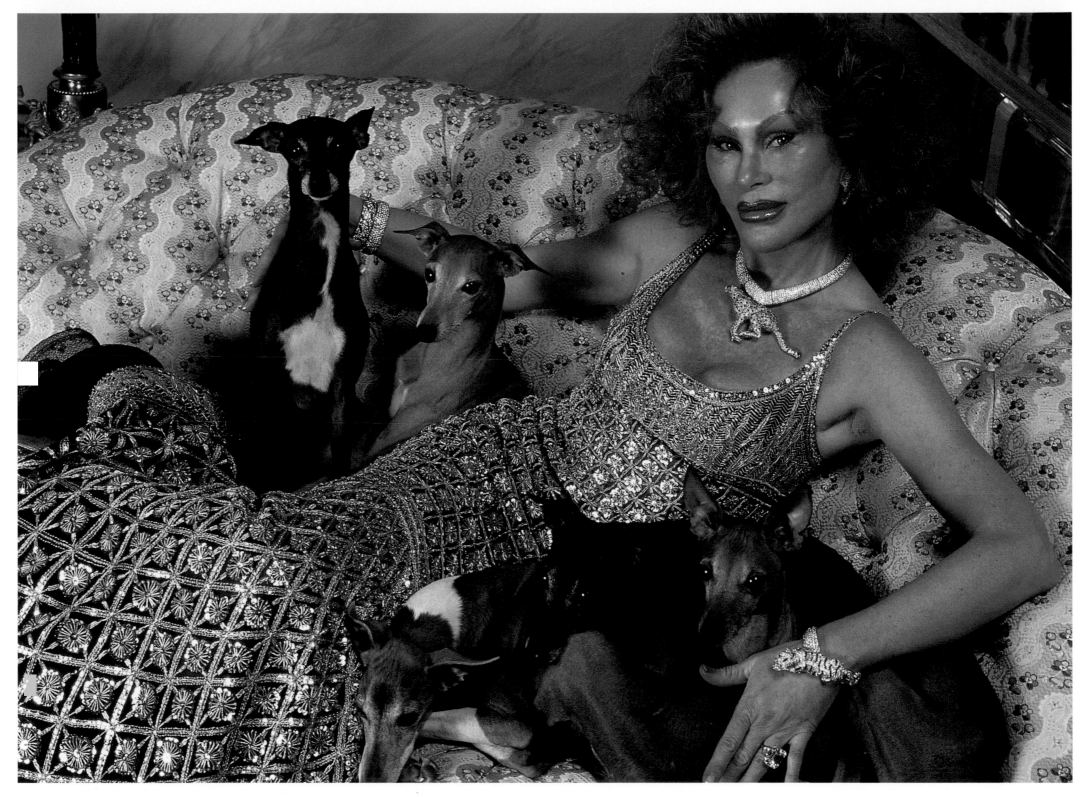

Jocelyne Wildenstein. NEW YORK, NEW YORK, 1998.

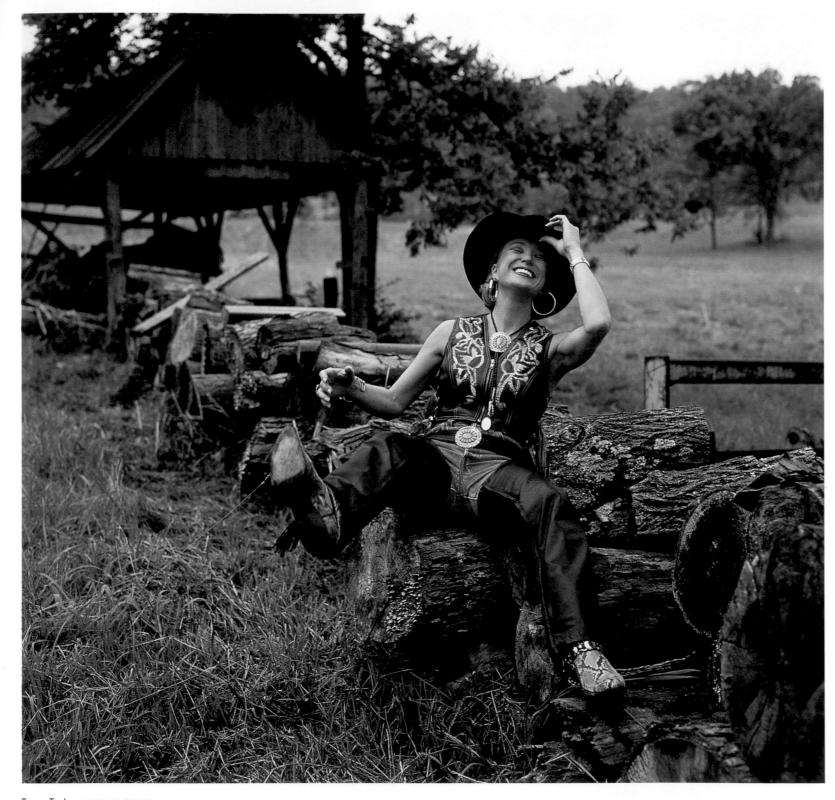

Tanya Tucker. NASHVILLE, TENNESSEE, 1994.

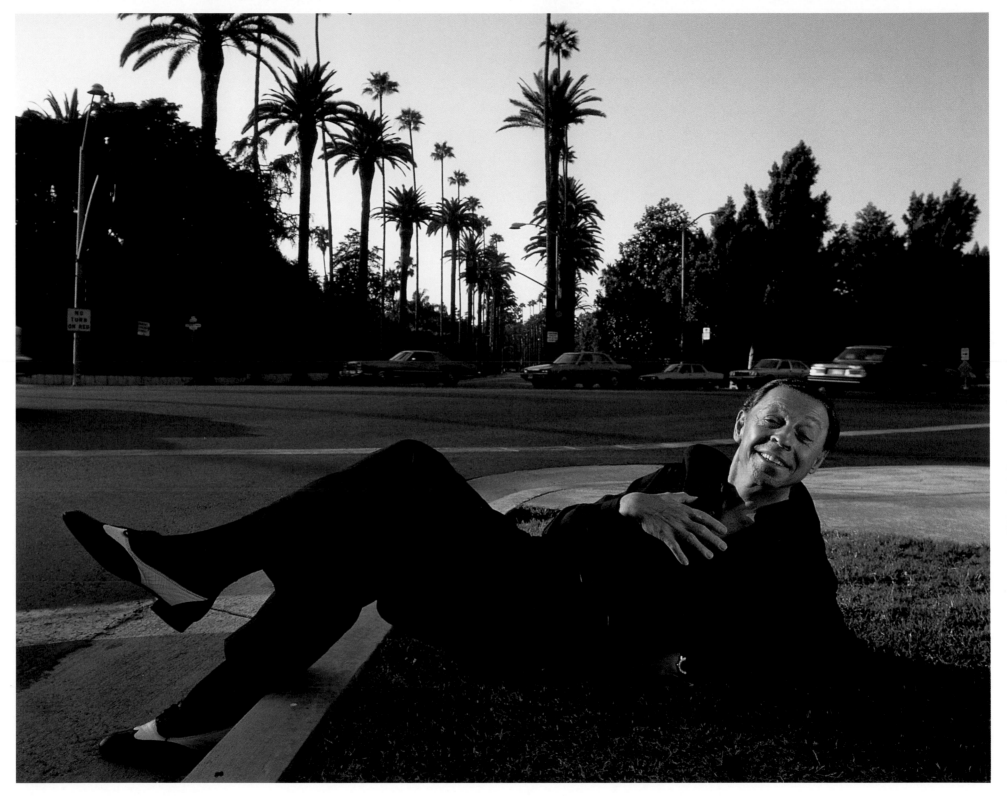

James Galanos. LOS ANGELES, CALIFORNIA, 1985.

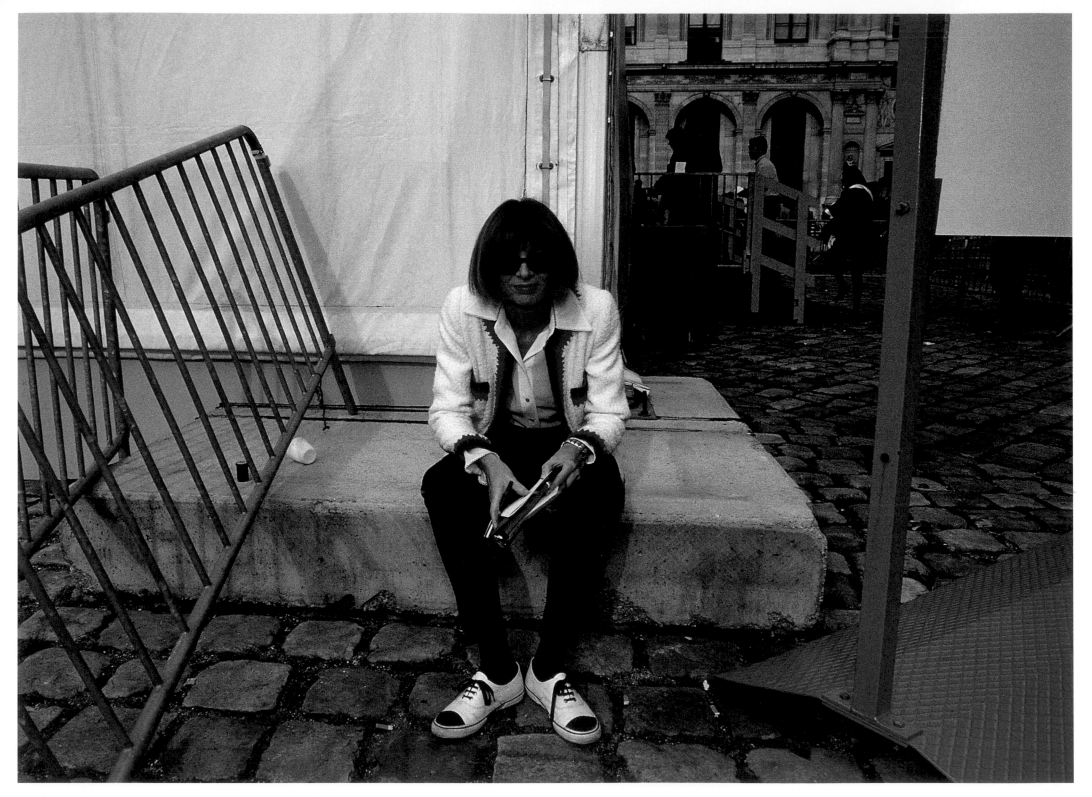

Anna Wintour. PARIS, FRANCE, 1994.

Amber Valletta. PARIS, FRANCE, 1994.

Cornelia Guest. CAP FERRAT, FRANCE, 1983.

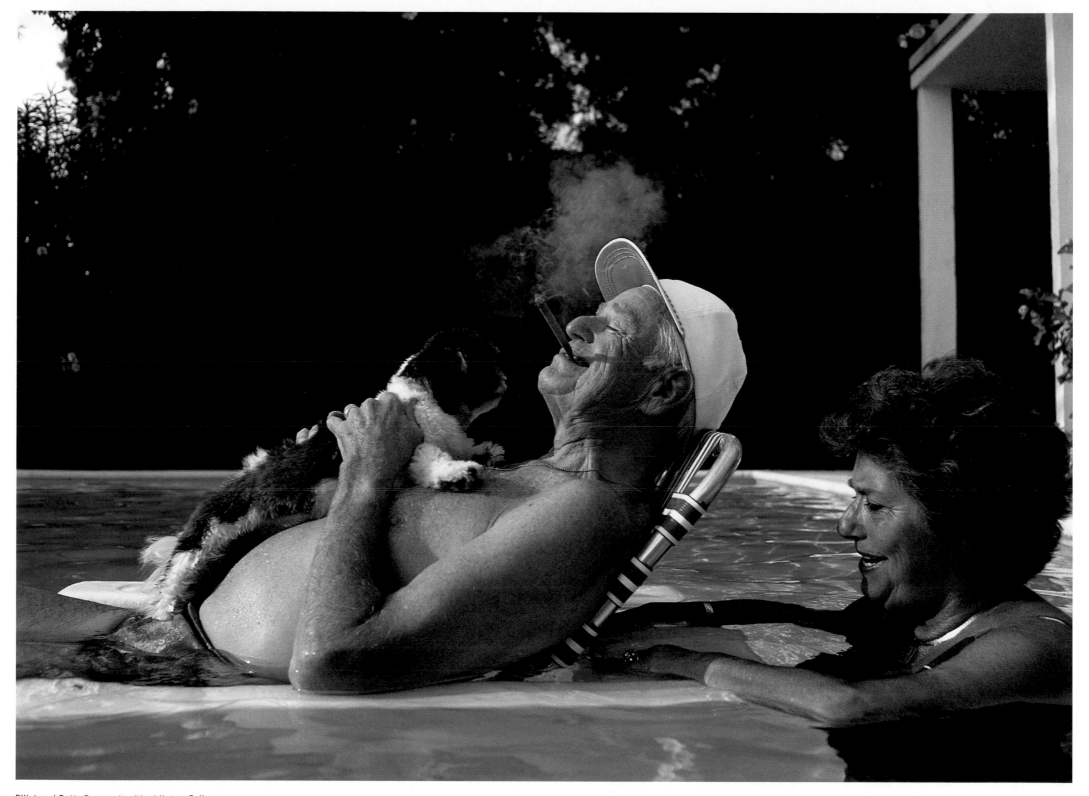

Elliot and Patty Roosevelt with shih tzu, Polly. INDIAN WELLS, CALIFORNIA, 1984.

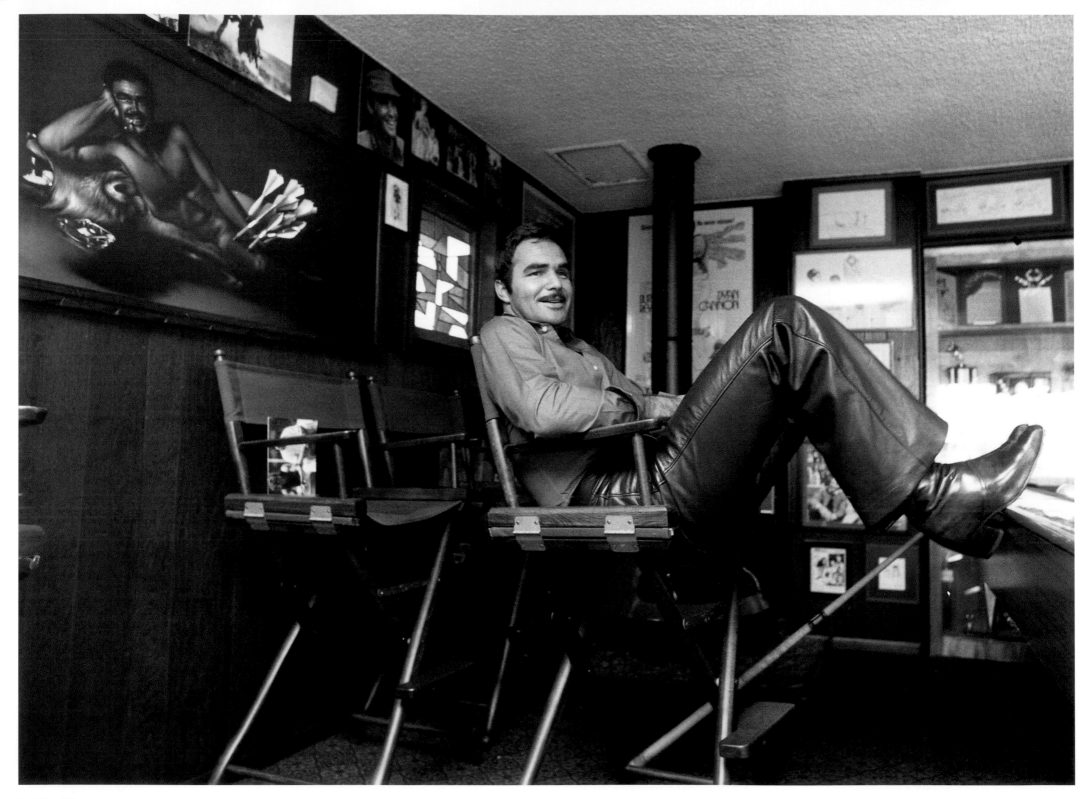

Burt Reynolds. HOLLYWOOD HILLS, CALIFORNIA, 1974.

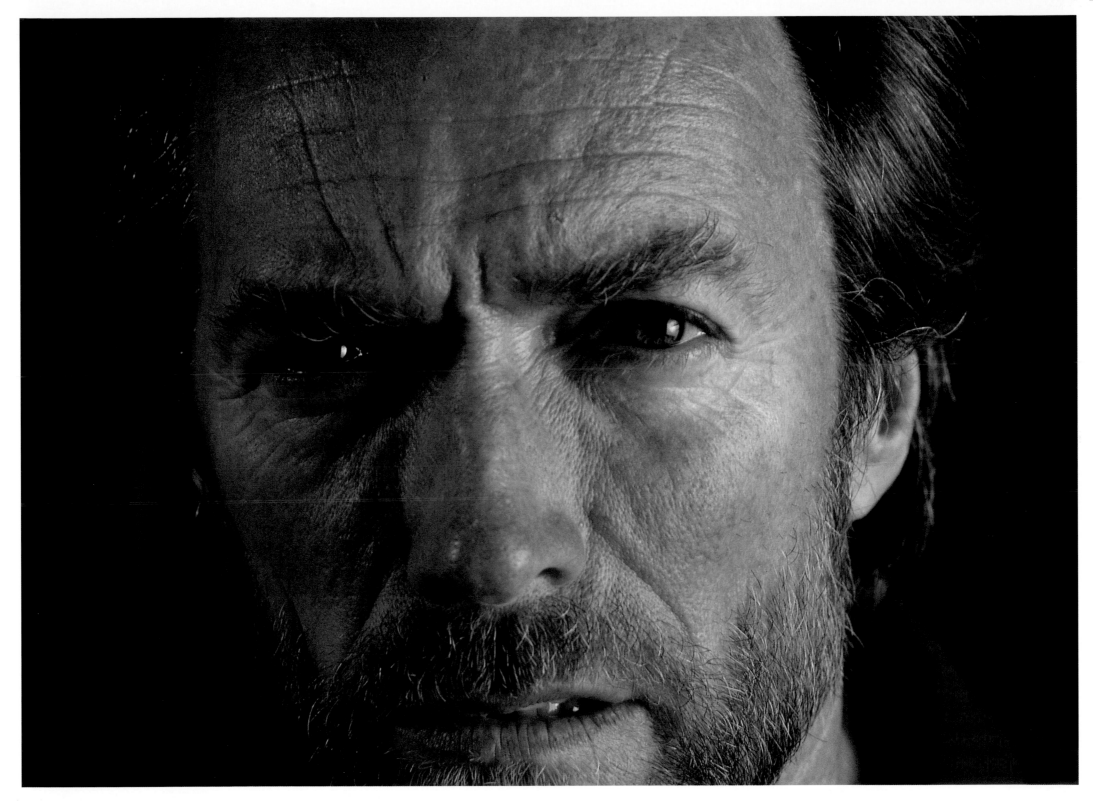

Clint Eastwood. LOS ANGELES, CALIFORNIA, 1984.

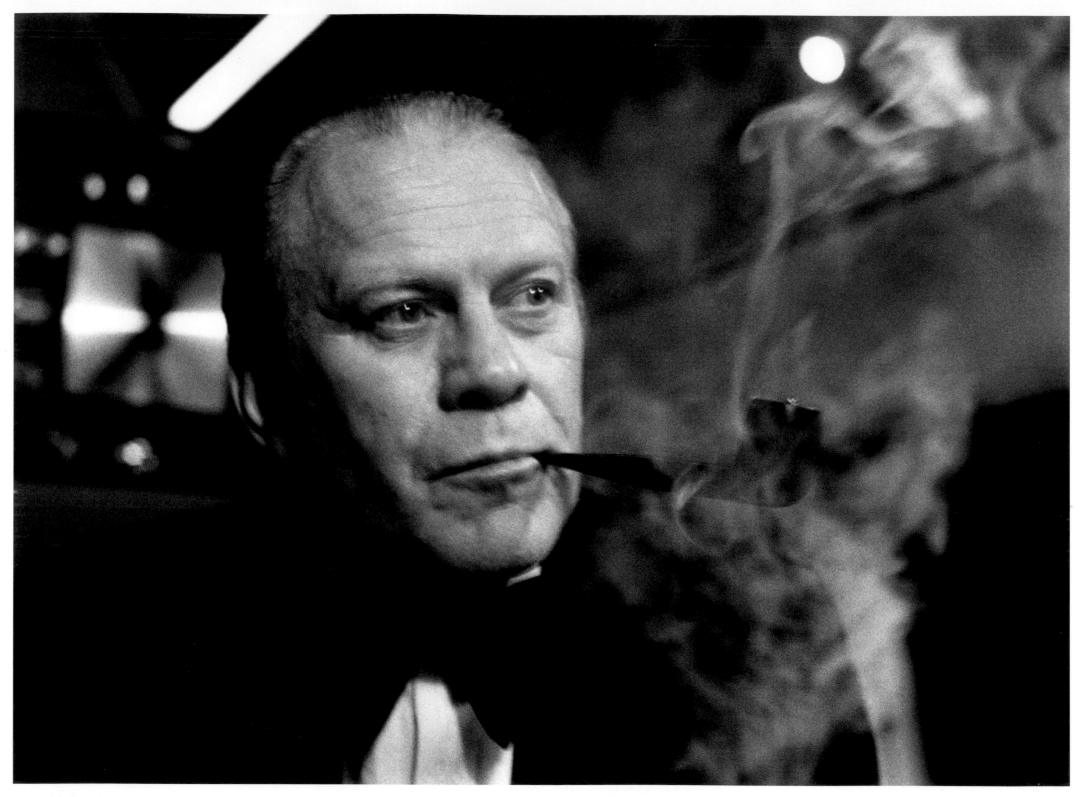

President Gerald R. Ford. *AIR FORCE TWO*, 1973.

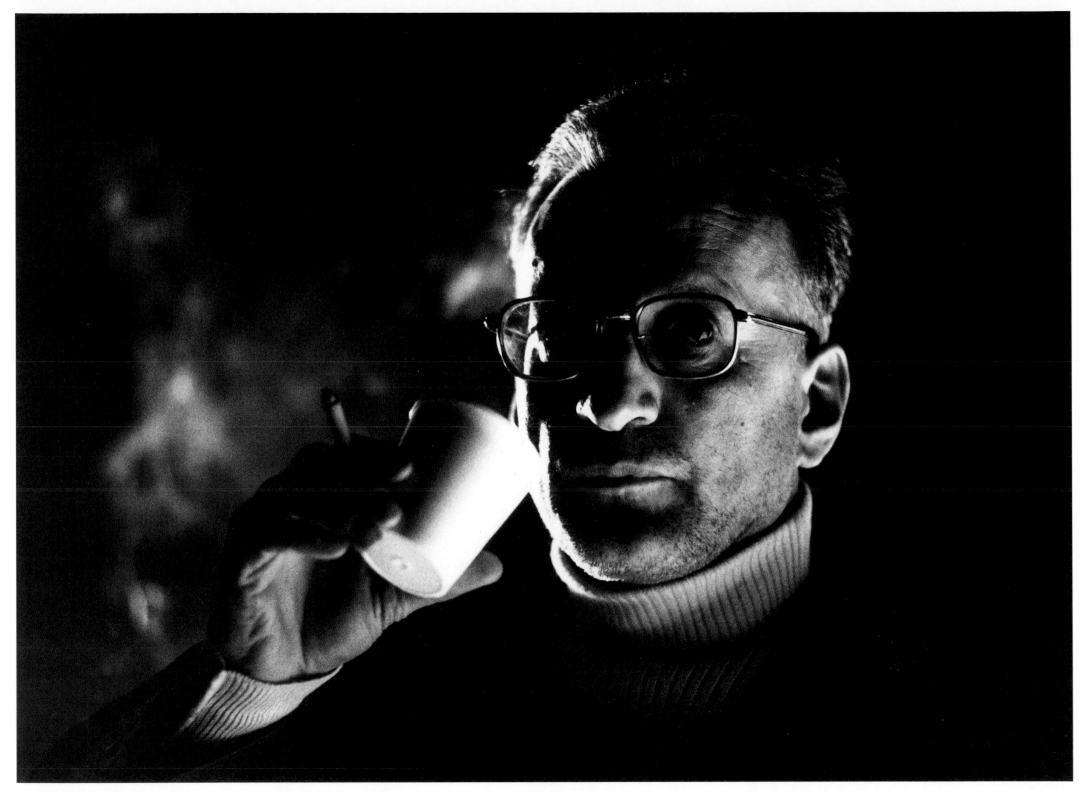

George C. Scott. TUCSON, ARIZONA, 1972.

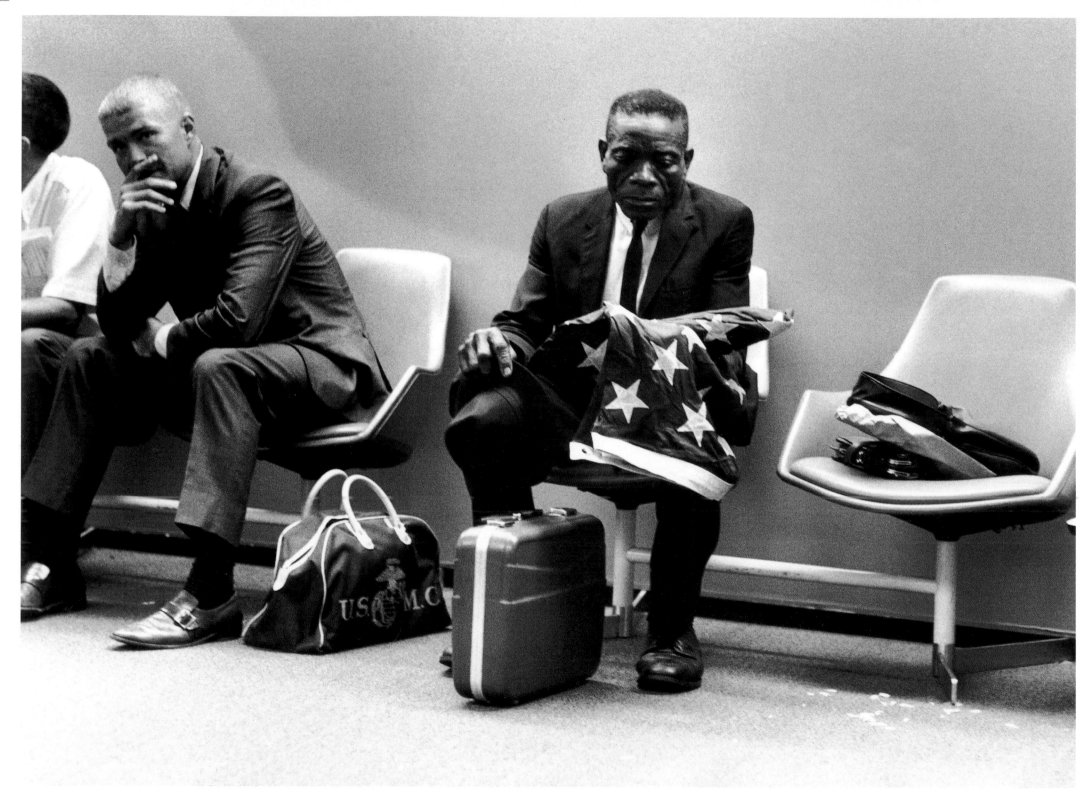

Man with flag. WASHINGTON, D.C., 1971.

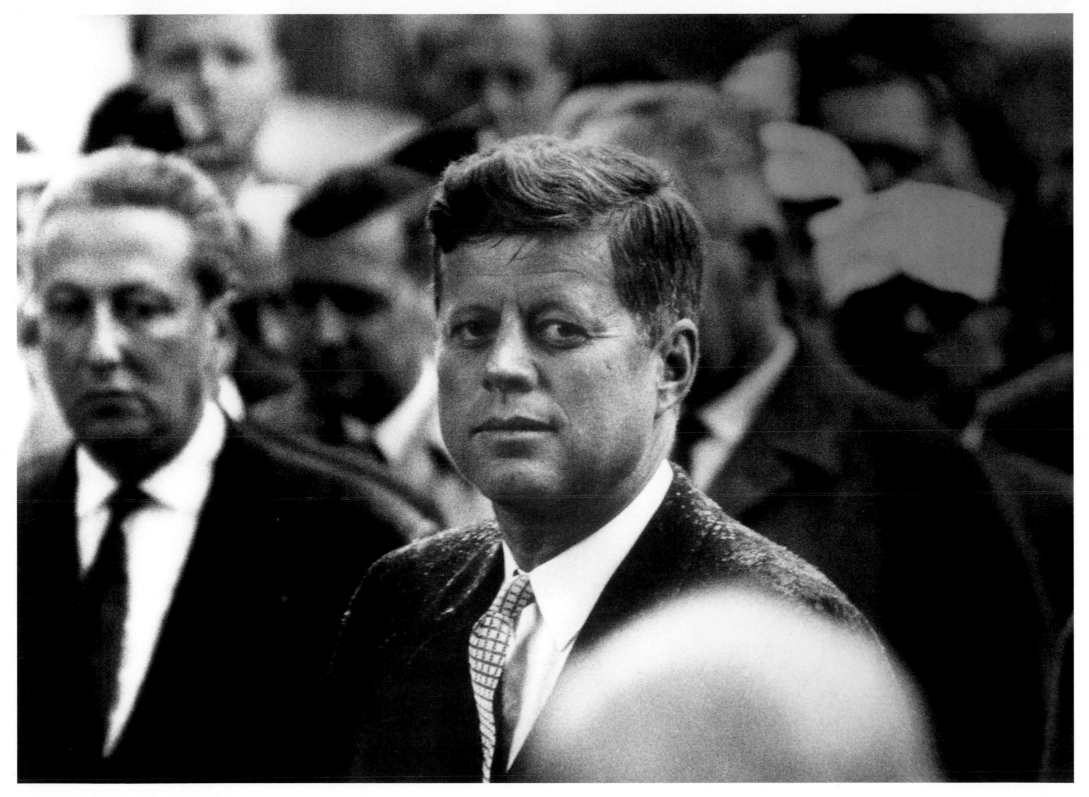

President John F. Kennedy. PARIS, FRANCE, 1961.

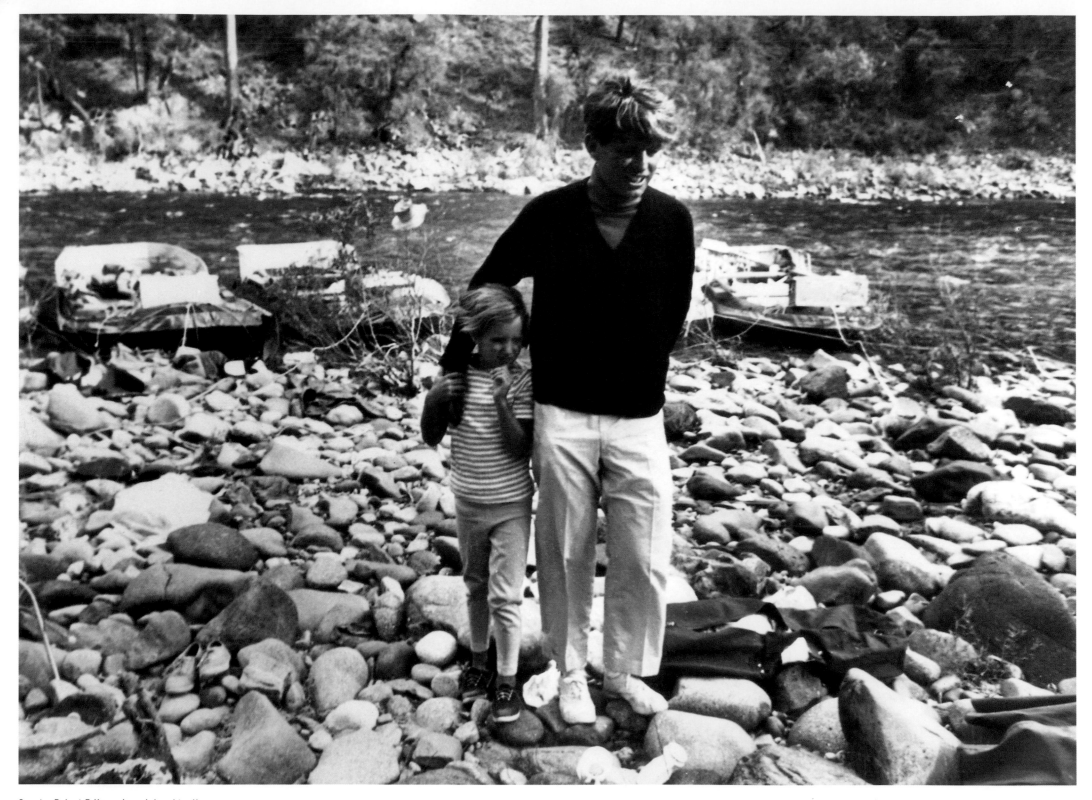

Senator Robert F. Kennedy and daughter Kerry. SNAKE RIVER, IDAHO, 1966.

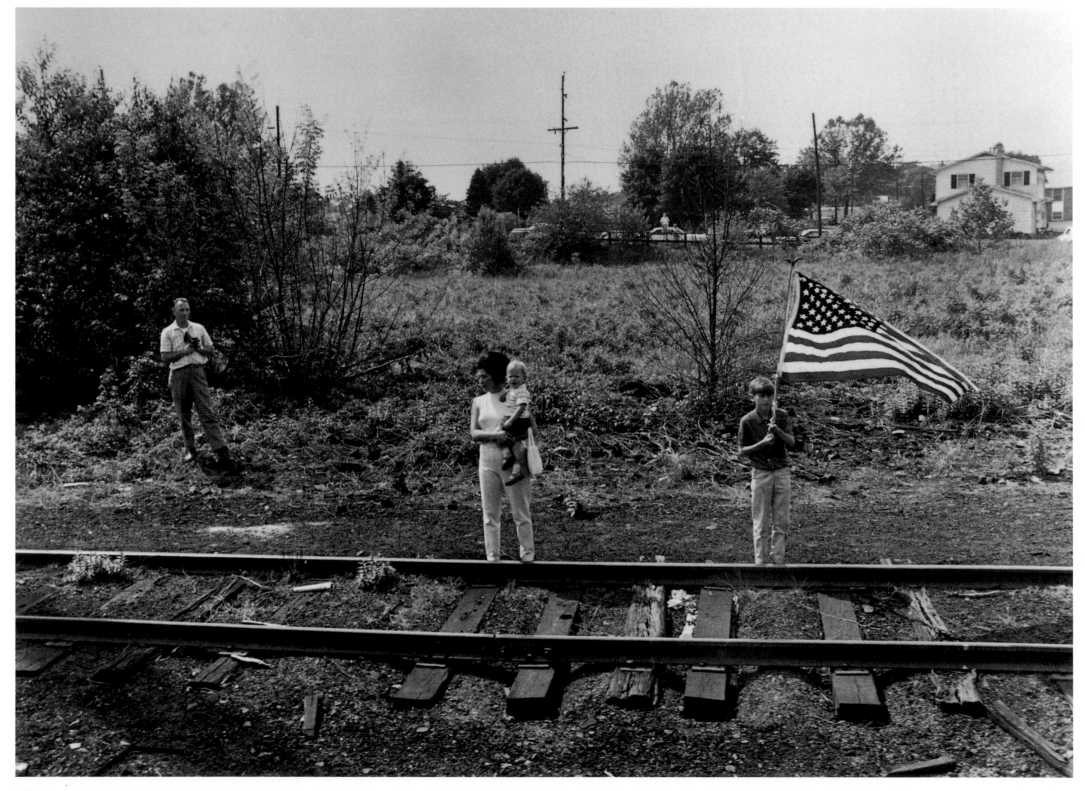

R.F.K. funeral train. BETWEEN NEW YORK, NEW YORK, AND WASHINGTON, D.C., 1968.

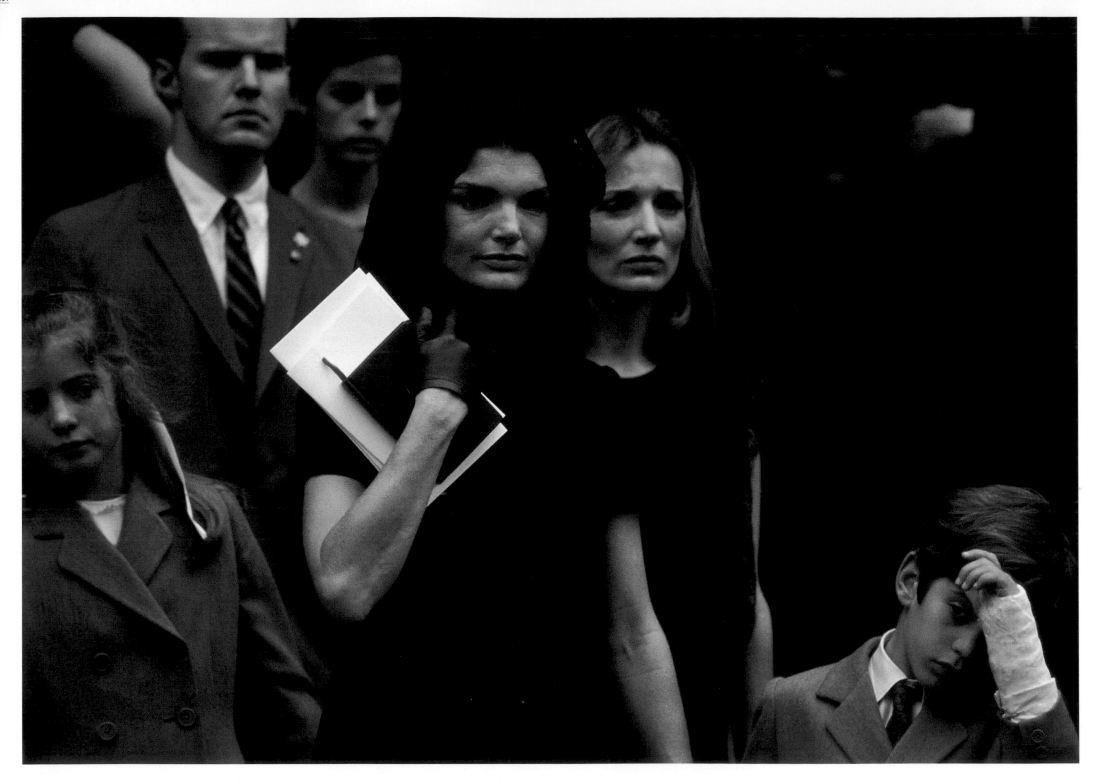

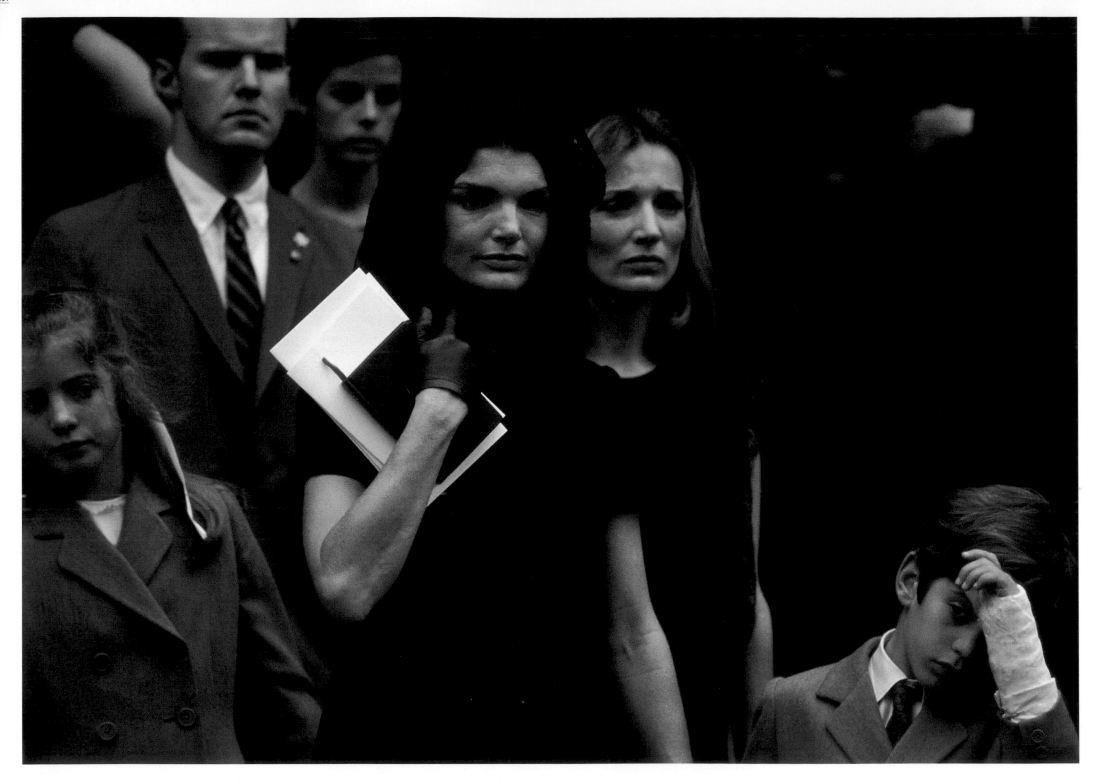

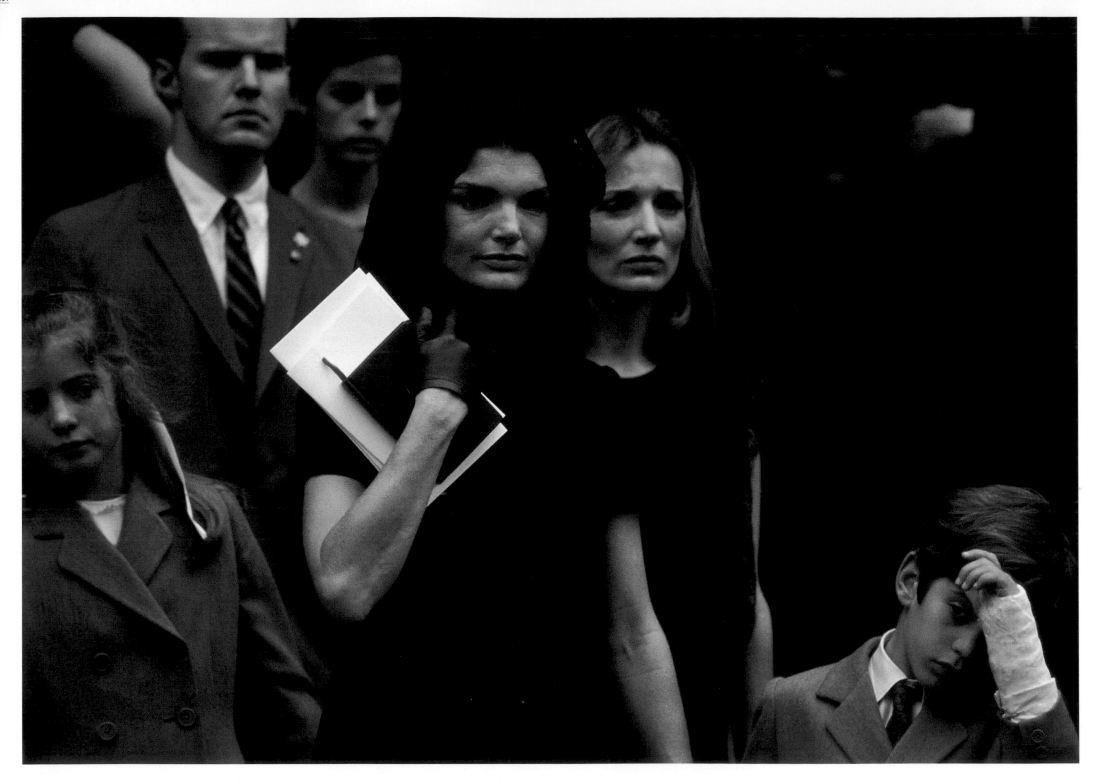

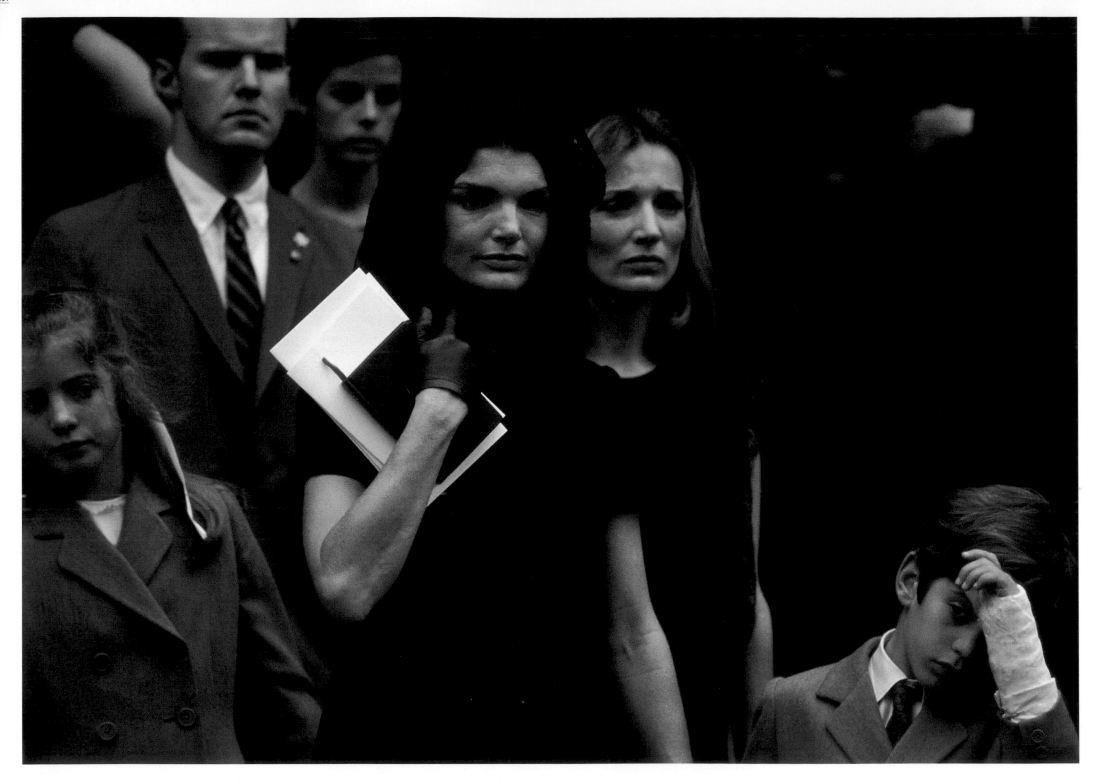

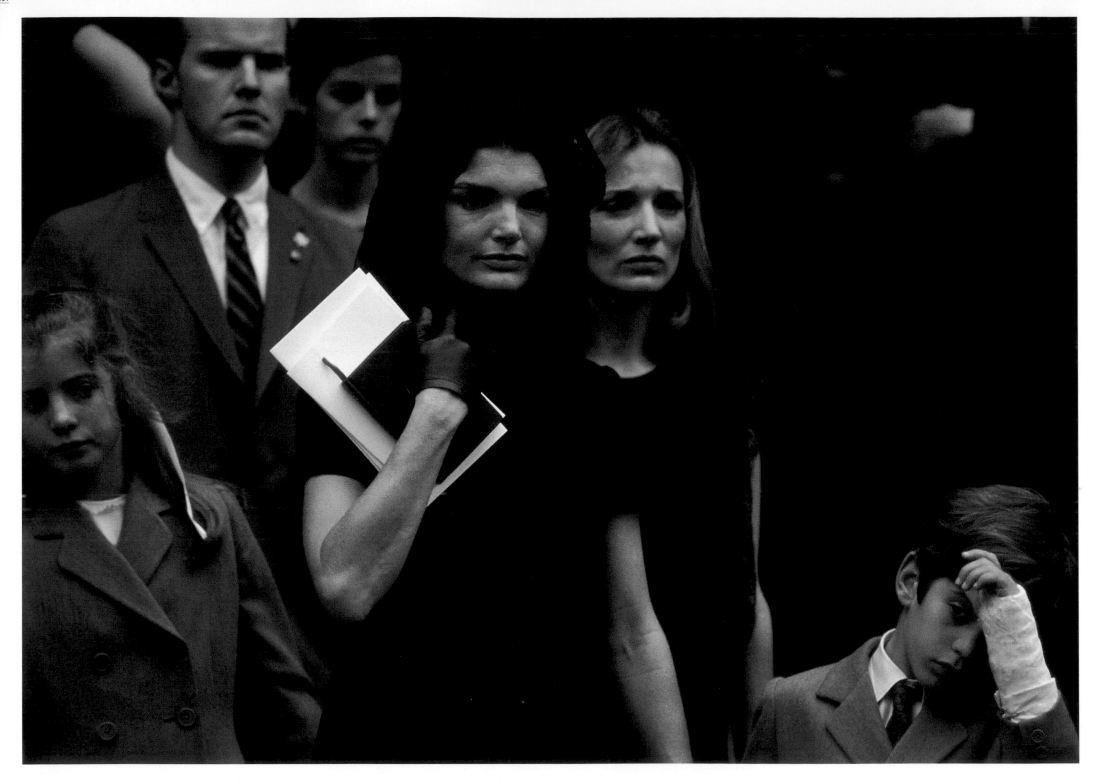

Jacqueline Kennedy and Lee Radziwill. NEW YORK, NEW YORK, 1968.

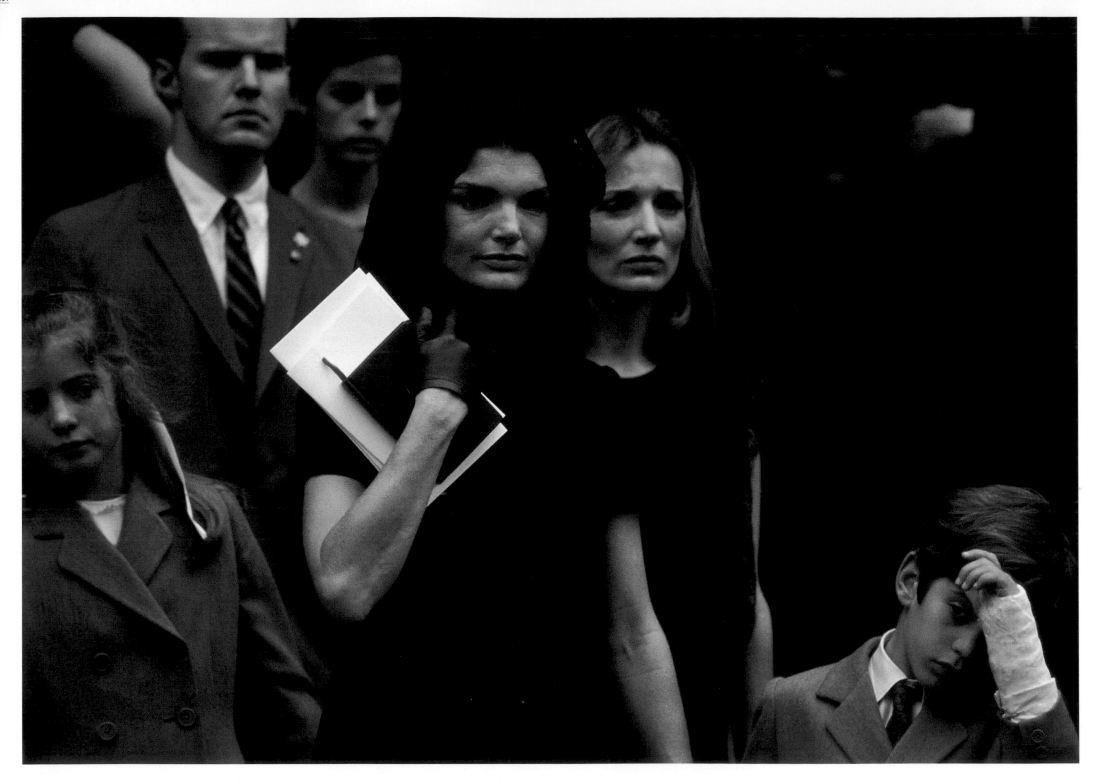

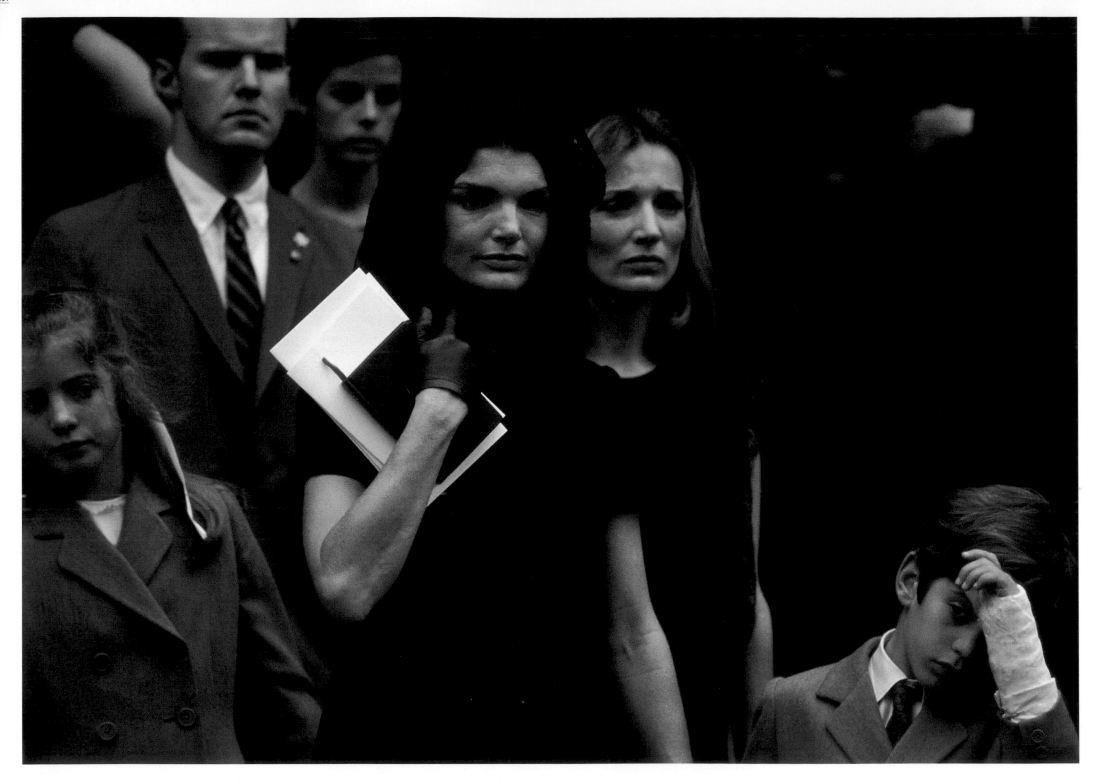

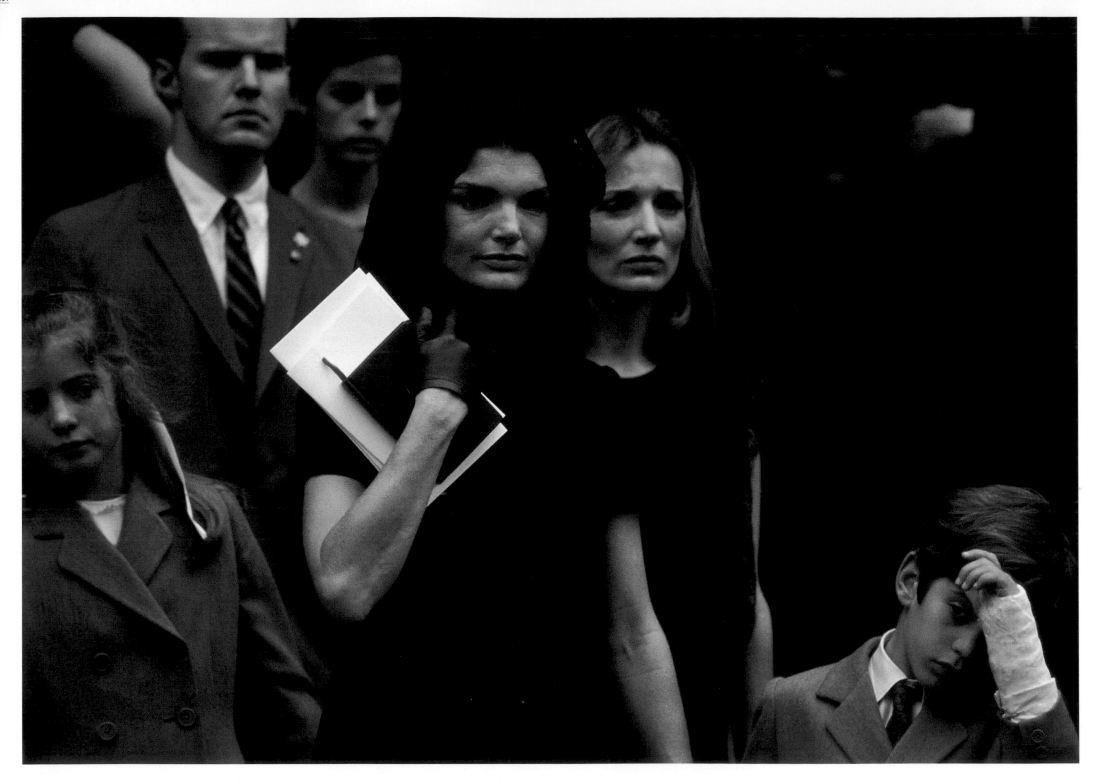

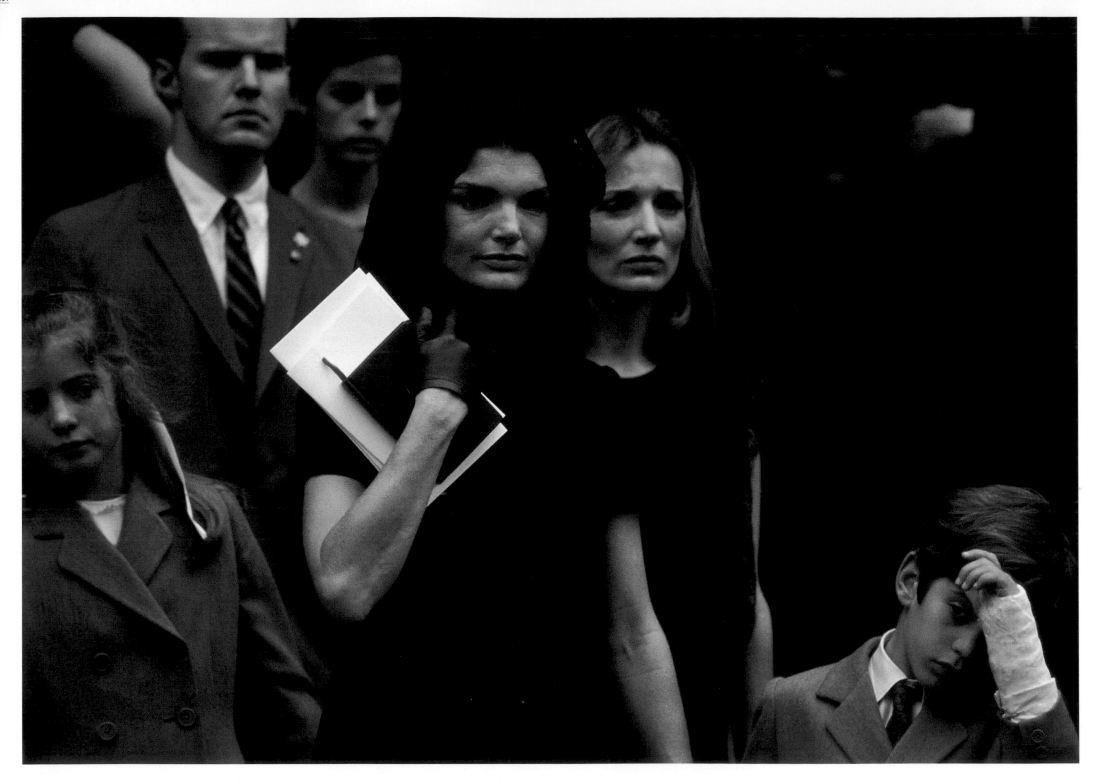

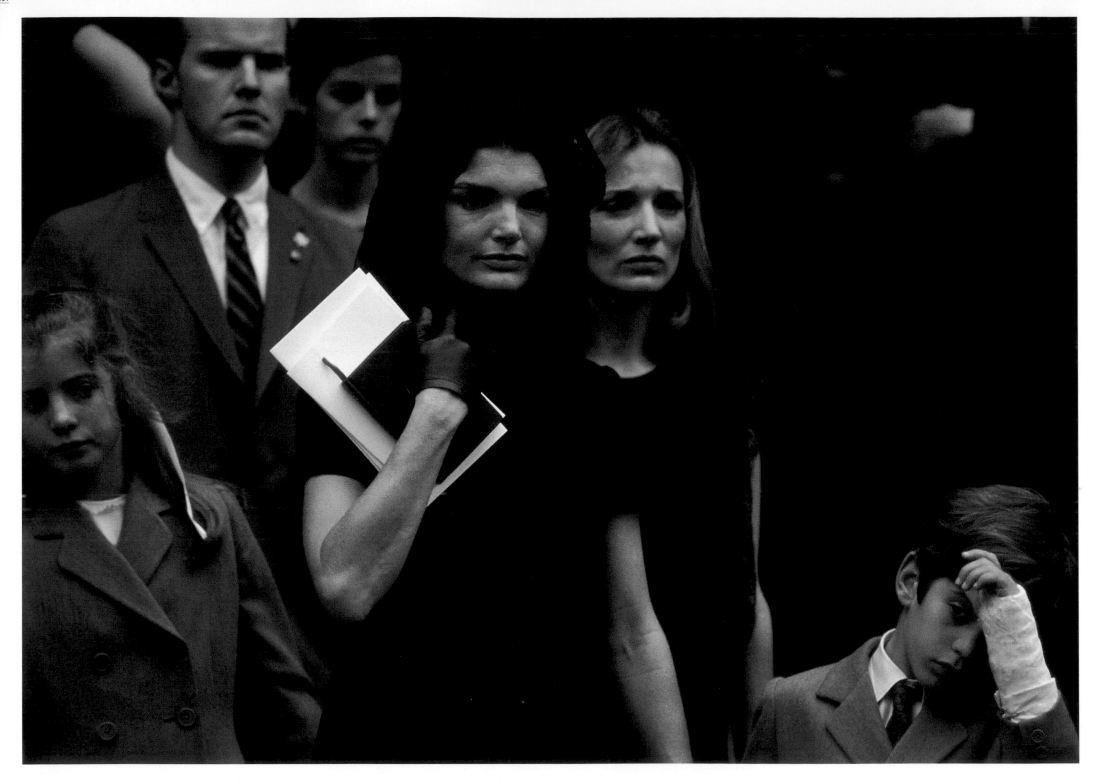

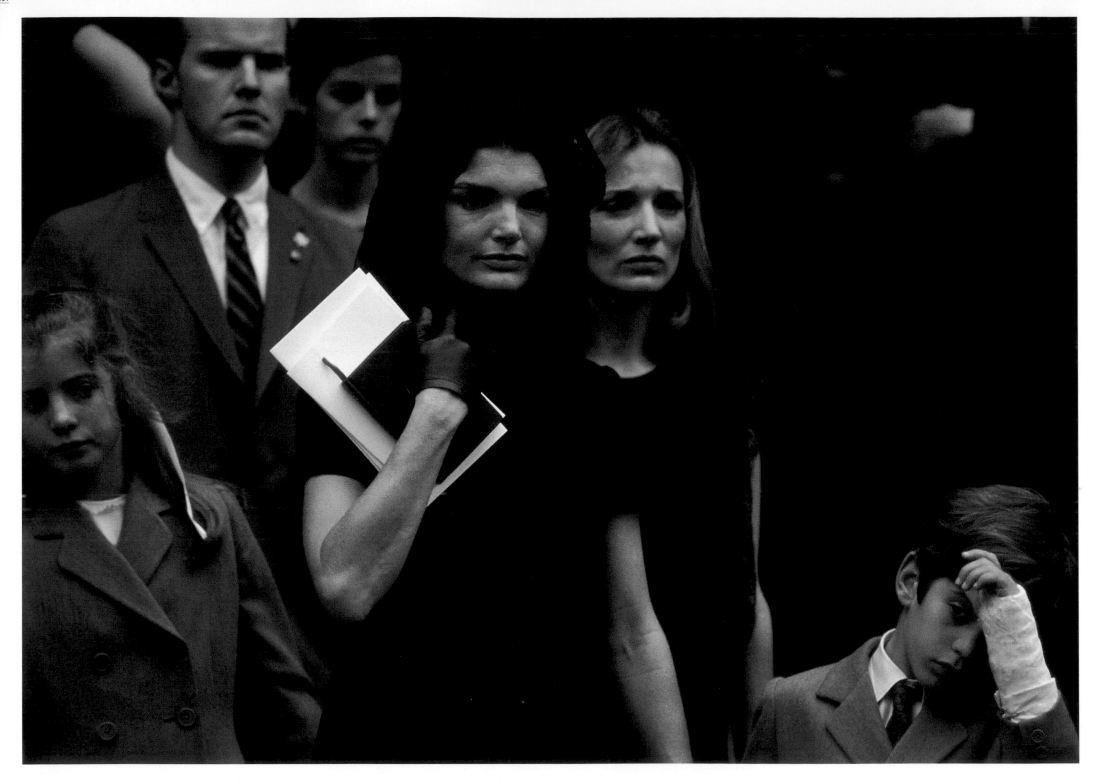

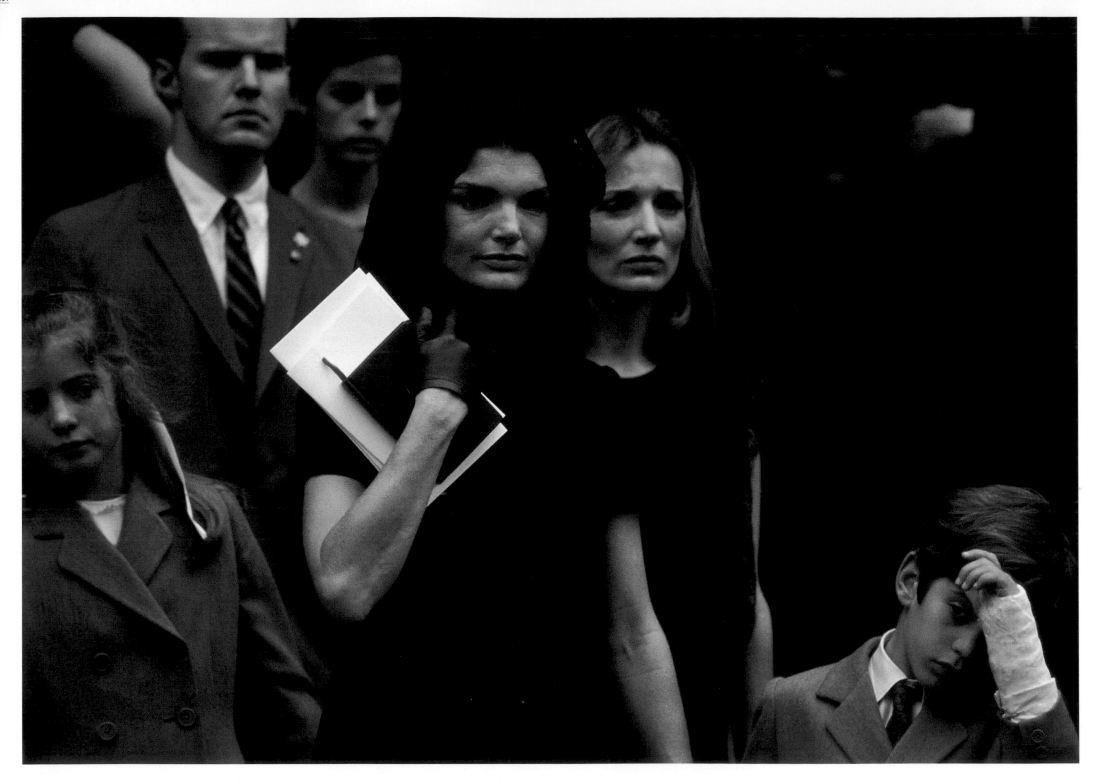

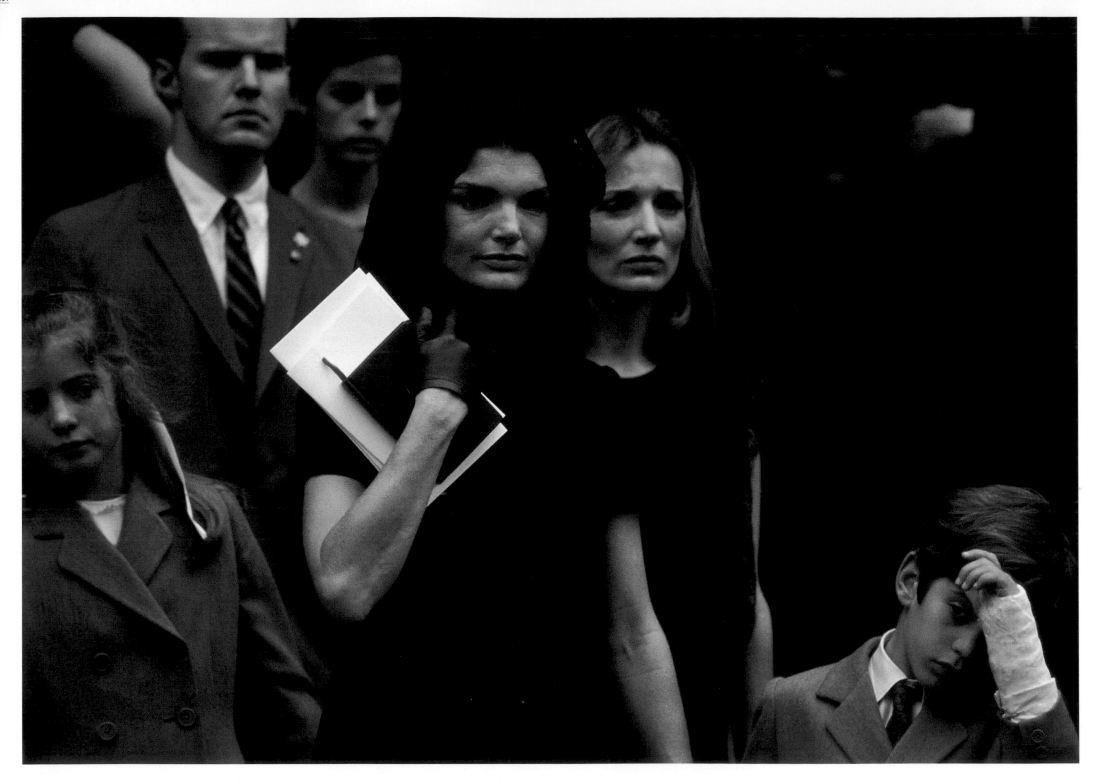

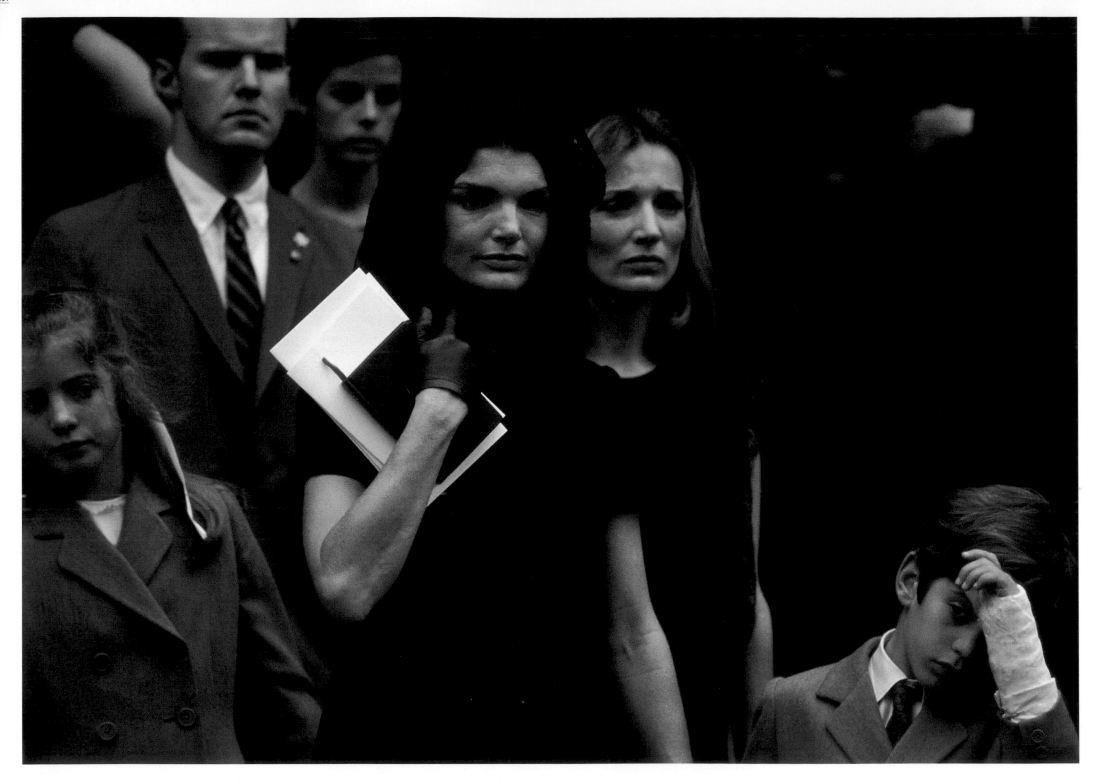

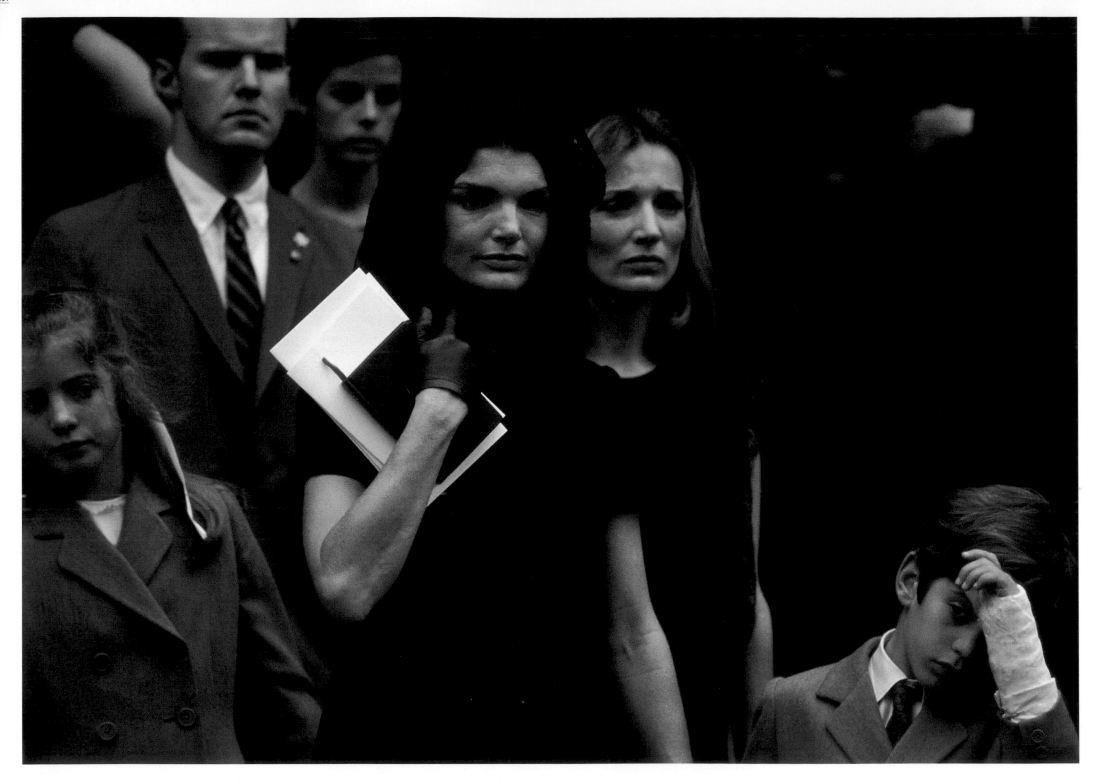

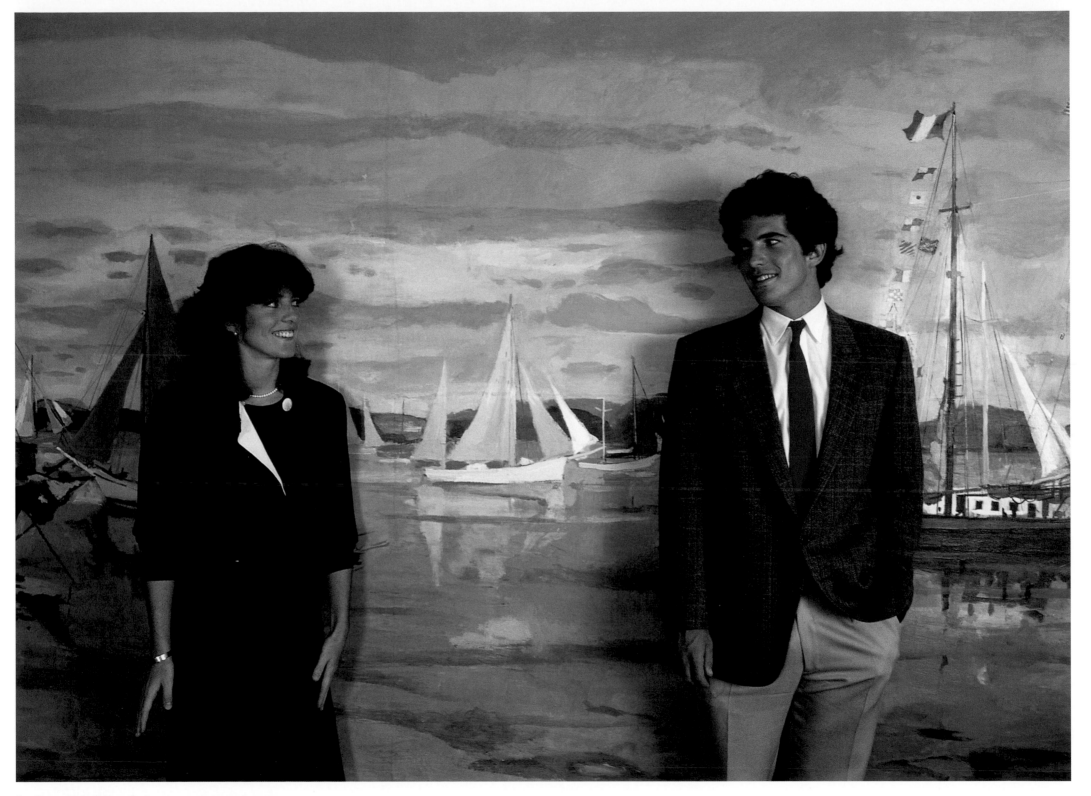

Caroline and John F. Kennedy, Jr. BOSTON, MASSACHUSETTS, 1984.

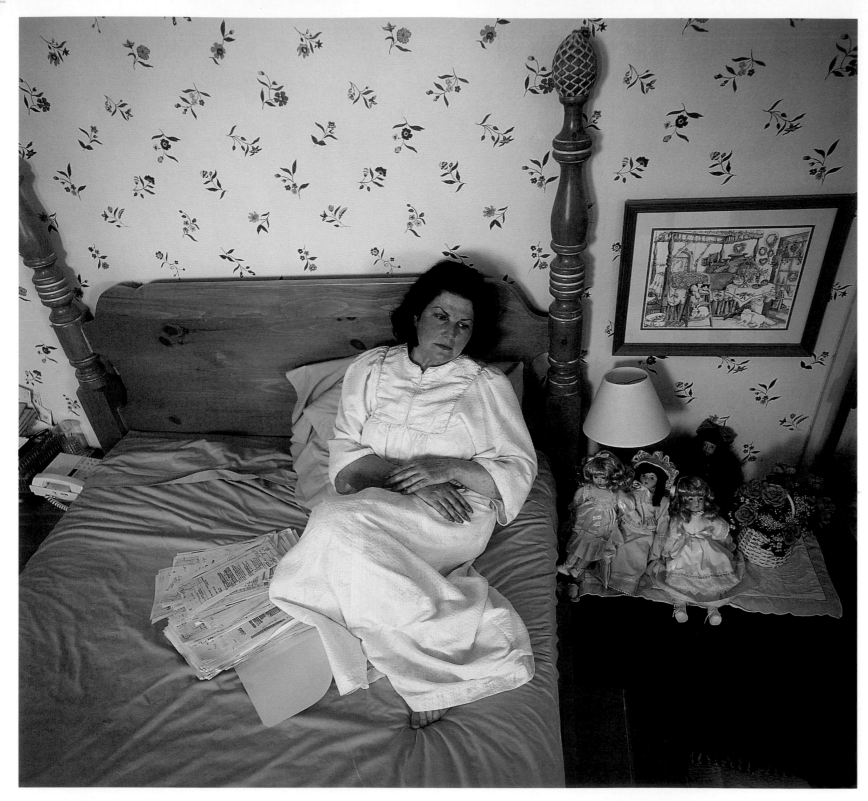

Judith Campbell Exner. MALIBU, CALIFORNIA, 1991.

Darryl Hannah. NEW YORK, NEW YORK, 1989.

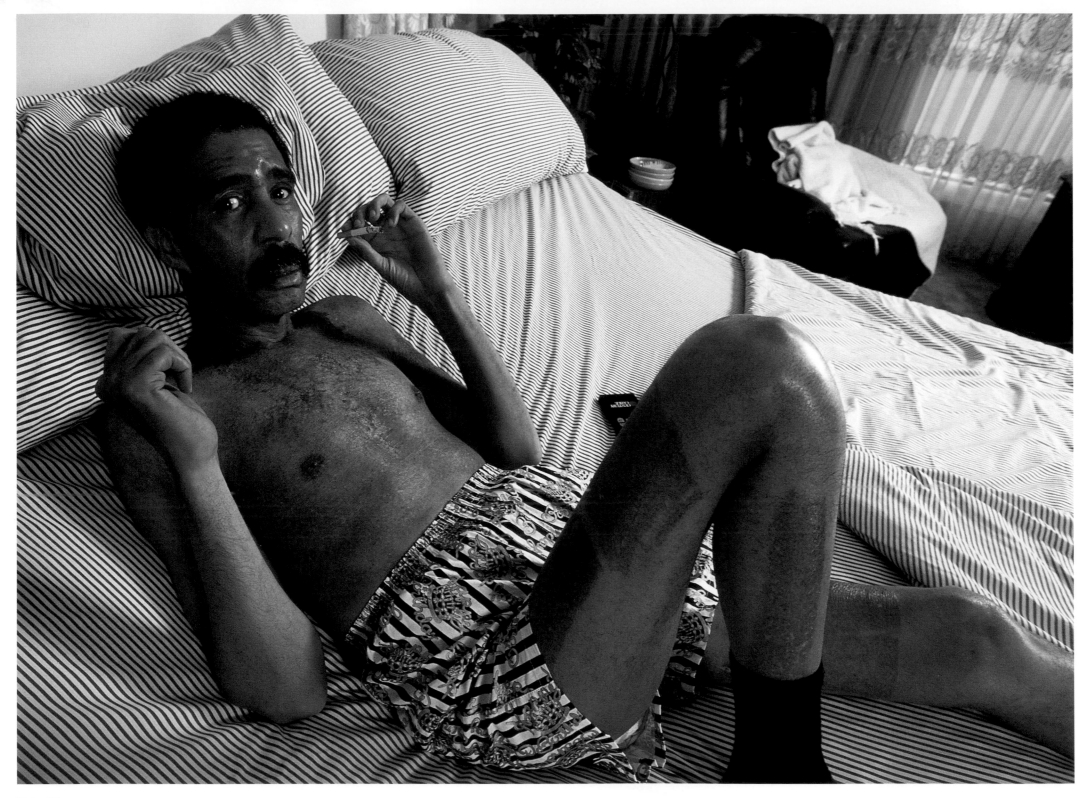

Richard Pryor. TARZANA, CALIFORNIA, 1995.

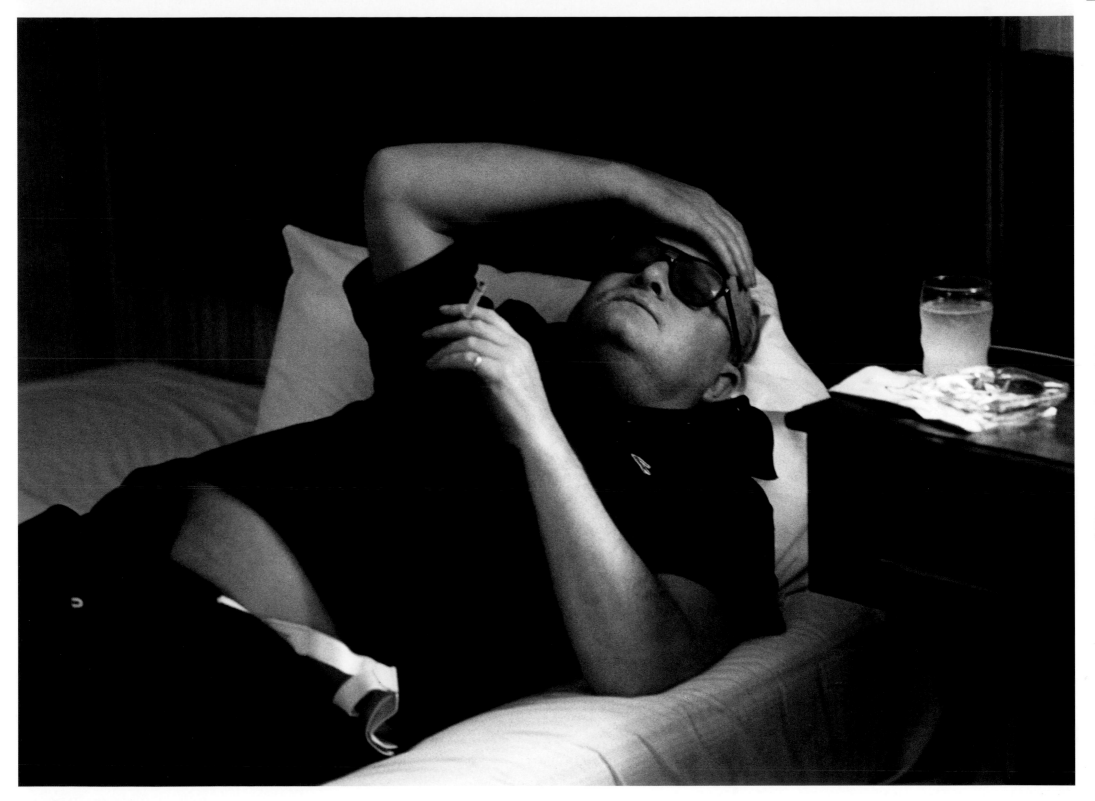

Truman Capote. DURHAM, NORTH CAROLINA, 1976.

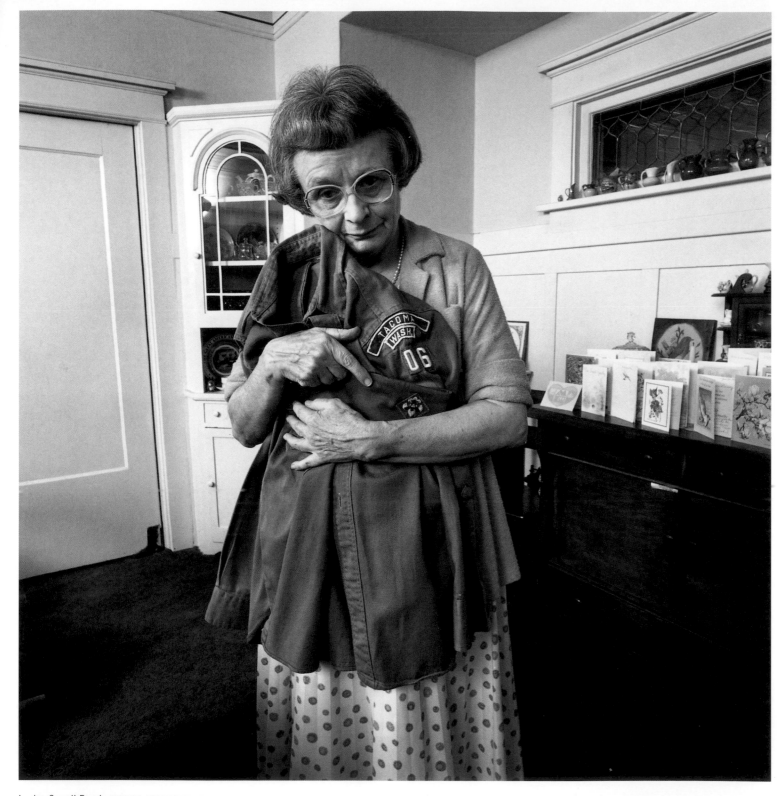

Louise Cowell Bundy. SEATTLE, WASHINGTON, 1989.

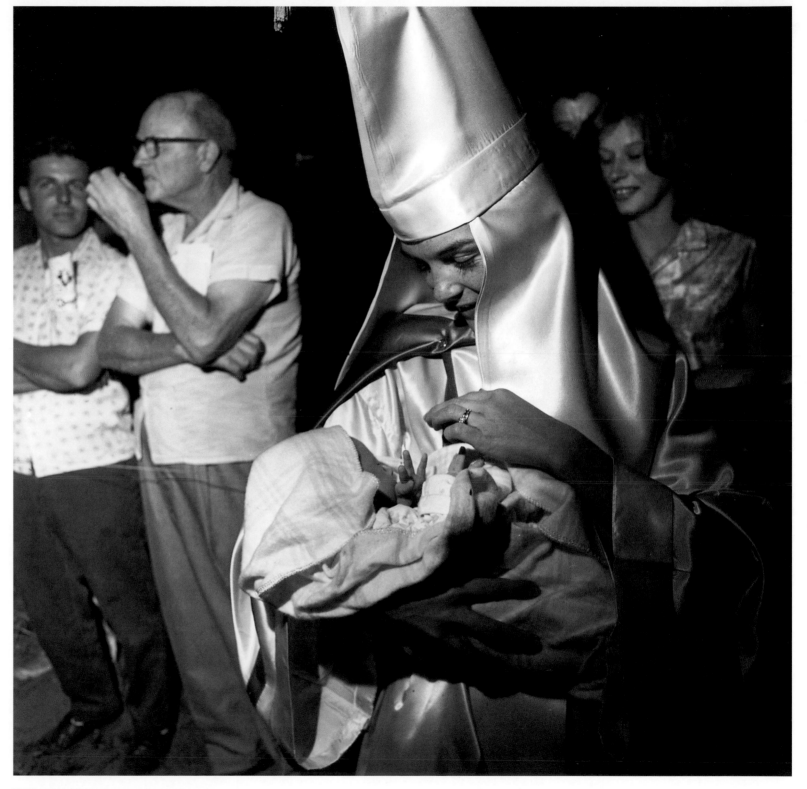

Mother with child. BEAUFORT, SOUTH CAROLINA, 1965.

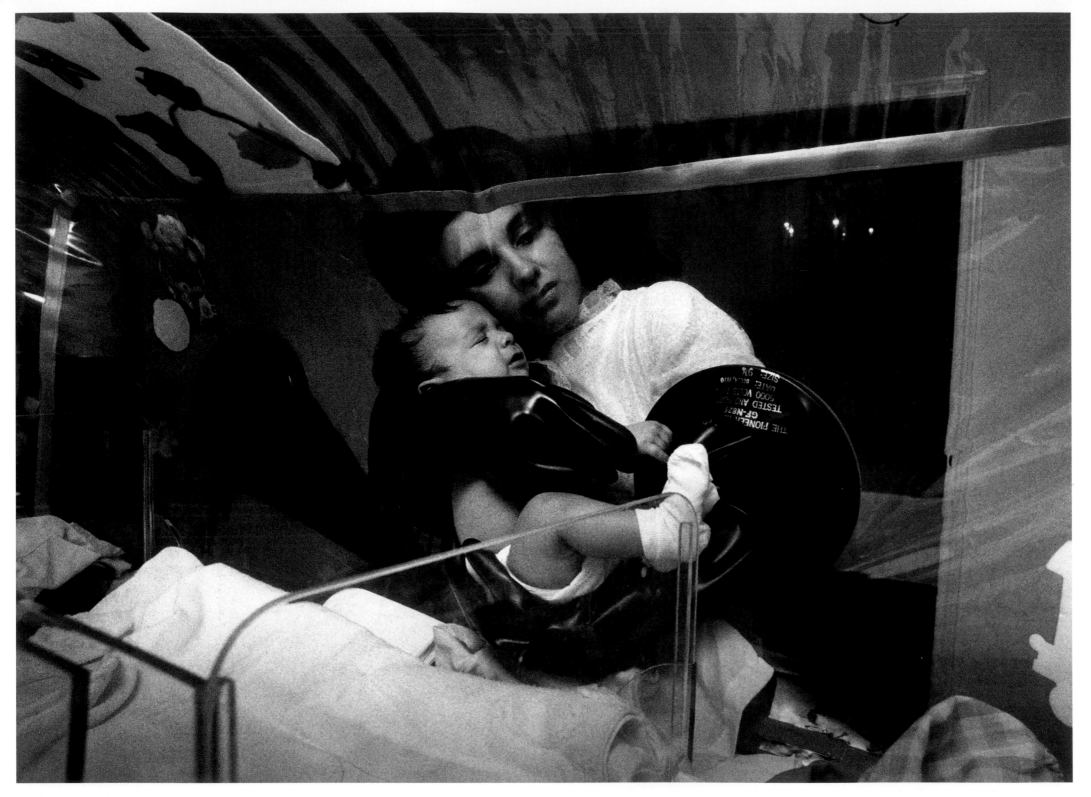

Baby David Vetter and mother, Carol Ann Demaret. HOUSTON, TEXAS, 1972.

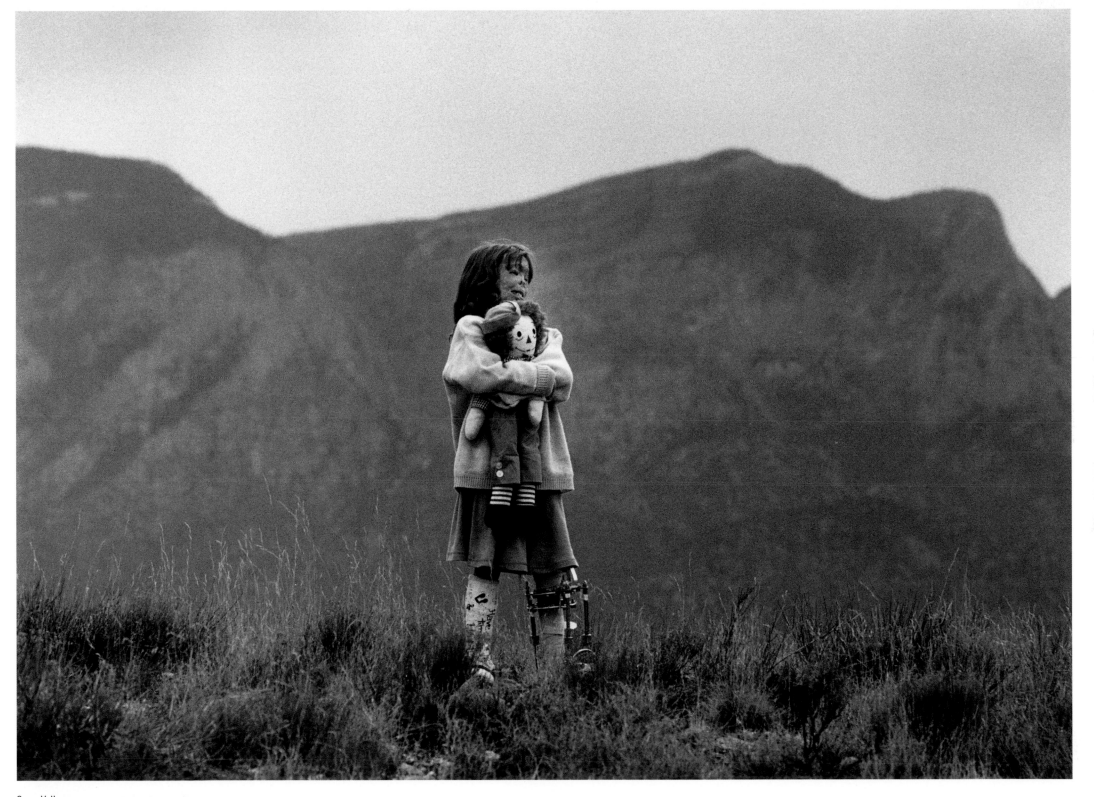

Sage Volkman. PLACITAS, NEW MEXICO, 1988.

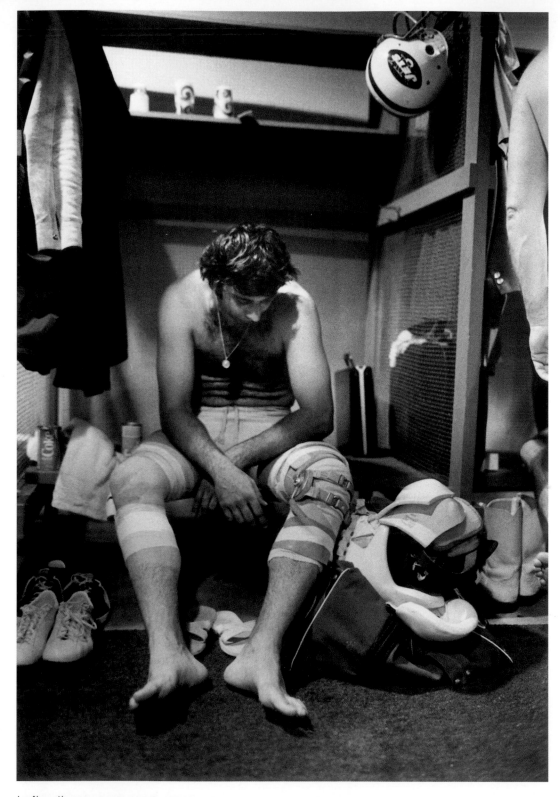

Joe Namath. SHEA STADIUM, QUEENS, NEW YORK, 1972.

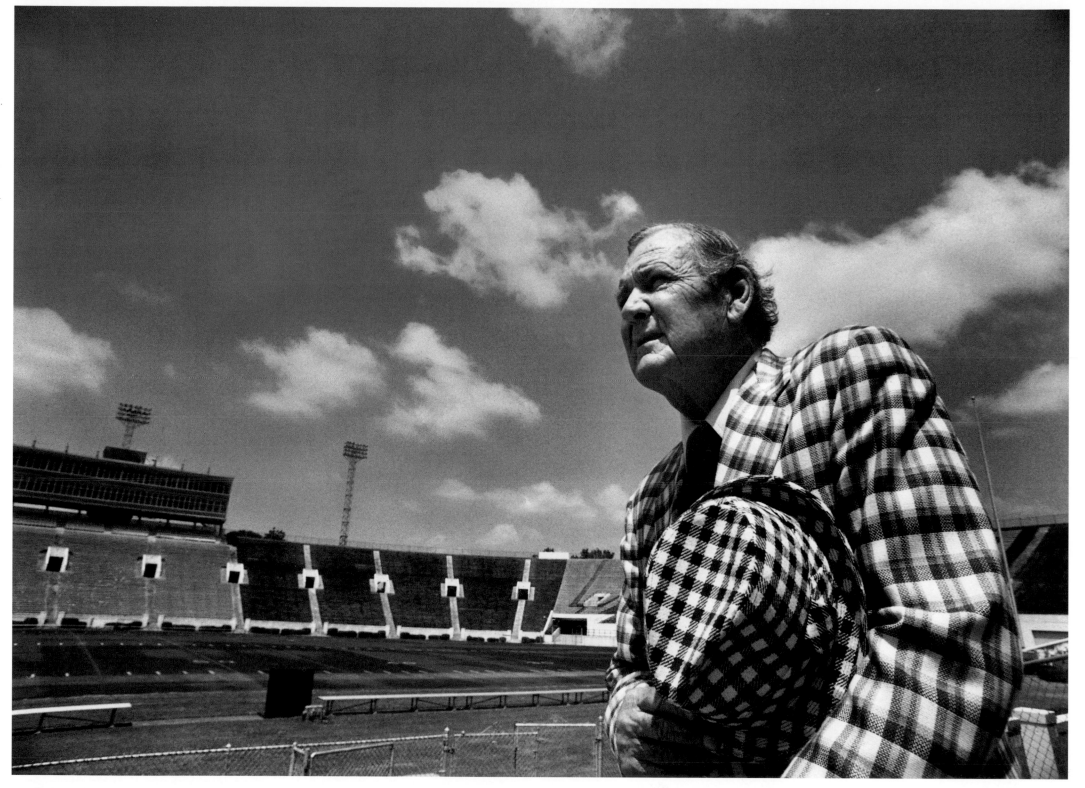

Paul "Bear" Bryant. TUSCALOOSA, ALABAMA, 1979.

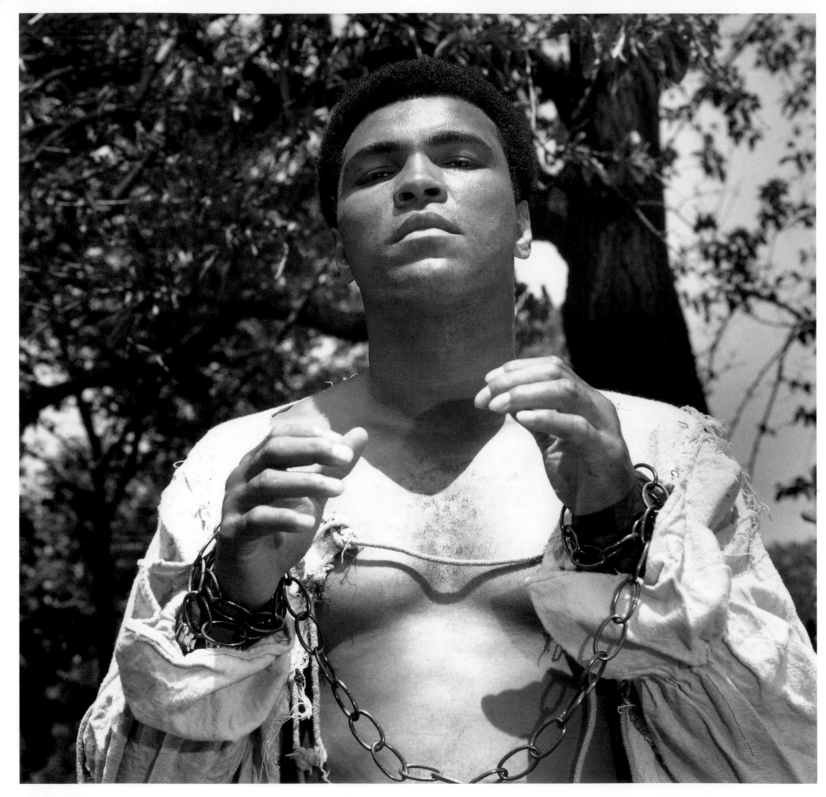

Mohammed Ali. CHICAGO, ILLINOIS, 1976.

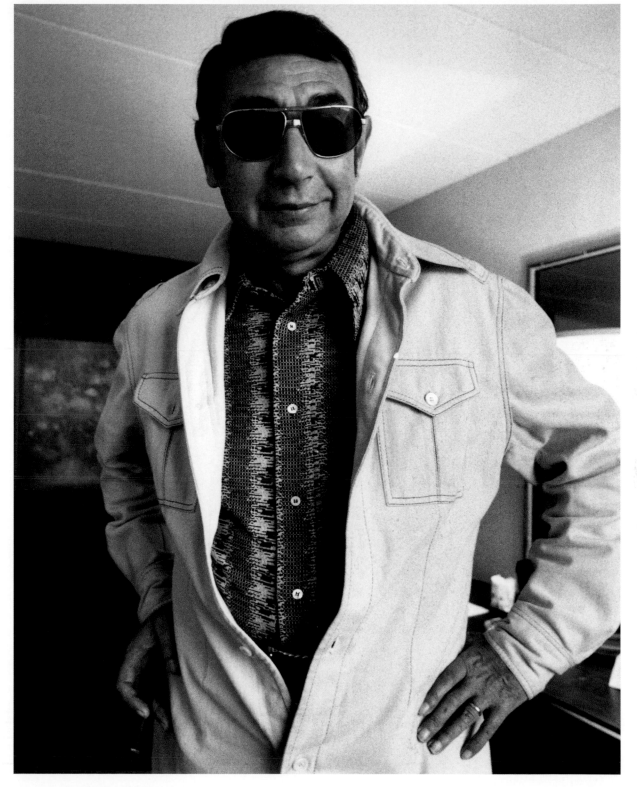

Howard Cosell. NEW YORK, NEW YORK, 1972.

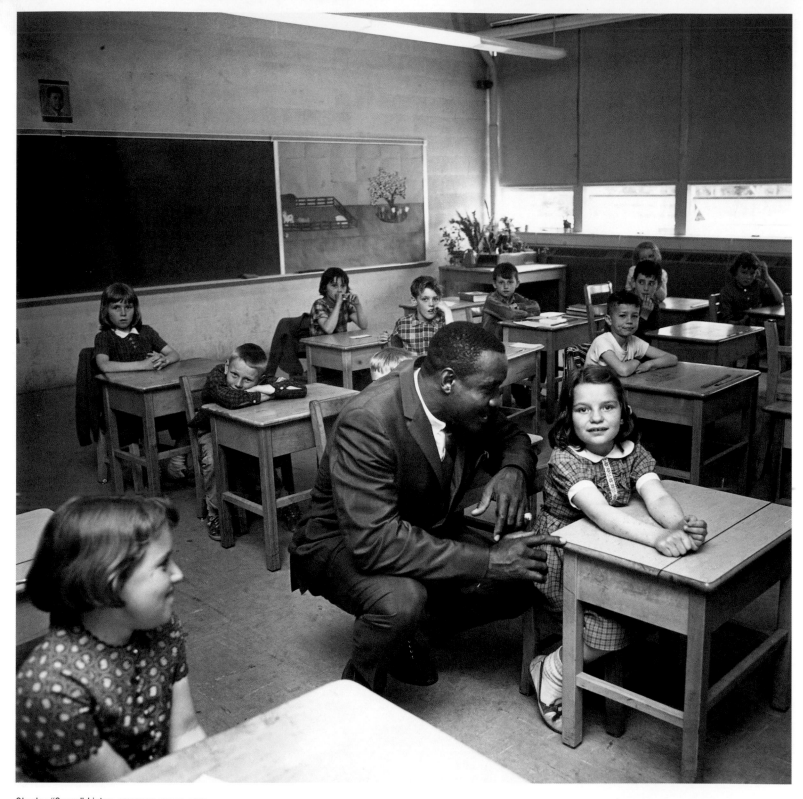

Charles "Sonny" Liston. LEWISTON, MAINE, 1965.

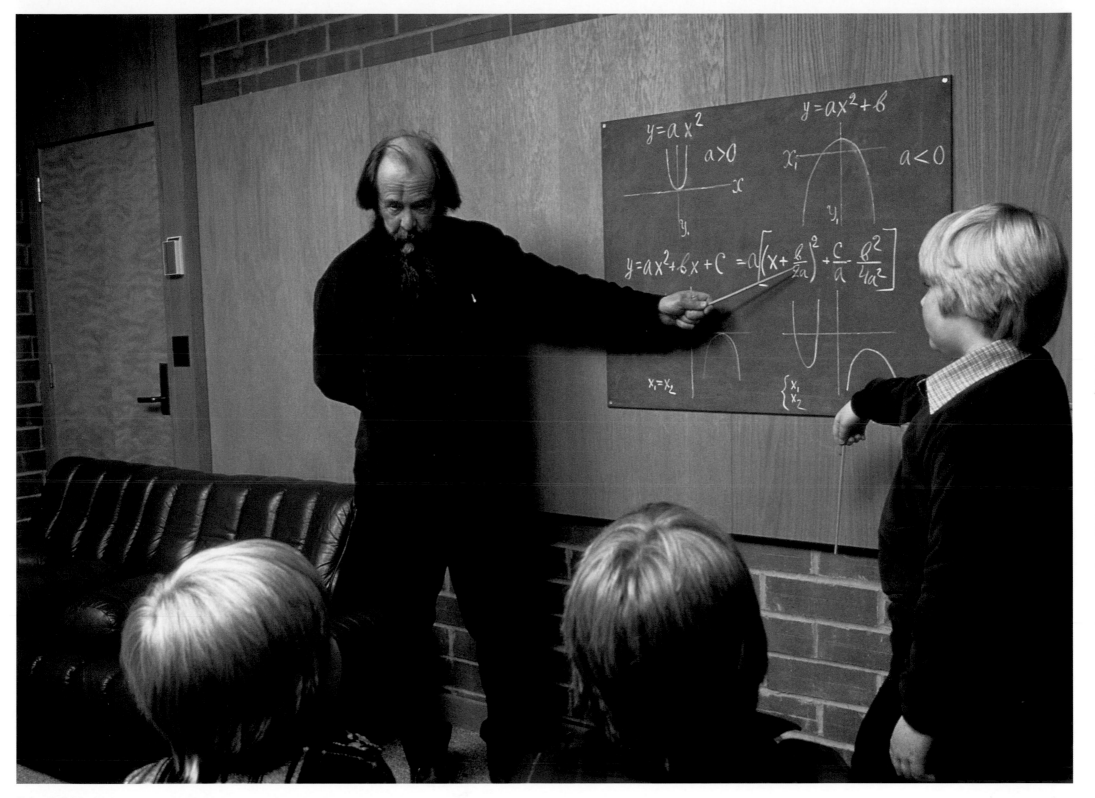

Aleksandr Solzhenitsyn. CAVENDISH, VERMONT, 1981.

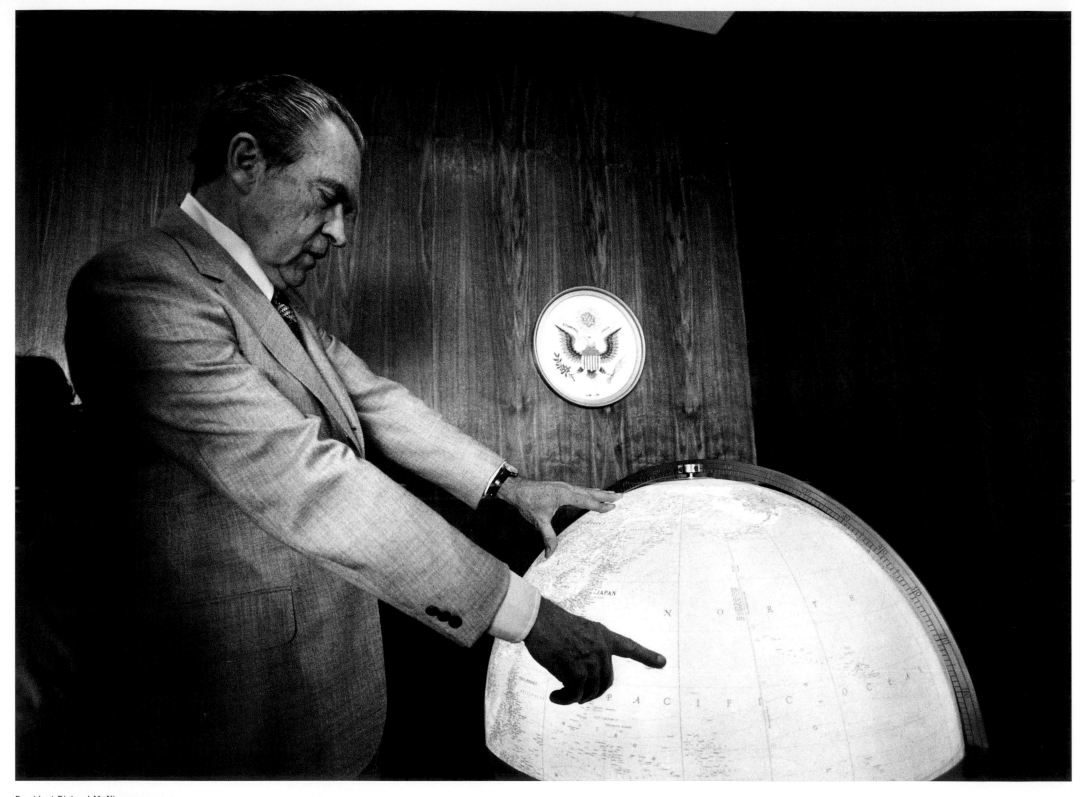

President Richard M. Nixon. SAN CLEMENTE, CALIFORNIA, 1974.

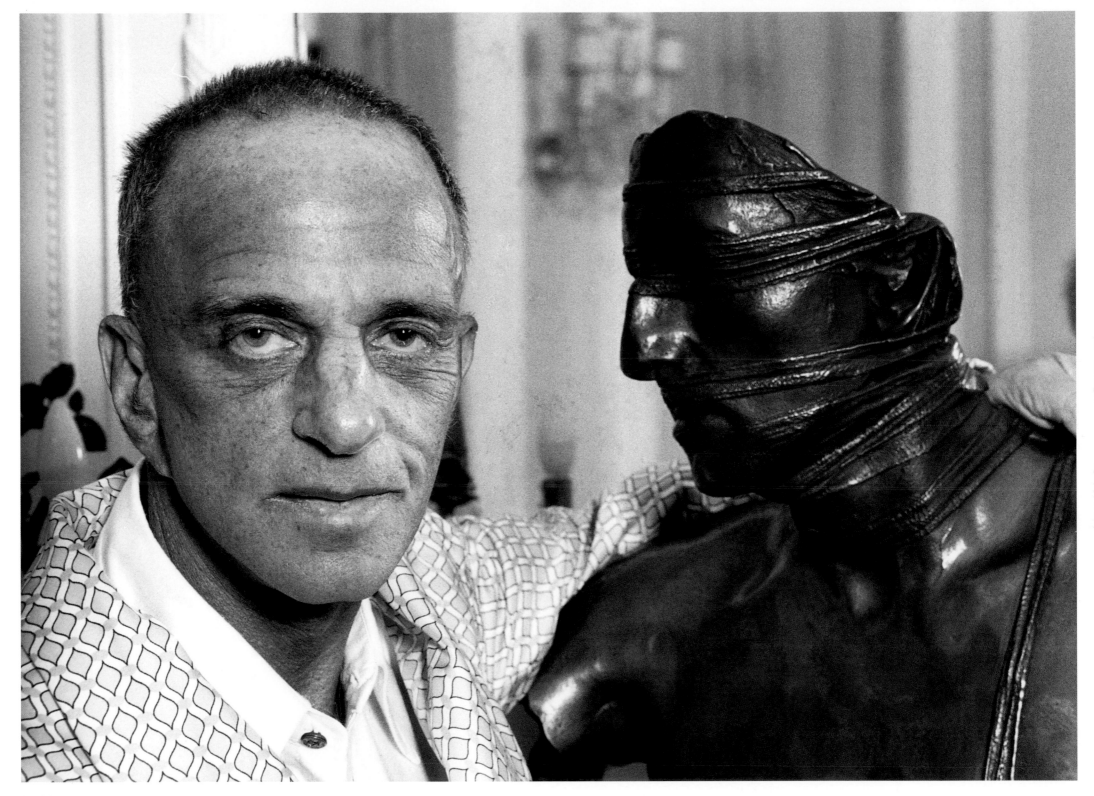

Roy Cohn. NEW YORK, NEW YORK, 1986.

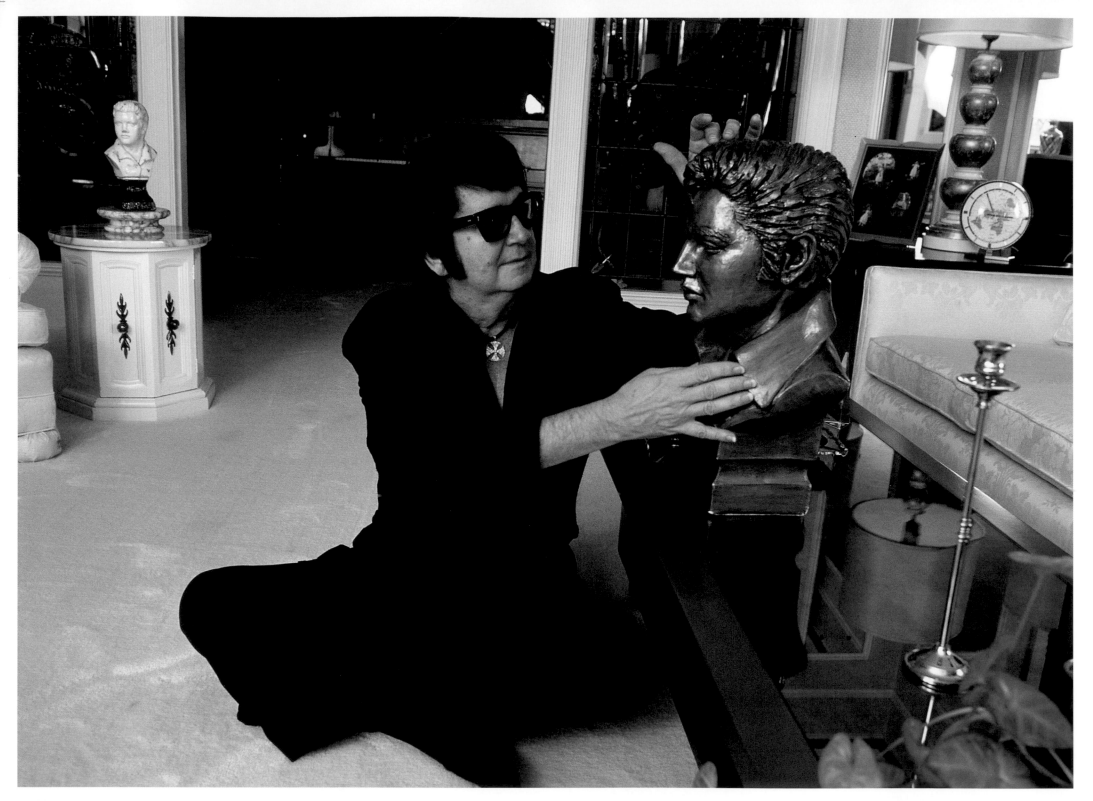

Roy Orbison. GRACELAND, MEMPHIS, TENNESSEE, 1987.

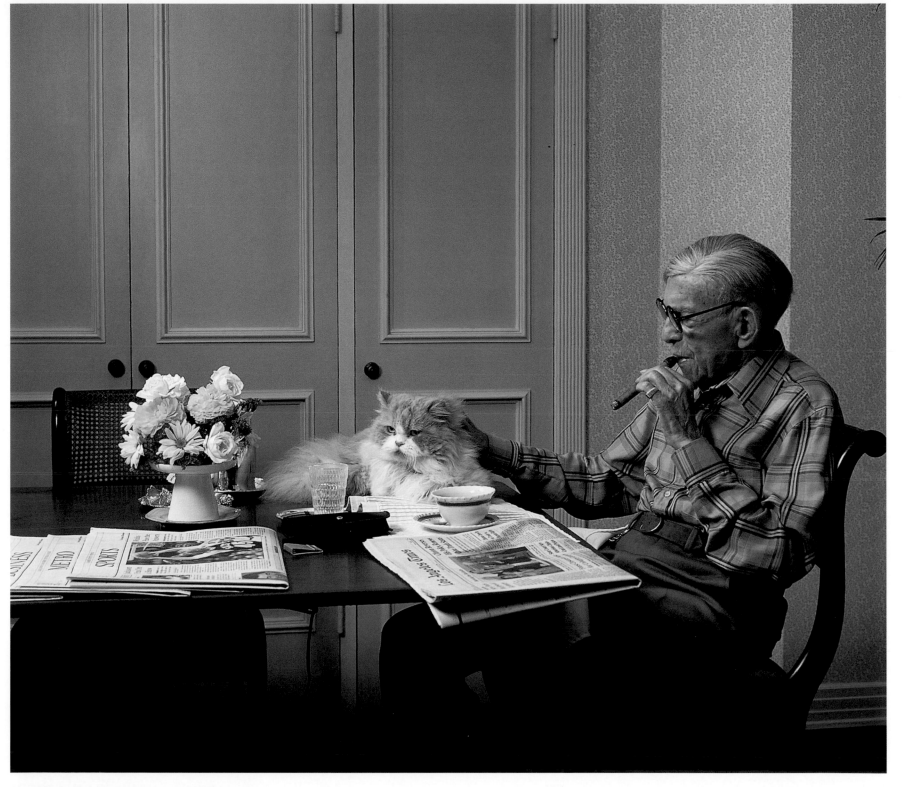

George Burns and his cat. BEVERLY HILLS, CALIFORNIA, 1992.

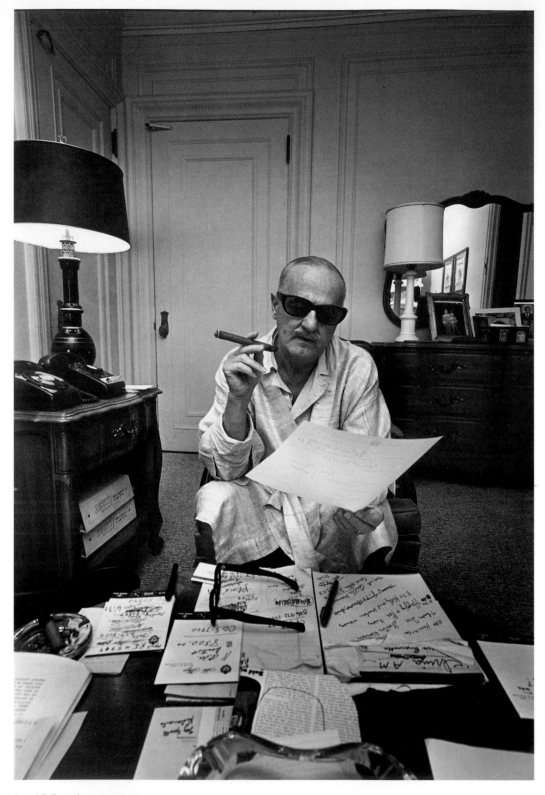

Darryl F. Zanuck. NEW YORK, NEW YORK, C. 1966.

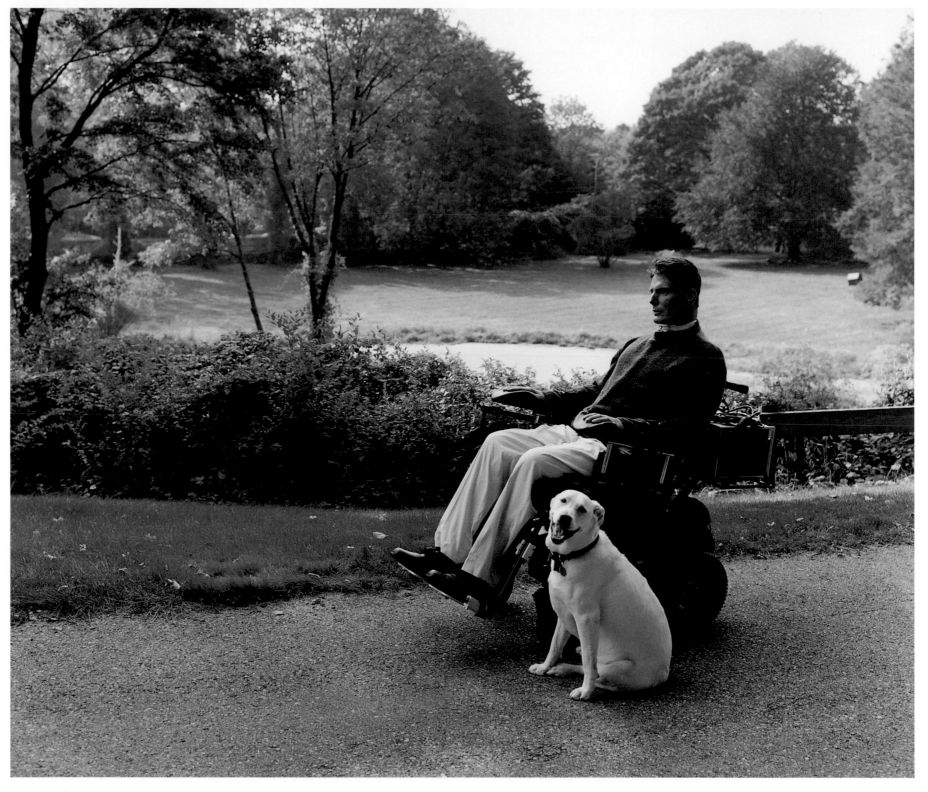

Christopher Reeve. POUND RIDGE, NEW YORK, 1998.

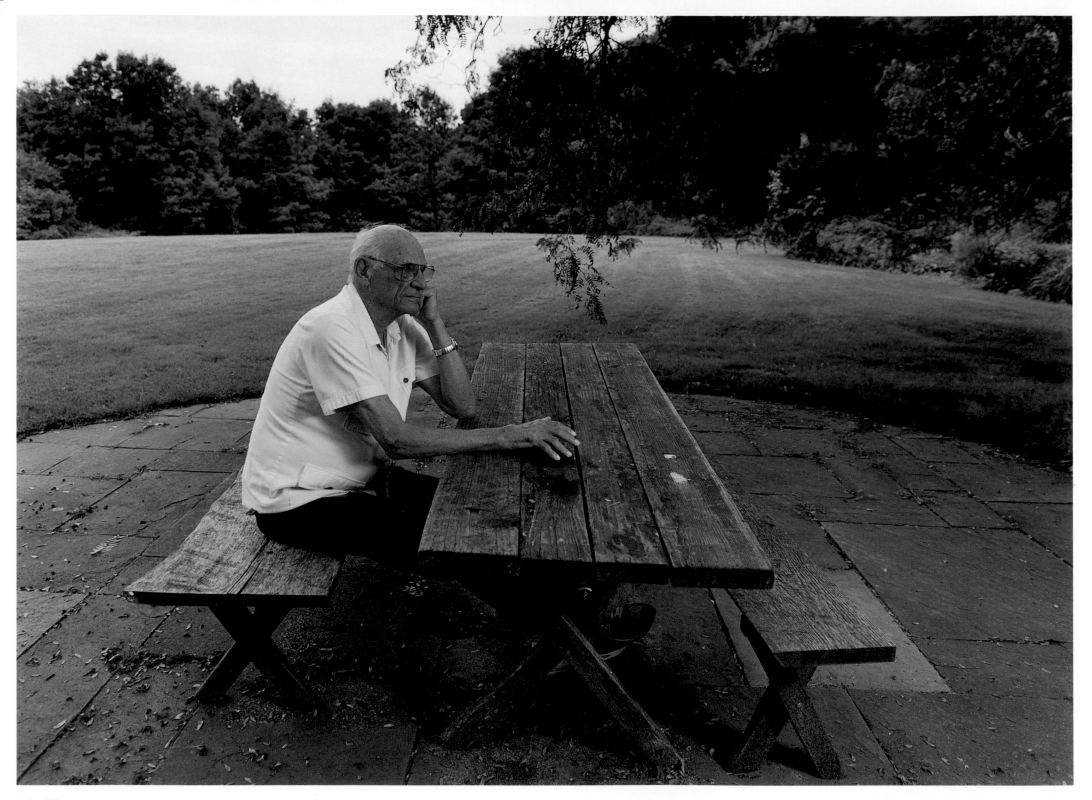

Arthur Miller. ROXBURY, CONNECTICUT, 2003.

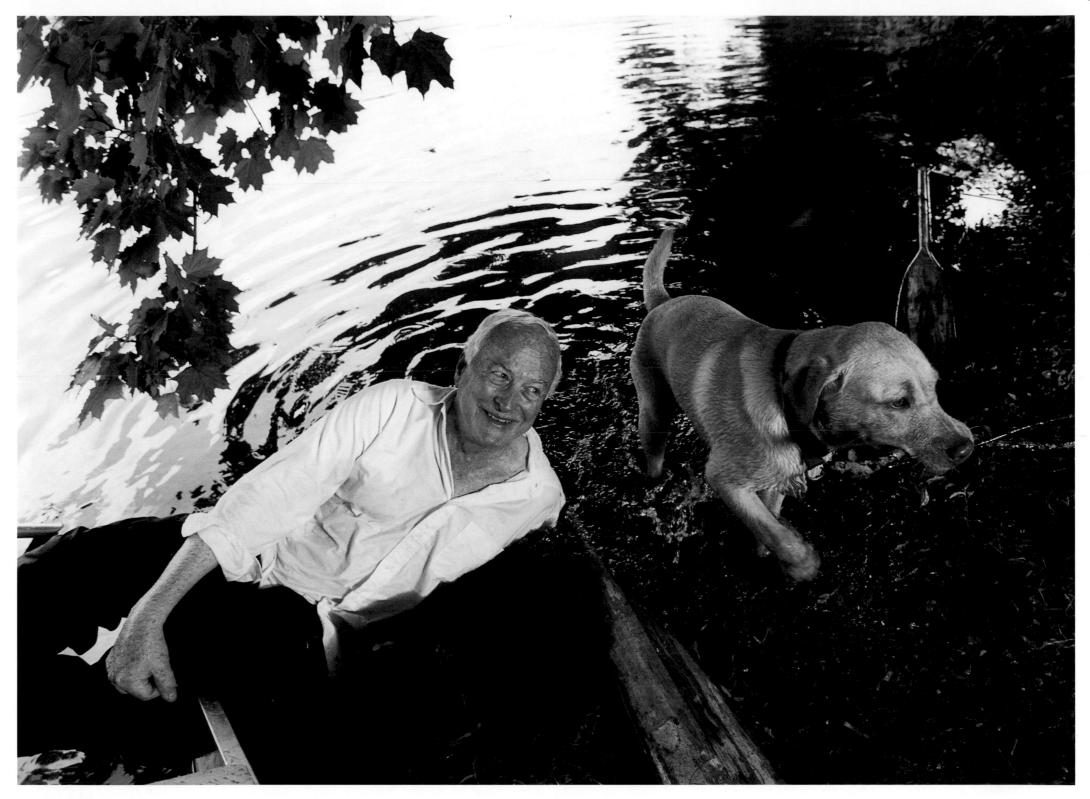

James Ivory and Rao. CLAVERACK, NEW YORK, 2003.

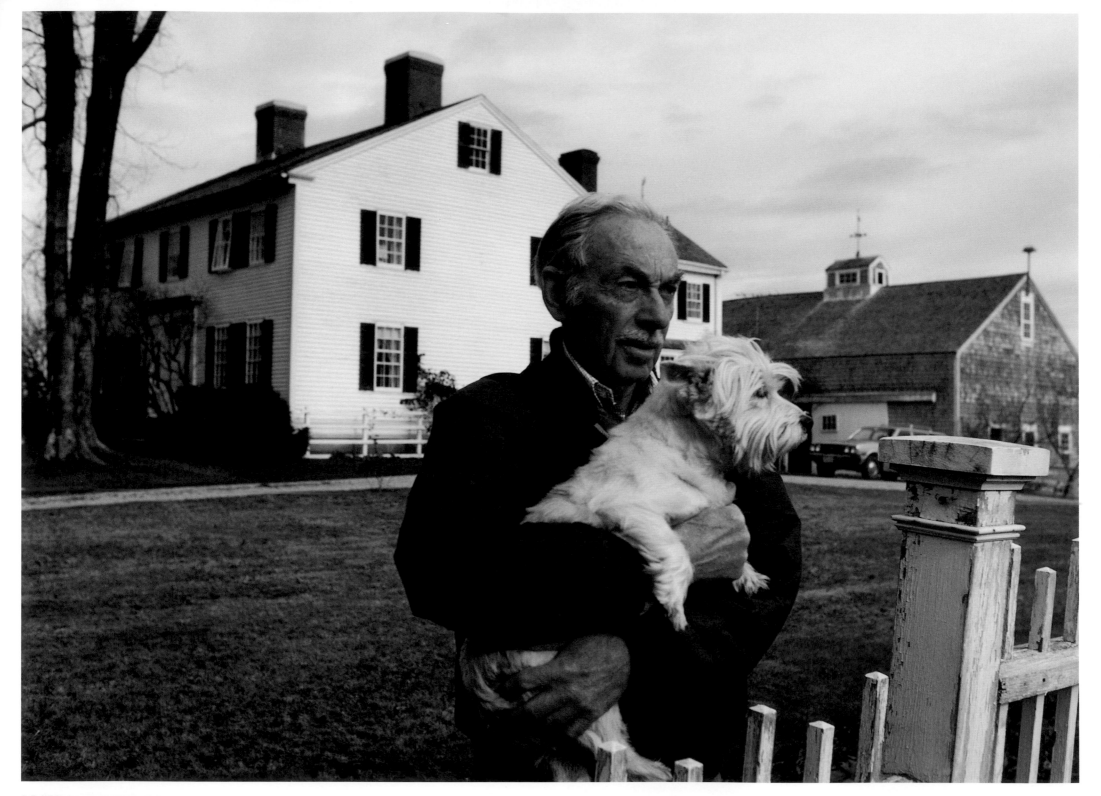

E. B. White. NORTH BROOKLINE, MAINE, 1977.

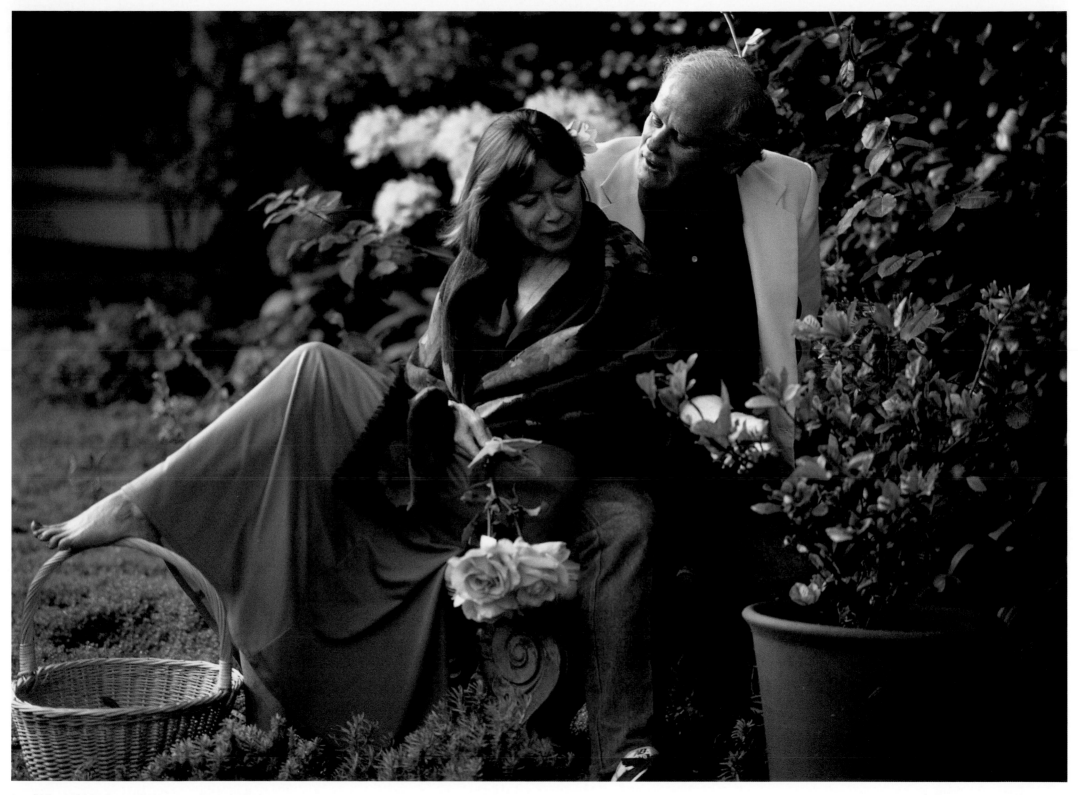

Joan Didion and John Gregory Dunne. LOS ANGELES, CALIFORNIA, 1972.

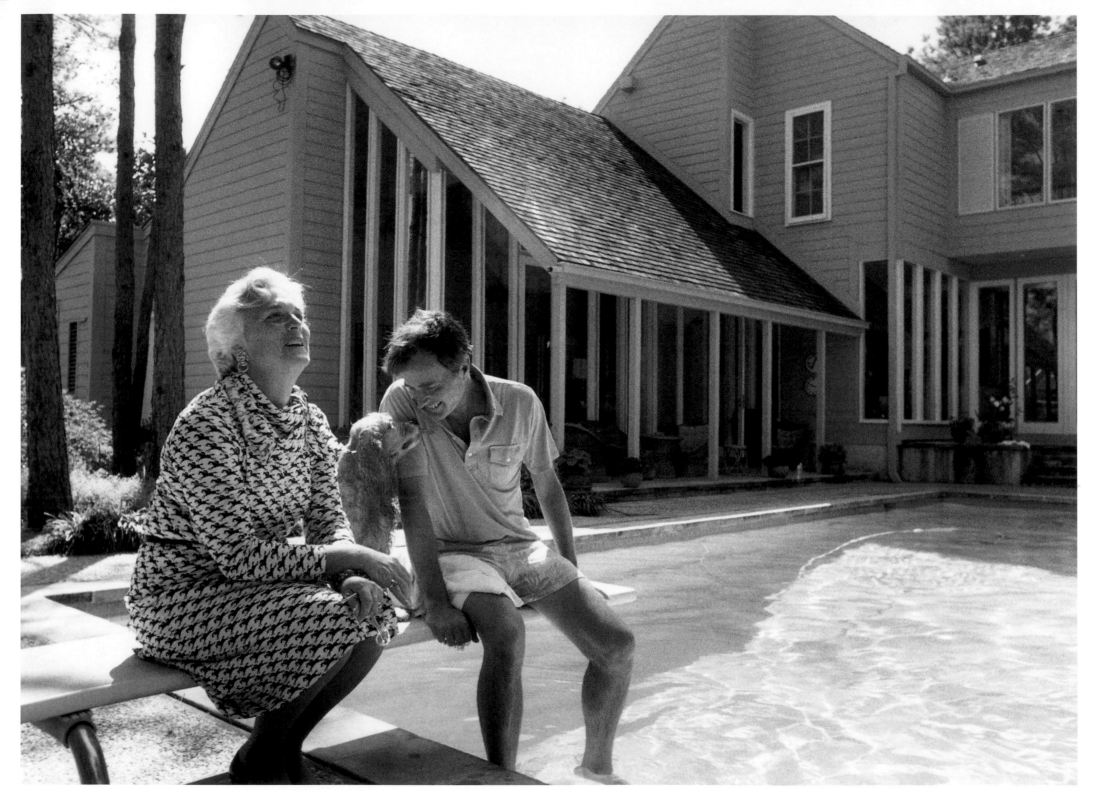

George H. W. and Barbara Bush. HOUSTON, TEXAS, 1978.

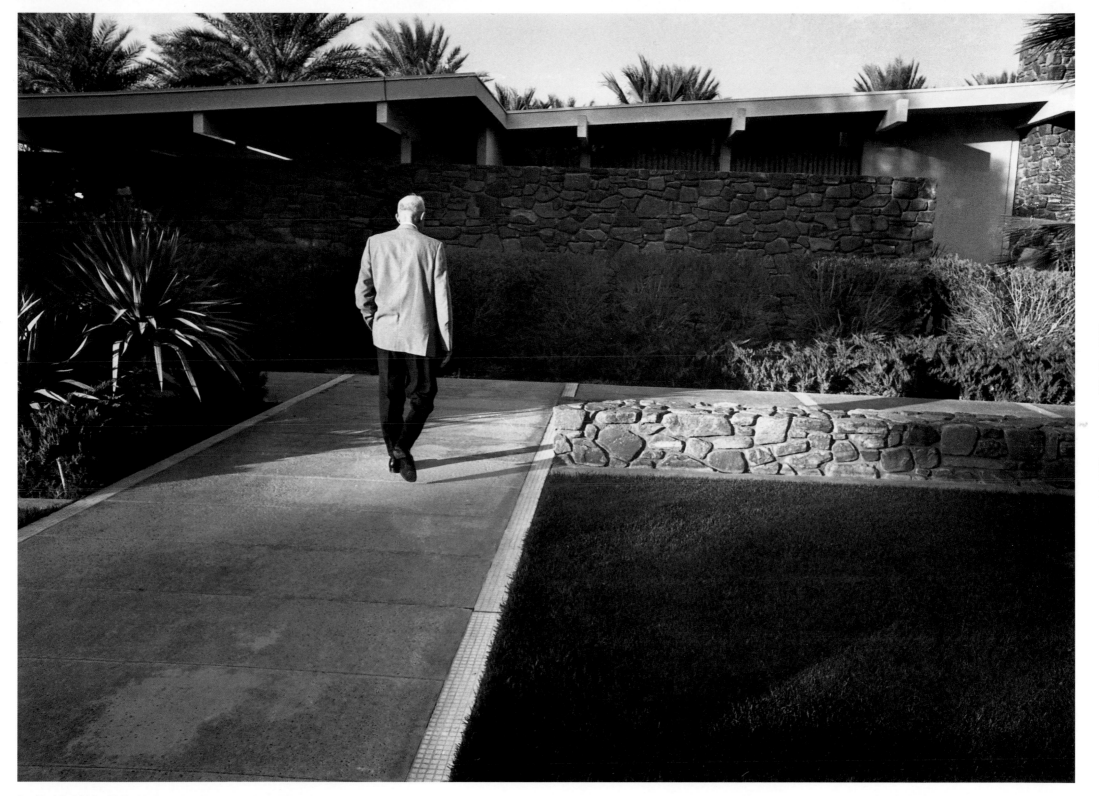

President Dwight David Eisenhower. PALM SPRINGS, CALIFORNIA, 1965.

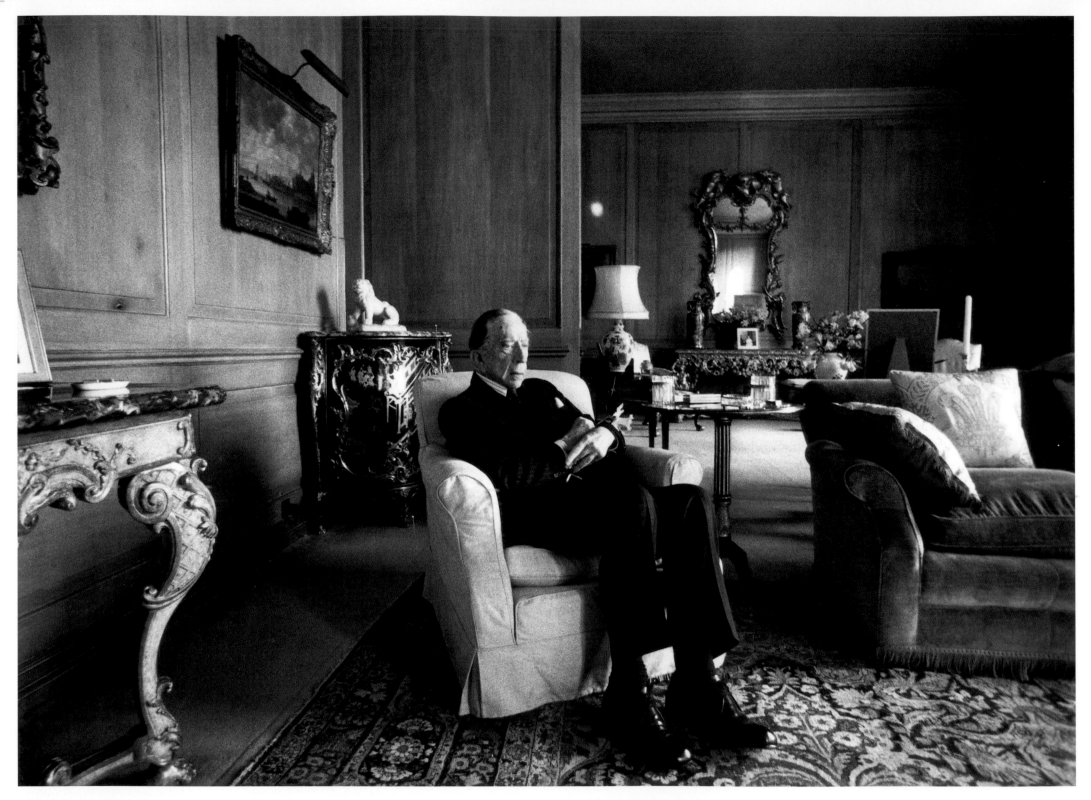

J. Paul Getty. GUILDFORD, ENGLAND, 1974.

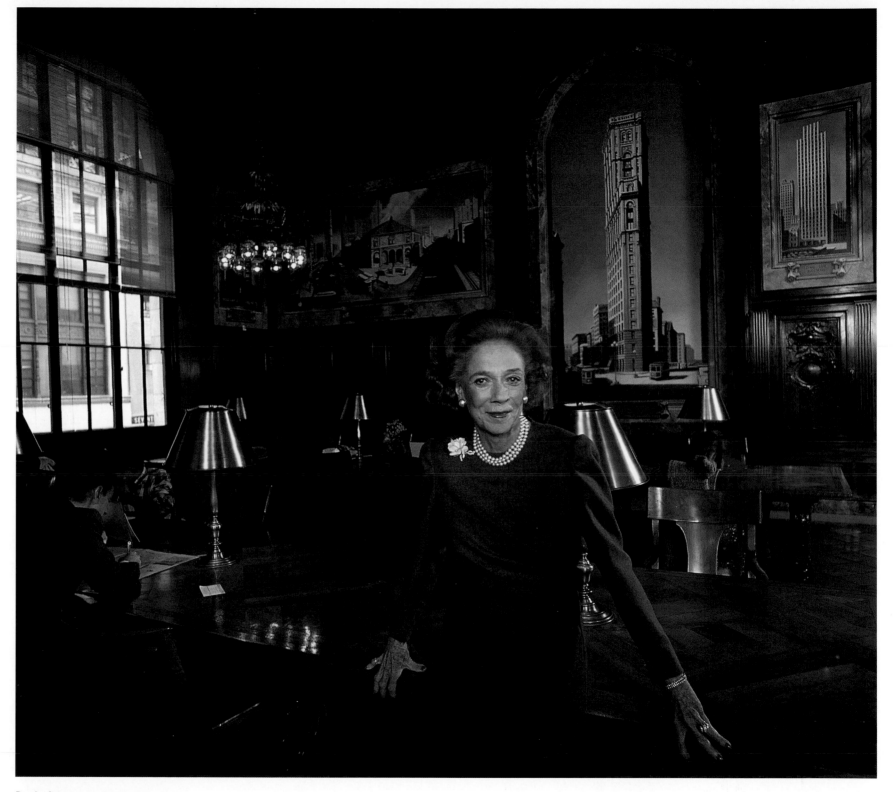

Brooke Astor. NEW YORK, NEW YORK, 1988.

President Richard M. Nixon. SAN CLEMENTE, CALIFORNIA, 1974.

Bob Hope. PALM SPRINGS, CALIFORNIA, 1998.

Charles "Chuck" Yeager. INDIANAPOLIS, INDIANA, 1986.

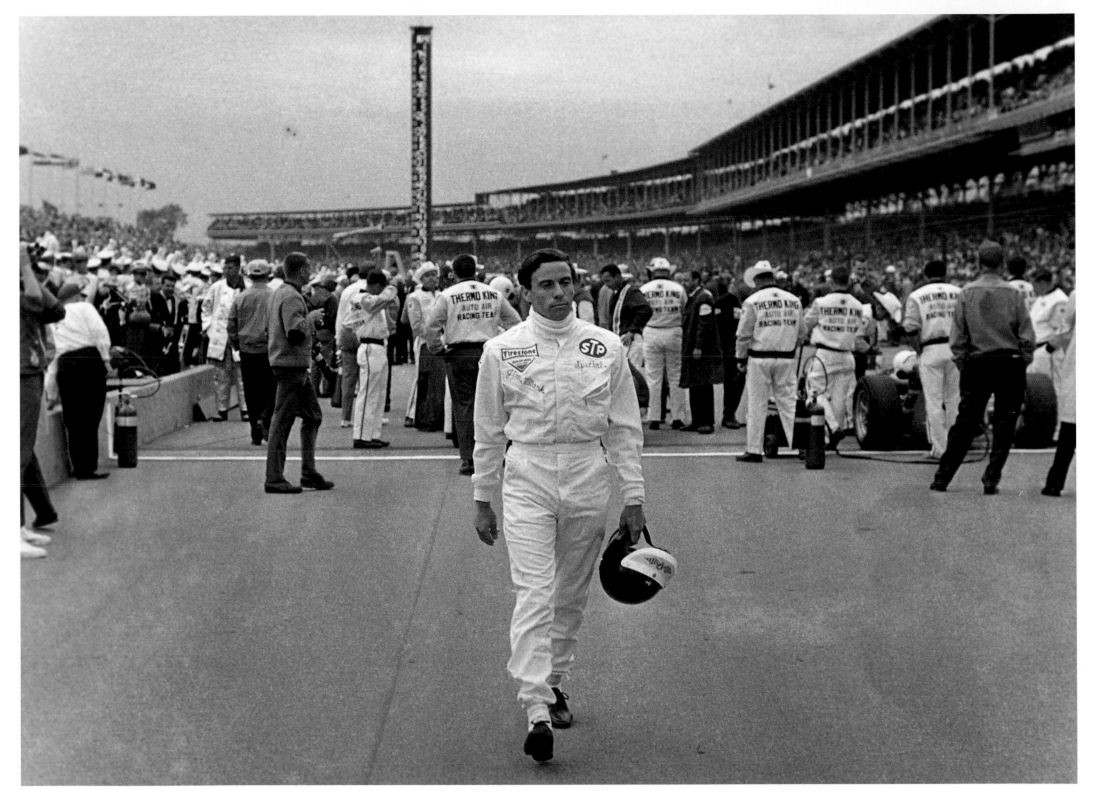

Jimmy Clark. INDIANAPOLIS, INDIANA, 1965.

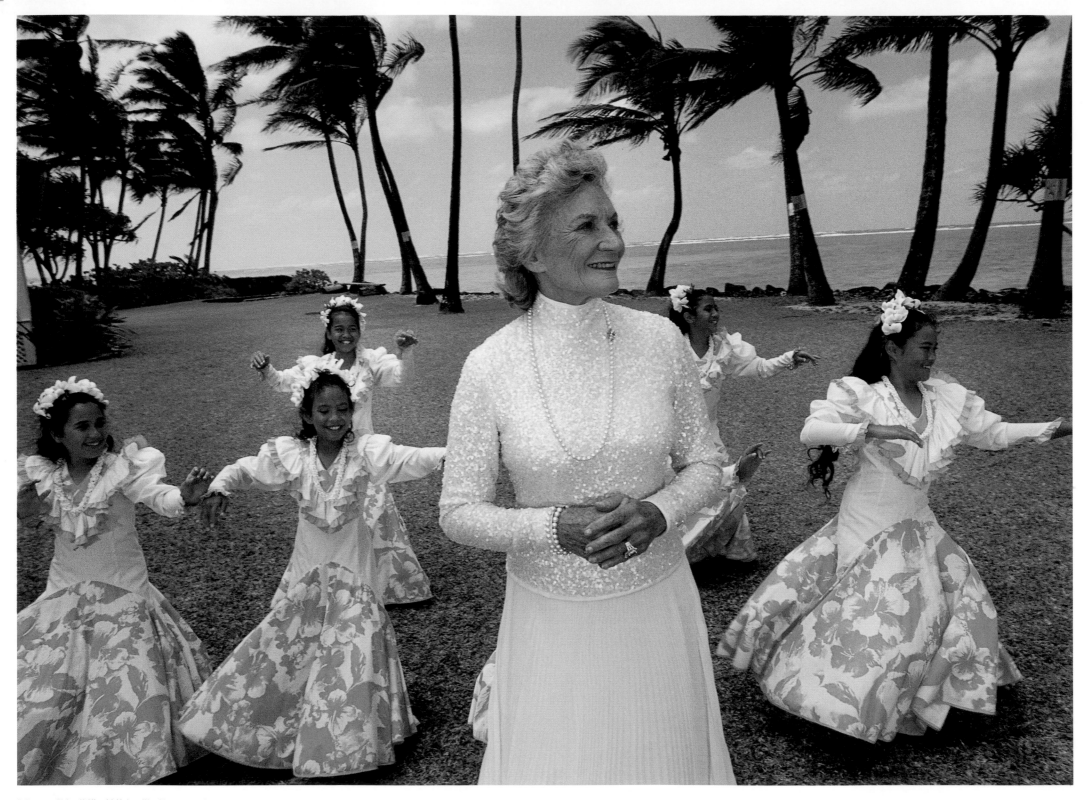

Princess Abigail Kinoki Kekaulike Kawananakoa. HONOLULU, HAWAII, 1998.

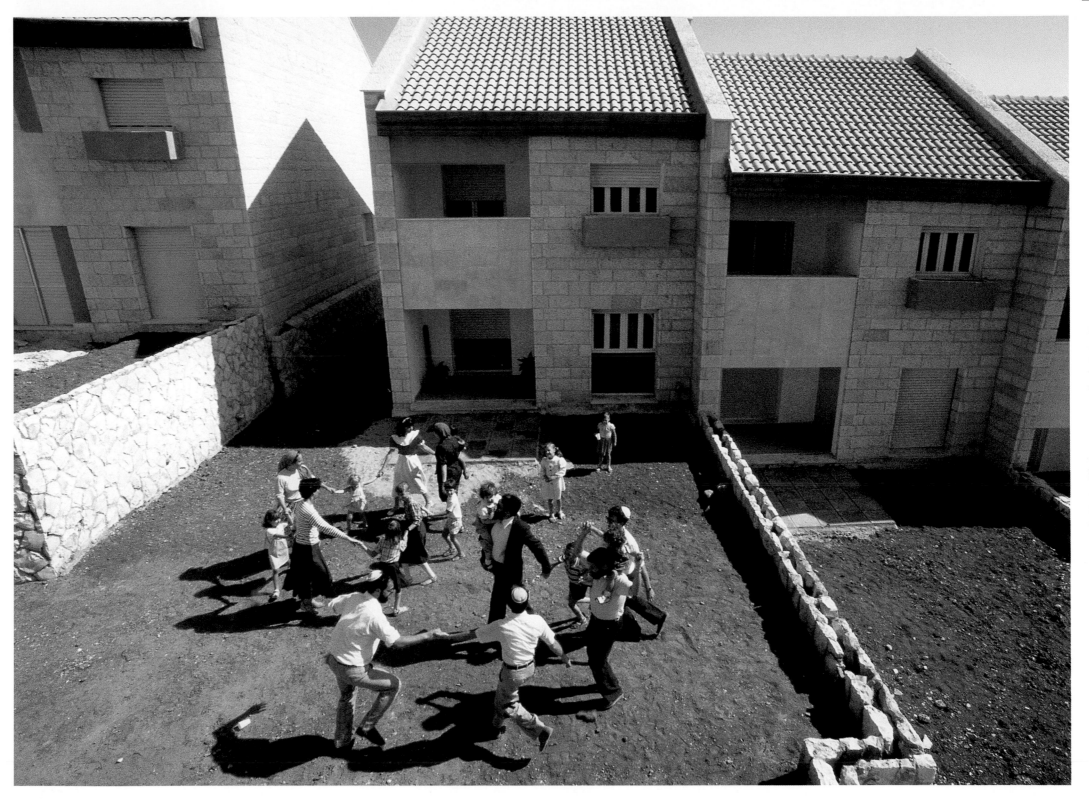

Efrat Settlement. WEST BANK, 1983.

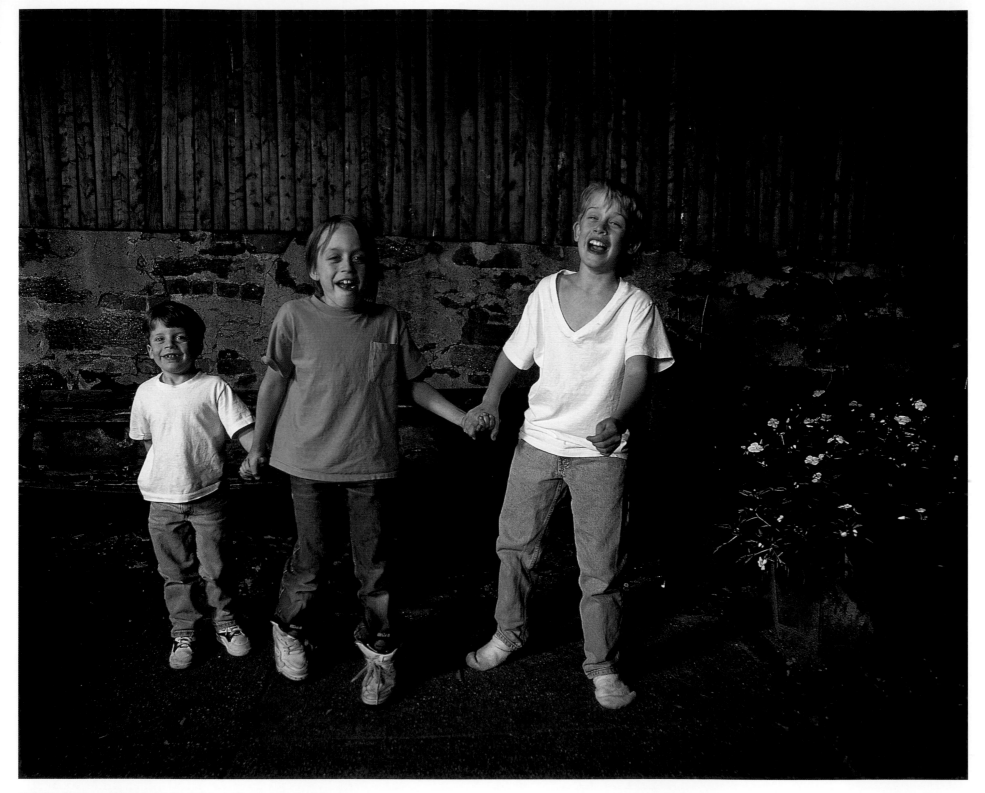

Christian, Kieran, and Macaulay Culkin (left to right). NEW YORK, NEW YORK, 1991.

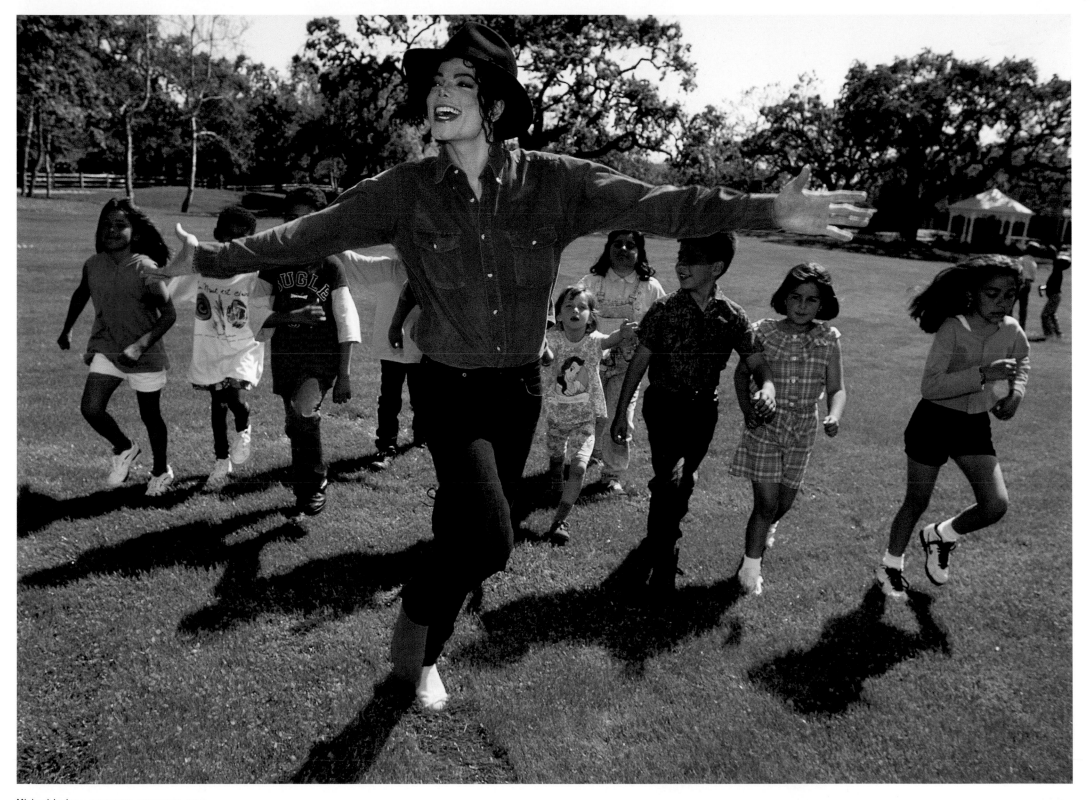

Michael Jackson. NEVERLAND, CALIFORNIA, 1993.

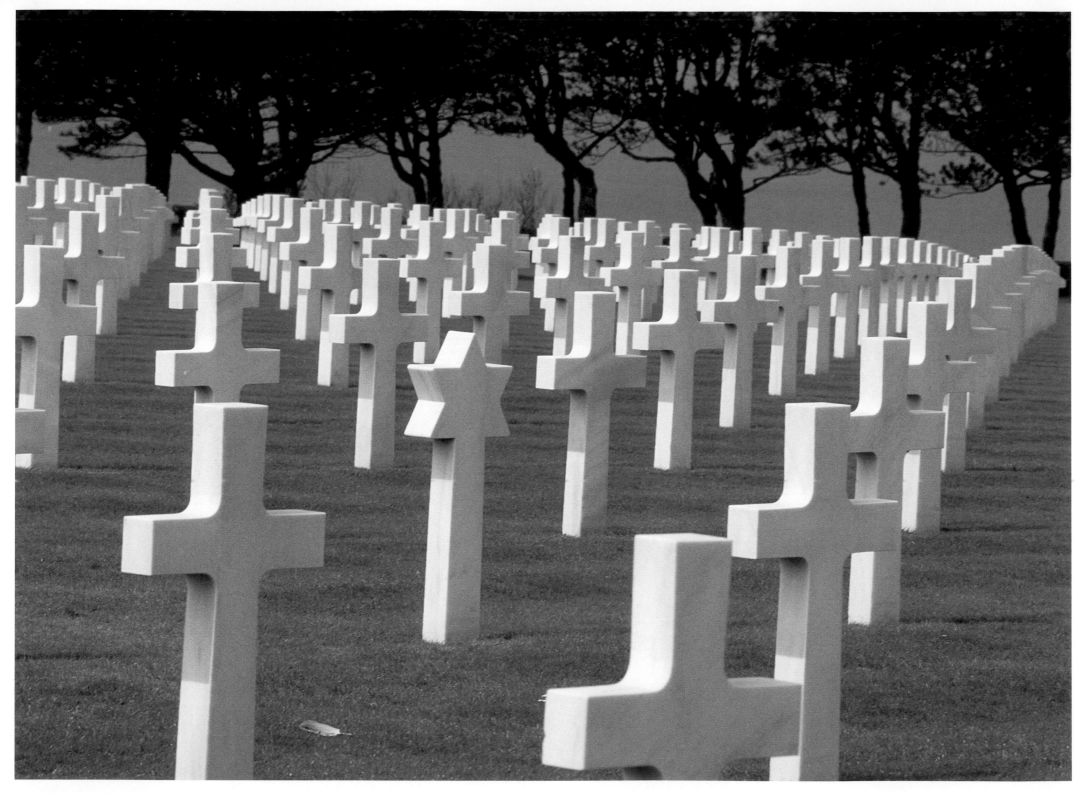

American cemetery. COLLEVILLE-SUR-MER, FRANCE, 1994.

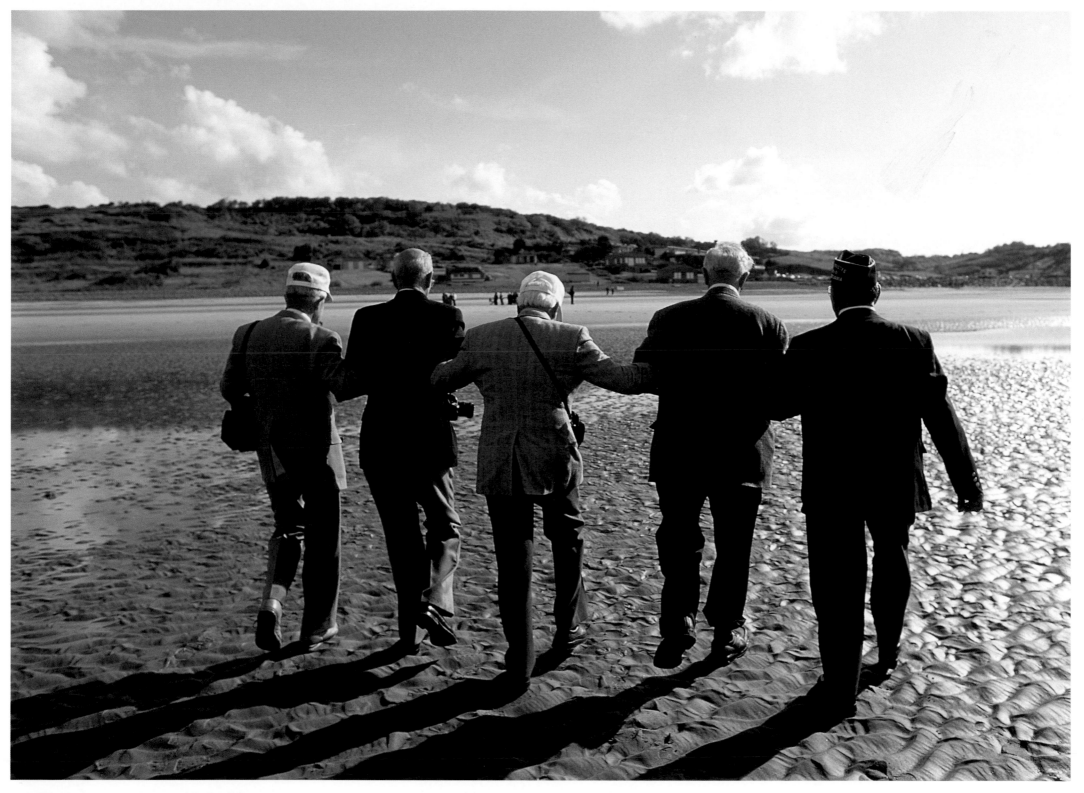

World War II veterans. OMAHA BEACH, NORMANDY, FRANCE, 1994

Tessa Wick. LOS ANGELES, CALIFORNIA, 2003.

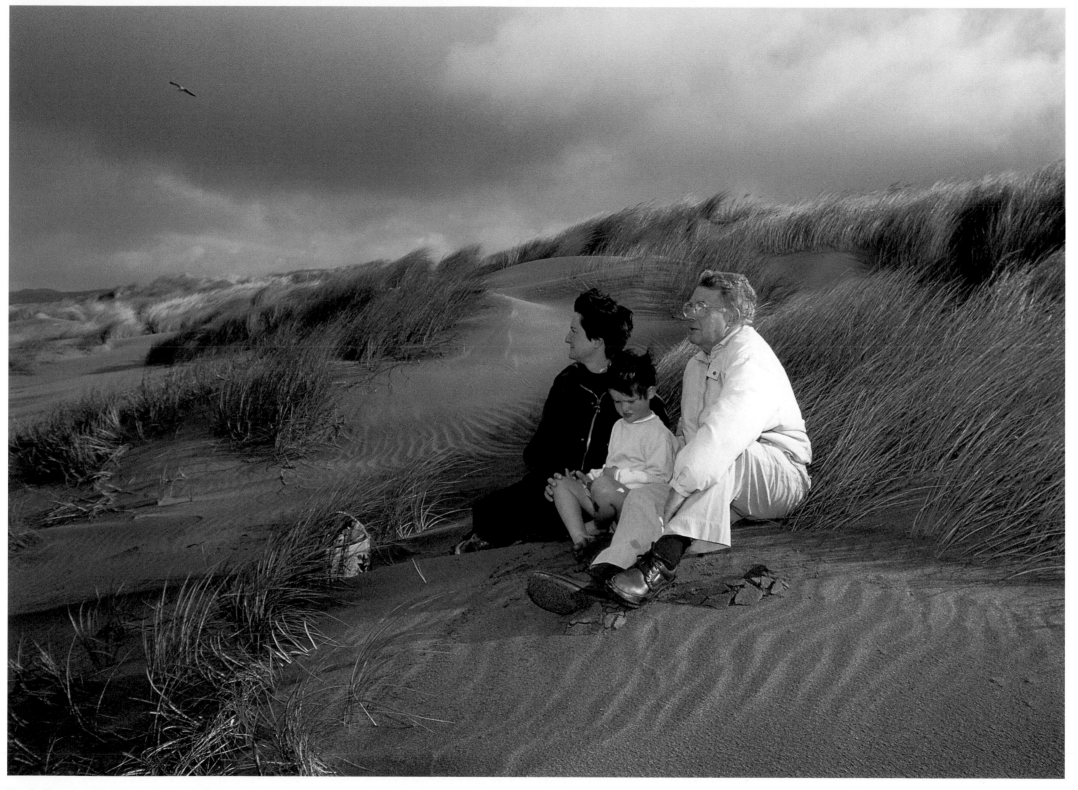

Maggie, Eleanor, and Reg Green. BODEGA, CALIFORNIA, 1994.

CASE
Me. New York, New York, 2004.

ENDPAPERS
My hotel keys. 1964–2004.

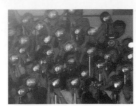

TITLE PAGE
Photojournalists. New York,
New York, 1994.

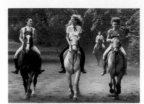

Cyndy, Jerry, Rosie, and Terry Hall
(left to right). Central Park,
New York, New York, 1978.
Tall Texan supermodel and actress
Jerry Hall loves to ride horses. Open and
unguarded, she was riding English saddle
with her sisters in New York's Central Park.
Jerry (with her twin, Terry), is the youngest
of five girls, who grew up in Mesquite,
Texas, and was discovered while sunning
topless on a Saint Tropez beach. Her look-
alike daughter by ex-husband Mick Jagger
is now following in her modeling footsteps.

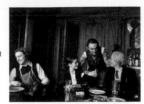

10 | 11

Jamie Wyeth, Bianca Jagger,
Larry Rivers, and Andy Warhol.
New York, New York, 1977.
Lunch at "The Factory," pop artist Warhol's
studio, was as infamous as the artist him-
self. Friends, including fellow artists Wyeth
and Rivers, and various celebrities such
as Mick Jagger's former wife, Bianca,
would be there every day. Born in 1928,
Warhol attracted many to his entourage
as he became more famous than his *32
Campbell's Soup Cans* (1961–62), his silk
screens of celebrities, and his underground
films. Never without his Polaroid camera,
Warhol chronicled his life and times for
his magazine *Interview* and survived an
assassination attempt in 1968. Since his
death in 1987, the Andy Warhol Museum
in Pittsburgh is home to many of his
works of art.

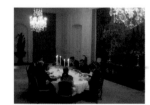

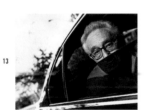

12 | 13

Dr. Henry Kissinger. Paris,
France, 1971.
Kissinger was dining with his staff at the
U.S. ambassador's residence in Paris,
which he has described as "my battle
station." The extremely tense Vietnam
peace negotiations were under way.
President Nixon had promised peace
and it was Kissinger's job to get it. Born in
Germany in 1923, the Harvard University
graduate and one-time history professor,
winner of the 1973 Nobel Peace Prize,
and U.S. Secretary of State (1973–77),
Kissinger has influenced political policy
for almost fifty years.

Dr. Henry Kissinger. New York,
New York, 2003.
When I met Dr. Kissinger recently, we
reminisced about the past thirty years or
so that I have photographed him during
historic moments in recent history. The
author of several books, his 2003 best-
selling memoir about the Nixon-Ford years,
Ending the Vietnam War, was followed by
Crisis, which consists of never-before-
released tapes of his private conversations.

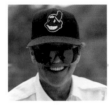

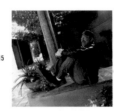

14 | 15

Jack Nicholson. Aspen,
Colorado, 1990.
Nicholson was directing as well as starring
in *The Two Jakes*, the sequel to *Chinatown*.
I had been waiting for the three-time
Academy Award–winner for four days when
he finally appeared and obliged with a two-
hour shoot. Abandoned by his father in
childhood, raised by his grandmother and
thinking his mother was his sister, he was
voted class clown in 1954 by his high
school graduating class in New Jersey.
Nicholson rode to fame in 1969's cult clas-
sic *Easy Rider*, and has been amazing us
with his film performances ever since.

Steven Spielberg. Los Angeles,
California, 2002.
Possibly the best-known producer and
director in the world, Spielberg was easy-
going and easy to photograph despite
his enormously hectic schedule. Born in
Cincinnati in 1946, he was turned down by
the University of Southern California film
school three times, and yet has given a
large grant to expand the film school there.
As a youngster he made his own small
films and worked in television before mak-
ing his classics *Close Encounters of the
Third Kind* (1977), *Raiders of the Lost Ark*
(1981), and *E.T.* (1982). With *Jurassic Park*
and *Schindler's List* (both 1993), *Saving
Private Ryan* (1998) and *Catch Me If You
Can* (2002), he continues to be a major
force in filmmaking today.

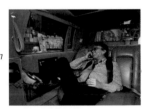

16 | 17

Carrie Fisher. New York,
New York, 1978.
The daughter of stars Debbie Reynolds and
Eddie Fisher, Carrie Fisher was born in
Beverly Hills, California, in 1956. She is
best known for starring as Princess Leia
in three *Star Wars* films, although she also
gained notoriety for writing the semi-auto-
biographical novel *Postcards from the Edge*
about growing up the daughter of a famous
overbearing film star. Divorced from song-
writer Paul Simon, she has a daughter by
Bryon Lourd. Surviving drug and alcohol
abuse, Fisher has appeared in many films,
including *Shampoo* (1975) and *Hannah
and Her Sisters* (1986), and has also
penned *Surrender the Pink* and *Delusions
of Grandma*.

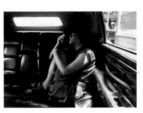

Robert Evans. Los Angeles,
California, 1994.
In the black limo, Evans epitomized my
idea of a Hollywood producer. Evans was
born in 1930 on Manhattan's Upper West
Side and the story goes that he came to
the attention of Norma Shearer, 1920s film
star and widow of Irving Thalberg, at the
pool at the Beverly Hills Hotel, and the rest,
as they say, is history. Married and divorced
six times, Evans produced the classics
Rosemary's Baby (1968), *Chinatown*
(1974), and *The Godfather* (1972), arguably
the best film ever made. *The Kid Stays in
the Picture* (2002), a documentary based
on his autobiography, brought him back
into the spotlight.

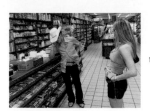

18 | 19

20 | 21

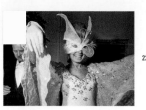

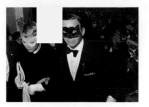

22 | 23

Ben and Dara. New York, New York, 2001.
These two New York City teenagers were dating at the time and were out for the evening when they stopped at a delicatessen. I like this photo because I think it could have been taken in any city in America.

Midtown disco. New York, New York, 2001.
It was the weeknight scene like many others in large cities across the nation. Some of New York's young people were out and about, most likely past their curfews, having a good time.

Nightclub. South Beach, Florida, 2002. (two photos)
Nightlife in Miami's South Beach is the closest thing to nightlife in Berlin that I have ever seen. No matter what lifestyle, there are clubs for everything and everybody here. No one is judgmental. Everyone

has fun. There are good restaurants and trendy clubs. Even more interesting is that it is not a fad but a constant. As long as I can remember, there has been something for everyone in South Beach.

Christina Ford. Plaza Hotel, New York, New York, 1966.
Henry Ford II, scion of the Ford Motor Company, paid no attention as his wife, Christina, showed off her costume. They were among the four hundred guests at author Truman Capote's Black and White Ball at the Plaza Hotel in New York to celebrate the publication of Capote's work of nonfiction *In Cold Blood*, and to honor Kay Graham, publisher of the *Washington Post*.

Mia Farrow and Frank Sinatra. Plaza Hotel, New York, New York, 1966.
Truman Capote's Black and White Ball at the Plaza Hotel was ostensibly in honor of the detectives who broke the case of the terrible random murders in Kansas that Capote documented in his nonfiction novel *In Cold Blood*. A rather odd way to celebrate, yet everyone who was anyone attended. It was the hardest ticket in the history of parties. You were not allowed in without a mask. Sinatra, with his tough-guy image must have felt rather silly coming up the stairs as a cat with actress/wife Mia Farrow as a butterfly.

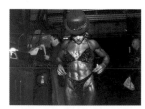

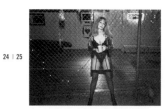

24 | 25

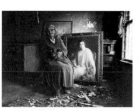

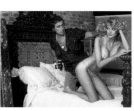

26 | 27

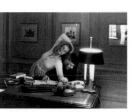

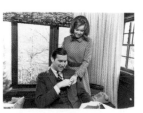

28 | 29

Female contestant, Arnold Classic. Columbus, Ohio, 2004.
The breadth of events at the Arnold Fitness Weekend took me by surprise. I was expecting bodybuilders, of course, but to see so many different competitors, young and old, coming together was unexpected. Backstage, a woman contestant composed herself before going in front of the judges. I always like what is happening backstage more than what you can see from the audience.

Candy. Fallon, Nevada, 1999.
Posing outside the Salt Wells Ranch, a few miles east of the Fallon Naval Air Station on U.S. Highway 50, Candy told me she was happy with her life and proud of her figure. Her costume was rather reminiscent of Liza Minnelli's *Cabaret* costumes.

Edith Bouvier Beale. Long Island, New York, 1972.
I had read that the Department of Health had asked Beale, the aunt of Jacqueline Bouvier Kennedy Onassis, to clean up her huge mansion, Grey Gardens, in the Hamptons. I drove up to her house and knocked on the door. When her daughter Edie heard I was from Scotland, she invited me into a living room filled with cats and debris. For the first time in over two years, Beale came downstairs to pose in front of a portrait of herself as a young woman, and chided her daughter, "Edie, it is time you did some dusting." Later Mrs. Onassis came to their rescue and had the place cleaned up. Beale died in 1977 and her daughter died in 2002 at the age of eighty-four.

Bob Guccione. New York, New York, 1984.
Born in 1930 in Brooklyn, the publisher of *Penthouse* liked to take the photos of the models for his magazine. The London edition of *Penthouse* first appeared in 1965, followed by an American edition in 1969. In 1984 Guccione published nude photos of Miss America Vanessa Williams, which caused her to relinquish the title. The same issue's centerfold featured fifteen-year-old Traci Lords. Circulation reached its peak at around five million copies in the 1980s, but by 2003 Guccione had declared bankruptcy and resigned as chairman of the Penthouse empire.

Cybill Shepherd and Peter Bogdanovich. Los Angeles, California, 1974.
Someone gave me their phone number and I called to ask if I could photograph them. They said fine. Actor/director/writer/producer Bogdanovich had fallen in love with the leading lady from his acclaimed 1971 film *The Last Picture Show*. The morning after the shoot, I discovered I had left a lens at their home. When I knocked, Shepherd appeared at the door in her dressing gown with my lens in hand. Born in 1950, Miss Teenage Memphis 1966 and a top model before turning to acting, she went on star in television's *Moonlighting* and *Cybill*. Director of *Paper Moon* (1973), Bogdanovich, born in 1939, has recently appeared as Dr. Elliot Kupferberg in HBO's *The Sopranos* (2003).

Jay and Sharon Rockefeller. Charleston, West Virginia, 1967.
Following in the footsteps of his family, Rockefeller has been in public service for forty years. After graduating from Harvard University in 1961, he worked in the Peace Corps, served eight years as governor, and since 1984 has served as United States senator from West Virginia. Strongly in favor of health care reform, the senator is currently vice chairman of the U.S. Select Committee on Intelligence. In 1967 he married Sharon Percy, whose twin sister's murder has never been solved. The Rockefellers have four children and several grandchildren.

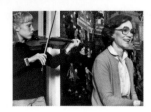
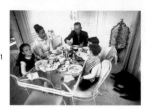

30 | 31

Rosalynn Carter, and daughter, Amy. Washington, D.C., 1979.
The First Lady provided a normal life for eleven-year-old daughter Amy in the private quarters on the second floor of the White House during her husband's presidency (1977–81). At the White House the Carters were as natural as you would expect them to be in their hometown of Plains, Georgia. Today the Carters continue to work for Habitat for Humanity. Amy graduated from Brown University in 1987, married computer consultant James Wentzel in 1996, and has a son, Hugo.

Kathryn and Bing Crosby. San Francisco, California, 1965.
Big-band radio crooner, recording artist, film star of the 1940s and 1950s, and real-estate mogul, Bing was born in 1903 in Tacoma, Washington. His *Road* pictures opposite Bob Hope are legendary. He won an Oscar for his portrayal of a priest in *Going My Way* (1944), and played opposite Grace Kelly in *The Country Girl* (1954). After the death of his first wife, Dixie Lee, the mother of his four sons, he married actress Kathryn Grant and fathered three more children; Harry, Nathaniel, and Mary, shown here at the breakfast table with their parents. An avid golfer and racehorse enthusiast, Bing died in 1977.

32 | 33

Jacqueline Susann. New York, New York, 1973.
The first thing she said when I arrived at her New York apartment was something derogatory about author Truman Capote, who had called her "a truck driver in drag." I liked her attitude; she fought back. Married to media-savvy press agent Irving Mansfield, Susann and he would take coffee to the truckers who were delivering her books to the stores, and drove cross-country to meet bookstore sales clerks. Cleverly, Jackie remembered their names the next time she was there, thus providing a primer in how to produce a bestseller. Her megahit, the Hollywood fictionalized drugs and sex tell-all *Valley of the Dolls*, sold 25 million copies and was on the bestseller list in 1966–67 for sixty-two weeks. *The Love Machine* (1969) and *Once is Not Enough* (1974) each sold more than five million copies. She lost the fight against breast cancer at the age of 53 in 1974.

John Cheever. Ossining, New York, 1969.
With his daughter Susan's golden retriever by his side in the room where he wrote his novels and short stories, Cheever was shy but well mannered in the New England tradition. *The Wapshot Chronicle* (1957) dealt with his own parents' relationship and his family's decline. In addition to winning the 1978 Pulitzer Prize for fiction for *The Stories of John Cheever*, his famous short story *The Swimmer* (1964) was made into a film starring Burt Lancaster. With his dark vision, he described the manners and morals of American families in his books. He died in 1982 at the age of seventy.

34 | 35

Bobby Fischer. Reykjavik, Iceland, 1972.
Fischer had just won the World Chess Championship by defeating Russian Grandmaster Boris Spassky. After Spassky told me he was not coming out for that day's game, I delivered the news to Fischer in his room at the Loftleider Hotel. Later he lay with his winning check across his chest. A child prodigy and true eccentric, he would not speak with anyone during the match, not even his mother, and was afraid the Russians were bugging his room, which they probably were. After winning, he disappeared into a religious cult called the Worldwide Church of God. His 1992 rematch with Spassky in Yugoslavia violated a U.S. sanction, and, ever since, Fischer has been fighting extradition to the United States. He was given asylum in 2004 by the Japanese government when he announced he would marry Miyoko Walai, the president of the Japanese Chess Association.

Lyle Stuart and Liz Renay. New York, New York, 1971.
Born in 1926, glamorous Renay went to prison from 1959 to 1963 for perjuring herself during her Mafia lover Mickey Cohen's tax evasion trial. Controversial publisher, author, gambler, and widower Stuart, in his office with a portrait of his wife watching over him, published Renay's memoirs of Cohen and Murder, Inc., in *My Face for the World To See*. He is the author of several books on gambling. Stuart's Barricade Books has been highly criticized for publishing *The Anarchist's Cookbook*.

36 | 37

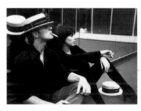

Frank Sinatra. Santa Clara, California, 1974.
After a two-year retirement, Rat Pack leader Sinatra went back to work with an eight-city one-man show opening at the University of Santa Clara as a benefit for the Variety Clubs' children's charities. With a standing ovation from the crowd, he raised $200,000 that night on the same stage he had played years earlier as an amateur. Born in Hoboken, New Jersey, in 1915, the crooner with the most wonderful voice began as a band singer with Harry James's and Tommy Dorsey's bands. He went on to win an Academy Award for his portrayal of Maggio in *From Here to Eternity* (1953). First wife, Nancy Barbato, is the mother of his three children. Married and divorced from Ava Gardner and Mia Farrow, he was married to Barbara Marx when he died in 1998.

Johnny and Ricky Carson. Lubbock, Texas, 1970.
The venerable *Tonight Show* host had been booked opposite the biggest football game of the season. Half the town was away at the game. In a makeshift dressing room Carson was not happy with the booking conflict as he prepared to go onstage for his one-man show. His son, Ricky, who was a fine photographer in his own right, was traveling with him on the tour. I liked them both. Johnny was completely the opposite from how he appeared on television. I've learned no one is exactly the way you envision him. Offstage, Johnny is very private. I liked the way we interacted; he was friendly, but not overly so. Born in Iowa in 1925, the six-time Emmy Awards winner was inducted into the Television Hall of Fame in 1987.

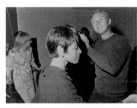

38 | 39

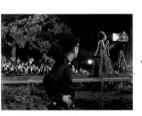

Mikhail Baryshnikov and Liza Minnelli. New York, New York, 1980.
Daughter of superstar Judy Garland and director Vincente Minnelli, Liza appeared in her mother's film *In the Good Old Summertime* (1949) when she was three years old. Liza won an Academy Award for her performance in *Cabaret* (1972). After surviving ups and downs in her career and her health and four failed marriages, she is still performing. Born in 1948 in the Soviet Union, Baryshnikov defected in 1974, joining the National Ballet of Canada before coming to the United States to become premier dancer for American Ballet Theatre. He and Liza, rehearsing for television's *Baryshnikov on Broadway* (1980), performed numbers from well-known musicals. He appeared in the final season of HBO's *Sex and the City* (2004) and he continues to dance with his company, White Oak Dance Project.

Steve and Neile McQueen. Los Angeles, California, 1966.
Dancing at a private party in Beverly Hills with his first wife, Neile Adams, actor McQueen seemed not to have a care in the world. While filming *The Getaway* in 1972 he fell for and later married co-star Ali McGraw, who was married to producer Bob Evans at the time. His rebel lifestyle was evident in the characters he played in *The Magnificent Seven* (1960) and *The Thomas Crown Affair* (1968). While married to third wife, Barbara Minty, he died in 1980 at age fifty from mesothelioma, a rare form of lung cancer.

40 | 41

Barbra Streisand. Central Park, New York, New York, 1967.
Fans flocked to "A Happening in Central Park," one of the first free pop concerts in New York's Sheep Meadow. They were mesmerized. Barbra Streisand lived up to her legendary reputation as being difficult; she looked at the photographers and shouted at us to "get away" as she headed for her trailer after the concert, which was filmed for television. The Academy Award-winning actress and singer, born in Brooklyn in 1942 and now married to actor James Brolin, continues to produce, direct, appear in films, and make occasional concert appearances.

Marlene Dietrich. New York, New York, 1967.
Surrounded by hordes of young men waving programs for her to sign as she left the Mark Hellinger Theatre after her one-woman performance, Dietrich obliged. She loved the adoration. Born outside Berlin in 1901, she catapulted to fame in the United States in 1930 as Lola Lola in *The Blue Angel* and gained cult status with her chilling performance as Christine in *Witness for the Prosecution* in 1957. Forever glamorous, her tuxedos became de rigueur eveningwear for women. She died in 1992 while living in France, and although anti-German during World War II, she is buried in Berlin. Her grave has to be guarded from destruction by pro-Nazi gangs.

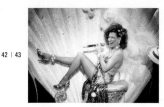

Cher. Long Beach, California, 1975.

Cher was greeted by Paul and Linda McCartney as she joined them on the dry-docked *Queen Mary* for the wrap party for Paul's album *Venus and Mars*. Born in El Centro, California, in 1946, she became a star in the 1960s with then-husband Sonny Bono with songs like "I've Got You, Babe." Her glamour and wit were the mainstays of their television show. Cher went on to win an Academy Award for Best Actress for *Moonstruck* in 1987. Still touring, she won a Grammy in 1999 for her song "Believe."

Bette Midler. New York, New York, 1975.

You can always count on Midler for cutting-edge humor. Her *Clams on the Half Shell Revue* opened at the Minskoff Theatre in New York on April 14, 1975, and sold out within hours. As she sat on a satin and velour clamshell during her raunchy and campy show, her fans went wild. Born in Honolulu in 1945, she arrived in New York in 1965, and became a singing sensation as "The Divine Miss M" at the Continental Baths in New York in 1971. Besides making best-selling albums, she has starred in films including *The Rose* and *The First Wives Club*, toured in a one-woman show, *Kiss My Brass*, and has tried her hand at television. She lives in New York with husband, Martin von Haselberg.

Tina Turner and Janis Joplin. New York, New York, 1968.

Turner was in the middle of her act at a Rolling Stones concert in Madison Square Garden when Joplin jumped up on the stage and started singing with her. At first I thought it was Mick Jagger in drag. Born in Tennessee, Tina has been singing for fifty years and is still recording and performing in concerts. She lives in Switzerland when not on tour. Joplin, born in Texas in 1943, attended the University of Texas and belted out raspy blues songs in cabarets in Austin before joining Big Brother and the Holding Company in 1966. Swigging Southern Comfort onstage while singing "Piece of My Heart," she was adored by fans. Addicted to speed and heroin, she overdosed and died in a Los Angeles motel at the age of twenty-seven. Two of her most popular songs, "Me and Bobby McGee" and "Mercedes Benz," were released after her death.

James Brown. Augusta, Georgia, 1979.

Born in South Carolina in 1933 and raised in poverty in Macon, Georgia, Brown joined the Gospel Starlighters (later called the Famous Flames) in 1953 after spending four years in prison for robbery. "Try Me" (1958) was the first of his ninety-six top one hundred hits. Best known for 1965's "I Feel Good," Brown played the crazy preacher in the Jim Belushi/Dan Aykroyd film *The Blues Brothers* (1980). A charter member of the Rock and Roll Hall of Fame (1986), the "Godfather of Soul" received the Lifetime Achievement Award at the thirty-fourth annual Grammy Awards (1992), and was one of five recipients of the 2003 Kennedy Center Honors.

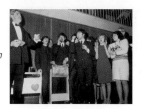

Paul and Stella McCartney. Los Angeles, California, 1975.

Three-year-old Stella, now a successful clothing designer married to Alasdhair Willis, sat spellbound by her father's playing and singing. It was one of the quieter moments for the former Beatle who had just completed an album for Wings.

The Beatles at the British Embassy. Washington, D.C., 1964.

On our way from New York to Miami for the second Ed Sullivan appearance, the Beatles and I took the train in a blizzard to Washington, D.C., for a performance at the Washington Coliseum and a party at the British Embassy. At the party several people who just didn't get what the Beatles were about were rude to them. Someone even sneaked up behind Ringo and cut off a piece of his hair. The rudeness caused an uproar in the press and the British Ambassador called the Beatles to apologize for his guests' behavior.

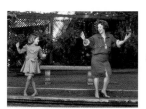
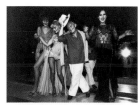

Shirley Temple Black and grand-daughter Teresa Falaschi. Woodside, California, 1988.

Shirley Temple danced her way into the hearts of the world in the 1930s in such classic films as *The Little Colonel*. She sang "The Good Ship Lollipop" and every mother in America gave their daughters singing and tap-dancing lessons and curled their hair in ringlets. Outgrossing Clark Gables's films from 1935 to 1938, by 1940 Temple's contract had been cancelled. Her first marriage to actor John Agar produced one child. She later married Charles Black and had two more children. President Nixon appointed her a delegate to the United Nations in 1969 and President Ford appointed her ambassador to the Republic of Ghana (1974–76). She became the first woman chief of protocol at the White House in 1976. A breast cancer survivor, she spoke out in the seventies, hoping to help other women fighting the disease.

Truman Capote. New Orleans, Louisiana, 1980.

I accompanied diminutive novelist Capote on a visit back to the town where he was born in 1924; he knew I needed to take some interesting photos. On Bourbon Street he jumped onstage and danced with the performers in one of the clubs, and they all laughed. Leaving school at seventeen, he found his way to *The New Yorker* magazine, which published his early short stories. When *Breakfast at Tiffany's* (1958) was made into a successful film starring Audrey Hepburn, Capote was disappointed; he felt someone like Tuesday Weld should have played the role. After *Esquire* published an excerpt from *Answered Prayers*, a tell-all about his friends, he was ostracized by all but a few. Deteriorating into alcoholism and drug abuse, Capote died in 1984.

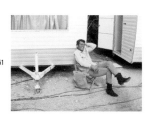

James Coburn. Antigua, West Indies, 1978.

Charismatic actor Coburn was having a good time making the caper film *Firepower* with Sophia Loren and O.J. Simpson in Antigua. Appearing in over one hundred films, his finest roles were in *The Magnificent Seven* (1960) and *Our Man Flint* (1966). Coburn won the Academy Award for Best Supporting Actor in 1997 for *Affliction*. His rheumatoid arthritis was greatly improved with a diet supplement that he urged other sufferers to try. Coburn, born in Laurel, Nebraska, in 1928, died in 2002 of a heart attack.

Dean Martin. Happy Shahan Ranch, Brackettville, Texas, 1967.

Outside his trailer on the set of *Bandolero!*, which co-starred James Stewart and Raquel Welch, Dean was his characteristically relaxed, smiling self. Starting out as a boxer named Kid Crochet, he became the straightman who sang with comedian and partner Jerry Lewis in 1946. Splitting with Lewis after eleven years, Dean went on to make fifty-one films and became even more famous singing in Las Vegas night-clubs as a member of Frank Sinatra's "Rat Pack." He fathered eight children by three wives. After son Dino was killed in 1987 while flying a plane for the National Guard, Martin sank more and more into seclusion and died on Christmas Day in 1995 at the age of seventy-eight.

Mobile-home park. Southern California, 1970.

While traveling for *LIFE* magazine doing a story on the growing number of people who vacation and/or live in campers and mobile homes, I came across this woman who was proudly giving her mobile home a wash.

Billy Carter. Plains, Georgia, 1976.

The antics of the younger brother of the thirty-ninth United States president Jimmy Carter caused the administration some frustration. A "down home" kind of guy who really liked to have a good drink, he launched his own brand, Billy Beer, in 1977 and visited Libya in 1978, causing a scandal complete with Senate hearings. Always in the shadow of his brother, he died of pancreatic cancer in 1988 at the age of 51.

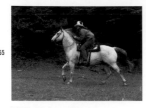

54 | 55

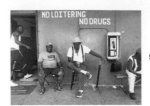

56 | 57

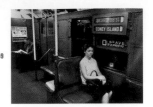

58 | 59

Farrah Fawcett. Beverly Hills, California, 1970.
Born in Texas in 1947, Fawcett was a Tri-Delt sorority girl at the University of Texas in Austin who watched soap operas every day after class before moving to Hollywood to try her luck at acting. Her infectious smile and piercing blue eyes catapulted her to superstardom in one season on television's *Charlie's Angels* (1976), and her red bathing suit poster sold 8,000,000 copies. Divorced from actor Lee Majors, Fawcett has one son by former live-in lover Ryan O'Neill. Most recently, she captivated audiences in Robert Altman's film *Dr. T and the Women* (2000).

Willie Nelson. Evergreen, Colorado, 1983.
Songwriter and country music legend, Nelson was born in Texas in 1933. His grandparents gave him his first guitar at age six. He was living in Nashville by 1960, writing hit songs for Patsy Cline and Ray Price, since no one was anxious to record anyone with such a raspy, craggy, and distinctive voice. How times have changed. Back in Texas and recording his own songs by 1970, he began his annual Fourth of July picnic that has drawn friends Johnny and June Carter Cash, Kris Kristofferson, and Waylon Jennings over the years. The father of seven children by four wives, Nelson has written 2,500 songs and recorded 250 albums. Soft-spoken and very physically fit, he loves playing golf.

Joe Namath. Tuscaloosa, Alabama, 1976.
For America's bicentennial celebration, I asked Mohammed Ali to pose as George Washington for a series I was photographing of famous people as our founding fathers. Ali refused and demanded to be the slave Nat Turner. Namath agreed to be Washington. Instead of the Potomac, we substituted a pond in Alabama. Signed as a rookie with the New York Jets in 1965 for an unheard-of $400,000, the quarterback led his team to Super Bowl victory against all odds in 1969. Both knees were badly damaged during his playing career; he retired in 1977. Born in Pennsylvania in 1943, "Broadway Joe" was elected to the Pro Football Hall of Fame in 1985. The divorced father of two lives in Florida.

Fourth of July parade. Seguin, Texas, 2002.
Amid the festivities, the hot and sunny hometown of my wife, Gigi, reminded me of Main Street, U.S.A. Hospital administrative consultant Don Richey, on his antique bicycle, is a parade fixture each year.

No Loitering, No Drugs. Belle Glade, Florida, 2003.
While I was in Belle Glade on assignment, the sign on the wall caught my eye as I happened upon these men sitting in the heat outside the café.

Noreen Quinlan. New York, New York, 1966.
Sitting quietly, not drawing attention to herself, petite New York City undercover policewoman Quinlan rode the subway eight hours a day armed with a handgun and two-way pager.

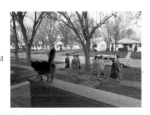

60 | 61

62 | 63

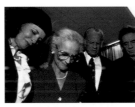

64 | 65

Housewives. Chadron, Nebraska, 1969. (two photos)
During the height of the Vietnam War protests, these wives and mothers marched in protest of X-rated movies being shown at the local cinema. The local theater had standing room only when *Isobel & Teresa*, an X-rated French film, was shown, and lackluster crowds when *Rumplestiltskin* was shown the previous week.

Billboard. Chadron, Nebraska, 1969.
On the outskirts of town, this billboard greets you as you approach Chadron. The scene is repeated in countless other towns and cities across America.

Billy and Ruth Graham with Johnny Cash and June Carter Cash. Charlotte, North Carolina, 1993.
The Reverend Billy Graham has reached millions as he has preached to filled stadiums and massive television audiences. He fell in love with his wife, Ruth, in 1943, when they were both students at Illinois's Wheaton College. They have two sons, three daughters, and myriads of grand and great-grandchildren. Backstage before one of his televised sermons, they prayed with friends and country-western legends June Carter and, her husband, Johnny Cash, who had come to perform. Carter died during a heart operation in 2003 and Cash, whose career spanned five decades, followed within three months. Diagnosed in 1991 with Parkinson's disease, Graham says he will continue until he has not the strength, but has turned over many of his duties to his son Franklin.

Tammy Faye and Jim Bakker. Malibu, California, 1987.
I had asked the Bakkers to go down to the water's edge, hoping the waves would wash over them. Tammy Faye was worried that her famous mascara would run. At the time the photograph was taken, Jim, a televangelist with a huge following, was being accused of diverting funds from his PTL (Praise the Lord) ministry for his personal use and had been accused of sexual harassment. Both Jim and Tammy Faye were seemingly unable to comprehend the severity of the charges. When Jim resigned, was convicted, and sentenced to forty-five years in prison, he had gone through $158 million of donations and had forty-seven bank accounts in his name. The Bakkers divorced in 1992 and Tammy Faye remarried. Jim was paroled in 1994 and in 2003, ironically, returned to televangelism.

Ethel Kennedy and family. McLean, Virginia, 1988.
On the anniversary of Senator Robert Kennedy's birthday, his family gathered at the family home, Hickory Hill. Most were celebrating the birthday of a father they never knew. A priest from Ireland also attended. Before dinner in the guesthouse near the tennis court, I asked the senator's widow if I could photograph the service. She said she didn't mind. There were photographs of Bobby all over the walls. It was hard to believe that he had been assassinated twenty years earlier in California while campaigning for the Democratic presidential nomination.

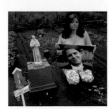

Pat Wotton with a portrait of her husband, Rod. Middletown, New Jersey, 2002.
When Rod, who worked for Fidelity, called his wife, Pat, and told her that he wasn't going to survive the attacks on the World Trade Center, she was distraught. Their baby was due the following week. Her son, Rodney Patrick, was born eight days after the September 11, 2001, tragedies. Pat and Rod had gardened together, and slowly, through her tremendous grief, she began to plant "Daddy's Garden."

Debra Grzelak and Neal Lavro. Staten Island Ferry, New York, New York, 2002.
On September 11, 2001, New York Police Department battalion chief Joe Grzelak was lost at the World Trade Center. As dawn broke one year later, his daughter, Debra, and her friend, Neal Lavro, were on their way to the anniversary ceremony taking place at the site of the fallen towers.

66 | 67

Lower Manhattan. New York, New York, September 11, 2001.
Watching television at my apartment when the World Trade Towers were hit, I, like the rest of the world, was stunned by the horror. When the first tower fell, I grabbed my cameras and got there as fast as I could, but the area was cordoned off by the time I arrived. It probably is just as well; I know I would have gone into the buildings if I had been there.

68 | 69

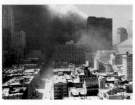

Peg Ogonowski and daughter, Laura. Dracut, Massachusetts, 2002.
The family seemed to be determined to go on with their lives although there were moments of sadness. Theirs was a lovely family, a lovely home, but it was never going to be the same again. It was going to take a long time to adjust. John Ogonowski was the captain of American Airlines flight 11 that left Logan Airport on Tuesday morning, September 11, 2001. His was the first plane to strike the World Trade Center. In the aftermath of grief and horror, John's wife, Peg, with Laura, one of their three daughters, and the family dog, Lily, walk into the backyard of the home John had built for them. Peg has remarked, "I can't believe he wasn't already dead; they would have had to kill him to get him out of that chair."

Colonel Herbert Smith and his pointer, Raisin. Ijamsville, Maryland, 1999.
Dr. Smith, a veterinarian and former Green Beret, can barely walk. He suffers from nerve damage diagnosed as neurapraxia. Born in 1940, the superstrong athlete's first symptoms appeared in Saudi Arabia in January 1991, the same month he was given the first of two shots of "Vac-A." Smith believes Vac-A is an untested anthrax vaccine containing a substance that has caused incurable diseases when tested in lab animals. His symptoms, aching joints and swollen lymph nodes, have become exceedingly worse and he has started having seizures and blackouts. The Pentagon will not confirm the diagnosis and has said Smith and others like him with "Gulf War Syndrome" are possibly suffering from a psychosomatic disorder.

70 | 71

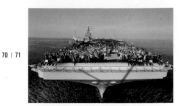

USS *Theodore Roosevelt*. Arabian Sea, 2001.
The crew topside aboard the aircraft carrier somewhere in the Arabian Sea hoisted the American flag that flew at Ground Zero after September 11, 2001, along with the banners of the New York Police and Fire Departments. It was the lead ship from which the bombing raids of the F/A-18 fighters in the background were launched in the invasion of Afghanistan. I came aboard by tailhook and left by catapult, the most incredible acceleration you can imagine—from 0 to 150 mph in three seconds. In a helicopter to take the photo, with radio contact to the ship, I kept asking the captain to turn the ship, "a little to the left. No, a little to the right," to get the sunlight in the right position, and he obliged.

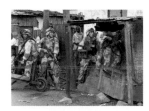

Marine raid. Baidoa, Somalia, 1993.
We arrived in two Black Hawk helicopters, which stopped on the outskirts of town. With cameras around my neck, I had a hard time keeping up with the soldiers who were running fast, in full battle gear, with weapons ready. They battered down some doors, finding weapons in a suspected arms storage hut. Baidoa, 160 miles northwest of Somalia's capital of Mogadishu, was once known as "Heaven's City" because it was so peaceful, with beautiful gardens everywhere. In 1993, when the seventh Marine Regiment, Lima Company, from Camp Pendleton, California, arrived, they found the buildings burned down, the people from the outlying villages starving, and clans of gunmen roaming the streets.

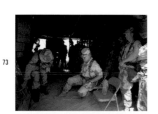

General H. Norman Schwarzkopf. Desert near the Kuwait border, Saudi Arabia, 1991.
During the Gulf War, known as Operation Desert Storm, the United States led a coalition force in the invasion of Iraq in response to Iraq's invasion of Kuwait in August 1990. In stifling heat of over 100 degrees, Col. Paul Kern of the United States Army's Twenty-Fourth Infantry Division gave General Schwarzkopf, the Allied commander-in-chief during the conflict, a briefing. The general, who worked eighteen-hour days in his pursuit of Saddam Hussein, has said, "I am certainly antiwar. But I also believe there are things worth fighting for." Launching over one thousand air strikes in January and February 1991, the United States ended the war that cost $61 billion dollars.

72 | 73

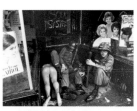

National guardsmen. Newark, New Jersey, 1967.
It was a very hot summer. I watched the news to see where the riots would be each weekend. In addition to inadequate public housing, Newark had an unemployment rate three times the national average. By 1966 the Black Power movement, endorsed by Martin Luther King, Jr., had begun, and President Lyndon Johnson had started the Model Cities Program to reduce poverty, discrimination, and poor housing conditions. There was dissention over a proposed medical center in Newark's inner city. The riots began after a black taxi driver, John Smith, was beaten by police. The National Guard was called in. Crouched in the doorway of a hairdresser's with a Candice Bergen Break shampoo ad in the window, we could hear bullets being fired around us. Five days of rioting left twenty-three dead and $10 million in property damage.

74 | 75

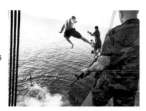

United States sailors. USS *Theodore Roosevelt*, Arabian Sea, 2001.
During the United States invasion of Afghanistan, aboard ship there was a stand down—one day of doing nothing. No one flew combat missions that day. The ship anchored and the sailors, some of whom might not get topside for days, were allowed to jump into the sea and swim. The sailor with a gun was watching for sharks. It was about a thirty-foot jump and I preferred to watch.

United States soldiers. Outside Berlin, Germany, 1961.
Late the night before, no one knew what was happening. I got a call to get to Berlin as fast as I could. I saw masses of Russian tanks line up at the Brandenburg Gate. Historically, the Allies had had the use of roads going into Berlin. The Russians had closed them off and had started building the Berlin Wall, separating East and West Berlin, closing off all streets and arteries into and out of the city. The United States soldiers were waiting to move into position in the U.S. sector of West Berlin the day the wall went up.

76 | 77

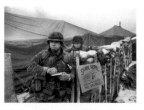

Shark Hotel. Near Tuzla, Bosnia-Herzegovina, 1996.
Echo Company Lieutenant Paul Dill, of Annandale, Virginia, and Sergeant Howard Hartung, of Chicago, Illinois, were stationed in the Confrontational Zone, where the Serbs and the Croats were separated by only a mile. The American peacekeeping forces stood guard along with the Russians in the war-torn former Yugoslavia. There were land mines hidden in the knee-deep mud near the tents, and the rule was to walk only where someone else has walked. All the soldiers carried photos of their loved ones and seemed convinced they should be there to help prevent further devastation.

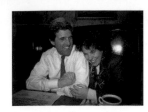

Senator John Kerry and Teresa Heinz Kerry. Boston, Massachusetts, 1996.
I caught up with the senator in one of the oldest restaurants in Boston after he and Teresa had made a stop at a local school to read to the children. Born in Colorado in 1943, the 2004 Democratic presidential nominee graduated from Yale University, as did his opponent, President George W. Bush. Kerry received the Silver Star, Bronze Star, and three Purple Hearts for naval service in Vietnam. A United States senator since 1982, he married Senator John Heinz's widow in 1995.

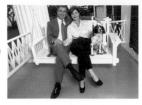

President George W. Bush and First Lady Laura Bush. Austin, Texas, 2000.
On the porch of the governor's mansion in Austin with a descendant of his mother's famous dog, Millie, by his side, the forty-third president did not have an inkling that three years later, his presidential legacy would include the World Trade Center attacks, the search for Osama bin Laden, and the Afghan war. Born in 1946, President Bush grew up in Texas, graduated from Yale University, and received a master's degree in business from Harvard University in 1975. After graduating from college, twins Barbara and Jenna worked for their father's successful reelection campaign.

78 | 79

Jacqueline Bouvier Kennedy. Laurentian Mountains, Canada, 1968.
Crowds of skiers were waiting to catch a glimpse of the elegant former First Lady, who was on a ski holiday near Montreal with her children, Caroline and John, Jr. She appeared right in front of me. You could tell it was her from a mile away, even with her face covered and with her trademark sunglasses propped on her head; you could still see her eyes. After graduating from George Washington University, she became a roving photographer for a Washington newspaper. She met and married then-Senator John F. Kennedy. Widowed in 1963 when President Kennedy was assassinated, she married Aristotle Onassis in 1975. From 1978 until her death in 1994, she worked as an editor for Doubleday.

80 | 81

Hillary Rodham Clinton. Little Rock, Arkansas, 1992.
Her husband, governor at the time, was running for the presidency and I went to Little Rock to photograph the family. Hillary is playing Hearts, a card game Bill Clinton's mother had taught him as a child. Little did anyone know that after serving two terms as First Lady, Hillary would become a Democratic United States senator from New York (2000–present). Born in Chicago in 1947, she attended Wellesley College and graduated from Yale University Law School in 1973, where she met and married former president Clinton. They have one daughter, Chelsea.

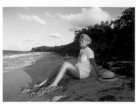

Geraldine Ferraro. Saint Croix, U.S. Virgin Islands, 1984.
Ferraro was born in New York to Italian immigrants. Her father died when she was eight and her mother worked as a seamstress to support the family. Ferraro taught school and went to law school before she was elected to the United States House of Representatives (1978–83). Democratic presidential nominee Walter Mondale chose her as his running mate in 1984. They were defeated in the election by the Ronald Reagan/George H.W. Bush ticket. Intelligent and aware, Ferraro is still active in politics and has served on the United Nations Human Rights Commission.

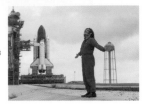

Kathryn Sullivan. Lyndon B. Johnson Space Center, Houston, Texas, 1982.
I photographed all of the first five extraordinary women chosen in January 1978 for the NASA astronaut corps, but to me this photograph, taken on the training field, best sums up their spirit. Specialist astronaut Sullivan is a marine geophysicist. Shown here on the training field at LBJ Space Center in Houston, she became the first American woman to walk in space during the 1984 flight of the space shuttle *Challenger*.

82 | 83

Martha Stewart. Westport, Connecticut, 1990.
Born in 1941 in Jersey City, New Jersey, Martha Stewart worked hard to become a household name, showing women how to run a successful household with her magazine *Martha Stewart Living*, her line of products for K-Mart, and her television show. In the fall of 2004 she asked to begin serving her five-month sentence for lying to prosecutors about the illegal sale of her ImClone stock. Although still pursuing an appeal, Stewart began serving her sentence in October 2004 in an effort to close this episode of her life.

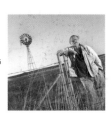

Jim Harrison. Patagonia, Arizona, 2001.
Harrison was waiting for me at an unbelievably good French restaurant. We shared a bottle of his favorite claret. He told me some stories and I told him some stories—a great afternoon. I wish everyone I photographed were like him. The stylishly nonconforming author of nine books of fiction and eleven of poetry divides his time between homes in Michigan and Arizona. He likes hanging out with actor Jack Nicholson, who starred in the film adaptation of his book *Wolf*, and has developed a cult following since his book *Legends of the Fall* appeared in 1979.

84 | 85

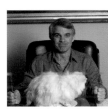

Steve Martin. Vail, Colorado, 1978.
Actor/comedian/author/playwright Martin is not at all what you would expect. Serious and reserved in person, the opposite of his zany screen persona, he is, nevertheless, very loyal to his cats. Born in Waco, Texas, in 1945, he was a member of the original *Saturday Night Live* cast. His film credits include *The Jerk* (1979) and *Bowfinger* (1999). Martin is currently reprising Peter Sellers's role as Inspector Clouseau in *The Pink Panther*, which will be released in 2005.

86 | 87

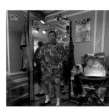

Jerry Lewis. St. Louis, Missouri, 1997.
Shown here in his dressing room, comedian Lewis was playing the Devil in the touring company of the musical *Damn Yankees*. Born in 1926 in New Jersey, he teamed up with Dean Martin from 1946 to 1956 and went on to star in such comedies as *The Nutty Professor* (1963) and *The King of Comedy* (1993), directed by Martin Scorsese. His brand of slapstick humor laid the groundwork for comedians like Jim Carrey. Lewis's annual muscular dystrophy telethon has raised millions and millions of dollars for research. With open-heart surgery in 1983 and prostate cancer in 1992 in his past, Lewis now suffers from diabetes and pulmonary fibrosis.

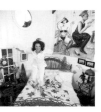

Diane von Furstenberg. New Milford, Connecticut, 1991.
The Brussels-born fashion designer was having fun at her home in Connecticut. As famous as her 1972 wrap dress, which landed her on the cover of *Newsweek* in 1976, she relaunched "the wrap" to a whole new audience in 1997. Married to Hollywood mogul Barry Diller, von Furstenberg has two grown children and three grandchildren from her first marriage to the late Prince Egon von Furstenberg.

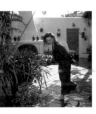

Jodie Foster. Beverly Hills, California, 1991.
Born in 1962 in Los Angeles, Foster was the Coppertone Baby at age three and as a teen worked in television and films, including *Taxi Driver* (1976) with Robert De Niro. Graduating magna cum laude from Yale University in 1985, she returned to acting, started her own production company, and won Academy Awards for Best Actress for *The Accused* (1988) and *The Silence of the Lambs* (1991). Her son, Kit, was born in 2001.

88 | 89

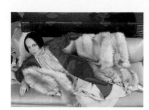

Mary McFadden. New York, New York, 1978.

Until she closed her showroom in 2002, the sophisticated fashion designer's distinctive styles had been the mainstay at many a charity ball for three decades. Influenced by her travels in Africa and Asia that she chronicled for *Vogue* magazine, McFadden has also designed jewelry, fabrics, and wallpaper. Born in 1938, she attended Columbia University. She entered the Coty Hall of Fame in 1979 and has served as the president of the Council of Fashion Designers of America. She is considering designing a low-priced line for Target, à la Isaac Mizrahi.

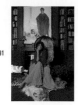

Pat Buckley with her pekingese, Foo. New York, New York, 1977.

Wife of William F. Buckley, Jr., the founding editor of the *National Review*, society maven Buckley has chaired every major charity benefit in New York, from events for the Museum of Modern Art to the American Ballet Theatre. Vassar-educated, the former Miss Vancouver is always in the front row at the Oscar de la Renta and Bill Blass fashion shows. She has been a force in New York society for the past forty years.

Diana Vreeland. New York, New York, 1980.

With a great sense of dramatic style, the former editor in chief of *Vogue* and consultant to the Costume Institute at the Metropolitan Museum of Art sat on the floor of my studio for a portrait. Astutely aware of her powerful influence in fashion, Vreeland began as a columnist for *Harper's Bazaar* and in 1962 joined *Vogue*, where she was editor in chief until 1971. Born in 1906 in Paris, she and her family moved to New York at the beginning of World War I. She married Thomas Reed Vreeland in 1924 and they had two sons. She died in 1989.

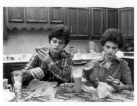

Donald Trump. Atlantic City, New Jersey, 1990.

At one of his hotels, the Taj Mahal, Trump mentioned something about a million dollars. I told him I had never seen that much cash at one time. Off we went into the security area called "the cage" with armed security guards everywhere. The outspoken and charismatic billionaire real-estate developer, whose reality television show *The Apprentice* has topped the ratings, is mobbed everywhere he goes. The New York native, born in 1946, graduated from the Wharton School of Finance. Divorced from Ivana Zelnicek and from Marla Maples, the father of four became engaged to model Melania Knauss in 2004.

Donny and Marie Osmond. Ogden, Utah, 1977.

I had been photographing the Osmond family for several days at their Utah compound, complete with recording studio. Even though I had just left them thirty minutes beforehand, every time I walked past any one of the family, they would pause and say, "Hi, Harry, how are you?" as if seeing me for the first time. Devout Mormons, Donny and Marie have had multiple gold records, adoring fans, their own television specials, and even Donny and Marie dolls. Their squeaky-clean image was no put-on, it was real. Starting in show business as little children with their brothers on the *Andy Williams Show*, Donny and Marie went on to become superstars.

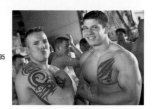

Two Marines. USS *Theodore Roosevelt*, Arabian Sea, 2001.

Two of the 5,500 young crew members aboard the nuclear-powered aircraft carrier proudly showed me their tattoos during stand down. From this ship, the lead vessel in the fleet, many of the tense bombing raids against Afghanistan were launched.

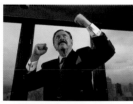

David Merrick. New York, New York, 1994.

Born David Lee Margulois in St. Louis, Missouri, in 1911, the rogue producer graduated from Washington University before beginning a legendary career in 1942 as a Broadway producer. This feared and revered premiere showman produced almost one hundred Broadway shows and won Tony awards for *Becket* (1960), *Hello, Dolly* (1964), *Travesties* (1975), and *42nd Street* (1980). In one of the most outrageous publicity schemes of his controversial career, he appeared onstage after the premiere of *42nd Street* and stunned the audience by announcing the death earlier that evening of choreographer/director Gower Champion. Married six times, Merrick suffered a stroke in 1983 and died in London in 2000.

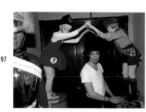

Michael Jackson. Santa Ynez, California, 1993.

Born in 1958 in Indiana, the singing superstar, whose career began in 1964 as the youngest of the Jackson 5, showed me around his home, Neverland. We stopped at the door to his bedroom and I asked him to stand there beneath the mannequins for a portrait. His *Thriller* album is the best-selling album of all time with over forty-six million copies sold. Over thirty million copies each of *Dangerous* and *Bad* have been sold. Jackson won eight Grammy Awards in 1984, was inducted into the Rock and Roll Hall of Fame in 1997, and cowrote the USA for Africa anthem "We Are the World" with Lionel Richie.

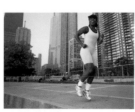

Oprah Winfrey. Chicago, Illinois, 1996.

Always concerned with her weight, Oprah runs every morning before taping *The Oprah Winfrey Show,* which began airing in 1986 and has consistently won Emmy Awards year after year. Born in Mississippi in 1954, she survived child abuse and was luckily denied a place in a juvenile detention home because all the beds were full. Moving in with her father, Vernon, she attributes her success to his strict discipline. Her broadcasting career began at the age of seventeen in Nashville, Tennessee, and by 1984 she had turned *AM Chicago* into a hit show. Nominated for an Academy Award for her role in Steven Spielberg's 1985 *The Color Purple*, Oprah was recently named one of the one hundred most influential people of the twentieth century by *Time* magazine.

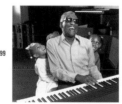

Ray Charles and grandchildren. Los Angeles, California, 1991.

Ray Charles Robinson was born in Albany, Georgia, in 1930 and grew up in Florida. At five he developed glaucoma and by the age of seven had lost his sight completely. Charles studied at the State School for Deaf and Blind Children, sang in a Baptist choir, and by 1947 had formed a jazz trio in Seattle. His new sound, a blend of gospel, soul, and blues, catapulted him into stardom in the 1950s with "What'd I Say?" During his legendary career he played to packed houses in nightclubs and concerts around the world and occasionally played himself in films. In 1965 he ended two decades of addiction to heroin. Twice divorced, he fathered twelve children. Pictured here in a recording studio with two of his adoring grandchildren, Charles's last album was released after his death in 2004.

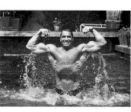

Arnold Schwarzenegger. Los Angeles, California, 1985.

Born in Austria in 1947, the bodybuilder-turned-movie-star went from *Conan the Barbarian* (1982) to the *Terminator* series in which he uttered the now-famous line, "I'll be back." He became a United States citizen in 1983 and married journalist Maria Shriver in 1986. They have four children. Schwarzenegger underwent surgery in 1997 for a congenital heart valve condition and was elected governor of California in 2003.

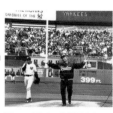

Mayor Michael Bloomberg. Yankee Stadium, Bronx, New York, 2002.

The mayor of New York City, elected in 2002, had just thrown out the first ball at Yankee Stadium. Bloomberg spent $74 million on his campaign for the second-most-important job in the United States and draws a $1 yearly salary from his post. Born in 1942, he graduated from Johns Hopkins University. With an MBA from Harvard University, he began at Salomon Brothers on Wall Street. He launched Bloomberg LP, the billion-dollar financial empire, which includes a television network and more than one hundred offices worldwide. Divorced and the proud father of two daughters, Bloomberg has quietly become a huge philanthropist.

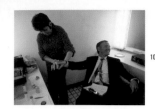 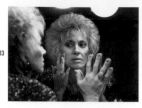 102 | 103

William F. Buckley, Jr. New York, New York, 1988.
Born in 1925 in New York City to a conservative Catholic family, Buckley graduated from Yale University in 1950. Here he is shown having a manicure backstage before taping his television talk show *Firing Line*, which began airing in 1966 after he ran unsuccessfully for mayor of New York on the Conservative ticket in 1965. The political columnist, founder of the *National Review* in 1955 and editor in chief until 1990, received the Presidential Medal of Freedom from President George H.W. Bush in 1991. He has authored a series of spy novels in which the hero is an undercover CIA agent. Buckley himself worked for the CIA briefly in the 1950s. His memoir, *Miles Gone By*, was published in 2004.

Tammy Wynette. Nashville, Tennessee, 1990.
The country music singing star was quietly checking her makeup before going onstage to belt out her classics, like the anthem "Stand By Your Man," to the crowd of fans that came to see her perform. Born in 1942 in Mississippi, she picked cotton and became a hairdresser before starting her music career. Divorced from country legend George Jones and plagued with health problems for over thirty years, Wynette died in her sleep April 6, 1998. Later that year she was inducted into the Country Music Hall of Fame.

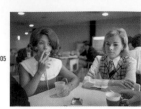 104 | 105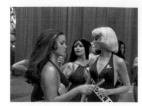

Miss U.S.A. contestants. Niagara Falls, New York, 1974.
Not to be confused with the Miss America pageant held in Atlantic City, the Miss U.S.A. contest was strictly a beauty contest with no talent competition. The winner in 1974 was Karen Morrison, Miss Illinois, who would go on to the Miss Universe contest. Before the winner had been chosen there was tension, expectation, and hopefulness. I found there were more interesting photos to be had backstage.

Two young women. Chadron, Nebraska, 1969.
These two young women having coffee in a diner caught my eye when I was in Chadron to photograph the housewives protesting against porn movies. The high-school girls were perfectly groomed and quite sophisticated for their age and told me they thought the grown-ups should grow up and accept the fact that since there was only one movie theater in town, it should be allowed to play all kinds of films.

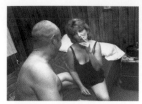 106 | 107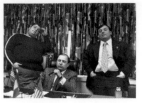

Salt Wells Villa. Fallon, Nevada, 1999.
There was no hustle, no pressure put on the customers who just came in for a drink. Some would just sit and drink, and some would go to a room in the back with one of the Villa's women. Top Gun fighter pilots from nearby Naval Air Station Fallon were frequent visitors. If a serviceman paid for his visit with a credit card, the receipt read "James Fine Dining." A typical fee was about $100 unless something special was requested, and the bar was decorated with the decals of fighter-squadron insignias left as souvenirs. The women said that when there was talk of war, business soared. The fear of possible death would bring in servicemen in droves. The women used to sunbathe nude on the roof, but they stopped because the Navy pilots continuously buzzed the Villa in their planes. The women thought that was silly behavior for grown men.

Joe Columbo and sons. New York, New York, 1971.
When New York Mafia boss Joseph Profaci died in 1962, Joe Bonanno made a power move and ordered Joe Columbo to help. Columbo told boss of bosses Carlo Gambino of the plan, and Bonanno was forced to retire. Rewarded for his loyalty, Columbo took over the Profaci organization in 1963. In 1970, against Gambino's wishes, Columbo formed the Italian-American Anti-Defamation League. Night after night they picketed in front of the FBI headquarters on Third Avenue in Manhattan, chanting "FBI Gestapo." While Columbo was making a speech on June 29, 1971, an African-American man shot him three times before being killed himself. Columbo remained in a coma for seven years. The shooting ended the Italian-American Civil Rights League, the group that evolved from Columbo's original anti-defamation group, but his crime family is still known today as the Columbo family.

 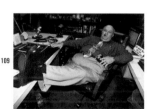 108 | 109

Bernice Golden. Belle Glade, Florida, 2003.
Bernice's life was shattered when her son, Feraris "Ray" Golden, was found hanging from a tree in his grandmother's yard in May 2003. After two days of testimony, Judge Harold Cohen ruled the death a suicide. Many think Ray was lynched because of his friendship with a white police officer's daughter. They allege that although the ground was muddy from torrential spring rains, the bottoms of Ray's feet were clean. Others claim that the victim's hands were tied and that there were tire tracks on his body. Community-based study circles were formed to diffuse the simmering racial tension and the NAACP has been investigating the death.

Police Chief Michael Miller. Belle Glade, Florida, 2003.
Miller spoke out to say that his office would do everything in its power to pursue all the evidence in the death of Ray Golden. Florida state representative Hank Harper, Jr., who wore a bulletproof vest when visiting Belle Glade, called for Miller's removal in the face of "rampant abuse of power by the police department." The intrigue, conflicting information, and political upheaval caused by the death of Ray Golden may have contributed to the 2004 resignation of Police Chief Miller.

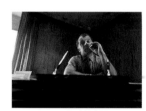 110 | 111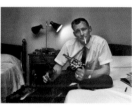

F. Lee Bailey. Boston, Massachusetts, 1972.
With bravado, the defense attorney gave the impression he could handle anything. His high-profile cases have included the murder trials of the "Boston Strangler"; Dr. Sam Shepard, whose testimony was the basis for the film *The Fugitive*; O.J. Simpson, acquitted of murdering his wife, Nicole; and Capt. Ernest Medina in his court-martial for the massacre of women and children at My Lai during the Vietnam War. Born in 1933 in Massachusetts and divorced three times, Bailey is the author of seventeen books.

Robert Shelton. Beaufort, South Carolina, 1965.
Mississippi's White Knights of the Ku Klux Klan Imperial Wizard Robert "Bobby" Shelton was to meet me in a diner in town. It was during the civil rights unrest. I arrived first. The men, all drinking coffee, eyed me suspiciously since my hair was longer than theirs. They could tell I was a stranger in town. My uneasy feeling and the tension in the room disappeared when Shelton arrived and sat down with me. He took me to the motel where he was staying and bragged that the gun he was holding had killed white civil-rights worker Viola Leuitzo.

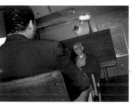 112 | 113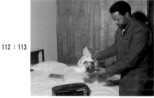

Dexter King and James Earl Ray. Tennessee State Penitentiary, Nashville, Tennessee, 1997.
Ray, the confessed killer of civil rights leader Dr. Martin Luther King, Jr., was sentenced to ninety-nine years in federal prison. Soon he recanted his testimony, swearing he had not killed Dr. King. King's son, Dexter, representing his mother, Coretta, and his three siblings, met with Ray and asked him directly if he had killed his father. Ray ambiguously replied, "No, I didn't. But like I say, sometimes these questions are difficult to answer." Ray died in prison in 1998. The King family continues to investigate his claim.

José Williams. Memphis, Tennessee, 1968.
I was nearby on another story when I heard the news that civil rights leader Dr. Martin Luther King, Jr., who preached nonviolence, had been shot on the balcony of the Lorraine Motel in Memphis. I got there within the hour and went to his room. The door was open. When I knocked and went in, Williams was holding a jar. The NAACP officer had marched alongside Dr. King. Still dazed by the horrendous event he had witnessed, Williams told me he had soaked up King's blood with a towel and squeezed the blood into the jar.

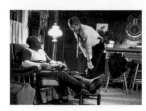
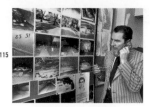
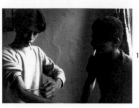
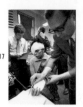
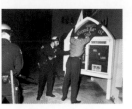
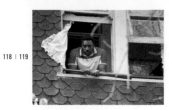

U.S. Marshall John Partington. Providence, Rhode Island, 1975.
A security inspector with the Witness Security Program that began in 1967, here Partington discussed the future with an informant in a safe house. Recently turned state's witness against three high-ranking organized crime figures, this man had a contract put out on his life. In exchange for his testimony, the United States had promised to relocate him and give him a new identity. Most witnesses are reluctant to enter the program, but if they are offered the option of a new identity for information leading to a conviction or spend the rest of their life in prison, they become keener to join.

New York Police Department deputy inspector Timothy J. Dowd. New York, New York, 1977.
The first thing Dowd said to me when I walked in was, "You've got a remarkable likeness to the man we're looking for." When he saw the look on my face, he laughed and said, "That always gets all the reporters." A thirty-seven-year veteran of the New York police force, sixty-one-year-old Dowd was brought in to head a task force of fifty detectives who were working on the "Son of Sam" case. The killer terrorized New Yorkers as he randomly killed six people in Queens and the Bronx from July 29, 1976, until his arrest on August 10, 1977. Caught outside his Bronx apartment, David Berkowitz immediately confessed and is serving six life sentences in the Sullivan Correctional Facility in Fallsburg, New York.

Shooting gallery. New York, New York, 1980.
A "shooting gallery" is located in an abandoned building where addicts gather to shoot up heroin. I was photographing these youths when undercover police, guns drawn, kicked in the door. They were as surprised to see me as I was to see them and told me I was crazy to be there.

Battered woman. Police station, South Bronx, New York, 1970.
I was doing a story on how overworked the police in the South Bronx were. Called Fort Apache, it was a very dangerous precinct to work in. It was late at night when a woman who had been beaten up came in, a victim of domestic violence. She had a little boy with her who seemed sad. At the moment I took this picture she was being helped to sign a report against her attacker.

Watts Riots. Los Angeles, California, 1965.
There was a history of animosity between the blacks who lived in the Watts section of Los Angeles and the Los Angeles Police Department. By 1965 the slightest spark would have set off a riot. The trouble began with the routine arrest of a drunk driver. During the six days of rioting in the boiling August heat, thirty-four people were killed. Buildings were burned. Looting was rampant, and the depressed conditions of the area were finally brought to the public's attention.

Erwin Keith. Cicero, Illinois, 1983.
After marrying a local woman, Keith moved to Cicero, a suburb of Chicago. He had heard about a black bus driver who, in 1951, was burned out of his apartment the day he moved in. At the time, the all-white community was composed mostly of immigrant Eastern Europeans. The harassment was still evident in 1983 in several civil cases pending against the town, including a $6-million lawsuit for denial of housing, education, and employment to blacks. Keith, a National Guard platoon leader born in Memphis, rigged floodlights at his home and stood guard weekend nights, but he said he had met some good people since moving to Cicero.

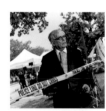
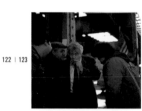

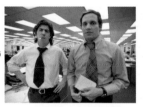

Johnny Cochran. Los Angeles, California, 1995.
Born in 1937, the defense attorney attended the University of California, Los Angeles. Cochran was part of the "Dream Team," a group of attorneys representing O.J. Simpson in his highly publicized trial in Los Angeles. Simpson was eventually acquitted of the murder of his wife, Nicole Brown, and Ron Goldman. Cochran was driving to court, surrounded by photographers, when I yelled, "Hey Johnny, it's me," to attract his attention. He turned and waved although he had no idea who I was. Later that night I photographed him at his home.

F. Lee Bailey. Los Angeles, California, 1995.
The flamboyant attorney was added to the "Dream Team" defense the weekend before the preliminary hearings began in the O.J. Simpson trial for the brutal stabbing death of his wife, Nicole Brown, and Ron Goldman. Bailey was making his way to the courtroom through the pack of newspaper reporters and television news cameras. The case had caused a media frenzy from the time Simpson, in his white Ford Bronco, gave the police a televised chase the morning after Nicole's body was found.

Dominick Dunne. Stamford, Connecticut, 2002.
Covering the trial of Michael Skakel for *Vanity Fair*, Dunne was at the courthouse every day where Skakel was convicted of murdering his neighbor Martha Moxley in 1975. Born in 1926 in Hartford, Connecticut, Dunne graduated from Williams College, served in World War II, and then married Ellen Griffin. They had three children: Alex, Griffin, and Dominique. In 1982 their daughter, Dominique, was murdered by her ex-boyfriend, who received only a short jail sentence. Thereafter intrigued with justice and the lack of it, Dunne has made a career writing about famous murder trials in best-selling books including *The Two Mrs. Grenvilles*, *An Inconvenient Woman*, and his book about the O. J. Simpson trial, *Another City, Not My Own*.

Jimmy Breslin. Queens, New York, 1988.
If I were to describe a New Yorker, I would just say, "Jimmy Breslin." Born in 1930, he attended his first Democratic convention in 1948 and ran for New York City council president with Norman Mailer as mayoral candidate in 1969. He has written for the *New York Daily News* and is presently a *Newsday* columnist. He tells it straight—like he sees it—and was awarded a Pulitzer Prize for Distinguished Commentary in 1986. Married to Ronnie Eldridge, he is the author of many books, including *The Gang That Couldn't Shoot Straight* and *World without End, Amen*.

Mike Wallace and Don Hewitt. New York, New York, 1993.
In their offices in the CBS building the two were clowning around for a moment during a hectic day. Wallace, born in Michigan in 1918 and educated at the University of Michigan, began as a radio announcer before settling into his role as a hard-hitting investigative journalist and winner of eighteen Emmy Awards for his work on *CBS Morning News* (1963–66) and CBS's *60 Minutes* (1968–present). Hewitt, the show's executive producer, revolutionized television news by using a magazine format when *60 Minutes* began in 1968. The first news program in the Nielsen rating's top ten, it has been the highest rated television program for over thirty years. Born in 1922 in New York City, Hewitt, a war correspondent in World War II, began in television news in its infancy in 1949.

Carl Bernstein and Bob Woodward. Washington, D.C., 1973.
Bernstein and Woodward, the determined *Washington Post* investigative reporters, broke the story on the Watergate break-in scandal with the help of "Deep Throat," their secret informant. The Republicans had had the Democratic National Committee at the Watergate Hotel burgled, and this scandal eventually led to the resignation of President Richard Nixon in 1974. Bernstein, born in 1944, and Woodward, born in 1943, cowrote the book *All the President's Men* and received the Pulitzer Prize in 1973. Bernstein has subsequently authored several books and worked for *Time* magazine. Woodward has written ten best-selling books.

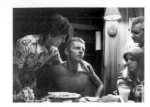

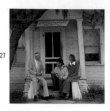

126 | 127

Billy Hayes. Long Island, New York, 1975.
Sentenced to a Turkish prison for thirty years after boarding a Pan Am flight from Istanbul for New York in 1970 with four pounds of hashish strapped to his waist, Hayes was imprisoned on the isle of Imrale in the Sea of Marmara, seventeen miles from the Turkish mainland. On a stormy night he escaped from the prison by boat and rowed ashore, where he dyed his hair black, put on dark make-up and caught a bus to the Greek-Turkish border. The U.S. consul in Thessaloniki provided a passport and plane ticket home. He defiantly mailed a postcard of a naked girl to the prison warden before he left. In this photograph he is adjusting to life back with his family on Long Island. He shuddered while eating a meal with his family. Today a filmmaker, he is married to the woman he met at the Cannes Film Festival when the film of his experiences, *Midnight Express,* premiered. They live in California.

Phillip Rogers. Freer, Texas, 1974.
He had been awarded several medals for bravery beyond the call of duty. In 1974 Vietnam War deserters were granted amnesty by President Gerald Ford and were given alternate service assignments. Rogers had been an infantryman in Vietnam when he deserted in 1971. He said, "Everybody knew I was AWOL but figured I had a good reason. I'd served two years, my Mamma was sick, and I needed to help support the family." He turned himself in and received eleven months of alternative service.

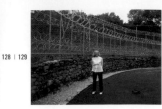

128 | 129

Aldrich H. Ames. Allenwood Federal Penitentiary, White Deer, Pennsylvania, 1994.
Born in 1941 in Wisconsin, Ames was not in the least like the gregarious, hard drinking Kim Philby, Britain's most famous spy, whose cover had been posing as a newspaperman. To my mind, the difference between Ames and Philby was that, although wrongly and naively, Philby believed he was preventing the spread of Fascism while Ames coldly betrayed his country just for money. Ames's job had been to uncover Soviet spies, but instead he became a double agent for the Soviet Union in 1985. Arrested in 1994 outside his home on charges of conspiracy to commit espionage, he is serving a life sentence without parole. For two million dollars he caused the deaths of Russian double agents working in the Soviet Union and revealed the name of every U.S. spy working in Russia.

Jean Harris. Bedford Hills Correctional Facility, Bedford Hills, New York, 1983.
When I went through security at the women's prison, a large female security warden said to me, "That's a real classy lady you are going to see. I've seen them all and this one is a real classy lady." Jean Harris was the headmistress of the prestigious girls' school, Madeira, in McLean, Virginia, before she was committed to a fifteen-year-to-life sentence for shooting and killing her lover, Dr. Herman Tarnower, author of the famed "Scarsdale Diet" book. Harris maintained that she had gone to the doctor's house to speak with him before killing herself and in the struggle he was shot. Refusing to plea bargain, she was found guilty of murder and sent to Bedford Hills. A model prisoner, she worked with the children of other inmates and was granted clemency by New York governor Mario Cuomo after three heart attacks and nearly twelve years in prison.

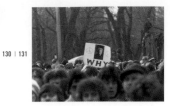

130 | 131

Mark David Chapman. Attica State Penitentiary, New York, 1987.
The man who shot John Lennon on December 8, 1980, apologized to me for killing my friend. As a young man, Chapman had been a popular counselor at the YMCA summer camp in Decatur, Georgia. After John Lennon said the Beatles were more popular than Jesus, Chapman refused to play any Beatles songs on his guitar. His deterioration into madness has been documented in a series of interviews and books. During the photo session, Chapman became animated and cavorted for the camera. He brought out his copy of *Catcher in the Rye,* the J.D. Salinger book he carried when he shot Lennon and from which he read just before he was sentenced in court.

John Lennon memorial. New York, New York, 1980.
On December 14, 1980, mourners gathered in Central Park for a memorial vigil for John Lennon, the Beatle shot and killed by Mark David Chapman. Carrying signs, candles, and flowers, they came together in sorrow. Sobbing as they sang songs written by Lennon, they mourned the loss of an icon.

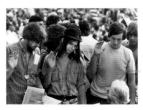

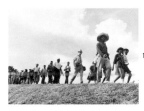

132 | 133

Eighteen-year-olds register to vote. Pittsburgh, Pennsylvania, 1971.
They wanted to change the system. Four thousand eighteen-year-olds registered to vote in one day in Pittsburgh in 1971. Three young men taking the oath caught my eye. Not preppy to say the least, they were preparing to participate in the system that had sent their peers to fight in Vietnam.

Senator Robert F. Kennedy at the Martin Luther King, Jr. funeral. Atlanta, Georgia, 1968.
The casket of slain civil-rights leader Martin Luther King, Jr. was being pulled by mules to the Ebenezer Baptist Church where he would lie in state. In the funeral procession, Kennedy was surrounded by well-wishers as he marched with the mourners who had come to honor King.

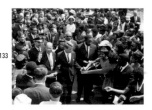

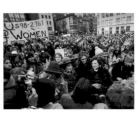

134 | 135

Meredith March. Nearing Canton, Mississippi, 1966.
I have always said the 1960s were when America had a nervous breakdown. In 1961, James Meredith was the first black man to enroll in the University of Mississippi. When Mississippi's governor and an angry mob barred his entrance, he became the focal point for the civil-rights movement when the NAACP sued in federal court for his right to attend the university, and won. President John F. Kennedy sent three thousand troops to restore order and escort him into the school, from which he graduated in 1963. Meredith began his 1966 "March against Fear" in Memphis and was shot on June 6th by James Norvell, who confessed and was sentenced to five years in prison. Dr. Martin Luther King, Jr., took up the march with thousands following and Meredith recovered from the shooting. I feel proud to have covered the march.

Bella Abzug and Gloria Steinem. New York, New York, 1975.
Gloria Steinem, founder of *Ms.* magazine, was born in 1935 in Toledo, Ohio. When her parents divorced, she and her mother struggled to make ends meet; yet she attended Smith College, as did her older sister. A founding editor of *New York* magazine, she has been a leader in the women's rights movement. Born in the Bronx, Bella Abzug (1920–1998), who received a law degree from Columbia University, fought against Senator McCarthy's House Un-American Activities Committee. The mother of two daughters with her husband, Martin, she ran on a strong women's lib platform and became a U.S. Congresswoman from Manhattan (1970–76), but lost in her race for the Senate. Steinem in large glasses (center), with Bella on her right in her signature hat, are surrounded at a women's rights rally in New York City.

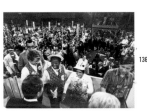

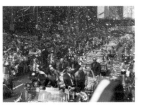

136 | 137

President and Mrs. Richard M. Nixon. GOP Convention, Miami, Florida, 1972.
Ron Ziegler, Nixon's press secretary, let me stand directly behind the president after he had accepted his party's nomination to run for a second term. All my colleagues were on a platform at the back of the room, in a specific area for photographers. They kept waving and shouting for me to move out of the way so they could get a photograph of the president without my head in the frame. I just smiled and waved back pretending that I didn't understand.

***Apollo 11* astronaut parade. New York, New York, 1969.**
On July 20, 1969, *Apollo 11* commander Neil Armstrong stepped off the lunar module *Eagle* onto the moon and made history. While the entire world watched in amazement on television, he and fellow astronaut Edwin "Buzz" Aldrin explored the moon's surface for over twenty-one hours and gathered forty-six pounds of lunar rocks before docking with the command module *Columbia* and astronaut Michael Collins. New York turned out to honor them with a ticker tape parade in lower Manhattan. Born in Ohio in 1930, Armstrong received a master's degree in aerospace engineering from the University of Southern California, and became a naval aviator and test pilot for the X-15 aircraft before being chosen for the astronaut corps. Married, with two sons, he was given the Presidential Medal of Freedom in 1969.

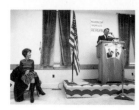

138 | 139

Ronald and Nancy Reagan, New Hampshire, 1976.

For over thirty years I have photographed the Reagans, from the announcement that he was running for governor of California to the last formal portrait of the president and Mrs. Reagan in 1998. Always elegant, approachable, and totally in love, they married in 1952, when both were actors. Reagan made over fifty films before going into public office. Here he is campaigning with Nancy ever by his side. Reagan served two terms as president of the United States (1981–89). His famous speech of June 12, 1987, delivered at the Brandenberg Gate in Berlin included the line, "Mr. Gorbachev, tear down this wall," referring to the Berlin Wall, which fell two years later. In 1994 the president announced his struggle with Alzheimer's disease. Born in Tampico, Illinois, on February 6, 1911, President Reagan died on June 5, 2004, at his home in Bel Air, California, with Nancy by his side.

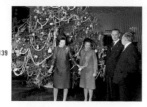

President and Mrs. Lyndon B. Johnson and Prime Minister and Mrs. Harold Wilson. The White House, Washington, D.C., 1966.

Texas-born Vice President Lyndon B. Johnson (1908–1973) became president of the United States after President John F. Kennedy was assassinated in Dallas in 1963. LBJ signed the Civil Rights Act in Washington, D.C., with Martin Luther King, Jr., at his side. Just before Christmas the prime minister of Great Britain, Harold Wilson, traveled to Washington on an official visit to discuss the Vietnam situation. The 36th president inherited the Vietnam War and chose not to run for a second term because of it.

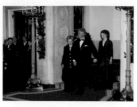

President William J. Clinton and First Lady Hillary Clinton with daughter, Chelsea. The White House, Washington, D.C., 2000.

There was a slight hysteria in the air before the millennium arrived. Some had predicted that all computers as well as the space station would fail when the last day of the twentieth century ended. The fears were in vain. I was at the White House for the New Year's Eve party on December 31, 1999, and the celebration was festive. Since leaving office, Clinton, who served two terms (1993–2001), has written his best-selling memoir and is sought after as a speaker. Hillary is now the junior senator from New York, and former first daughter Chelsea is working in New York City since graduating from Stanford University.

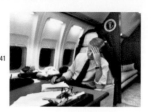

140 | 141

President James E. Carter. *Air Force One*, 1979.

When I asked press secretary Jody Powell if I could get a lift back to New York, no one had been allowed to photograph President Carter on *Air Force One*. The United States embassy staff was being held hostage in Iran (they were released fourteen months later when Ronald Reagan became president) and the tension had begun to show in Carter's face. The strain of campaigning for reelection was also visible. Born in 1924 in Georgia, he graduated from the Naval Academy. Married to Rosalynn Smith, they have four children. Elected governor of Georgia in 1970, he was president from 1977 to 1981. The champion of human rights, Carter established full diplomatic relations with China, and brought peace between Egypt and Israel with 1978's Camp David agreement. Carter received the Nobel Peace Prize in 2002.

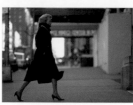

Diane Sawyer. New York, New York, 1983.

Here Sawyer arrives at her office at CBS TV at daybreak to co-host *CBS Early Morning News*. Sawyer began her career as a weather reporter on a Kentucky television station. Before joining CBS news in the Washington bureau, she worked for President Nixon's press secretary Ron Ziegler until 1974. She married writer/director Mike Nichols in 1988 and left CBS's *60 Minutes* (1984–89) to coanchor *Prime Time Live* on ABC. Presently the coanchor of *Good Morning America*, Sawyer has won nine Emmy awards. One of the highest-paid women in journalism, intelligent and strikingly beautiful, she was born in 1945 in Kentucky and graduated from Wellesley College in 1967.

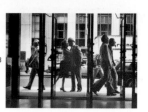

142 | 143

Helen Gurley Brown and David Brown. New York, New York, 1982.

They married in 1959; he was the ultimate Hollywood producer, and she was the dynamic magazine editor. Born in New York in 1916, educated at Stanford and Columbia School of Journalism, as a producer Brown teamed with great directors in such films as Steven Spielberg's *Jaws* (1975), Bruce Beresford's *Driving Miss Daisy* (1989), and Robert Altman's *The Player* (1992). Born in Arkansas in 1922, Gurley Brown graduated from Texas Women's University and became an advertising copywriter. Writing what others were afraid to verbalize in the 1960s best-seller *Sex and the Single Girl* (1962), in 1965 she was named editor of *Cosmopolitan* magazine, where she reigned until moving over to international editions in 1996.

144 | 145

Gilda Radner. New York, New York, 1977.

She said her mother loved the movie *Gilda* and named her after the Rita Hayworth character. As one of the original cast members of NBC's *Saturday Night Live* in the late 1970s, she simply made people laugh with her skits of Jackie O, Baba Wawa (Barbara Walters), and Roseanne Roseannadana. Lorne Michaels, producer of *SNL*, saw her in a production of *Godspell* by Toronto's Second City Improvisational Company and hired her without an audition. Tap dancing here in her New York apartment, she said, "The best thing about tap dancing—you can stamp your little guts out if you're pissed off." Always upbeat and a fighter, she wrote a memoir, *It's Always Something*, as she was dying of ovarian cancer after repeated misdiagnoses. Born in Detroit in 1946, Radner was only forty-two when she died.

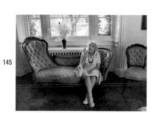

Alice Paul. Washington, D.C., 1970.

I found Ms. Paul to be a feisty woman who was still working for her cause. Born into a New Jersey Quaker family in 1885, she attended the London School of Economics and the University of Pennsylvania and helped form the Women's Social and Political Union and later the National Women's Party (1916). She, along with Lucy Burns, marched, picketed, and lobbied for a constitutional amendment to give women the right to vote. They were arrested three times and went on a hunger strike, but they did not give up. In 1920 the nineteenth amendment to the United States Constitution was passed, which allowed women to vote in federal elections. Paul died in 1977, proud of the huge accomplishment that she had fought hard to achieve.

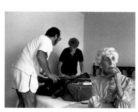

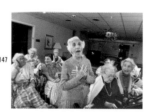

146 | 147

Celia Goldie. Chicago, Illinois, 1998. (2 photos)

When I arrived at Mrs. Goldie's apartment, her son, Bob, and daughter-in-law, Marsha, were not there. She took me by the arm and said, "Don't let them take me away." Many, if not all, families will face this crisis with their aging parents. Living alone since her husband, Jack, died in 1968, Mrs. Goldie had had a heart attack and stroke in 1985. Bob and Marsha made the heart-wrenching decision to place his ninety-year-old mother into a nursing home after she had recently fallen and begun calling them in a panic at night. She fought the decision, realizing what giving up her home of twenty-five years meant: the end of the road. While packing her things, they had to leave a lot of memories behind. Sobbing, she didn't go without a fight, lashing out and accusing them of betraying her. Visiting the Lieberman Geriatric Health Center a month later, I found her leading the singers in the dining room in old standards such as "California Here I Come." She had resigned herself, was settling in, and making friends.

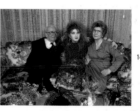

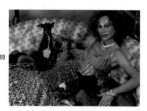

148 | 149

Cyndi Lauper. Queens, New York, 1984.

Dressed in vintage clothing with more than a hint of punk, outrageous and fun-loving Lauper and her mother, Catrine Domenique, visited her grandparents at their home in Queens. Lauper won a Grammy for Best New Artist in 1984 for the hit single "Girls Just Want to Have Fun." Another hit, "Time after Time," followed. Married to David Thornton, with one son, she toured with Tina Turner in 1997 and Cher in 1999 and has released a new album, *At Last*.

Jocelyne Wildenstein. New York, New York, 1998.

During a bitter divorce from millionaire art dealer Alec Wildenstein, she posed with her favorite whippets in the townhouse where they had lived while married. Born in Switzerland, Jocelyne met her future husband while on a lion hunting expedition on his 66,000-acre Kenyan estate. While married, he lavished her with jewelry and her own exotic pet monkey.

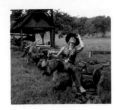

150 | 151

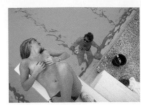

152 | 153

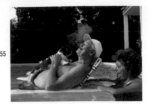

154 | 155

Tanya Tucker. Nashville, Tennessee, 1994.
Born in Seminole, Texas, in 1958, Tucker first hit the top of the country charts in 1972 at the age of thirteen with "Delta Dawn." The vivacious country singer is best known for her anthem to her home state "Texas (When I Die)." She has recorded over thirty albums and was inducted into the Country Music Hall of Fame's Walkway of Stars in 1993. When not performing, Tucker, the mother of three, is an avid competitor in cutting-horse competitions.

James Galanos. Los Angeles, California, 1985.
Easygoing and affable, the fashion designer known for his impeccable workmanship and intricate tailoring refers to his designs as "custom ready-to-wear," while others call him America's only couturier. Born in Philadelphia in 1924, Galanos worked in Paris before opening his California salon in 1952. Ivana Trump and Diana Ross sat in the front row at his shows. Designing inaugural gowns for one of his favorite clients, Nancy Reagan, brought him to the general public's attention. The winner of the Coty Fashion Award (1954 and 1965) and the Council of Fashion Designers of America Lifetime Achievement Award (1985), Galanos retired in 1998.

Anna Wintour. Paris, France, 1994.
Although she rules the New York fashion scene, she looked like a Raggedy Ann doll when I caught her between shows at the Paris collections. Wintour's father, Charles, was the editor of the *Evening Standard* newspaper when I worked on Fleet Street. She worked in the fashion department of *Harpers & Queen* before moving to New York to work at *Harper's Bazaar* and *New York* magazine before being named creative director of American *Vogue* in 1983. Returning to British *Vogue* in 1986, Wintour rejoined American *Vogue* as editor-in-chief in 1988. The divorced mother of two has helped raise over $10 million for AIDS charities.

Amber Valletta. Paris, France, 1994.
Backstage at the Paris collections, Valletta was sleeping whenever she could. The supermodel was born in Arizona in 1974, discovered in Tulsa, Oklahoma, and has countless covers and ad campaigns to her credit. With Shalom Harlow she succeeded Cindy Crawford as cohost of MTV's *House of Style*. Divorced from model Hervé Le Bihan in 1996, Valletta has a son, born in 2000, with Olympic volleyball player Christian Macaw. Turning to acting, she appeared in *What Lies Beneath* with Harrison Ford in 2000.

Cornelia Guest. Cap Ferrat, France, 1983.
Daughter of the late Winston (ten-goal polo player and cousin of Winston Churchill) and C.Z. Guest, and granddaughter of Frederick E. Guest, whirlwind eighteen-year-old Guest was called "Deb of the Decade." An accomplished international equestrian and sought-after chairwoman for major charity events, she divides her time among New York, Palm Beach, London, and Los Angeles.

Elliot and Patty Roosevelt with shih tzu, Polly. Indian Wells, California, 1984.
With head thrown back and a cigar jauntily held between his teeth, Roosevelt is the spitting image of his father. Born in 1910, the fourth son of four-term United States President Franklin Delano Roosevelt, he called himself the Roosevelt who did not go to Harvard University. With a varied career, from World War II hero to broadcast journalist to rancher to mayor of Miami, Roosevelt, who died in 1990, was married five times and wrote four volumes of memoirs and a mystery series.

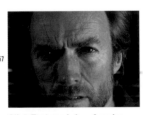

156 | 157

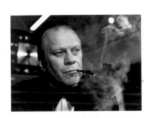

158 | 159

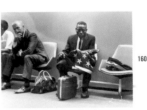

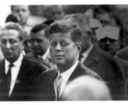

160 | 161

Burt Reynolds. Hollywood Hills, California, 1974.
Reynolds sat by his pool table in front of an almost life-size poster. As *Cosmopolitan*'s first male centerfold (1972), the actor's sense of self-parody is keen, as he has proved in films from *Semi-Tough* and *Smokey and the Bandit* (both 1977) to *Boogie Nights* (1997), for which he won a Golden Globe and garnered an Academy Award nomination. Born in Georgia in 1936, he was a star football player at Florida State University. His son, Quinton, is a major priority in Reynolds's life today. Among his films scheduled to release in 2005 are *Cloud Nine* and a remake of his 1974 hit *The Longest Yard*.

Clint Eastwood. Los Angeles, California, 1984.
Tall, serious, and soft-spoken, Eastwood has been a star since he epitomized the macho man in spaghetti westerns such as *A Fistful of Dollars* (1964). He reprised his signature role as Dirty Harry in two sequels, and won an Academy Award for directing *Unforgiven* (1992). Appearing in over fifty films and directing over twenty-five, Eastwood was the 2000 recipient of the John F. Kennedy Center Honors. In 2003 he directed *Mystic River* to much critical acclaim. His next film, which he directs and stars in, *Million Dollar Baby*, is expected to be released in 2005. Born in 1930, the California native served as mayor of Carmel by the Sea in the late 1980s, and is married to Dina Eastwood.

President Gerald R. Ford. *Air Force Two*, 1973.
After the resignation of Spiro Agnew in 1973, House Minority Leader Ford was selected by President Nixon to be his vice president. Ford eventually ascended to the presidency in 1974 when Nixon resigned over the Watergate break-in scandal. Born in 1913 in Nebraska, he played football for the University of Michigan and received his law degree from Yale University. A lieutenant commander in the Navy during World War II, the father of three with wife, Betty, as president, Ford tried to heal America after the upheaval of Nixon's resignation.

George C. Scott. Tucson, Arizona, 1972.
Scott was making his directorial debut as well as starring in the film *Rage*. Everyone on the set was well aware of his temper, but I got on quite well with him. He even asked me to be in the film, telling me to "run like a photographer" past a fire and take a photo; I wound up on the cutting room floor. Born in Virginia in 1927, Scott spent four years in the Marines and attended the University of Missouri before turning to acting. After being nominated for an Academy Award in 1959 for *Anatomy of a Murder*, he refused the nomination in 1962 for his role opposite Paul Newman in *The Hustler*, and would not accept the award for *Patton* in 1970. Married four times, he fathered six children, including actor Campbell Scott. He died in 1999.

Man with flag. Washington, D.C., 1971.
On my way back to New York, I noticed a man sitting with an American flag folded on his lap at Washington's National Airport. Through his excruciating sorrow, he told me his son had been killed in the Vietnam War and had just been buried in Arlington National Cemetery.

President John F. Kennedy. Paris, France, 1961.
The president and first lady took Paris by storm on an official visit to French president Charles de Gaulle. All day I ran around trying to get a photograph in which I could see President Kennedy's face. The chance came on the Champs Elysées during a ceremony at the Arc de Triomphe. As it began to rain, Kennedy pushed an umbrella away as I tried to climb up a slanted ledge. I kept sliding off and Kennedy kept looking at me until I got the photograph. Born in Massachusetts in 1917, the second of nine children of Ambassador Joseph P. and Rose Kennedy, President Kennedy promised a "new frontier" in politics before being assassinated in 1963 by Lee Harvey Oswald.

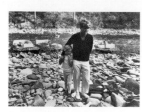

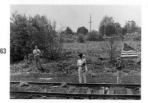

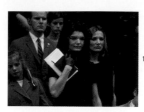

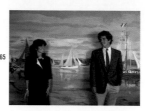

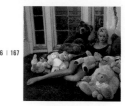

162 | 163

164 | 165

166 | 167

Senator Robert F. Kennedy and daughter Kerry. Snake River, Idaho, 1966.

The New York senator took his wife, Ethel, whom he married in 1950, and their ten children (his eleventh child was born after his assassination in 1968) on a vacation to ride the rapids. Astronaut John Glenn and other friends joined the entourage of the former attorney general. The children took turns playing tricks on each other and their father, tossing him into the river at one point. At that time Kennedy had not announced his intention to run for the presidency. Daughter Kerry, now the mother of three, is a photographer and environmentalist.

R.F.K. funeral train. Between New York, New York, and Washington, D.C., 1968.

The heat was stifling as the train slowly crept along, carrying the body of the slain senator and presidential candidate. Thousands of mourners lined the tracks, some with flags, others just standing and crying. Senator Robert F. Kennedy was to be buried near his brother, President John F. Kennedy, in Arlington Cemetery.

Jacqueline Kennedy and Lee Radziwill. New York, New York, 1968.

Leaving St. Patrick's Cathedral after her brother-in-law's funeral service, Jacqueline Kennedy, a widow for less than five years, was accompanied on the solemn occasion by her children, Caroline and John, Jr., and her sister, Lee. Senator Robert Kennedy was only forty-two when he was assassinated in Los Angeles during his campaign for the Democratic nomination for president.

Caroline and John F. Kennedy, Jr. Boston, Massachusetts, 1984.

At the John F. Kennedy Presidential Library in Boston, Caroline told me that although they had each been photographed all their lives, they had not posed formally before. Caroline, born in 1957, graduated from Harvard University in 1980, and Columbia Law School in 1986. Author of *The Bill of Rights in Action*, she is president of the Kennedy Library Foundation and a cofounder of the Profiles in Courage Awards. She asked me to take her wedding photographs when she married Edwin Schlossberg in 1986. They have three children. John, Jr., born in 1960, graduated from Brown University in 1983, received a law degree from New York University in 1989, and worked as an assistant district attorney for New York before launching *George* magazine (1995–2001). He married Carolyn Bessette in 1996. She and her sister were with John, Jr. when his Piper Saratoga plane went down en route to Martha's Vineyard in 1999.

Judith Campbell Exner. Malibu, California, 1991.

I found her to be a sad woman who, when looking at my picture of John Kennedy, said, "Oh, Jack, you were a naughty little boy." As a beautiful young woman she kept her association with President John F. Kennedy a secret until 1975, when the Republicans on the United States Senate Committee forced her to publicly testify about their relationship. Exner had been introduced to the president by Frank Sinatra in 1960 and continued her friendship with Chicago Mafia don Sam Giancana at the same time. The FBI under Herbert Hoover knew about her liaison with both men. She published her version of the events in 1977's *Judith Exner: My Story*. Born in 1934, Exner died of cancer in 1999 and is survived by one son.

Darryl Hannah. New York, New York, 1989.

The actress, born in Chicago in 1960, graduated from the University of Southern California and gained fame in Hollywood as the mermaid in *Splash*. Against type, she played the plain Jane in *Steel Magnolias*. Hannah won the Best Short Subject Award from the 1994 Berlin Film Festival for *The Last Supper*, which she wrote, produced, and directed. She dated rocker Jackson Brown and John F. Kennedy, Jr., before his marriage to Carolyn Bessette. In 2003–2004 she played a villain in Quentin Tarantino's *Kill Bill* films and costarred in *Silver City*.

168 | 169

170 | 171

172 | 173

Richard Pryor. Tarzana, California, 1995.

The legendary standup comedian battled the censors over his controversial, profanity-filled commentary on the black experience in white America, but *Richard Pryor— Live in Concert* was finally released in 1979. Four films costarring Gene Wilder, including *Silver Streak* (1976) and *See No Evil, Hear No Evil* (1989), were huge successes. Pryor was almost killed by setting himself on fire while free-basing cocaine in the early 1980s. Married and divorced five times, he is presently remarried to wife number four, Jennifer Lee. Sadly, the Illinois native, born in 1940, has suffered since 1986 from multiple sclerosis and can no longer speak.

Truman Capote. Durham, North Carolina, 1976.

Drinking heavily on the plane, we were met by two Duke University students and driven to our hotel. On the way Capote told the most salacious stories about the celebrities he knew, and he knew them all. Calling Jackie Kennedy and Lee Radziwill "geishas" is the only repeatable quote from the trip. The students were in shock. Capote had come to give a lecture and they got their money's worth. Capote was born Truman Streckfus Persons in New Orleans. His parents divorced before he was five. His alcoholic mother, who remarried a businessman named Capote, committed suicide in 1953. Capote was sent to live with his mother's relatives in Monroeville, Alabama, before he moved to New York as a young writer. His *Breakfast at Tiffany's* and *In Cold Blood* established him as one of the preeminent writers of the twentieth century. I liked him. He was a tough little guy.

Louise Cowell Bundy. Seattle, Washington, 1989.

Holding her son's Boy Scout uniform, serial killer Ted Bundy's mother had more or less resigned herself to the fact that he had committed the murders. An unwed mother in 1946 when Ted was born, Louise married Johnnie Bundy in 1951, but Ted remained estranged from his new father. In 1967 the charismatic young man became obsessed with a young woman who rejected him. He never seemed to recover. Ted confessed to twenty-eight rapes and murders of young women in the 1970s, but estimates put his crimes at close to one hundred. He was executed by electric chair in Florida in 1989.

Mother with child. Beaufort, South Carolina, 1965.

When I met Ku Klux Klan Grand Wizard Bobby Shelton, he asked if I would like to attend a rally. It was just like in the movies. White men and women with lighted torches set a cross on fire in the middle of a field. The KKK began in Tennessee in 1866 to insure white supremacy after the Civil War ended slavery. They tarred and feathered, lynched, burned, or threatened to kill black Americans and sympathetic whites. Under United States President Ulysses S. Grant the Klan lost power and membership, but was re-formed in 1915 by William J. Simmons, a preacher influenced by the D. W. Griffith film *Birth of a Nation*. By 1925 membership had reached its peak at four million. Disbanded in 1944, the Klan reemerged in the 1960s during the civil rights movement.

Baby David Vetter and mother, Carol Ann Demaret. Houston, Texas, 1972.

Four-month-old "Baby David," as he was called to protect his identity, was born with an x-chromosome defect to his immune system known as severe combined immune deficiency, which left him defenseless against germs and highly susceptible to multiple infections. His mother had to hold him through the plastic bubble tent, where he lived for twelve years. Bravely he underwent an experimental treatment in 1984 and died at the age of twelve. Medical advancements have now made it possible for those afflicted to live almost normal lives. Demaret is a member of the board of trustees of the Immune Deficiency Foundation, a nationwide patient advocacy group.

Sage Volkman. Placitas, New Mexico, 1988.

When on a camping trip with her father and brother in 1987, five-year-old Sage, left alone in the camper while the men were fishing, knocked over a lighted candle in her sleep. Her father saw the flames and rushed back. She was lifeless, but he resuscitated her. At the hospital, the family was told she had received third- and fourth-degree burns over 75 percent of her body and would likely not live. In a coma for six weeks, she underwent many difficult operations along with skin grafts, which followed over the next ten years. Although her physical therapy brought the most excruciating pain, she asked to be called a burn survivor not a burn victim. When she was seven she took her first steps. Determined to live a normal life, she has graduated from high school with honors. She has always been optimistic, and will major in psychology in college to help introduce other burn survivors back into society.

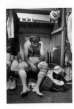

Joe Namath. Shea Stadium, Queens, New York, 1972.
After the New York Jets lost to the Houston Oilers, the quarterback sat in pain in the dressing room before taking the brace off his injured knee. The fans loved it when Broadway Joe bragged to the media that he would lead the Jets to victory over the favored Baltimore Colts in Super Bowl III in the Orange Bowl on January 12, 1969. He made good on his promise and became an instant superstar. Born in Pennsylvania in 1943, Namath played for Coach "Bear" Bryant at the University of Alabama. He was drafted by the St. Louis Cardinals but went to the AFL's N.Y. Jets (1965–76) and the Los Angeles Rams (1977) and was inducted into the Pro Football Hall of Fame in 1985.

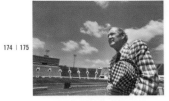

174 | 175

Paul "Bear" Bryant. Tuscaloosa, Alabama, 1979.
College football coaching legend Bryant coached many conference-winning teams at the University of Maryland (1945), the University of Kentucky (1946–53), Texas A&M University (1954–57), and the University of Alabama (1958–82). Mentor to many players who became professionals, perhaps his biggest protégé was quarterback Joe Namath. Namath has said "Bryant taught me the fundamentals of life. You must be honest with yourself." Known for his signature checkered hat, Bryant died less than a year after retiring from the University of Alabama at the age of seventy.

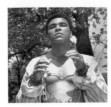

Mohammed Ali. Chicago, Illinois, 1976.
I asked the heavyweight champion to pose as George Washington for a story I was doing for America's Bicentennial. He said absolutely not—he wanted to be Nat Turner, the slave who in 1831 led an insurrection in Virginia but was captured and hanged. I found a seamstress to make the costume and a hardware store where I bought the chains and away we went in a limo. We jumped out at a park on the south side of Chicago. I held the chains so Ali wouldn't trip. He started shouting to a group of young blacks who were watching, "This white man has me in chains, he's made me a slave and he's taken my money." The young men started walking toward us when all of a sudden Ali broke out in laughter and hugged me. After the photos, I thought, I wouldn't want to go through that again.

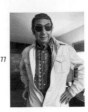

176 | 177

Howard Cosell. New York, New York, 1972.
Sportscaster Cosell, known for his outrageous antics and distinctive, gravely voice, once declared, "They didn't give me looks, but they gave me an absolute monopoly on brains and talent." The son of Polish immigrants, he grew up in Brooklyn and graduated Phi Beta Kappa with a law degree from New York University at twenty, and was editor of the *Law Review*. His on-air banter with Mohammed Ali is history and literally made his career. Ali once pulled off Cosell's toupée while being interviewed on live television.

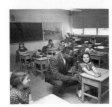

Charles "Sonny" Liston. Lewiston, Maine, 1965.
Before his return title fight with Mohammed Ali for heavyweight champion of the world, Liston had the reputation of not being very nice, so photographers and writers were very careful about how they approached him. I left the Lewistown gym just as his car was driving away and I followed. He pulled up to an elementary school with a "Sonny Liston Day" banner flying. He was quiet and gentle with the children, who sang and gave him a big cheer when he left. He went there with no fanfare and no press. Born in 1932, the 1962–64 heavyweight champion lost both fights against Ali, some say with a "phantom punch." With a pro record of fifty wins and four losses, with thirty-nine knockouts, Liston was found dead in his Las Vegas apartment in 1970 under mysterious circumstances.

178 | 179

Aleksandr Solzhenitsyn. Cavendish, Vermont, 1981.
The Soviet dissident was born in 1918, studied at Moscow University, fought in World War I, and graduated from Rostov University in 1941. Arrested in 1944 because of disrespectful remarks about Soviet leader Joseph Stalin in a letter to a friend, imprisoned and sent to the dreaded work camp Kazakhstan in 1950, Solzhenitsyn was exiled for life there in 1953. His masterpiece, *One Day in the Life of Ivan Denisovich* (1962), was followed by *Cancer Ward*, and *First Circle* (1970), the same year he won the Nobel Prize for Literature. He was expelled from the Soviet Union in 1974 after the first of three volumes of *Gulag Archipelago* were published. With his wife, Natalya, he moved to Vermont, where his three sons were home schooled. He returned to Russia after the fall of Communism.

President Richard M. Nixon. San Clemente, California, 1974.
Nixon was the stateliest of all of the presidents I have photographed. Here in the room he called the Western White House, he talked about the countries he had visited on his Middle East trip, on which I had accompanied him. While president, his summit meetings opened a United States relationship with China, eased tensions with the Soviet Union, and negotiated a nuclear weapons reduction treaty. The White House staff loved his wife, Patricia, and their daughter Trisha was married in the White House with her sister, Julie, as maid of honor.

180 | 181

Roy Cohn. New York, New York, 1986.
Cohn gained prominence in the 1950s as the steely-eyed chief counsel for Senator Joseph McCarthy during the Senate hearings' witch-hunt for Communists. In 1986 he still had that fighting spirit although he was fighting AIDS-related cancer and had just been disbarred by the Appellate Division of the New York State Supreme Court. He graduated from Columbia University Law School at nineteen, worked for the United States Attorney's office, and helped prosecute Julius and Ethel Rosenberg, who were convicted as Soviet spies and executed in 1953. Making up in feistiness what he lacked in integrity, he told me, "Harry, if you have anyone giving you any trouble, I'll send them a letter and it will scare the living hell out of them." He died later that year.

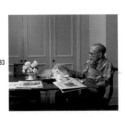

Roy Orbison. Graceland, Memphis, Tennessee, 1987.
The Texas-born rock and pop singer whose classics "Oh, Pretty Woman," "Only the Lonely," and "Blue Bayou" played on every jukebox in every bar across America in the 1950s, Orbison had a voice that was instantly recognizable. The forlorn lyrics seemed to speak to the young and old alike. After triple-bypass surgery in the 1970s, he began a revitalization of his career in the 1980s, shedding thirty pounds and recording a new album. Here, with a bronze of Elvis's head, he was visiting Graceland in a birthday tribute to the king of rock and roll. I found him to be a soft-spoken and kind person. In December 1988 the Rock and Roll Hall of Fame star died of a massive heart attack at the age of fifty-two.

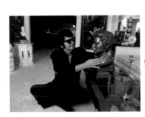

182 | 183

George Burns and his cat. Beverly Hills, California, 1992.
"What do you think? When you are ninety-six-years old and come home at night, you don't play with your cat," answered Burns to the reporter's question. Burns and his wife, Gracie Allen, entertained in vaudeville in the 1920s, on radio and in twenty films as themselves in the 1930s and 1940s with Burns as the straight man to Gracie's portrayal of the scatterbrained wife. Television audiences in the 1950s loved them as well. Forever smitten, Burns said, "I have a very special talent: Gracie Allen." To ease the sorrow of her death in 1964, he went back to doing stand-up comedy in Las Vegas. In 1975 Burns won the Academy Award for Best Supporting Actor for his role opposite Walter Matthau in Neil Simon's *The Sunshine Boys*. Until shortly before he died in 1996 at age 100, Burns played bridge at the Hillcrest Country Club with old friends.

184 | 185

Darryl F. Zanuck. New York, New York, c. 1966.
The legendary Hollywood producer looked exactly what I thought a mogul would look like. Cigar in mouth, sitting in his dressing gown, with scripts and papers about, continuously on the telephone, Zanuck was enjoying himself in his New York "office" in the Plaza Hotel. Born in 1902 in Nebraska, abandoned by his parents at age thirteen, he fought in World War I, knocked about, and became head of production for Warner Brothers by the time he was twenty-three. He gave the green light for the first talking picture, *The Jazz Singer* (1927). Leaving Warner Brothers, he founded Twentieth Century Films, took over Fox, and ruled for decades, producing classic after classic, including *All About Eve* (1950), *The Sun Also Rises* (1957), and *The Longest Day* (1962)—over 200 films in all. He died of pneumonia in 1979.

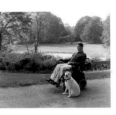

Christopher Reeve. Pound Ridge, New York, 1998.
Born in New York City in 1952, Reeve graduated from Cornell University in 1974 and studied acting at Julliard. He went on to become the star of the four Superman films. In 1995 Reeve, an avid equestrian, was thrown from his horse at a competition, and was left paralyzed from the neck down. With wife, Dana Morosi, and their three children by his side, his outspoken involvement as an activist raised the average American's awareness of the importance and necessity of embryonicstem cell research in finding new treatments for paralysis. Never giving up hope, he starred in a remake of the Hitchcock film *Rear Window* in 1998. In 2004, shortly before his death from complications of an infection of a pressure wound, a common complication for people in wheelchairs, he directed *The Brooke Ellison Story* for television.

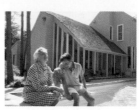

186 | 187
188 | 189
190 | 191

Arthur Miller. Roxbury, Connecticut, 2003.
A young woman answered the door and the reporter mistook her for the secretary. "No," she said, "I am Arthur's friend, not an employee." The son of Polish-Jewish immigrants, Miller was born in 1915 in New York. Winner of the 1949 Pulitzer Prize for his play *Death of a Salesman*, he wrote of his failed marriage to Marilyn Monroe in the play *After the Fall* and wrote the screenplay of *The Misfits* as a present to her. Perhaps America's most important playwright of the twentieth century, at eighty-eight he is still writing. His daughter, Rebecca, by his late wife, Inge Morath, is married to the actor Daniel Day-Lewis.

James Ivory and Rao. Claverack, New York, 2003.
Producer/director Ivory had agreed to a photograph in his rowboat at his upstate New York home when the boat tipped over. I told him to just "hold it for a second" and he did, while Rao went to fetch a stick Ivory had thrown into the water. In collaboration with Ismail Merchant and Ruth Prawer Jhabvala, Ivory's lavish period productions include *A Room with a View* (1986), *Howards End* (1992), and *The Remains of the Day* (1993). Born in California in 1928, Ivory graduated from the University of Southern California's School of Cinema-Television in 1957 and directed *Le Divorce* in 2003.

E. B. White. North Brookline, Maine, 1977.
The author of the children's classics *Stuart Little* and *Charlotte's Web*, which won the 1970 Laura Ingalls Wilder Medal, was known as a bit of a recluse. I rang his doorbell and handed a note to his housekeeper asking to photograph him, saying I was a dachshund lover. White came to the fence with his Cairn terrier and stood politely for a minute or two. I got a photograph of him the old-fashioned way, going directly to him. White received many awards, including the Presidential Medal of Freedom from President Kennedy in 1963. Born in New York in 1899, he died of Alzheimer's disease in 1985.

Joan Didion and John Gregory Dunne. Los Angeles, California, 1972.
Born in 1934, the diminutive writer was the features editor at *Vogue* before starting out on her own. She is best known for her book *Play It As It Lays*, a stunning depiction of American life in the 1960s, which was made into a film starring Tuesday Weld. Didion's other books include *Slouching Towards Bethlehem: Essays* and *The White Album*. Her husband, John Gregory Dunne (1932–2003), younger brother of writer Dominic Dunne, was a novelist, screenwriter, and literary critic. Born in Connecticut, he graduated from Princeton University, worked for *Time* magazine, and collaborated on screenplays including *Panic in Needle Park* (1971) and the remake of *A Star Is Born* (1976). His last book was the 1996 acclaimed *Playland*.

George H. W. and Barbara Bush. Houston, Texas, 1978.
Before being tapped as Ronald Reagan's running mate, the former congressman, born in Massachusetts in 1924, and his wife, sat by their pool with their cocker spaniel, C. Fred. After eight years as vice president, Bush served as president of the United States from 1989 to 1993, during which time the Berlin Wall fell and the Soviet Union dissolved into independent countries. When Saddam Hussein invaded Kuwait and threatened Saudi Arabia, Bush, with United Nations backing, sent 425,000 United States troops into Iraq in the war known as "Desert Storm." Recently, to celebrate his eightieth birthday, Bush went sky-diving. Barbara, daughter of a magazine publisher, children's literature advocate, and mother of President George W. Bush, authored *Millie's Book* about C. Fred's successor while in the White House.

President Dwight David Eisenhower. Palm Springs, California, 1965.
You could see he was an old soldier by his stance. His whole demeanor was that of a soldier. Born in Texas in 1890 and reared in Kansas, Eisenhower graduated from West Point and married Mamie Doud in 1916. During World War II he commanded the Allied forces' landing in North Africa in 1942, and by D-Day in 1944, he was Supreme Commander of the troops invading France on Normandy and Omaha beaches. The war hero was elected to the presidency for two terms beginning in 1952 and concentrated on maintaining world peace, which was won at such a high cost during the war. He died in 1969.

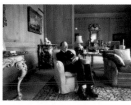

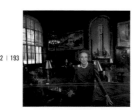

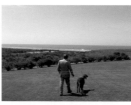

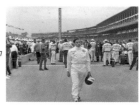

192 | 193
194 | 195
196 | 197

J. Paul Getty. Guildford, England, 1974.
Although it was autumn, there were daffodils everywhere in Getty's Tutor estate, Sutton Place. "Some flowers remind me of death," Getty, at the time considered the richest man in the world, said, "but daffodils remind me of spring. It's always springtime for me now." We recalled when he had given Britain's biggest-ever party at his home in 1962. I had gate-crashed, walked up to him, shook his hand, and said, "Mr. Getty, I hope you are enjoying your party.'" I ended up photographing him on the lawn of Sutton Place until six in the morning. The American industrialist, born in 1892, founded the Getty Oil Company. He published a collection of his essays under the amusing title *How to Be Rich*. He died in 1976 and his collection of art is housed at the J. Paul Getty Museum in Los Angeles.

Brooke Astor. New York, New York, 1988.
The petite socialite, born in 1902 in New Hampshire, was married three times, the third time in 1953 to Vincent Astor, the elder son of *Titanic* victim John Jacob Astor IV. Brooke took charge of the Vincent Astor Foundation when her husband died in 1959. The generous philanthropist received the Presidential Medal of Freedom in 1998 for her tireless dedication and charitable work for the homeless, conservation, and literacy. At 102, remarkably, she is still occasionally seen out and about at her favorite charitable events.

President Richard M. Nixon. San Clemente, California, 1974.
The president walked with his Irish setter, King Tamahoe, on the grounds of his home overlooking the Pacific, just days after his resignation. Born in 1913, Nixon served as Dwight D. Eisenhower's vice president (1953–61) and was the thirty-seventh president of the United States from 1969 until his resignation in 1974 over the Watergate break-in. "You must always allow a professional to do his job," the president told me as I photographed him at San Clemente. He died in 1994.

Bob Hope. Palm Springs, California, 1998.
Born in England in 1903, the comedian who delivered a line like no one else lived to be one hundred years old. His *Road* pictures with Bing Crosby are classics and for over fifty years Hope entertained U.S. troops abroad and hosted the Academy Awards more times than I can count. Delores, his wife of 69 years, is a singer who joined Hope in his vaudeville act in the 30s. In his later years, he liked to peoplewatch at the Palm Springs airport late at night and chat with the patrons in the coffee shop. He liked to stay up late and said it kept him in touch with people. In his bedroom with J. Dennis Paulin, the personal assistant who cared for him, Hope told me, "There's my Mama," and pointed to a picture of his mother on the wall by his bed.

Charles "Chuck" Yeager. Indianapolis, Indiana, 1986.
On October 14, 1947, Air Force Brigadier-General Yeager broke the sound barrier at 45,000 feet and the first sonic boom was heard. The event marked the beginning of the supersonic age. Project X-1 was kept secret for seven months but when it was announced, Yeager became the most famous pilot in the world. His fearless experiment was the forerunner of the *Apollo 11* moonwalk. He trained the first astronauts but wasn't recruited as one himself because he lacked a college degree. Born in 1923 in West Virginia, Yeager was a World War II ace pilot and a primary subject of Tom Wolfe's book *The Right Stuff*.

Jimmy Clark. Indianapolis, Indiana, 1965.
Just a few days after this photograph was taken, Scottish-born racing car legend Clark won the Indianapolis 500 in a Lotus, leading the race for 190 out of 200 laps. After his victory, he invited some of the press into his room for a drink, hoisting a single bottle of champagne over his head. Unbeknownst to Clark, a Scottish journalist in the crowd picked up the phone and, in his best imitation of Clark's voice, ordered twenty-five additional bottles sent to the room. Born in 1936, Clark drove in local races as a young man and began his Formula One career with Lotus in 1960. His twenty-five-race winning streak ended in 1968 when he was killed as his back tire failed and he crashed into a tree in a Formula Two race in Hockenheim, Germany.

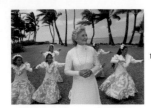

Princess Abigail Kinoki Kekaulike Kawananakoa. Honolulu, Hawaii, 1998.
One hundred years after sugar barons from the United States staged a coup and overthrew Hawaii's Queen Liliuokalani in 1893, President Clinton signed an apology bill. In 1898 the United States annexed the nation of Hawaii and on August 21, 1959, it became the fiftieth state. Princess Abigail is descended from Hawaiian royalty on her father's side and from her grandmother's side she inherited a portion of a $2-billion family trust. With the young dancers of the Ohana Hula Halau, the princess, born in 1927, strives to keep the memory and tradition of the monarchy alive.

198 | 199

Efrat Settlement. West Bank, 1983.
A Brooklyn Yeshiva class dances the Hora at an Israeli reunion on the West Bank. They had just arrived at the newly built settlement that day.

Christian, Kieran, and Macaulay Culkin (left to right). New York, New York, 1991.
Born in 1980, child star Macaulay earned $100,000 for *Home Alone* (1990). The film was such a hit that he received $4,500,000 for *Home Alone 2* (1992). As he grew older, children's roles went to his younger brothers Kieran and Rory. Burned out by 1995, Macaulay finally returned to acting in 2001 on the London stage. Divorced from actress Rachel Miner and godfather to Michael Jackson's first child, he recently starred in the film *Party Monster* (2003).

200 | 201

Michael Jackson. Neverland, California, 1993.
The "King of Pop," Michael Jackson had invited all the children of the people who worked at his home, Neverland, to visit for the day, ride the rides at his own amusement park, and see the exotic animals in his zoo. They took a train ride around the property and had a tour of the house before they all went home later that afternoon.

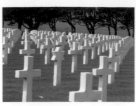

American cemetery. Colleville-sur-Mer, France, 1994.
Of the more than 10,000 American soldiers killed in the June 6, 1944, D-Day invasion by Allied forces on Omaha Beach, 9,387 are buried in Normandy. That day turned the tide in favor of the Allies in World War II. Supreme Commander General Dwight D. Eisenhower called the landing "a great and noble undertaking." In the face of German soldiers high above the beach in bunkers with machine guns, the Americans stormed the beachhead and, in bitter fighting, secured it within a day.

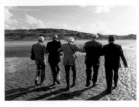

202 | 203

World War II veterans. Omaha Beach, Normandy, France, 1994
These five men were on the first wave that landed on Omaha Beach on June 6, 1944. They returned for the fiftieth anniversary of the invasion by the Allied forces, who established a beachhead on the coast of France. That landing was the beginning of the end of World War II. Under the command of General Dwight D. Eisenhower, Supreme Commander of the Allied Forces in Europe, 4,500 ships landed 150,000 troops to secure the French coastline. Ten thousand Allied troops were lost that day and the bloodiest battle was on Omaha Beach, where German soldiers fought back from concrete bunkers up the embankment from the beach. I introduced the men to a former German soldier who had been in a machine-gun net on the beach when they landed. When they met, there was absolutely no animosity. Strangely, there was a kind of warmth among them.

Tessa Wick. Los Angeles, California, 2003.
When twelve-year-old Tessa was diagnosed with juvenile diabetes at the age of eight, she decided there needed to be a cure. The determined daughter of noted filmmakers Lucy Fisher and Doug Wick organized her friends into "Tessa's Troopers." They have raised over $1 million dollars for research. Tessa appeared before a United States Senate panel to raise awareness of the importance of stem cell research in the search for a cure.

204 | 205

Maggie, Eleanor, and Reg Green. Bodega, California, 1994.
Reg, Maggie and their two children, Nicholas, 7, and Eleanor, 4, were on holiday in Italy when a masked man fired shots into their car and sped off. Both children were sleeping peacefully in the back seat. At the next town, they stopped at the police station and saw blood coming from Nicholas's head. Reg said, "I knew at that instant I would never be happy again." Nicholas was brain-dead in a deep coma when Reg and Maggie made the decision of their life. On October 2, 1994, seven Italian children received Nicholas's organs and cells. The world read of their horrendous ordeal and their unselfishness. The shooter was caught and sentenced to life in prison. The family, which now includes twins Martin and Laura, continues in their efforts to recruit organ donors.